CW00945811

Why Are Artists Poor?

Why Are Artists Poor?

The Exceptional Economy of the Arts

Hans Abbing

Amsterdam University Press

Photo front cover: Hans Abbing, Amsterdam

Cover design: Joseph Plateau, Amsterdam
Lay-out: Adriaan de Jonge, Amsterdam

ISBN 90 5356 565 5
NUGI 911/651

© Amsterdam University Press, Amsterdam, 2002

Table of Contents

Epilogue: the Future Economy of the Arts

Is this Book's Representation of the Economy of the Arts Outdated? 295

Preface

Why is the average income of artists low? Why do so many people still become artists despite the prospects of a low income? And why is it that the arts rely so heavily on gifts like subsidies and donations? Are these three phenomena related? Is it because most artists earn so little that the arts receive so many subsidies and donations? Or is the abundance of artists and their low incomes due to the fact that the arts receive donations and subsidies? Do artists who earn low incomes sacrifice themselves for their art, or are they being sacrificed by a system that pretends to support them?

In this book I will study the causes and consequences of the pervasive gift sphere in the arts, as well as low incomes and a large quantity of artists. I reject the argument that people do not care enough about art and that, consequently, an artist's income remains low and thus donors eventually get involved. (Regardless of one's definition of art, the expenditure on art products has never been large. Nevertheless, during the last decades, western nations expenditures on art have risen more than incomes. Thus, the notion of under-consumption is hard to maintain.) In order to explain the pervasive gift sphere, I examine the artists' motivations, attitudes in the art world, and the myths surrounding art. The argument I advance in this book is that the economy of the arts is exceptional. The impact of the mystique of the arts calls for a multidisciplinary approach. Therefore, I will employ insights taken from sociology and psychology. Nevertheless, my neoclassical background in economics will shine through throughout the course of the book.

As an *artist* I am immersed in the art world. When I look around me there is much that puzzles me. I know of artists who earn a lot of money and I have one or two colleagues who do relatively well. Other colleagues manage to survive, like I do, because they sell their work regularly, receive grants and subsidies, or they have interesting second jobs. Most of my colleagues, however, are poor. They hardly sell, have lousy second jobs, and yet they carry on. I don't understand why they just don't quit the profession.

As an *economist* and social scientist I cannot ignore this confused state of affairs. Using a phrase of Deirdre McCloskey, I climb up to the tenth floor and gaze down at the art world. I notice that the economy of the arts, in its basic structure, resembles that of, say, food-production. Both economic sectors are involved in buying and selling, while prices govern supply and demand. Nevertheless, I remain puzzled by what I see. For instance, I can't comprehend the numerous donations and subsidies nor the abundance of artists willing to work for low pay. Even from this perspective on the tenth floor I find it difficult to see patterns in the ongoing process.

The contrasts and Janus-like quality of the arts are puzzling for artist and economist alike. Therefore, this book proposes that the artist and economist join forces. They will look down from the tenth floor together. Because their knowledge and perspective can reinforce each other, they start to discern patterns in the arts economy. This book tries to explain these patterns.

The most striking aspect in these patterns is the two-faced character of the economy of the arts. The contrast is visible from outward signs. On the one hand there is a world of splendor, of magnificent opera houses, chic openings, of artists earning very high incomes and of rich donors whose status is enhanced by their association with the arts. On the other hand there is the large majority of artists earning little or nothing; often they lose money by working in the arts and make up for the losses by working in second jobs or accepting support from their partners. Moreover large sums of social security and other allowances not intended for the arts flow into it.

The contrast also shows from attitudes in the arts that are intrinsically two-faced. On the one hand money and commerce are rejected. On the other hand trade is very present in the temple of sacred art, as it was in the temple of the Jews. The temple of art cannot exist without trade. Moreover, the trade in art profits from the belief that art is sacred and beyond commerce. For art-dealers denying the economy is profitable: it is commercial to be anti-commercial. Such denial and simultaneous embrace of money is present in almost any transaction in the arts. Does this double moral standard contribute to the strong contrast between wealth and poverty in the arts? These are challenging questions that this book on the exceptional economy of the arts tries to answer.

The Art Forms Addressed Because I am a visual artist I shall use examples from the visual arts more than from other art forms, but this does not imply that my analysis only applies to the visual arts. On the contrary, in principal, I treat any object or activity that people in the West

call art. For the analysis of the economy of the arts it is important however, to acknowledge that experts (or the general public) sooner call certain objects and activities art than other objects and activities. For instance opera is often 'more art' than pop music. In order to study this phenomenon, no art form, low or high, will be excluded from the analysis.

There is one exception; my analysis does not refer to the applied arts, but only to the 'fine arts' as they are called in the Anglo-Saxon countries or the 'autonomous arts' as they are called in mainland Western Europe. In the applied arts, the surplus of artists is not as large and income is more reasonable. In other words, the economy of the applied arts is not that exceptional.

The book analyzes the economy of the arts in mainland Western Europe, Britain and the USA. A recurring focus in the book will be comparing the economy of the arts in mainland Western Western Europe and the USA. In many respects Britain fits in somewhere in the middle. Therefore the book pays no separate attention to the economy of the arts in countries like Canada, Australia, or Japan.

Method and Form Letting the artist and economist join forces is easier said than done. The culture of economists differs from the culture of artists, as was observed in *The Two Cultures* by C. P. Snow.[1] Artists and economists speak different languages. Nevertheless, the apparent conflict also offers ample material for analysis. Therefore I shall begin each chapter with a confrontation between my beliefs as an artist and my beliefs as an economist and social scientist. In other words, by taking both points of view seriously, I will try to deal with the economic impact of the mystique of the arts. In doing so, I will also employ insights from the fields of sociology and psychology.

But by using the artist's perspective along with that of more than one academic discipline I run the risk of losing readers along the way. On the one hand, artists and other people working in the art as well as readers educated in another social science may find the story to be too economic, while those educated in economics may find the arguments too artistic or sociological. I must also warn the reader that this book does not intend to produce the precise, rigorous and parsimonious research often associated with economics. In order to make sense of the exceptional economy of the arts I shall stress the many ambiguities that confront the study of this peculiar economy. Nevertheless, by attempting to satisfy both the artist and economist inside me, I hope to satisfy the reader as well.

The analysis in this book rests on existing theories, available data, and on my own 'fieldwork' in the arts. The observations I make as an artist

are an important ethnographic empirical source within an interpretative approach to economics.[2] They contribute to the picture of the arts economy as I portray it in this book. I have tried to create a convincing picture. In this context, I advance a series of theses and propositions. I would be the first to acknowledge that the empirical support for some of these theses is insufficient. I also feel that more input from institutional economics would have been fruitful. Because, after all, I am desperate to resume my artwork, I am more than happy to let other, more skilled and patient researchers fill these lacunae. I certainly hope that my picture of the economy of the arts will inspire readers to draw their own picture. Only then will something like a 'true' picture begin to emerge.

The questions that are raised at the end of each chapter will hopefully serve to stimulate the discussion. I included them to make the reading of the text less passive. The questions do not have a single 'correct' answer. The questions will hopefully invite the reader to reflect on the chapter's findings.

For Whom I Have Written the Book The first group I had in mind while writing this book is *artists*. My colleagues are likely to recognize much of what I have written. The analysis will hopefully help them to develop a better understanding of their economic situation. I do not expect them to agree with all of my conclusions, but I think they will enjoy the discussion. Because of its critical stance, I think that this book should be a must read for all prospective artists. It should make them want to reconsider their decisions that led them to become artists.

This book is also written for *economists* interested in culture. I expect that for them it will contain some new and sometimes controversial insights. The same goes for other *social scientists*. I have tried to present economic insights in a way that will make them more accessible and interesting for non-economists.

Foremost, I have written this book for *art administrators* and people working in arts-related jobs. Because they are the 'mediators' between the arts and the rest of the world, they must be especially puzzled by the exceptional character of the economy of the arts. I expect that they as well as students who intend to find arts-related work shall benefit most from my book. This would apply to *students* following a variety of courses in cultural studies, cultural economics, art economics, art history, art marketing, and art management. The book does not offer straightforward advice, but hopefully its insights will provide the reader with cognition, inspiration, pleasure, *and* some useful despair.

Acknowledgements The Art Department of the ING Group, the Erasmus University, the Ministry of Education, Culture and Sciences (OCW) and the Netherlands Organization for Scientific Research (NWO) all made financial contributions.

I am especially thankful to my friends Arjo Klamer and Olav Velthuis. Klamer contributed in several ways to this book. First, he came to Rotterdam and gathered an inspiring group of young scholars around him. This gave my withering interest in economics a new impetus. Second, it is nice competing with Arjo. I try to show that some of my views are better than his. Thirdly and most importantly, he contributed by respectfully criticizing the manuscript. (Even an extremely authority-phobic person as I am could handle this criticism from a 'superior' friend.) Olav and I share important socio-political views. Therefore he has been a most welcome sparring partner throughout the writing process. Our discussions encouraged me to go further than I otherwise would have gone.

I also want to thank the following people who all made essential contributions to the book: Steve Austen, Maks Banens, Mark Blaug, Deirdre McCloskey, Krista Connerly, Peter Cross, Wilfred Dolfsma, Maarten Doorman, Bregje van Eekelen, Karlijn Ernst, Marlite Halbertsma, Sicco Heyligers, Teunis IJdens, Suzanne Janssen, Rianne Lannoy, Berend Jan Langenberg, Wouter de Nooy, Henk van Os, Pieter van Os, Bart Plantenga, Merijn Rengers, Marc Roscam Abbing, Barend Schuurman, Irene van Staveren, Ruth Towse, Rolf Toxopeus, Giga Weidenhammer, Rutger Wolfson, and P.W. Zuidhof.

Finally, I would like to acknowledge the following towns which I visited between August 1997 and February 2001 while writing this book. Apart from Amsterdam I also ventured to Bangkok, Barcelona, Brussels, Budapest, Istanbul, Liège, London, Poznan, Prague, and Recifi. These lively towns and the people I met there made this project worthwhile. For most of the people I met, art meant little or nothing. I am amazed that I still manage to make such a fuss about it.

Chapter 1
Sacred Art

Who Has the Power to Define Art?

Feeling Uncomfortable About Art

Alex, who is both artist and economist, lives in a house with six adults and two children. They share a living room and eat dinner together. The other adults have above average educations and work in technical professions. Alex noticed that at home he usually behaves like an economist rather than an artist. That way they all speak the same language. When he begins to behave like an artist, his housemates feel less comfortable.

Once a week Alex picks little Judith, one of the children in the house, up from school and they spend the afternoon together. Sometimes they visit galleries or museums. Judith is four and still enjoys it. The other day her father, Eddy, confided to Alex that he is pleased that Alex is bringing some cultural education into Judith's life. She really can't expect to receive much cultural education from her parents, Eddy added apologetically.

Cultural Superiority versus Inferiority

Alex finds it hard to characterize his own art. People knowledgeable about art usually characterize his artwork as so-called contemporary or avant-garde. They add that his art reveals aspects of outsider art or 'art brut'.[1] Alex thinks that this puts him in a no-man's-land where his work is respected in both avant-garde art and traditional circles. He exhibits in both areas. However, Alex soon discovered that these two areas in the arts do not carry the same weight in the art world.

Each year Alex exhibits his pastel drawings of 'heads' – as he calls them – in an annual portrait show. The portrait painters who exhibit in this show have one thing in common: they are not ashamed to reveal their traditional schooling. One day during the course of the show, Alex had to be an attendant. He had plenty of time to watch people. From earlier experience he already knew that the longer visitors remain in front of a particular artist's work the higher their appreciation of the work. Most of the people, however, pass right by his work without stopping, as if there's nothing to see. When he confronts them later, they usually apologize, even though they do not realize he is the artist. They usually say something like: "I suppose it is

good, but personally I don't like it." But he is delighted to learn that some visitors – a minority – only have eyes for his work. When Alex confronts them they will angrily declare that his work is the only thing here that could be called art. Alex notes that these visitors express this as if it were a fact. Unlike the earlier group, they did not express it as a personal opinion. There was no apology. Alex is struck by the asymmetrical nature of the behavior of these two groups.

Why is it that Eddy, in the first illustration, apologizes for being unable to provide his daughter with a more culturally oriented upbringing? And how can we explain why the exhibition's ordinary visitors, the ones who prefer the traditional paintings, apologize for not showing more interest in the avant-garde paintings, while those who prefer the avant-garde paintings are angry at being confronted with the more traditional paintings?

To be honest, *as an artist* and an art lover, I take the difference in behavior for granted. I think that certain kinds of art are superior to others, and therefore, I find it natural that one group has no respect for the art preferred by the other and that the latter group looks up to the art of the first group. *As a social scientist* however, I am sometimes bewildered by the asymmetry in the groups' respective appraisals, and I desire to understand it.

Is it possible that certain artworks are 'more' art than others? This depends on one's definition of art. So, *what is art?* Although this is probably the last question one would expect in a book about the economy of the arts, I intend to show that the discussion of the question is essential for the analysis of the arts economy.

1 Art is What People Call Art

When I am among colleagues in the arts, we always end up in discussions about what art is and what isn't. But when I am among economists in the art-economics field, we never discuss this question. Likewise, in books and articles on the economics of the arts, economists seldom pay attention to the definition of their subject matter. David Throsby, in an important review on the progress of cultural economics, writes: "When asked to define jazz, Louis Armstrong is reputed to have replied, 'If you got to ask, you ain't never going to know.'"[2] Throsby then dismisses the question of defining art. What he is suggesting by this is that if you need to ask what art is, you will never know. At the same time, Throsby expects his readers to know what art is. Meaning that it is tacit knowledge; that it's

not only impossible but also unnecessary to put such knowledge into words.

Not defining the subject matter can be tricky. After all, economists discussing art always have an implicit notion of what art is and isn't in the back of their minds, and this notion necessarily influences their findings.[3] For instance, in many studies on the economy of the arts no attention is paid to pop music, while the reasons for this oversight are unclear. Is it because pop music isn't art, or are there other reasons?

As an artist and art lover I want to believe that works of art are products that have intrinsic qualities that ultimately turn them into art. Certain forms of music and painting are art, others are not. But if somebody were to ask me to name the qualities that turn paintings into art, I may well point to qualities that some of my colleagues would disagree with. Hence the heated discussions. Evidently, contradicting views exist on what art is, and this does not help in the construction of a timeless definition of art.

Given these kinds of controversies, it is understandable that economists do not feel competent enough to make absolute statements about what art is. The subject matter can also be discussed in relative terms, however. How do people define art? Do some people have a larger say in the definition of art than others? And how do these differences translate to the economy of the arts?

In mentioning Louis Armstrong, Throsby touches upon a phenomenon that is important in the present context. If Throsby had written his article on the economics of the arts in the days Louis Armstrong was active as a musician he would never have cited him. The amazing thing is that in those days most people would not have called Armstrong an artist. At that time jazz was not art. It is likely that Armstrong did not see himself as an artist. He must have certainly seen himself as a fine musician and a great entertainer, as did his audience, but not as an artist. Since then, Jazz has turned into art, even with retroactive effect. So Throsby can cite Armstrong with no qualms in his treatise about art.

It is surprising how the boundaries of art can change so profoundly. Values have changed and so has the definition of art. Back then Jazz was not considered 'real' art and now it is. On the other hand, many art lovers consider the late nineteenth century German symbolist paintings hardly as 'real' art anymore. Thus it follows that what people call art is relative; it is not based on intrinsic qualities, as the artist inside me would like to believe.

Because what is considered as art is relative, I prefer to follow the sociological approach: *art is what people call art*. The demarcation of what art is, is based on the judgment of people, where 'people' can be a small

group of insiders or the general population. In the sociological approach to art it is often an 'art world' that defines what art is in a specific artistic area.[4] The term implies that people who have a relative big say in the definition of art are related; they are part of a group or 'world'. Such worlds can be defined narrowly or broadly. If not indicated otherwise, I use art worlds in a broad sense.

In calling certain phenomena art, people are in effect ranking these phenomena. People are always distinguishing products that are considered art from those that are not. Behind this binary ordering lies a continuous ordering. People classify products as being more or less 'art'. Somewhere a demarcation line is drawn: above this line art is considered high art, fine art, or 'real' art, while below this line we find low art, popular art, or non-art.

Because the arts evolve and new genres arise, an art world is continuously repositioning this demarcation line. This is apparent from the Jazz example. When relatively small art worlds are analyzed, there can be as many orderings and lines and subsequent definitions of art as there are art worlds. Within society, however, such different opinions 'add up' and a dominant definition emerges. That definition ends up governing the economy of the arts.

It is clear that this book will not answer the literal question 'what is art?' Nobody can accurately detect art by using some objective device. Instead people are asked what they think art is. In this context it should be noted that when people call certain things art, they do not all have the same say or vote. Some have a bigger say than others. This is comparable to the market where some have more money to spend than others. Therefore, *art is what people call art, acknowledging that some people have a bigger say in it than others have* (thesis 1).

2 Cultural Inferiority and Superiority Color the Economy of the Arts

As an artist I cater almost exclusively to the rich and well-educated. Sometimes I feel uncomfortable about this. I often don't feel my work is any better than that of 'artists' whose work can be found in open-air markets for instance, and who sell their work to the not so rich and the not as well educated people. I don't understand why my work is judged to be true art while theirs is not. As a social scientist I want to understand this phenomenon. That's why I climb up to the tenth floor in the hope of seeing a pattern to what is going on.

From the tenth floor I notice that the phenomenon is not unique. First of all, I see many other examples of systematic differences in taste

between the higher and lower strata in classes. I notice, for instance, that the printer of this book, with his working-class background, buys Guns and Roses CDs, comic books, and a little sculpture of a dolphin to put on his windowsill. These things represent art to him. The editor of this book, who has a more upscale upbringing, buys CDs with music composed by Paganini and goes to the museum of modern art to look at paintings by Lichtenstein and sculptures by Jeff Koons. That is her art. Tastes differ; this is not so special. At first sight, these divergent preferences appear to originate from non-overlapping, separate realms, which are based on completely different and irreconcilable views of what art is.

Then I notice that the editor and the printer know about each other's choices when it comes to art, albeit not in detail. They judge each other's art. On the one hand, comic book drawings are less art to the editor than Lichtenstein's blow-ups. As a matter of fact, she actually resents the printer's choices in art: "This is not art!" On the other hand, the printer could well say something like: "Well, yes, this classical stuff – what was the name? Paginanni? – is of course 'real' art and Guns and Roses is not. Yes, I know, classical music is 'real' art, and I suppose I should know more about it, and about the things in museums of modern art as well but, well, you know, it's just not for people like me." Evidently he looks up to the editor's high art, while the editor looks down on the printer's low art.

Research has shown that social classes are not only vaguely aware of each other's preferences, but that they order them more or less similarly.[5] What is high for the editor is also high for the printer. Therefore judgments regarding art are largely similar between various social groups. They run parallel. However, judgments concerning each other's art choices do not run similar. On the contrary, they are asymmetrical.

It is this apparent asymmetry or non-reciprocity in judgments that is so striking. People have notions regarding the art of other social groups and they assess these notions. Group A puts down the art of group B, while group B looks up to the art choices made by group A. I call this the phenomenon of *asymmetric judgment* or *cultural asymmetry*.[6] It is this asymmetry that is revealed by the illustrations. In the first illustration the a-cultural housemate apologizes for not being culturally educated. The second illustration reveals a group apologizing for preferring traditional art, while the group that prefers contemporary art scolds the traditional art group for their preferences. The fact that those moving up the social ladder are more likely to change their choice of art than those moving down also proves that judgments are asymmetrical. Two types of art exist: superior and inferior art, high and low art, or real and non-art.

Normally, people are so involved in discussions regarding high versus low art that they are unable to develop a tenth-floor perspective to see

patterns in their and other people's behavior. From the tenth floor, however, we observe that there is considerable social agreement on what is 'real' art and what is not. Within a given culture, a dominant and universal undercurrent exists which determines what is more and what is less art.[7]

Much of the reasoning in later chapters rests on the thesis that because of cultural inferiority and cultural superiority judgments are asymmetric. The thesis rests on five generally held assumptions.

1 There exists a general social stratification in society. Some people hold higher positions, with more wealth and honor than other people, and most people are aware of these positions.

2 People want to 'better themselves'. (This is a basic assumption in economics.) This implies that people prefer climbing up the social ladder to falling down.

3 Because people aspire to higher positions on the social ladder, they focus on the symbolic goods and practices, including works of art and ways of consuming art, of those people in higher positions. They look up to these goods and practices. It is their future. On the other hand, they try to distance themselves from people lower than them on the social ladder. They look down on their goods and practices.

4 Because of its symbolically rich content art is used to mark one's social status.

5 Social coherence in society is strong enough to maintain a shared notion of high and low art.[8]

If these assumptions are correct, they offer a solution to the questions raised in the illustrations. 'Why do the lower classes look up to the art chosen by the upper classes, while the latter look down upon the art of the former?' 'How can we explain why Eddy and the people at the exhibition look up to the fine arts and apologize for knowing so little about it?' Because people want to improve their social standing, they are generally oriented towards the art of the people above them, and apologize for their own choices. 'And why do people broadly agree on what real art is?' Due to social cohesion people share a general notion of high and low in society.

Generally these assumptions are seldom disputed. Nevertheless, some people argue that the differences between high and low art have started to disappear.[9] It's true that some contemporary consumers of high art also quite publicly consume low art as well. This could signify that cultural asymmetry would become less important. For instance, I listen to Tom Jones even though I have little in common with the average Tom Jones fan. This kind of cosmopolitan omnivorousness, as Peterson calls

it, however, does not necessarily contradict the notion of asymmetry.[10] (1) This phenomenon is for the most part non-reciprocal; it applies mostly to elite art consumers and seldom to the average consumer of low art.[11] (2) It is often more relevant to look at the ways in which art products are consumed.[12] Even when certain works of art, like Van Gogh paintings, are 'shared' by high and low groups, the ways in which the art-works are consumed and the symbolic practices in which they serve differ between the various classes.[13] For instance, when lower class art becomes part of the omnivorous consumption patterns of higher classes these patterns are sometimes 'camp'. A double moral standard is involved here: consumers both admire and mock the culture of the lower classes. Therefore, I do not think that the difference between high and low art is necessarily disappearing and I maintain that the thesis of asymmetric judgment remains valid.[14]

By the way, as is common in the field of economics, I use such terms as 'consumption', 'to consume', and 'consumer' in a broad sense. Some readers will probably associate consumption with 'using up', but in this book, consuming art does not imply that art is swallowed. Watching, listening, and attending can all be forms of consumption.

As long as there is social stratification and as long as art products are used to mark a person's position on the social ladder, an asymmetric judgment of art products will exist. People higher on the ladder look down on the art of people lower than them, while the latter do not look down on, but look up to the art of the former (thesis 2). It follows that *the power to define art is not distributed equally among social classes* (thesis 3). *People in higher positions have a de facto larger say in the definition of art than people in lower positions* (thesis 4). Whether they are aware of it or not, people in higher positions appropriate the definition of art.

3 'Art is Sacred'

Art is apparently attractive to the higher social classes. So what are the attractive qualities that people in the art world associate with art? Sacredness is one such quality and a relatively constant one at that.

Long before Romanticism, people associated art with what was considered sacred, an association that became firmly established during this period. And ever since Romanticism, people have tended to call what they perceive as sacred objects and activities art and vice versa. By calling objects and activities art they become consecrated. What people label as art tends to be considered sacred or to stand for sacred matters.[15]

It is important to emphasize that this view does not imply that art is

sacred in any objective sense. (Nor that the author believes art to be sacred. On the contrary, many insights in this book tend to demystify art.) Yet, it is also important to acknowledge that when a general belief in art's sacredness exists in society, anyone can harbor traces of this belief.

I am no different. I too tend to put art on a pedestal, as if it were holy and therefore in need of special treatment. Let me offer two examples. First, when I meet youngsters who are interested in becoming artists, I immediately start to stimulate them. I would not bother if all they wanted to become was a hairdresser or a manager. Only later will I inform them that there are already too many artists and that art might end up disappointing them. Second, recently in a Dutch journal I advocated for lower subsidies for the arts in the Netherlands. After I had written down my opinion, I noticed that I was my own worst enemy. Even before anybody reacted, I started to feel guilty and I had many sleepless nights. It felt as if I had somehow desecrated art.

Many artists and art lovers experience art as intrinsically sacred. The work of art is animated. Not only is the artist 'in' the work of art, but often God or a supernatural power as well. Art is miraculous. It is a gift from above and artists are gifted. Because the source of the gift is unknown, a miracle is involved that goes beyond human understanding.[16]

It has been suggested that in its sacredness, art has joined religion and to some degree taken its place.[17] Whether this is true or not, part of art consumption clearly resembles religious consumption. For instance, the silence in museums and at classical concerts reminds us of religious worship.[18] Art has an aura, as Walter Benjamin called it. He drew attention to the cult value of art and the ritual functions of art.[19] The higher the cult value of objects and activities and the more important their ritual functions, in other words, the more sacred objects and activities are, and consequently, the more likely they will be called art. (Benjamin expected that the technical reproduction of art would lead to its demystification. But thus far, technical reproduction has not put an end to the cult of art. It has instead only added new forms.)

The fact that art or the fine arts are put on a pedestal may serve a purpose. Art probably represents or expresses values that are of the utmost importance to society. Art, like religion, manifests the basic values in society and the changes in those values. Moreover, works of art comment on these values, often less directly, but not necessarily less effectively than the stories in the great religious books once did. In their recording capacity, art offers an amazing archive of what came before. No history book can compete with the vividness of old paintings, sculptures, and literature. 'Art' is a treasure trove consisting of almost everything of value

that our ancestors have left behind. This way art stands for the accumulated past. It is above all this quality that adds to the assumed sacredness of art. Artists, like priests, both guard this treasure trove and add to it. Because art represents high values, it is looked up to. Art as a bearer of the values of civilization must be sacred.[20] The same applies when art expresses important values inherent to the identities of nations or of ethnic and religious groups.

The perversity of the low or popular 'art' of the common man adds to the sacredness of high art. Low 'art' degrades, while fine art ennobles. To Allen Bloom in his book *The Closing of the American Mind,* rock music offers "nothing high, profound, delicate, tasteful, or even decent", while fine art, including classical music, is "something high, profound, respectable".[21] Therefore, the asymmetrical valuation in the arts does not only follow from the sacredness and therefore absolute superiority of the fine arts, but also from the perversity of low 'art'.

In other respects as well, art's sacredness does not stand on its own. It interacts with other relatively constant factors to determine what people call art, like the authenticity, uselessness, and remoteness of art, elements that will be discussed in the following sections.

4 'Art is Authentic'

A work of art and its maker are said to be authentic. In a formal sense, they are authentic if the artist in question is the only one who could have made the particular work of art.[22] A unique fingerprint of the artist somehow manages to creep into the work of art, its style, the signature or some other quality.[23] In expressionist works of art the personal touch is very visible; people 'recognize' the artist in the work of art. In other works of art this quality remains more hidden; in fact, so much so that sometimes only the artist's signature can be verified as genuine.

Because of authenticity people look up to art and artists. What else can explain that in 1998 the Dutch government was prepared to pay 36 million Euro (appr. 32 million Dollars) for an unfinished painting by Mondrian, as mentioned in the illustration on page 232? After all, it's just a piece of linen on a wooden frame with some dots of paint on it.[24] Much cheaper copies could easily be produced, which in their appearance could offer almost anything the original offers. Nevertheless, people believe that the original is irreplaceable, because they *know* that Mondrian made this specific work of art. They feel that in one way or another he is 'in' the painting. Or, to give another example, only the extreme importance of authenticity can explain that the price of a Rembrandt painting drops to

less than a tenth when experts prove that a student of Rembrandt painted it.

The extraordinary value of authenticity in modern art has a long history, which commences in the Renaissance. Prior to the Renaissance, works people now call art were basically multiples usually made by trained artisans. The producers never intended to let their personalities influence their work. It was during the Renaissance that works of art began to become animated – the artist 'entered' the work of art. Therefore, the signature of the artist was no longer irrelevant. Animation was clearly a magical act. Gradually it began to render the work of art sacred, and little by little this sacredness started to rub off on artists as well.

Before the Renaissance, people were primarily part of a group. Since the Renaissance, authenticity has gradually become one of the highest ideals in modern society. Only with Romanticism did this ideal become clearly embodied in specific individuals, above all in so-called bohemian artists. Culture as a representation of a superior reality was an 'invention' of Romanticism, as was the notion of free disinterested, spontaneous 'creation', founded on innate inspiration.[25]

At the beginning of the nineteenth century, artists began to emerge as bohemians who stood next to the bourgeoisie. At first these bohemian artists were relatively unimportant. By the end of the nineteenth century, their numbers had increased and by the early twentieth century the presence of bohemian artists was felt everywhere. At present, the bohemian artist serves as the role model for almost all artists. Even for those (postmodern) artists who oppose this model and try to develop a new model, the old model remains the point of reference.

Artists were and are the only people who can give verifiable proof of their uniqueness, of their authenticity. Although in everyday life, the bourgeoisie may have shown their contempt for bohemian artists, they also developed feelings of jealousy for these artists as well as an increasing esteem for successful artists and art generally. Successful artists were viewed as the sole producers of authenticity. True artists were and are geniuses. This worship of art has become very important in the twentieth century.

Beginning with the Renaissance and up to Romanticism, some artists were held in high esteem but they did not offer an alternative to the bourgeois lifestyle, which was firmly implanted in the world of business and commerce of those days. However, over the last one hundred and fifty years artists and the arts have become symbols of an alternative to the bourgeois lifestyle. It was a romantic, not a realistic alternative; and this probably added to its allure. Since Romanticism, society has worshipped authentic and sacred art.

Art consumers often try to identify with one or more of their favorite artists. By listening to their works or by surrounding themselves with their works they share a little of the artist's uniqueness.[26] Artists are adored. In the market, this leads to extremely high prices as well as high incomes for a small select group of artists.

Even today people are still jealous of artists. It is telling that when I am at a social gathering of scientists, the host will usually introduce me emphatically as an artist. Moreover, I get far more attention than I would get, were I presented as an economist. This implies that a romantic vision of the arts still exists. In our rational modern society art fills a void or compensates for what is missing in our everyday lives. *The arts offer a romantic alternative* (thesis 5).[27]

5 'Art is Superfluous and Remote'

Remoteness and uselessness are two other relatively constant factors that can often be found in objects and activities that people call art and consequently, add to the notion of art's sacredness. Art tends to be detached from the needs of everyday life.[28] Food for instance, fulfills needs. Among its functions are nourishment and social gatherings. But art seems to serve no such purpose; it is superfluous, luxury par excellence. The aesthetic experience thus is an aim in itself.

According to Laermans, classical music and modern visual art are considered art because people have conferred the characteristics of uselessness and luxury on them. Their only acknowledged purpose is the rendering of an aesthetic experience. Pop music and other forms of mass-produced low art products, on the other hand, are not art, because people need them in order to identify with other people, to find role models, to understand life and most importantly, to learn about what is good and what is bad.[29]

In this respect it is revealing that when artists in low art genres such as pop music or advertisement design try to join the fine arts, they often claim that their products have become more formal and more detached and therefore less useful.

If art has little use value it becomes a luxury and thus works of art can be found primarily among wealthy people and institutions. Since their daily needs are fulfilled they can afford art. In this respect, art is aristocratic. It comes to people who never had to work hard to be able to buy it and who apparently do not 'need' it. The fact that art and the consumption of art are elevated above the daily worries of the vast majority of mankind, gives art its special status.

Art as a luxury good is also remote; it is hard to access. It is often expensive. Many people lack the funds or the mental space to afford such a luxury. They are too involved in the provision of the demands of every day life. So they look up to those who can afford art. And they look up to art. It partly explains the asymmetry in the perception of art that was discussed earlier. Outsiders get glimpses of the large and impressive paintings in the museums of modern art and of expensive operas performed in splendid opera houses; therefore they look up to these institutions, which, to them, are so inaccessible in their remoteness. There is a parallel here with the church. In churches and cathedrals people also received a hint of the actual thing that remained partly hidden. Therefore, those who have access to works of art are a bit like gods, apparently free of earthly worries.[30]

In 'what people call art', a subjective experience of uselessness is a relatively constant factor that makes art even more sacred. This is what matters in the context of this chapter. Nevertheless, from the tenth floor we can see that 'useless' fine art is actually put to many uses. From here we can see, for instance, that all the different aforementioned uses of pop music apply to the fine arts as well. High art also serves a function in the development of identities and in the learning about good and bad. Moreover, high art has functions of its own. It is used for distinction.[31] People impress other people by displaying the assumed uselessness of their art; in consuming art they reveal how free they are of daily worries. And they use art to defend their high social position.

6 'Art Goes Against the Rules and so Adds to Cognition' (Goodman)

Two more relatively constant factors in the definition of art need to be discussed because they play a role in this book's analysis: inventiveness and illusion. Ever since Hegel, philosophers of art have viewed works of art as part of a chain of inventions. Hegel, Adorno, Goodman, Barthes, and Lyotard, all of whom represent important schools of thought, have emphasized that works of art follow from one another.[32] Art is unfinished in its form.[33] Later works of art both follow and challenge their predecessors. By innovating, artists deliberately break rules.[34] Sometimes innovation or change is seen as progress in art but not necessarily so.[35] (It clearly does not represent progress for a postmodernist like Lyotard. Moreover, innovation is certainly not a constant feature of art at all times and in all cultures.)

In Goodman's approach for instance, artists violate existing rules by introducing new metaphors, which link two symbol systems.[36] In doing

so they create illusions. Therefore, *new art challenges minor or major taboos* (thesis 6). When Van Gogh changed the existing visual 'language' he encountered nothing but resistance, while today people everywhere appreciate the changes he instituted. And meanwhile, Marcel Duchamp was at first unsuccessful in attempting to exhibit his now famous fountain. He was altering the parameters of art and so, of course, he encountered resistance.[37] Breaking down taboos can take many forms. In the seventies, the Dutch author Kellendonck was the first to write dialogues in dialect in a short story, which was otherwise written in standard Dutch. In doing so he broke with the formal rules of that time.[38] Meanwhile, the visual artist Marcus Harvey 'painted' the portrait of an English woman, who had murdered many children. He composed the face of this woman by using hundreds of prints of the hands of actual children.[39] Thus he managed to break both contextual and formal rules – rules with respect to decency (subjects that can and cannot be treated) and with respect to the means used.

According to Goodman then, what differentiates art from non-art (but not from science) is the alteration of the rules by the artist. Unlike artisans, artists change the rules more or less deliberately. This is how art contributes to cognition.[40] It shares this quality with science. Goodman takes the drive in both art and science to be curiosity, with its purpose being cognition in and for itself.[41]

7 'Artists Resemble Magicians' (A personal view)

Why do works of art, as Goodman proposes, contribute to cognition? They do so because they touch and amaze audiences. They make audiences think again. The artist creates an amazing illusion. The music of Brahms for instance, does not really take the listener on a trip in an Arcadian landscape. Nor does a painting by Breughel make the viewer literally join in a gay wedding. Artists use their imagination to create illusions. These illusions often lead the person who enjoys the work of art to an illusionary 'better' world. In this manner, artworks are romantic. But the illusions in art not only serve as a form of escapism; they also rouse the audience. This happens when the creative artist introduces new and unexpected metaphors. Because of their freshness such illusions draw attention.

Through imagination and the creation of illusion, artworks annoy, amaze, or touch art consumers and force them to reconsider their views.[42] Science cannot exist without illusion either. A graph is just as far removed from reality as a life drawing. By creating illusions, both art

and science add to cognition, although granted, in different ways. But since we live in a scientific society the discrete illusions of science look familiar; they no longer amaze us. Artistic illusions on the contrary, continue to surprise us. Thus we are more likely to experience them as 'magical'.

The connection between art and the miraculous has always existed. Works from the past, which we now call works of art, often had the status of a miracle in their time. They derived that status from the use of exceptionally precious materials or from a new or virtuoso technique. More recent artworks amaze because of the introduction of innovations that were hitherto inconceivable, and which make us think and feel differently. In this respect, it is the density in most works of art as opposed to the discreteness in works of science that makes them mysterious.[43] In many ways, art appears magical and the artist resembles a magician. Metaphorically speaking, the artist *is* a magician. Actually they are pseudo-magicians; they only *pretend* that they can perform magic. It looks like they have access to supernatural powers, but they do not. They create illusions.

Art can be 'magical' without being sacred. The 'magical' aspect of art merely explains why art is more likely to be perceived as sacred than science.

8 The Mythology of the Arts Influences the Economy of the Arts

Society either harbors beliefs about art that contribute to the fact that it is perceived as sacred, or such beliefs follow from art's sacredness. The beliefs that I have overheard I have listed in the following table. I will discuss these beliefs or myths in the course of the book. The collection of related myths I call the mythology of the arts.

These widely shared beliefs can also be called myths, because people don't believe that they need verification. They depend on one another, but they are not always consistent. People in the art world tend to resolve discrepancies in order to keep the myths intact. For instance, even though artists may suffer from poverty, lack of recognition, and other drawbacks, they are compensated by the fact that they receive endless satisfaction from their work. Another example is that although art is remote and sacred, everyone has an equal chance to succeed. Meanwhile, art that is sacred and remote seems to imply that a separate caste of people, the high priests of art, control and protect art and keep intruders at a distance. This contradicts the message that anybody who is talented enough has an equal chance of becoming a successful artist. Because the

TABLE I THE MYTHOLOGY OF THE ARTS

1	Art is sacred.
2	Through art, artists and art consumers relate to a sacred world.
3	Art is remote and superfluous.
4	Art is a gift.
5	Artists are gifted.
6	Art serves the general interest.
7	Art is good for people.
8	Artists are autonomous; other professionals are not autonomous.
9	There is freedom of expression in the arts.
10	The work of art is authentic and the artist is the unique creator of it; in other professions such authenticity does not exist.
11	Creating authentic work gives one endless private satisfaction.
12	Artists are selflessly devoted to art.
13	Artists are only intrinsically motivated.
14	Money and commerce devalue art.
15	Artistic quality can only exist if it is independent of costs and demand.
16	Artists have to suffer.
17	Talent is natural or God-given.
18	Everybody has the same chance of being gifted or talented.
19	Certain talents in the arts only appear later in someone's career.
20	Because extraordinary talent is rare, only a large pool of artists can provide society with a few extremely talented artists.
21	Success in the arts depends on talent and commitment exclusively.
22	The arts are free. The barriers that exist in other professions are absent in the arts.
23	Successful artists are often self-taught.
24	Given talent and commitment, equal chances exist in the arts; the best is victorious.
25	Because the best win, the arts are democratic and righteous.
26	The high incomes earned by some artists are fair.

high priests sometimes allow people to join the caste irrespective of their birth or social class, equal chances go hand-in-hand with remoteness and sacredness.

In this book I intend to show that *the myths or persistent beliefs about art and artists make the economy of the arts exceptional* (thesis 7).

9 Conclusion

How come Eddy and the people at the exhibition, in the two illustrations at the beginning of the chapter, look up to the fine arts and apologize for knowing so little about it? The answer lies in the way art is defined.

The way people define art is an important preliminary subject for anyone studying the economy of the arts. Although tastes differ between individuals and between social groups, there exists an almost universal underlying stratification of high and low art and of art versus non-art in society. Even when people do not like high art they still look up to it, while people who do not like low art look down on it. Cultural inferiority and cultural superiority lead to this asymmetry in judgments. There exists a shared underlying ordering of higher and lower art. Not everybody has the same powers to influence this stratification and thus help define art. Art is what people call art, but some social groups have a bigger say than others. They appropriate the definition of art. Their art is considered true art.

Certain objects and activities are more likely to be called art than others. This tends to be so when these objects or activities are authentic and remote and are relatively easily associated with the sublime and the sacred. Moreover, art has become a symbol of the prestige of individuality. This prestige originated in the Renaissance and gained momentum during Romanticism. As a result, authentic art and artists are now highly valued and the arts are extremely attractive. The arts offer a romantic alternative to everyday life.

Viewed from a distance, another constant that determines what people call art can be observed. Art tends to be part of a chain of inventions. Many philosophers of art have expressed this notion. For instance, Goodman stresses the changing of the symbolic 'languages' by artists. He stresses that art and science have much in common. Unlike the scientist, however, the artist is more like a magician. This explains why art is more likely to be viewed as sacred than science. But although art is thought to belong to a sacred world, it also has strong ties with Mammon. The following chapter examines the consequences of having ties with both the sacred world and the world of money.

Discussion

1 Is there an underlying ordering of works of art, which is largely shared within a certain culture?
2 Is it true that an asymmetry in judgments exists implying that con-

sumers of high art look down on low art, while consumers of low art look up to high art?

3 Due to rapid technical developments, the coherence of cultural values can be reduced to the point that an underlying ordering from high to low art temporarily ceases to exist. Is this the present-day case?

4 Can you provide some arguments that contradict or support the thesis that art partially replaces religion?

5 Can you defend the argument that high art is useless against the arguments in the text that stress its usefulness?

6 Can you provide some arguments, which contradict the notion that art, like science, contributes to cognition?

Chapter 2

The Denial of the Economy

Why Are Gifts to the Arts Praised, While Market Incomes Remain Suspect?

'How Much Does this Painting Cost?'

When you enter a commercial gallery and you want to know the prices of the exhibited artworks, you're in trouble. If you're not familiar with galleries, you'll probably look for a price tag placed near the artworks. Anywhere else, from the supermarket to the car showroom this procedure will get you the information you want. Not so in a gallery. If you're clever you'll look in an odd unexpected corner to find a sheet of paper with a pricelist. But often there is no pricelist and so you muster up a little courage and approach a desk somewhere in the back of the gallery. There you'll find the owner or an assistant busy on the phone, trying to make the fax work, typing or just looking bored; anyway, she pretends you are not there. Almost annoyed, she hands you the list. Meanwhile, you will have noticed that there is no cash register anywhere. You wonder if there is some old cigar box with money in it somewhere hidden in a cupboard.

When artworks are sold, you may find that red stickers cover their prices on the list. For an instant you're tempted to lift up a sticker to find out the price. After all, like most shoppers, you like to make price-quality comparisons. But then you feel the eyes of the assistant on you and you decide not to.

You remain much longer in this gallery than you had intended. Since it was such a big deal to get the list you feel you cannot hand it back too soon. Anyway, you will certainly think twice about entering a gallery ever again.

How to Make a Deal in a Chic Way

Sacha Tanja runs the art collection of the ING Group, the second largest bank in the Netherlands (and one of the largest bank-insurance companies in Europe) and as a result she oversees the highest private budget spent on visual art in the Netherlands. Sacha Tanja visits the Alex's studio together with two assistants. They stay for about one and a half hours. They drink tea and chat about everyday matters. There is no exalted discussion about high art. In the meantime, she and her assistants sort through Alex's work. They make selections and sub-selections. They do it efficiently. Within the first quarter of an hour, one of the assistants – not Mrs. T! – casually asks for

Alex's prices. During the rest of their visit there is no further reference made to prices or money whatsoever. At the end of the visit, Sacha tells Alex she wants four drawings. Alex thinks she has made a good choice. Of course Alex is happy. Nevertheless, Alex wonders what would have happened if he had asked less for the drawings. If she had only given him a hint, Alex would have offered her a considerable discount for the four drawings. Would she then have bought six instead of four, or maybe she would return sooner to his studio to buy more? Alex decides to give her a discount the next time she comes – if there is a next time.

Although Sacha Tanja did not bargain, it is not true that her bank does not care about prices. By chance, Alex's economics colleague, Arjo Klamer, happens to meet Sacha in a different context only a week later. As a true economist he questions her about prices, and he asks her about Alex's prices. She admits that she likes Alex's drawings, but finds them a bit expensive. 'For work on paper, that is', she specifies. With so many purchases every year she certainly knows the market.

Somewhat further in the past, Mr. O. visited Alex's studio. He had been there before. O is a wealthy man and a passionate collector. He has money to spend, but he also cares about his collection. Therefore, he naturally wants to get as much for his money as possible. This time there was no chitchat. The artist and O talk about art, about how art enriches one's life, and about the unique qualities of Alex's work. Alex's work is put on a pedestal. It embarrasses him. Mr. O selects drawings, asks Alex for advice, but finally makes a choice very much independent of Alex's opinion. Then, after about an hour, the money part starts. He finds Alex prices too high, although Alex has already offered him a discount for being a regular customer. Alex's work is no longer special. O knows the market too and talks about other recent purchases. So they come up with some arguments, each of them relevant and surprisingly down to earth. Alex enjoys this part of the visit much more than the fuzzy talks about high art, and he guesses that Mr. O. does as well. In a complicated deal involving some frames as well, they end up with a price, which is 15% less. Alex would have made the deal for less, just as Mr. O probably would have been prepared to pay more. So they both feel good, but they don't reveal it. This episode takes about fifteen minutes. After this and before Mr. O leaves they engage in another discussion about high art. Mr. O praises Alex's work even more. Alex gets the feeling that he wants to obliterate the earlier talk of money, which he considers degrading to both of them.

In the case of Sacha Tanja, the conversation concerning money was reduced to an absolute minimum. In Mr. O.'s case it was set neatly apart from the rest of the conversation. If Alex was asked which approach he prefers, Alex would answer that although he likes bargaining he prefers

Mrs. T's minimalist approach. He finds it chic.

Most of Alex's art colleagues, who evidently lack his economic training, hate the money part. When Alex and his colleagues get together, it is common practice to sneer about those rich but greedy collectors who always want to bargain. But, although they don't like to admit it, Alex knows that some of his colleagues are really good at playing the money game.

Allow your Dealer to be the Maecenas

Alex recently found himself another dealer with whom he is very pleased. Amazingly, she pays him every three months. With his former dealer Alex had fights over money all the time. She always owed him money. Her arrears extended back almost two years and that was just too much – even in this arena where everybody is always short of money. Alex's former dealer was obviously short of money, but Alex found out that she owed him more than any of her other artists. Why? Maybe Alex had been too easy on her in the past. He never confronted her. At some stage in the game he changed tactics and got tougher. He remained polite, but every time he saw her, he brought up the issue of money. He wrote letters threatening to involve a collection agency. This new strategy made a difference, but not in the way he had hoped. She owed him almost as much in debt as before but now she was also afraid of him. She didn't mount any new shows and dropped him from her other activities as well. Alex wondered what he'd done wrong. Was there something his colleagues knew that he didn't?

Eventually, Alex discovered that his colleagues and dealer were playing a game that he didn't play. As soon as she had any money, she would pay the most grateful of her artists. This meant that an artist with a heartbreaking story would get paid before someone more legally deserving. One artist complained about how she was freezing in her studio while stirring the paint, which was thickening due to the cold, all because she did not have enough money to pay for heat. And another colleague got hysterical and shouted awful insults at the dealer. Afterwards they made up and became even better friends. The dealer paid them instead of Alex .

Alex began to understand that the name of the game was generosity. Alex's dealer had to be allowed to play the part of the generous one. It's a role that history had made for her: she had to be the Maecenas. Never mind that Alex was actually sponsoring her with an interest-free loan. Alex did not play the game right because he did not give her the chance to play her role as the generous one. The rules of the game include a taboo that prevents an artist-dealer relationship from being a normal business relationship.

Nevertheless, Alex kept thinking that his former dealer was just being irrational. She stood to lose one of her better selling artists. If she just changed her role she would ultimately be better off, at least in the short run. Alex real-

ized that over time she got stuck playing the game. She's probably too old to learn a new game. But should she? Alex gradually began to understand that he might be the irrational one, the exception to the rule. If this was the game the art world played, Alex's dealer would be better off if she stuck to the game.

Alex has tried to learn the rules, but unsuccessfully. Now he more or less 'knows' the rules, but he has never managed to internalize them and apply them 'naturally'. Alex thinks it's because he started off as an economist and only later went to art school. In the relationship with his dealer he automatically fell back on the economist's game of quid pro quo: you get something from me if I get something from you. This and similar experiences taught Alex that all these games are extremely serious. One has to believe their importance and their possible rewards. Games cannot be played consciously and deliberately, as Alex has tried. Only those who do not intend to play the game are really good at it.

Is the presence of money and dealing in the arts unable to bear the light of day? The three illustrations above clearly show that art is traded, but in a veiled manner. In the commercial gallery the paintings have no price tags. Sacha Tanja, who buys drawings for her bank does not openly ask for the price of the drawings she wants, and collector Mr. O. strictly differentiates between talking about the artworks' qualities and bargaining over prices. But ultimately, the example of the gallery owner is the most amazing. Why does the owner only want to pay Alex the money she owes him as long they both agree to pretend that her paying him is a gift not an obligation? All this leads to the central question of Chapter 2: *why is the economy denied in the arts?*

Behind this denial lies a controversy. *As an artist* (and an art lover) I believe that art is special. And therefore I am convinced that *money should not interfere with art*. Being an artist I must relate to art, not to the market. I want to keep money out of my relationship with art. But at the same time, it confuses and annoys me that I have to deal with money to keep my little enterprise in business. I understand that to serve a higher purpose I need money to survive, but it doesn't feel right. I want art to belong to a sacred world and not to the world of Mammon.

As an economist I cannot tell whether dealing in art is good or bad, but I know that the use of money and markets has its advantages, which is also true in the case of art. Because art is so diverse, exchange in kind would certainly be less efficient than deals involving money. Therefore, *as an economist, I am not amazed to see that Mammon is present in the arts and that much art is traded, from theatre seats to paintings.*

1 The Arts Depend on Gifts and Trade

For many people the commercial low arts, embedded as they are in the world of money, serve as a warning against the intrusion of money into the fine arts. It is generally thought that contact with commercial popular culture debauches people.[1] Thus it follows that if high art were to become commercialized it would lose its ennobling character. Nevertheless, as an artist, I have to admit that money also plays a role in the fine arts.

I don't like it, but I notice that art is often used for investment purposes, for speculation, or to launder money received under the counter, and that large sums are earned from forged art. Moreover, I see that art is often used as entertainment, for decorative purposes. I feel bad when I see my dealer selling my drawings to people who primarily want them to impress other people. To be honest, as an artist I even find it hard to swallow that works of art are traded, sometimes for large sums of money. And ultimately I am uneasy with the fact that art is measured in monetary terms.

At first this list of connections between art and Mammon seems to be at odds with the persistent beliefs that connect art with a sacred world, listed in table 1 in section 1.8. However, the two lists are not of the same order. Table 1 refers to beliefs while the list above refers to perceived phenomena. People believe in art's sacredness and therefore don't consider art as an instrument of Mammon. They cannot deny however, that art is sometimes used for monetary gain.

In the second place, when artists and art lovers resist money, this seldom means money in a literal sense. After all, the arts welcome large sums of money received in the forms of subsidies and donations. Therefore, money (or the world of money) represents a type of measurement in the market, and is not directly associated with donations and subsidies.

It is obvious that art is bought and sold and thus measured in monetary terms. But because art is considered sacred and because the sacred doesn't rhyme with commerce, one would expect commerce in art – like other 'evils' in the arts – to be relatively unimportant. Is commerce then, unimportant in the arts? In order to determine its role, we need to first make some slightly technical remarks about what commerce is and isn't.

In every economic sector goods and money continuously change hands. First, commerce can lead to reallocation, i.e., market transactions. For instance, when a painter sells a painting, the painting is handed over to the buyer, for which the painter receives money. Second, reallocation can result from gifts. When a composer receives a stipend, money is shifted from donor to recipient. Finally, forced transfers can

also lead to reallocation. Visual artists, for instance, are obliged to pay value-added tax and thus, funds move from artists to the taxman.

Market transactions and gifts are voluntary transactions. Seller and buyer can both say no to a particular transaction and the same applies to the donor and recipient. Forced transfers are involuntary transactions. They encompass such varied phenomena as taxes, tributes, duties, blackmail, theft, and forced confrontations (like the inevitable 'consumption' of sculpture and advertising in public space).

These latter involuntary transactions can be said to take place in an imaginary area of obligatory transfers. Voluntary transactions take place in an imaginary area of voluntary exchanges that consists of two sub-areas: the *gift sphere* and the *market sphere*. (The latter can also be called the economic, monetary, or commercial sphere.) I call these areas spheres, because they not only differ in the kind of transactions – trade or gift – but also in attitudes and values. Anti-market values, for instance, are an important factor in the gift sphere.

Given the way I have defined these three areas, the government operates in all three of them. Through taxes and regulations it operates in the area of forced transfers. When a government agency purchases a work of art, for instance to hang in a museum, it is active in the market sphere, like any other buyer. And when the government subsidizes art or artists or offers a tax deduction, the government is operating in the gift sphere like any other donor.[2]

After these observations on transfers, market transactions, and gifts, I now return to the question of the importance of commerce in the arts. Although the line between gifts and market exchange is not that clearly defined, it is clear enough to present some rough estimates on the relative size of these two spheres in the arts. It turns out that gifts are relatively important in the arts. Donations and government subsidies on average constitute about 85% of the income generated in structurally subsidized classical music, dance and theatre in mainland Western Europe, Britain, and the US. The other 15% are derived from market activities.[3] It is worth noting that the total amount of donations and subsidies is almost as high in the US as it is in mainland Western Europe. (In European countries like France, Germany, the Netherlands, and Sweden direct per capita government spending on the arts is around eight to ten times higher than in the US and two or three times as high as in Britain. Taking into account tax deductions the per capita government spending on art is however, higher in the US than in Britain and it is less than half of the spending in mainland Western Europe. Adding private giving, total combined per capita giving, including government, foundations, companies, and private citizens, in the US is around 80% of that in mainland West-

ern Europe. Because private per capita consumption of structurally sub-sidized performing art in the US is also somewhat lower than in Europe, the relative difference disappears.[4] The relative size of the market sphere is not larger in the US than in Europe.)

However, these are figures for structurally subsidized art companies; they are not representative for the arts, not even for the arts in a narrow sense. Outside of the structurally subsidized companies, many other companies receive fewer donations and subsidies and depend far more on the market for their income. In literature and the visual arts market income share is seldom less than 70 percent. (In the Netherlands with its generous subsidies the visual arts nevertheless, derive 73% of their income from the market.[5])

To estimate these figures for the arts in general it makes a difference where the line between art and non-art is drawn. Is pop music included or excluded? But even when art is defined in a narrower sense, a propor-tion of 50% gift and 50% market is a reasonable guess in my view.[6] Irre-spective of exact proportions, one can safely state that *the arts have a strong footing in both the gift sphere and the market sphere* (thesis 8).

2 The Amount of Donations and Subsidies is Exceptional

Many gifts to the arts are easily overlooked. For instance, in the US, uni-versities employ many artists who are seldom required to teach very much. Therefore, a large portion of their salaries can be considered a subsidy. Tax deductions and a lower value added tax for art products also represent indirect forms of subsidies. The same applies to perform-ing artists in France who thanks to special rules receive a considerable subsidy from the nation's total work force. Sometimes the source of gov-ernment gifts is hard to trace. For instance, the gifts of some large foun-dations partly stem from government money, although they appear to derive from private sources. Meanwhile, in Britain, lottery money is poured into the arts. This is often considered an important alternative to subsidies. Nevertheless, looking from the tenth floor, it is a veiled form of subsidies and not an alternative to subsidies.[7]

As noted earlier, the fact that gifts are important in the arts does not mean that the market is unimportant. But is commerce as important as it is in other professions? No, it's not. Compared with professions that require a similar level of training, artists receive the lowest amount of income from the market, and the highest amount from gifts. There is one exception: the clergy; only reverends and priests receive more income from gifts than artists. This comparison between artists and the church

confirms the parallel between art and religion that was discussed earlier, and it makes the existence of a special or sacred status of art more plausible. In every other profession, the share of market income is much larger.[8] *The large presence of donations and subsidies in the arts is exceptional* (thesis 9).

Have the arts always relied so heavily on gifts?[9] The gift sphere has not always been *that* important in the arts, and it may not always remain this important. Although in the past, Patron and Maecenas aided artists, their aid was of secondary importance. Their primary aim was to obtain artistic services and products. The Maecenas commissioned art to be made for them. Patrons employed artists. They were employers, more in a feudal than in a capitalistic sense. Aid was a secondary consideration.[10]

The same applies to the financial support offered by the bourgeoisie in the late nineteenth and early twentieth centuries. During that period, courts and nobility had largely given up being involved in the arts and governments had not yet stepped in. The bourgeoisie sometimes formed associations in order to consume art collectively, primarily in the performing arts. The aim was to enjoy works of art in the select company of like-minded people. This primarily involved market transactions. The motive of supporting art was of secondary importance.[11]

Today however, gifts are far more important in the arts than in other sectors. This led to one of the three central questions of this book: *Why is the gift sphere so large in the arts?* Is it possible that donors and governments support the arts to reduce the level of poverty among artists? Do donors and governments support the arts to prevent the arts from diminishing or even disappearing because rising costs would otherwise make art products unaffordable? Is it possible that gifts to the arts serve as corrections of so-called market deficiencies, because otherwise certain art products would be unavailable in the market? Or do donors and governments support art because they receive benefits in return?

Successive chapters will address these questions. The answers shall supplement one another. In advance of the analysis, it should be noted that because of the high level of esteem and sacredness of the arts, artists, private donors, companies, foundations and governmental bodies receive benefits from their gifts to the arts. They share in the high level of esteem that is accorded the arts. In this respect, the sizeable gift sphere is not only a consequence of the many gifts; it is also a condition for these gifts. The arts can only be accorded such high esteem if the arts continue to receive large numbers of gifts, which allows the arts to appear to belong to the gift sphere as opposed to the market sphere. This is because the gift sphere is associated with high values, while the market stands for low values.

3 'Art that is Given Must not be Sold'

Is giving more honorable than trading? And if so, why? Why does the gift sphere represent high values and the market low values? The following two sections will discuss a number of the assumed virtues of the gift sphere.

But first I will mention some of the characteristics that make market transactions and gifts similar and different. Both gift giving and market exchange are *voluntary* and they imply *reciprocity*; some kind of return is involved. Nevertheless, in market transactions the *quid pro quo* is more important. Here there's usually a stronger focus on returns and *anticipation of returns* and there is generally more *certainty about returns*. A larger part of returns is *covered by* a form of *contract* and can, if necessary, be *legally monitored*. Finally, *prices* and the *willingness to pay* play a larger role in market transactions than in the gift sphere where *trust* and *idiosyncrasy* play a relatively more important role, and returns come more commonly from *third parties*.

Unlike the market, money does not rule the gift sphere where there is no transparent profit motive. *Giving* naturally represents a virtue in this sphere. Giving promotes other virtues like *sharing, generosity, selflessness, social justice, personal contact* and *respect for non-monetary values*. These virtues and their inherent values overlap and are interdependent.[12] They are attractive to the arts. At the same time they are supposed to be vulnerable: the market and its inherent system of measurement and calculation is thought to endanger these values. Also, the virtue of one sphere is the vice of the other. Therefore, in discussing the virtues of the gift sphere, I shall add critical comments which indirectly refer to market virtues.[13] (The comments commence with the word '*however*' in Italics.)

1 *The virtue of giving* befits the arts. The act of giving is often celebrated. When donors give to the arts it is a clear example of a virtue. Sometimes the act of receiving art is also celebrated. Often art itself is seen as a gift; it is a gift from God or from a supernatural benefactor, and hence the artist is seen as gifted. This is part of the mythology of the arts as noted in table 1 in section 1.8. Next, if art manages to affect the viewer or listener this is also considered a gift. Because a work of art is the emanation of its maker's gift and the audience receives it as a gift, it is a gift and it should be treated as a gift. It cannot be left to the market. Turning a work of art into a commodity can lead to its ultimate destruction.[14]

However, as long as the gift comes from human benefactors, people can question the gift giver's motives. When a donor uses a gift as a

way to show off, a virtue turns into a vice. (And when it comes to the notion of a supernatural donor, not everybody agrees that such a donor even exists.)

2 *Sharing* is another virtue of the gift sphere. A gift is usually given by a donor to a recipient implying that the donor no longer has access to this gift. In sharing however, the object is used collectively. People share culture. They share it in different circles including family, neighbors, towns, and nations. No payments are involved. This kind of sharing is often automatic; a clear example of this is a shared language as part of a culture. But a sculpture located in a public space is also shared. When a collector lends a painting to a museum it is a form of sharing. Sharing is praised in the art world. It is often a dogma, that (high) art should be shared by disseminating it so that everyone can enjoy it.

However, sharing not only implies inclusion; it also implies exclusion. The sharing of important aspects of art and culture is often limited to certain groups. For instance, the fine arts are shared and simultaneously monopolized by certain elites. Generosity to insiders goes together with a de facto exclusion of outsiders.[15] With regard to the diffusion of the fine arts, the modern market is probably more responsible for the democratization and emancipation of the fine arts than the gift sphere.[16]

3 Also related to sharing and giving are the virtues of *generosity* and *self-lessness*. Art and artists stand for autonomy, disinterestedness, and even self-sacrifice. Art benefactors *and* artists are supposed to be self-less, and only concerned about art. The life of the ideal artist is supposed to be a continuous story of giving, giving to art.

However, as we shall see in Chapter 4, artists are not that selfless; they are focused on the rewards that come with 'serving art' to better themselves.

4 The gift sphere, unlike the market, is also supposed to contribute to *social justice*. Most charity appeals to principles of social justice. In this context, it is striking how often people in the art world stress that art should be accessible to all and how unfair its inaccessibility due to high prices is. Art is not just some ordinary consumer good; it's supposed to be vital for people's development and therefore their chances in life. Therefore a *social right to have access to art* is often mentioned, which, in turn is a common argument for subsidies.

However, the wish to diffuse art often stems from a double standard. When diffusion fails to broaden a particular genre of art, it turns out that art is not for everybody after all and this, in turn, only adds to the prestige of the art consumer.[17]

5 *Personal contact* can also be considered a virtue of the gift sphere. Personal identity matters here and relationships are therefore idiosyncratic. In the market, many deals are made regardless of who you are. But donors give to artists not only because of their work, but also because of their personalities, their looks, their age, sex, interests, etc. People care about the person they give to and about their relationship with that person. This fundamental human need is easier catered to in spheres outside the market. Commerce not only devalues the artwork, but also the unique personalities of the donor and artist.

However, idiosyncrasies are not absent from the market sphere.[18] For instance, in the visual art market idiosyncrasy plays an important role. Many visual art buyers have relationships with particular artists and dealers. In the second illustration, the deal between Alex and collector Mr. O was only successful because of their particular personal relationship, while in the third illustration, the dealer only paid the artist after he showed his gratitude.

Secondly, the problem of inclusion and exclusion arises again with regard to idiosyncrasy. Including a group based on personal grounds implies the exclusion of other groups. Thus, idiosyncrasy can imply inequality and even racism. In this respect, the relative lack of personal contact encountered in the market can actually be a virtue instead of a vice. Nobody checks behavior or clothing or starts an insider conversation in the book or CD departments of most large stores (This is certainly the case in branches of a well-known chain of cheap drug stores in the Netherlands, where anybody can buy excellent Bach CDs.) On the other hand, in the gift sphere, many personal barriers hamper cultural exchanges.

6 Finally, while the market devalues art, the gift sphere makes a virtue of how it *respects the unique and indivisible qualities of art*. In the market art has a pricetag. Once art is priced it is compared with other art and other consumer goods. By considering works of art in terms of money, the indivisibility of a unique work of art is necessarily lost. By pricing works of art, their use and usefulness is captured in exact numbers. Art ceases to be useless and turns into a non-art commodity. Therefore, pricing and money are not neutral. According to the sociologist, Georg Simmel, money disrupts art.[19] The economist, Arjo Klamer, agrees.[20] On the other hand, the gift sphere doesn't offer pricetags that measure art in monetary terms and thus devalue it. The gift sphere respects the value of art.

However, in contemporary gift-giving, money also plays a role as an

intermediary. Therefore, if anything is to blame for art's devaluation it's not so much money but the exchange rates or prices, which are the cornerstone of markets. And, in this respect, the gift sphere is ultimately not that different. Exchange rates – albeit vaguer ones – also operate in the gift sphere.

In this context, I will make a few comments on the devaluation argument. First, devaluation can only be relevant if a depreciation in value and its opposite, an appreciation in value, are viewed as social processes. And thus, *because* the gift sphere increases the prestige of art, the market concomitantly devalues art.

Next, it should not be forgotten that although most donations and subsidies in the arts lead to lower prices, these artworks are not free. They are still priced and sold in the market. Even though 50% to 85% of all income in classical music comes from the gift sphere, virtually one-hundred percent of classical music, live concerts, and CDs are sold on the open market, albeit for artificially low prices. And although live classical music has a pricetag, it nevertheless has also has a lot of prestige. Therefore, it seems that the pricing does not necessarily devalues art.[21]

People in the art world often argue that exact monetary valuations undermine the aesthetic value of art. Some social scientists agree with this view; others disagree.[22] I don't disagree because, as I shall show in Chapter 3, any social circumstance can influence an aesthetic experience. Therefore, it would be strange if pricetags didn't influence aesthetic value. But within a social process, such influence can take a variety of forms, it not only decreases value, it also increases value.

In the everyday world, people measure art and aesthetic value. They do it all the time. Past and present aesthetic experiences are discussed and compared with friends. Opinions change. Even the most unique, sublime, moving, or astonishing art experiences only have these qualities in relation to other experiences. Without comparing price, size, length, key, or color there would be no aesthetic experience. There would be no art, sublime or not. Comparing and ordering are such basic activities that there is no a priori reason why they should necessarily devalue art or increase its value. *Because any aesthetic experience rests on measurements and comparisons, there is no basis for the notion that measurement devalues art* (thesis 10).

Nevertheless, with the virtues people attribute to the gift sphere it is not that amazing to predict that as long as the arts belong to the gift sphere they will remain highly esteemed.

As Bourdieu has emphasized however, gifts need to be interpreted as a denial of self-interest in the short run, so that benefits can be reaped in the long run.[23] Nevertheless, because of the seeming absence of self-interest, giving has a higher status than buying and selling. Long-term support for anti-commercial values does exist in our society. Even with all the present-day praise of the market, commercial values are always on the defensive. They are suspect. Participating in market activities can easily give someone a bad conscience. The contempt for money and those who openly pursue monetary gain is widely shared and has deep roots. *The gift sphere has a lot of status; the values of the gift sphere have more status than the values of the market sphere* (thesis 11).

Works of art often symbolize the superiority of the values of the gift sphere and the inferiority of market values. For instance, in theatres all over the world, the commercial aspect continues to be ridiculed and disparaged. Scrooge appeals to the imagination. Like earlier audiences, modern audiences continue to laugh at the *Pantalone* character in a *Commedia del Arte* play, Shakespeare's *Merchant of Venice*, Molière's *The Miser,* or the greedy right wing homosexual in Schlingensief's contemporary piece, '*Bring Me the Head of Adolf Hitler*'.[24] Moreover, even today, people continue to jeer at the cartoon figure of Disney's *Uncle Scrooge* (Dagobert Duck). This demonstrates that the contempt for the pursuit of money still is an essential ingredient in our education.

Art apparently has a lot of status. Below are some indications of this.

TABLE 2 SIGNS OF THE HIGH STATUS OF THE ARTS

1	Some artists earn extremely high incomes.
2	The prices of most old and some contemporary art are extremely high.
3	Donations and subsidies form a large part of the income in the arts.
4	Donations and subsidies are seldom questioned.
5	Many people want to become artists in spite of the prospect of low financial rewards.
6	*Artists and others employed in the arts give large amounts of money to the arts by funneling income from second jobs, allowances, or inheritances into the arts.*
7	Art students have more status than other students have.
8	Even young and unsuccessful artists have a special status.
9	People admire and envy artists.
10	The government, royalty, and important corporations all consume art.

11 Works of art are used at funerals, when heads of state visit as well as for many other important ceremonies and functions.

12 Members of the social elite, like ministers, heads of ministries and CEOs visit important concerts, plays and exhibitions. They consume far more art than average people.

13 The public consumption of works of art – classical concerts, modern art exhibits – requires that the audience observe a certain kind of silence, speaking in whispers if at all. This solemnity is comparable to that of religious ceremonies.

It might be instructive to apply the above list, which is not exhaustive, to other sectors of production, for instance to that of food production and food producers, science and scientists, or religion and priests. What we discover is that right now in Europe even priests score lower than artists on the esteem scale. (In the US however, many people may well admire successful businessmen like Bill Gates more than well-known artists.)

The status of artists is indeed high.[25] Even many scientists, despite the relatively high status of their profession, look up to artists, while few artists envy scientists. It is this strange 'inexplicable' level of envy that points to 'something unusual' going on in the arts. (Sometimes people's attitudes towards artists appear two-sided, ambiguous. People pity and mock poor artists, but nevertheless envy them.[26])

The arts have an exceptionally high status (thesis 12). It is likely that their status can only be this high because the arts are inextricably affiliated with the gift sphere, which also has high status. To a lesser degree, the high status of the gift sphere also depends on the high status of the arts. *The arts adhere to the values of the gift sphere and reject the values of the economic sphere* (thesis 13).

6 The Economy in the Arts Is Denied and Veiled

The value system in the arts is two-faced and asymmetrical. Although in general the market is oriented towards money and profit, the arts cannot openly reveal this kind of orientation when they operate in the market. This approach would certainly harm artistic careers and therefore, long-term incomes as well. It specifically harms the profitable affiliation of the arts with the gift sphere, and it is therefore punished by the art world. Thus, profit motives are not absent, they are merely veiled, and publicly the economic aspect of art is denied.

Another value system exists in the gift sphere. It emphasizes selfless

devotion to art and condemns the pursuit of monetary gain. This value system is highly valued and is expressed quite openly. It thus looks as if this value system controls the art world. Nevertheless, many transactions are guided by a normal, but veiled orientation to market values.

Because one value system is veiled, while the other is open, an asymmetrical two-faced value system exists. In this respect, it is noteworthy that it is often commercial to be a-commercial. Expressing anti-market values can add to one's success in the market. Artists, dealers, or editors who exhibit a lack of concern for money may well enhance their market value. This implies that the economic sphere and the gift sphere are related.

The two-faced or plural value system coincides with a dual economy where one economy operates in the market sphere and the other in the gift sphere.[27] In both, people increase their welfare by 'serving art', gaining recognition, earning money, etc. A dual economy exists in other sectors as well.[28] But only the arts maintain a one-sided appeal on the values of the gift sphere.[29]

The way companies sponsor art also reflects the denial of the economic aspect. Nowadays most sponsorship comes down to a simple market deal: the sale of specific advertising rights. But the rituals that belong to the gift sphere are maintained because they are valuable to the participants.[30] Market deals take on the appearance of gifts.

It is now possible to answer the questions raised earlier by the illustrations at the beginning of this chapter. Why does the dealer want the artist to pretend that when she pays him his cut, she is doing him a favor? It is because by pretending that they are operating in the gift sphere, they can veil their market transaction. Artist and dealer deny the market economy. In the other illustrations, the economy is denied by not including price tags in a commercial gallery, by limiting the talk of money to an absolute minimum and by placing the talk of money in a separate sphere unrelated to art. Most of the other illustrations in this book also indirectly demonstrate the denial of the economy in the arts.

In order to maintain their high status *the arts reject commercial values and deny the economy* (thesis 14).

7 A Dual Economy Requires Special Skills

How can artists and intermediaries who deny the economy make a living? Some evidently do. Anti-market behavior can be profitable. Sometimes, the more anti-commercial artists and intermediaries present themselves, the higher their status and incomes are. Such a-commercial

attitudes don't follow from a strategy. Artists behave a-commercially because they are artists. In the course of the history of the artistic profession this type of behavior became part of the artist's 'character'.[31] Artists have learned to play 'games' in two spheres. That is how they earn a living.

Any game requires knowledge of the rules and subtleties of the game.[32] Although this is often denied, profits can be made or prizes can be won in both market games and non-commercial games. Moreover, all these games have an internal logic. Therefore, as has been noted earlier, economies can be said to exist in- and outside the market.

While operating simultaneously in both the market sphere, and the gift sphere, artists and other people working in the arts have developed skills in the games of both spheres. (Although Alex's colleagues in the second illustration declare that they don't like the money game, they are good at it.) Many present-day artists and others working in the arts have a sense for market games. But they honestly deny this and openly play non-commercial games, most of all the game of being selflessly devoted to art. They do so by denying the economy and veiling their market activities.[33] In this sense they have a split personality.

Marcel Duchamp, Andy Warhol, and Jeff Koons are possible examples of artists who contradict the denial of the economy. These artists knew the rules of the various games inside and out. Duchamp challenged the rules by showing the relative value of artistic objects. Meanwhile Warhol and Koons openly displayed their interest in money and market values.[34] (Maybe this is a case of desiring 'to kill the very thing you love'?) These artists are exponents of a trend that lasts to the present day. Again and again artists provoke the existing order of denying the economy. Their behavior is shocking, but at the same time the art world loves it. By being ironic about what lies at the core of the arts, the art world playfully consolidates the denial of the economy. De facto the repressive tolerance of the art world renders the artists who were involved harmless.

Another example demonstrates that games used to deny the economy can take different forms that demand different skills. A colleague of mine, Olav Velthuis, has questioned gallery owners about their pricing policies.[35] Given the denial of the economy, you would expect the people he interviewed to feel uneasy and reluctant to talk about their own calculations and strategies. Velthuis found that gallery owners in the 'lower' art circles showed more uneasiness and were more reluctant to answer his questions about prices than those in the higher or contemporary art sectors. The 'low' art group of gallery owners apologized more often about the fact that 'after all they had to run a business' as if this were a sin. And between responses they made all sorts of remarks to demon-

strate their unassailable love of art. I asked Velthuis if he therefore believed that the denial of the economy is less strong in high art circles. He did not think so. He prefers to describe their tactics as a 'double denial'. The game is more refined in these circles. The 'low' art gallery owners, in their search for recognition, felt obliged to stick to the rules, whereas the avant-garde gallery owners applied the rules naturally and knew when they could deviate from them. In the presence of my colleague they could playfully joke about money and prices and thus display the true aristocratic traits that the newcomers lack.[36]

Evidently, in spite of their denial of market values and their split personalities, artists and other people working in the art operate comfortably in both the gift sphere and the market sphere without losing their sanity.

8 Conclusion

Why can't the presence of money and commerce in the arts bear the light of day? In the commercial gallery in the earlier illustration, the paintings had no price tags. Sacha Tanja who bought drawings from Alex for her bank did not directly ask about their prices, and collector Mr. O kept the bargaining and conversational aspects of art strictly separate. Finally, the example of the gallery owner is the most extraordinary. Why indeed did the owner only want to pay Alex his cut in the context of the charade where they both pretended that payment was a gift not an obligation? The answer lies in the necessary denial of the economy in the arts.

Even though artists and art lovers tend to disapprove of the monetary connection in art, this connection is nevertheless undeniably present. Although donations and subsidies are more important than they are in other sectors, approximately half of the art world's income derives from the market. Evidently the arts seem to operate successfully in both the market and gift spheres. (The latter includes subsidies.)

Nevertheless, the values of the gift sphere come first. The virtues of the gift sphere are attractive. The high status accorded the gift sphere enhances the status of the arts. Several phenomena confirm the high status of art and artists.

The association of the arts with non-commercial values has grown in importance over the last one hundred years. The economy is denied. Art products are sold in the market, but often in a veiled manner. Art and artists are highly esteemed. This kind of status could never have existed if the arts had embraced commerce instead. It is commercial to be non-commercial.

It can be argued that the denial of the economy in the arts has passed its zenith.[37] For instance, among performing art companies there is less resistance to commercial attitudes than there was twenty years ago. Other signs (to be discussed later) point in the same direction. Nevertheless, even if the denial has passed its zenith, it is still strong and it is likely to continue to influence the economy of the arts for at least another fifty years.

Finally, even if readers agree that money and markets are indispensable to the arts, they can still maintain that money is a necessary evil in the arts. 'After all, aesthetic value has nothing to do with market value.' Therefore the next chapter examines the relationship between aesthetic and market values.

Discussion

1 Gallery owners in the 'low' arts were said to be relatively orthodox in their denial of the economy. They feel the need to be more Catholic than the pope. Or is there a better, more down to earth explanation? One could maintain that they are secretive about their price policies because they are more closely related to normal commerce and therefore they are more aware of competition than high art galleries. They hide their price-policies, not because they deny the economy, but because of competition. How can one tell the difference?
2 Is the contempt for money in society and in the arts becoming less important? For instance, art administrators in the performing arts appear to deny the economy less than they did twenty years ago. Does this change in behavior reflect a trend that contradicts this chapter's findings?

Chapter 3

Economic Value Versus Aesthetic Value

Is There Any Financial Reward for Quality?

Market Success Demonstrates Low Quality, But not if the Artist's own Work is Successful

When Alex goes to the local pub with his artist friends, a recurrent theme in their conversations is the question of whether the prices of artworks reflect their artistic quality. The other day the work of a colleague who has recently become successful in the market was being discussed. They scolded him for accepting such high prices for such dreadful paintings. (This particular colleague frequents a different bar.) They are angry at the stupid art world, which buys all this crap – literally and figuratively. They question the existing order, in what it does to sales and reputations, but mostly regarding its critical judgment.

Alex and his colleagues can be expected to think this way. Within their group, they have developed a specific notion about aesthetics. As artists, it is essential to them to offer, through artistic means, critical commentaries on society, including the market. Because people cannot be expected to purchase painful commentary, society should furnish a sanctuary for art outside the realm of the market. For them this is the raison d'être for subsidies. Thus, it's fairly obvious that their notions about aesthetics means that art with a low market value has a high aesthetic value and vice versa.

Later on, that evening something strange happens. Alex's colleagues ask him whether he has sold anything during his present exhibition. They congratulate Alex when he tells them he has sold several drawings. They say he deserves it. One colleague says she thinks Alex's work has improved a lot over the past two years. Alex suddenly realizes that they often berate the market when it favors artists who are not their friends, and conversely, if one of their own suddenly tastes success, they tend to attach almost too much significance to it. The market suddenly goes from being something coincidental to something righteous. And so they have to justify its righteousness by concluding that Alex has worked hard and that his work has improved. But Alex wonders: maybe his work did not improve at all. Is it possible that his colleagues look at his work afresh because it is selling and that they suddenly see qualities they did not see before?

Deciding on the Value of One's Work

Adrian, a former student and Alex's good friend, has become successful, in the market as well as in the eyes of the critics. Since Adrian is now well known, sometimes at exhibitions people tell Alex that they like his work, but that it is too much like Adrian's work – as if Alex is trying to copy Adrian's work. Alex finds this hard to swallow. After all, he is twenty-five years older then Adrian. When they first met, Alex already had his own style, all before Adrian had even entered art school. Adrian's work hangs on his wall and Alex's work hangs in Adrian's house. Due to a common interest and because of some mutual influence, their work is related. But if one influenced the other at all, Alex must have influenced Adrian, not the other way around.

Whenever somebody close to him, like Adrian, becomes successful, Alex feels the need to suddenly reevaluate his own work. The market value of Adrian's work has increased a great deal to the point where it now has a much higher market value than Alex's work. Thus, it's only natural that Alex questions the aesthetic value of his and Adrian's work. Does increased market value mean that the quality of Adrian's work is also that much higher than his own? Somewhat to his relief, Alex realizes that it's not just the work that matters. External factors also play a role. Adrian's youthfulness and good looks certainly make a difference in the art world. Plus Adrian's artistic form and temperament seem to suit the spirit of the times.

Therefore, Alex tries to formulate all the possible external factors that might influence public opinion, but also his own assessments of his own and his friend's work. This way he hopes that his work will no longer be inferior. Even though the market and critics prefer his friend's work, when it really comes down to it, his own work is just as good.

But Alex remains uncertain. He tells himself that the market and the critics can't be totally wrong, and so Adrian's work must have qualities his own does not. Moreover, Alex finds the notion that he could be just fooling himself by bucking the opinions of both the market and the critics unbearable. In the end, he has decided that his friend's work is better. Adrian is a damn good painter.

Art That Ends Up on the Garbage Dump

Alex and his colleagues are serious about their art materials and techniques. Because of the paint, paper, and canvas and the techniques they employ, their works might well last a thousand years. They seriously ponder the possibility that their art might live forever. Which means that if their art is valuable now, it will continue to be valuable in the future. And if it is not valuable now, it is bound to become so in the future.

Two decades ago, Alex met an art historian, Sofia, whom rudely opened his

eyes when she told him that the overwhelming majority of artworks end up in a garbage dump. This might happen in part during an artist's lifetime and in part shortly after his or her death. Within fifty years of an artist's death, some ninety percent of his or her manuscripts, scores, compositions, and paintings have disappeared into the rubbish bin. These are averages of course. A rather small selection of artists still has its work intact but for the vast majority, their work has all but vanished. She also noted that of all the paintings that hung on walls in the Netherlands during the Golden Age, less than one percent have survived to the present day.[1]

Alex was shocked. It was not so much the perception of his art that was threatened, but of art itself. Deep down Alex had always cherished the holiness of art and its enduring value. He thought that this value stemmed from an intrinsic quality of art that other products lack. And because an intrinsic quality doesn't just disappear over time, Alex assumed that valuable art now would still be valuable in a thousand years.

In the following years, Alex gradually came to terms with the temporality of his art and of the art he loved and admired. To his own amazement, Alex felt an enormous sense of relief. He no longer had to work for posterity. Instead, he could produce drawings for people, alive now, some of whom are his personal friends. These people evidently have some use for his drawings. But it's very likely that in half a century his drawings will be lost. Who cares? He'll be dead by then anyway. Since this revelation, Alex has found it easier to take responsibility for his art. Having a responsibility for the rest of eternity was always a bit too much responsibility. And so like a loaf of bread, most art works get used up. And Alex now thinks this is the way it should be.

Does aesthetic value diminish? Is that why so many works of art end up in a garbage dump? And why do artists remain so ambiguous about market value? One minute, artists are scolding the market because it has nothing to do with quality and the next their appreciation of Alex's work is determined by its success in the market. And so when Alex's friend Adrian becomes successful on the market, Alex first tries to play it down by questioning market value, but in the end he comes to the conclusion that his friend's work is simply better.

Although I do not always behave accordingly, as an artist it is my conviction that the quality of my artwork is not related to my success or lack of success in the market. I don't think that artists who earn more necessarily make better art. In my view artists who earn much money can still make bad art. If there is any relationship at all, I would have to agree with my colleagues who insist that success and low artistic quality go hand-in-hand. Although I actually earn a substantial portion of my income

through the market, *as an artist I am convinced that aesthetic value is independent of market value.*

But as an economist, I disagree with this. *As an economist I believe that quality in general corresponds with success in the market.* I'm sure that artists and art lovers alike will accuse me for being cynical. They would do well to paraphrase Oscar Wilde: "Here is this economist who knows the price of everything and the value of nothing". Be that as it may; I think I have a point. Otherwise, Alex and his colleagues would not be so ambivalent when it comes to market value.

In this chapter, my aims are limited. I don't intend to present a comprehensive study of how prices and aesthetic judgments in the arts evolve.[2] Nor do I contrast cultural values with economic values as Throsby does.[3] I merely want to demonstrate that aesthetic value, defined in a limited sense, and economic value are systematically related.

1 Aesthetic Value and Market Value Differ in Definition

Before embarking on a discussion of the relationship between aesthetic and economic value, the meanings of these terms should be clarified. As with the term 'art', I prefer to define *aesthetic value* more obliquely. So-called experts define aesthetic value. Aesthetic value is what experts call aesthetic value. The experts include artists, critics, mediators, and consumers with authority in the art world. They comprise the acknowledged leading experts of the art world. Similar to our earlier definition of art, not everyone wields the same amount of authority in the establishment of aesthetic value: the influence of some experts is larger than that of others. Aesthetic value resembles a weighed average. But unlike market values, aesthetic values differ only in an ordinal sense. For instance, some experts might find that painting A has more aesthetic value than that of painting B, but they cannot tell how much more.

This sociological approach to aesthetic value – which places the power of evaluation in the hands of experts – can offer a special perspective to the questions raised in the illustrations above. But it should be borne in mind that it also circumvents numerous issues and problems regarding the value of artworks that are of interest in other settings.[4]

The *economic value* of a work of art is its value in terms of money. (Here as in 'economic sphere', and later in 'economic capital' and 'economic power', 'economic' is used in a monetary sense.) Most of the time 'economic value' is synonymous with 'market value', i.e., the amount of money involved in the selling and buying of artworks. Because economic value is measured in terms of money, it is possible to make precise com-

parisons. For instance, the market value of painting A is 1.8 times as high as that of painting B.

Although *price* is often thought to represent market value, this correlation is only appropriate in the case of unique works of art. In all other cases, like the sale of books, CDs and seats at a performance, only *revenues from sales* can represent market value. These revenues are determined by multiplying price by quantity.[5] For instance, CDs by My Morning Jacket are the same price as Spice Girls CDs, and yet the market value of a Spice Girls CD is much higher, because sales of Spice Girls CDs are much higher. (In this specific case, quantity is a fair determinant of market value, but to be safe, it is always better to multiply price and quantity.)

2 'In the Market there is no Reward for Quality'

There is no reward for good art in the market. And it's not just artists and art lovers who go around saying this. The notion that artistic quality does not 'pay' permeates every level of society. The cleaning woman and the lawyer alike may express as their opinion that true art does not pay and that artists must suffer. This is common wisdom that is deeply rooted in our society. As an artist, I also adhere to this view.

As an economist however, I oppose the notion that there is no relationship or even a negative one between quality and market value. I believe that market value and aesthetic value generally correspond. 'In the market, artists are justly rewarded for the quality of their artworks.' These two opinions are basically as different as day and night. I begin by putting them in some perspective.

First, I look at the artist's argument, which also includes most art lovers: *market value does not reflect quality*. The relationship can, in fact, be negative. High aesthetic value can actually be linked to low market value and vice versa. Three different interpretations of this premise are possible.

1 Aesthetic value and economic value belong to *independent spheres*. Values deviate randomly and are only coincidentally similar. There is no relation whatsoever between these two values.

2 Aesthetic value and economic value belong to *non-reciprocal spheres*. Aesthetic value is independent, while market value depends, to varying degrees, on aesthetic value. Buyers listen to experts but not vice versa. A positive but one-way relationship exists in which aesthetic value remains an autonomous uncontaminated factor.

3 Aesthetic value and economic value belong to *hostile spheres*. An

inverse relationship exists. Market value reduces aesthetic value. The implicit message is that market value is dangerous for art; thus it must not interfere with aesthetic value. Because aesthetic value is not naturally autonomous, autonomy should be the goal of those you care about art.[6]

My description of the market and the gift sphere in the previous chapter implies the presence of hostile spheres not unlike interpretation number three. In commerce everything is measured in monetary term, which tends to degrade art; it lowers a particular artwork's aesthetic value. And so evidence of commerce must be swept under the mat. Meanwhile, art lovers consider aesthetic value the essence of art. If art is sublime or sacred, it's because of its aesthetic value. And thus, artists and art lovers feel the need to safeguard the notion of aesthetic value from contamination by market value.

Governments also seem to think there is a negative relationship between aesthetic and market value. For instance, in efforts to promote 'quality' in the arts, many governments tend to subsidize young artists who have not yet succeeded in the market. So, in the eyes of many governments, low market value can correspond with high aesthetic value. In fact, the very existence of government subsidies in the arts presumes an overall negative relationship between aesthetic value and economic value.[7]

I now turn from the artist's opinion to the opposing argument, that of the economist: *market value corresponds with aesthetic value in the arts*. The economist, William Grampp, defends this position most fervently. "In saying that economic and aesthetic values are consistent, I mean that if outside the market painting A is said to be superior to painting B then on the market the price of A will be higher than B."[8] Formulated in a different manner it begins to sound less pleasant: If the price of A is higher than that of B, then A is superior. I shall refer to this assumed (ordinal) correspondence as the *thesis of correspondence between aesthetic and economic value* or simply, *Grampp's thesis*.[9] Grampp does not say so, but a clear implication of his thesis is that, if one artist earns more than another, the first is the better artist. For instance, if Lucian Freud earns more than Jeff Koons, his work must be artistically superior. It is an implication most art-lovers will strongly repudiate. (Grampp refers to unique paintings and can therefore use price instead of market value. Because the analysis in this chapter also refers to multiples, like graphics, books, and CDs, I use market value to represent economic value.)

Grampp's discussions of the correspondence between the two values certainly does not imply a one-way influence, i.e., that market value is

determined by aesthetic value. They depend on one another. In his view, aesthetic value cannot be an independent value as it also depends on economic variables such as relative scarcity. For instance, Grampp suggests that if Rembrandt had produced even fewer self-portraits both their market and aesthetic value would be even higher than they already are.[10]

In the context of our purposes, the thesis of correspondence offers a fruitful starting point for our analysis of economic and aesthetic value. The thesis is clear and precise, however in principal, it can be refuted.[11] The thesis of correspondence is part of a broader and more relevant thesis. Economists like Grampp and Tyler Cowen claim that *free markets and commerce in the arts more often promote quality or aesthetic value than harm it.*[12] But because this kind of thesis is harder to assess, it is not dealt with in this chapter.

To repeat, *the economist defends the position that market performance and quality in the arts largely correspond.*[13] Thus, on average, artists get what they deserve. If they suffer, it's because the quality of their work is low. On the other hand, *the art world defends the position that quality in the arts exists irrespective of market performance.* Artists may suffer because they lack market income while they are indeed making great art.

Before attempting to assess these positions, I will briefly discuss the question of whether market value and aesthetic value are social values.

3 Values are Shared

Social variables are essential in this book's approach to the economy of the arts. Nevertheless, the term 'social' does not really exist in the traditional economic approach. This approach is based on individual preferences. Although individual preferences do get funneled into the market, thus influencing market value, it is not considered a social process. Market value then, is the automatic outcome of the interactions of numerous independent individuals who cannot alone influence the outcome. Therefore, market value is not a social value, but an objective value.

Modern economists, however, are well aware that preferences are not given and independent; preferences are interdependent.[14] Nevertheless, in their view standard economic theory offers a useful 'approach', not necessarily a realistic view of the world. At the same time, most economists do not disagree with the thesis that market value is a social value.

It should be acknowledged however, that individuals are the building blocks of economic theory. Economists adhere to so-called methodologi-

cal individualism.[15] If social values in fact exist, they stem from individual values or preferences. Sociologists, on the other hand, base their approach on social values, which they believe are not the sum total of individual values. Social values maintain a relative autonomy.[16] As long as we take social values seriously, there is no need to take sides in this complex controversy.[17]

In the context of this book, an analysis of value concepts is not necessary and would ultimately be confusing.[18] The distinction between first order and higher order values (or meta-values) – as noted by social scientists as well as economists – cannot be ignored however.[19] Taste and consequent shopping behavior rest on first-order values. Take Mr. Williams; he has a higher order value because he wants to be regarded as 'a man of his time'. Thus, he prefers fiction by young authors, which represents a first-order value. This implies that higher-order values and first order values are contingent or interdependent, but not in a deterministic way. Contradictions between first and higher order values are not uncommon. Mr. Smith, for instance, buys Tom Jones CDs and goes to see pornographic films, but at the same time, he is ashamed of this kind of consumption. Evidently, his conscience tells him that he should prefer other kinds of music and films. In his conscience, he has internalized higher values that are more important to him than his daily values.

Without the possibility of individuals maintaining contradictory values, the cultural inferiority and consequent asymmetry in judgment described in Chapter 1 could not have existed. For instance, in practice people with lower levels of education buy different art than people with higher levels of education; their first order values differ. Nevertheless, when the first are asked to order low and high art their higher order values correspond in a general sense with the elite ordering. Therefore in their case, first and higher order values must contradict.

Social values that are primarily shared within a specific group result in a group attitude. Artists and economists, for instance, have different attitudes. To a lesser degree, the same applies to different groups of artists, such as composers and choreographers. The typical elements of these attitudes are commonly knowledge. So, it should not be too amazing to learn that the controversies between the artist in me and the economist in me – presented in each chapter's introduction – are largely predictable.

4 There is No Such Thing as a Pure Work of Art

Are art lovers correct in saying that aesthetic value is independent of values such as market value and other social values? If the various spheres are indeed independent or non-reciprocal, then there is either no relation between aesthetic and market value, or market value adapts itself to aesthetic value, but not vice versa.

The way aesthetic value has been defined here makes it a social value by definition: individual experts who necessarily listen to one another, collectively determine aesthetic value. Nevertheless, for many experts aesthetic value is an altogether independent value that is hidden in the artwork.

Let us take a closer look at expert behavior. I mention four cases in which market value is influenced by social circumstances, in two of which aesthetic value is also effected.

1 The instant that new techniques of measuring characteristics unseen by the human eye revealed that a painting by Rembrandt was made by one of his students or that a Picasso lithography was a fake, the prices of these works tumbled as does their aesthetic value in the eyes of experts.

2 When any of the Marilyn Monroe portraits by Warhol goes up for sale, it consistently fetches higher prices than his other portraits. Moreover, within Warhol's oeuvre, the Monroe portraits received a lot of attention from experts who wrote more positive reviews about them than about the others.

3 Until recently, companies, but also foundations and government-institutions, bought relatively many large and colorful abstract expressionist paintings to use as decoration in halls or behind desks. Because of this demand the market value of this type of painting was higher than it would otherwise have been. Experts however, will fervently declare that the aesthetic value of these paintings was not influenced by the use these institutions made of the paintings.

4 Copies of an etching are exactly alike, but they differ in their provenance, i.e., the documentation of their ownership history: one etching has been part of a royal collection since it was created, while the other has not. And so, the first sells at a higher price than the latter. But for experts this difference does not matter.[20]

In all four examples, social factors have influenced market value. In the first two, they have also influenced the experts' aesthetic opinion.[21] (In the third experts deny any influence. If we were to look from the perspective of the tenth floor however, we could probably prove that also in the

third example the experts were influenced by the omnipresence of those eye-catching abstract expressionist paintings, but were evidently unaware of it.) In any case, the first two examples tell us that even experts admit that their aesthetic judgment is sometimes influenced by social circumstances.

The examples are instructive because they show that experts draw a line. In this case, the line is drawn between the second and the third example. Rules and conventions among experts govern what enters into the determination of aesthetic value. The existence of these rules and conventions means that aesthetic value is in practice a social construction.

These remarks have not even touched upon the possibility that art might have intrinsic aesthetic value independent of expert decree. Can art be intrinsically valuable? People clearly desire this idea of intrinsic value. Many art lovers, and I'm no exception, are looking for pure works of art. They want to believe in a naive or virginal approach to listening, reading and looking, as if the book, tone or painting is the first one. They believe that only in this mode can they remain truly receptive to art. The belief that art is sacred only feeds the notion of a primeval aesthetic experience comparable to that of a unique religious experience. But people are never completely open nor do they live in a void. Their social values and relation to art, determines which elements in an artwork are read, heard, or seen.

If a Van Eyck painting were left behind for an indigenous tribe in New Guinea, the tribe would probably treat it like any other panel. Because the members of the tribe have a different social setting, they won't see anything extraordinary on the canvas. The only value it might have is as a shingle to fix a roof or as firewood.

In one of the above illustrations, Alex tries to compare his work with that of his successful friend, Adrian. His friend's work has a higher market value and experts pay more attention to it. Alex however, believes (or hopes) that when the social impact is removed, his work will be considered no worse than Adrian's. He prefers to compare the 'intrinsic' values of 'pure' artworks. But it's impossible to eliminate all social values and begin with a blank slate. In practice, Alex only discounts those values that he personally doesn't want interfering with the artwork's 'intrinsic' value, such as their age difference. But a more agreeable value, such as the homoerotic content of their work, continues to assert its influence on his judgment of 'intrinsic' value.

Barbara Smith has pointed out, that by subtracting all social values one is left with no value at all. She writes, "When all such utilities, interests, and particular sources of value have been subtracted, nothing remains. Or, to put this in other terms: the 'essential' value of a work of

art consists of everything from which it is usually distinguished."[22] Therefore, the division between aesthetic and non-aesthetic values necessarily depends on social judgment.

Aesthetic judgments vary according to time and to the social group involved. It thus follows that, contrary to the claim of many art lovers and artists, *art has no intrinsic value* (thesis 15). *Aesthetic value is not an independent value, but a social value* (thesis 16). This conclusion clears the path for the discussion of the main question of this chapter: how are aesthetic and market value related? Is there a negative relationship as many artists and art lovers believe, or is it positive as the economist believes?

5 Buyers Influence Market Value and Experts Aesthetic Value

Who determines aesthetic value and market value? In discussing the controversy regarding the relationship between aesthetic and market values, it might be helpful to try to answer this question first.

Who determines market value? As previously noted, in standard economics, there are numerous independent players who determine price. In neo-classical economics, so-called 'sovereign' consumers come first. Producers are relatively unimportant; they adapt their behavior to the wishes of consumers. Our argument as well is based on the notion that producers are relatively unimportant when it comes to directly influencing the market value of art-products.[23] (If they do manage to, it is usually via experts as co-producers. As we shall see, such experts influence market value via their opinion on aesthetic value.)

Not all consumers influence market value. And when they do, they do so to varying degrees. In so-called *deep-pocket markets*, buyers need deep pockets (lots of money) to participate and ultimately influence market value.[24] Important paintings are sold in deep-pocket markets. I will first look at an individual transaction. When a specific painting is sold, it appears that one rich person's willingness to pay determines its market value. As noted earlier, however, other wealthy people operating in the background also help to determine market value. This becomes particularly clear in an auction setting. The more interested people with money attending the auction, the higher the price. (In a commercial gallery the mechanism is much the same, but more indirectly and with more constraints.[25])

If instead of noting the market value of a single painting, we look at the value of the entire body of work, for instance of a certain genre, its market value depends on the willingness of a group of buyers to pay. Sup-

pose we compare the developments in the sales of new figurative paintings and abstract expressionist paintings. And suppose we find that the sales of the first increase more than the latter's. In that case, it means that the relative willingness of rich consumers to pay for new figurative art has increased. Metaphorically speaking, people who can afford such paintings can be said to have 'voted' for the goods on sale. Therefore, market value is not unlike the outcome of an electoral process where people with enough money 'vote' for products. In this example, new figurative art is the winner compared over abstract expressionism.

Not only deep-pocket markets but also so-called *mass markets* exist in the arts.[26] For instance, CDs and books are sold in mass markets. They are relatively cheap and therefore more people can afford them. Here as well market value depends on consumers' willingness to pay. But here willingness to pay is reflected not in higher prices but in higher sales. In a mass market, the metaphor of an electoral process is even more apropos. Buying a CD by a popular composer or a book by a successful author immediately adds to sales. The fact that these purchases are often recorded in best-seller lists adds to the voting analogy.

But not just technically reproduced art is sold in mass markets; art museums and cinemas also operate in mass markets. The live performing arts operate in an intermediate position, because attending a live performance is relatively more costly, but not as costly as buying paintings. Meanwhile, overly expensive performance art outings – operas or small exclusive pop concerts – tend to operate in deep-pocket markets.

In both mass and deep-pocket markets, the sine qua non of influence on market value is *purchasing power*. People must have sufficient money and be prepared to spend it on the works concerned. The difference, then, between mass and deep-pocket markets is that low prices means more people are able to participate in mass markets than in deep-pocket markets. Thus, market value in deep-pocket markets depends on the willingness of a small group of rich people to pay, while in mass markets it depends on the willingness of large groups of less wealthy consumers to pay.

In keeping with our electoral process metaphor, people can be said to vote for various products in the art market, and market value can be said to be the outcome of this process. It is not a democratic process however. The number of votes people can cast depends on their purchasing power.

In extreme deep-pocket markets, small groups or maybe even a single person can decisively influence market value. When one of the Saatchi brothers, from the London advertisement agency Saatchi and Saatchi, started buying Damian Hirst's artworks for their private collection, the pricetag for these works immediately increased. And when he then subse-

quently sold off the collection's Sandro Chia paintings, the monetary value of Chia's oeuvre decreased considerably.

Because the rich have large reserves of disposable income, their economic influence on market value is considerably larger than of the poor. But this only applies to individuals or to groups of the equal size. If prices are low enough and the group of 'poor' people is large enough, their collective economic power can be just as decisive. Social groups who in the past had little disposable income to spend on luxury goods have since gained a considerable degree of purchasing power. They tend to spend more and more on cheap, mainly technically reproduced, art products and thus they have a sizeable influence on the market value of these products. Therefore, it's really not so surprising that, unlike art dealers, record companies prefer to target the tastes of these masses instead of small wealthy groups of art consumers.

Thus, in mass markets large groups willing to spend money on art determine market value, while in deep-pocket markets a small group of rich people willing to spend their money on art determines market value.

If these groups, in fact, determine market value, *who determines aesthetic value*? Given the definition of aesthetic value as formulated above, experts determine aesthetic value. Like buyers, experts can be compared to voters. And like market value, aesthetic value can be compared with the outcome of a voting process. In the case of aesthetic value however, it is not purchasing power, but the power of words or cultural power that determines the number of votes participants have. An expert with a good reputation evidently has a larger say in the determination of aesthetic value than an unknown art historian who has just earned his or her masters degree.

It must be noted that in our approach in this chapter, we do not pay separate attention to the influence of producers – artists, record companies, publishers, and other participants in the art world. – but this doesn't mean that producers are irrelevant in the determination of aesthetic and market value. For the sake of the argument however, I place 'producers' in the category of 'experts'. In the words of Bourdieu, they produce belief.[27] They influence aesthetic value and, if market value and aesthetic value are not independent of one another, they also indirectly influence market value. (In later chapters, specific attention will be paid to the power of producers and their institutions.)

6 Power Differences Rest on Economic, Cultural and Social Capital

Is it possible that the powers of the social group that leading experts

belong to are different from those of consumers? On average art con-
sumers are part of a social group that has relatively more *economic capi-
tal* (wealth) and income at its disposal and thus has more purchasing or
economic power. When buying art they use their economic power to do
so. Their *spending* influences the market or economic value of art. Mean-
while, experts are part of a social group that has much *cultural capital*
and therefore, more cultural power. The experts use their cultural power
in the arts. Their cultural influence or cultural authority affects the aes-
thetic value of art.

Economic capital consists of money and assets like real estate that can
be quickly converted into cash. (As with the terms 'economic' sphere,
'economic' value and 'economic' power, the use of the term 'monetary'
or 'financial' capital instead of 'economic' capital would have been
preferable, but by using 'economic capital' I do not deviate from
common usage.[28])

Sociologists introduced the concepts of cultural capital and social cap-
ital. Recently, an increasing number of economists have started to use
these terms as well.[29] *Cultural capital* refers primarily to incorporated
abilities and dispositions. Cognitive abilities are part of cultural capi-
tal.[30] *Social capital* refers to present and potential resources that arise
from a network of social relations. Reputations often symbolize the pos-
session of social and cultural capital. Unlike economic capital, social and
cultural capital cannot easily be exchanged or bought and sold.[31]

The differences are relative. On the one hand, the experts' social
group not only has cultural capital, but also some economic capital.
After all, most experts have more money to spend than average people.
But each expert has less to spend than the average rich person who buys
paintings; and as a group experts have also less to spend than the large
group of buyers of books. On the other hand the 'money-people' buying
visual art not only have economic capital but also some cultural capital.
They certainly have more than average cultural capital, but nevertheless
their cultural capital is less valuable than the experts' cultural capital.

Economic capital is important in the market; it enables spending. Col-
lective spending determines the market value of a group of art products.
In determining aesthetic value, cultural capital is the most important.
With their capital, experts influence aesthetic value. They do so within a
discourse among themselves and within larger social groups of which
they are part. Collectively, they select and weigh the factors that deter-
mine aesthetic value. Social scientists have written extensively about this
selection and weighing process.[32]

*In the establishment of aesthetic value, the possession of cultural capi-
tal is decisive and in the establishment of market value, it is the posses-*

sion of economic capital that matters (thesis 17). If the social group accommodating important buyers and the social group accommodating leading experts differ in their composition of capital and, consequently, in their tastes as well, this explains that economic and aesthetic value do not always correspond.[33] They may even have a negative relationship as some artists and art lovers insist.

7 In Mass Markets Quality and Sales Easily Diverge

Why does the art that experts judge as inferior often sell so well in mass markets? In fact, it sells better than 'quality art'. This is a common phenomenon in the mass markets of books, CDs, films, and videos. For instance, the market value of Steven Spielberg films is much higher than the market value of Werner Herzog films. The same applies to the books of Allistair McClean in comparison to those of William Golding. Nevertheless, most experts would agree that Herzog and Golding offer higher aesthetic value.

Unlike deep-pocket markets, it is unlikely that this phenomenon is caused by the variance in the composition of capital between average experts and average buyers. (Experts are likely to have both more money and more cultural capital than average buyers, but not necessarily in different proportions.) It is caused by differences in the collective purchasing power that determines market value. Average buyers with average tastes enter mass markets in large numbers and so boost the market value of art that experts have deemed to have little aesthetic value. Therefore, the difference in purchasing power between large groups with little cultural power and small groups with a lot of cultural power offers a rather obvious, but easily ignored, reason for the occurrence of deviations between mass market aesthetic and market values.

In mass markets, the general rule is that aesthetic value deviates from market value. This is shown in the cases of the two directors and the two authors. In mass markets, large groups of consumers buy works of art, such as books and CDs or tickets to live performances and films. Even though individual people may have little disposable income, collectively they have a great deal of money to spend and they spend it on numerous cheap works of art, thus boosting their market value.

Whereas, the collective influence of mass consumers on market value increases in proportion to their numbers, the same does not apply to their influence of aesthetic value, however. It is true that they have their own experts who share their various tastes. These experts tell their stories on popular television programs and in the daily newspapers. Nevertheless,

despite their large numbers, the overall influence of these experts in terms of determining aesthetic value is relatively small. They have little cultural power or influence, especially compared to the group of high culture experts. And because these high culture experts tend to belong to different social groups, their cultural preferences differ and they attach little aesthetic value to the art preferred by the average consumer. (In this case, although collective spending is the sum of individual spending, the collective cultural influence is not the sum of the individual cultural influences. Unlike money, cultural capital is embodied and is thus difficult to transfer from one person to another. Numbers do not necessarily add up to cultural power.)

The lack of correspondence between aesthetic and market value in mass markets is related to the phenomenon of cultural asymmetry, which was discussed in Chapter 1. The argument was that as long as there is social stratification and as long as art products are used for designating one's position in social space, judgments about art will remain asymmetrical. People from the upper echelons of society 'naturally' look down on the art of those below them, while the latter 'naturally' look up to the art of the former. Although the lower classes of consumers are not wealthy, cumulatively they have a lot of money to spend. And even though they may admire their social superiors, they do not spend their money accordingly. And so here is where market value deviates from aesthetic value.

Because high culture experts come from the upper echelons of society, their tastes are necessarily different from the average consumer. Therefore, *economic value and aesthetic value tend to systematically deviate in mass markets* (thesis 18). This proves that both the economist and the artist are sometimes right and sometimes wrong. High aesthetic value and low market value can go together, but not necessarily. The deviations in value reveal differences in power. It took quite an effort to reach this rather obvious conclusion. But this will make it easier to explain deviations in economic and aesthetic value in deep-pocket markets.

8 The Strife for Cultural Superiority in the Visual Arts (An Example)

The visual art market is a deep-pocket market. It offers a good opportunity for us to discuss the possible deviations between aesthetic and market value. In numerous countries over the last decades, a divergence between market and aesthetic value has developed in two important styles in the visual arts. In comparing these styles, a refutation of the economist's notion that quality and sales correspond seems to emerge.

The two style groups are not always called by the same names. I follow

Nathalie Heinich who uses the relatively neutral terms 'modern art' versus 'contemporary art'.[34] Within brackets I shall however, also use the more commonly used terms 'traditional art' versus 'avant-garde art'.[35] The styles involved are difficult to describe. They are probably best understood in connection with the names of well-known artists associated with the two groups. In Britain for instance, Damian Hirst represents contemporary (avant-garde) art, while Freud, Auerbach, and Kitaj represents modern (traditional) art. It must be emphasized that in this book the term 'avant-garde' refers to a group of related and established styles and not to avant-garde in a literal sense. (After all, art cannot be established and avant-garde at the same time. Currently, 'cutting edge art' sometimes replaces the terms 'contemporary art' and 'avant-garde art'. In Britain, 'traditional art' or 'modern art' is also called 'serious art'.)

Modern (traditional) artists develop their art from within an existing long-standing artistic tradition. The motto is continuation with modification. Another characteristic is the emphasis on authenticity. The personal touch of the artist is easily recognizable. Contemporary (avant-garde) art, on the other hand, tries to offer an alternative to earlier art movements, such as realism and impressionism, in particular. Sometimes visible references are made to these earlier styles, but more as a comment, than as an extension of the already established tradition. Authenticity is not altogether absent, but also not over-emphasized. This kind of art tends to be self-referential. That is particularly true in conceptual art and in installations.

The market value of modern (traditional) art is as high or higher than the market value of contemporary (avant-garde) art. Top incomes are higher in the modern (traditional) area than in the contemporary area. For instance, Lucian Freud earns considerably more than Damian Hirst. Nevertheless, the main difference has less to do with extremely high incomes, than with the number of artists who earn attractive to fairly high incomes. That number is also thought to be higher in the modern (traditional) area.

In the Netherlands, these two markets could be separated reasonably well until quite recently. Because most important critics tend to ignore traditional art, people tend to think that the market is small. But judging from art fairs, and artists I know, a different picture begins to emerge. Modern (traditional) visual art by living artists probably has at least as large a share (if not a larger share) of the total market than avant-garde art does.[36] But when it comes to aesthetic value, a different picture begins to develop. Whereas the market value of modern (traditional) art tends to be higher, its aesthetic value is lower than that of contemporary

(avant-garde) art. Most of the acknowledged leading experts tend to favor avant-garde art. It should be noted, however, that both modern (traditional) art and contemporary (avant-garde) art have their own circles of experts. For instance, in Britain in the nineties, Damian Hirst was the darling of the avant-garde experts and his work was considered of the highest aesthetic value. Traditionalist experts meanwhile, preferred the work of Freud and Auerbach.

At present, in most countries the contemporary (avant-garde) art experts are more influential. They don't value modern (traditional) works of art. That is why the aesthetic value of traditional visual art is considered less than that of avant-garde art despite its higher market value. The influence of traditionalist experts, then, is obviously much less, but not altogether absent either. This varies from country to country. Dutch traditionalist experts find themselves more and more in the shadows of the avant-garde experts. In Britain however, the two aesthetic camps continue to compete. There traditionalist experts and artists do not submit to the dominance of the avant-garde and still fight for a return of their past supremacy.

9 The Power of Words Challenges the Power of Money

Why do the contemporary (avant-garde) visual art experts have more cultural authority than the modern (traditional) visual art experts? Apparently the avant-garde's cultural capital is more valuable than the traditionalists. The avant-garde experts belong to the so-called 'new cultural elite', which challenges the traditionalist 'economic elite'. The traditionalists are connected with the economic elite that has most economic capital.[37] Thus we can say that the two groups differ in the composition of their capital.

These elites are obviously made up of different types of people. The economic elite can buy art; sometimes art that costs millions. The cultural elite meanwhile is made up mostly of well-educated wage earners with less money to spend and thus buy fewer and cheaper artworks. These elites have different social histories and thus, different tastes.[38] The cultural elite tends to prefer avant-garde art, while the economic elite prefers more traditional visual art.

Nevertheless, one elite does not exclusively determine market value while the other does not exclusively determine aesthetic value. Indirectly, the economic elite influences aesthetic value while the cultural elite influences market value. On the one hand, experts, such as art historians, who are part of the cultural elite, advise collectors with a lot of economic

capital. On the other hand, price and revenue fluctuations from sales influence the decisions of experts whether they are aware of it or not. Therefore, values are not independent of one another and most likely over time they tend to converge.

Nevertheless, this convergence can be disturbed by future events that come from outside. The very emergence of a cultural elite itself can be seen as an important convulsion. The phenomenon of people with much cultural capital and little economic capital is new. (It could be a temporary phenomenon.) The present-day cultural elite did not exist a century ago. This new elite both depends on the old economic elite, and challenges its power.

No area is better suited for opposition than that of artistic values, the area where the cultural elite feels most at home and where its cultural capabilities or capital serve it well. In order to challenge the economic elite, the cultural elite embraces the avant-garde, especially in the visual arts. It tries to legitimize its emergence by associating itself with modern, innovative, and often intellectual art. The economic elite, with stronger roots in the past, naturally prefers serious or traditional art, which tends to legitimize its long-term existence.[39]

Successful challengers move from a position of social inferiority to one of equal status, and finally to a situation of social superiority. In all of these situations different kinds of deviation in aesthetic and market value may occur. And so, the artist is often correct because aesthetic and market value can have a negative relationship. Nevertheless, in deep-pocket markets deviations tend to be temporary, because money and cultural authority tend to coincide over time. In this case the economist is right. It follows that *the deviation of aesthetic and market value in deep-pocket markets stems from strife for social superiority* (thesis 19).

10 The Government Transforms Cultural Power into Purchasing Power

How can influential experts with little money but with an opinion that deviates from the established market 'opinion' make themselves heard in deep-pocket markets? Why are the artworks these experts prefer made at all if most wealthy art buyers express no interest in it? After all, experts are powerless unless their opinion circulates and their choice of art is exhibited. Who finances their art and dissertations?

Even though the old economic elite primarily buys modern (traditional) art, a considerable market for contemporary art also exists. Four circumstances should be taken into consideration regarding this situation.

1 A major portion of contemporary artworks are produced by young artists and are sold for relatively low prices. Almost anyone with an above-average income, from teachers to civil servants, can afford to buy contemporary art, even though it might not be every month. And small sums multiplied by large numbers of sales begin to add up. (Especially at the bottom end of deep-pocket markets large numbers are not irrelevant.)

2 Although the economic elite in general has a more traditional taste, considerable deviations do exist. Different subgroups within the elite have different social histories. For instance, some families have been rich for a long time; they earned their money in industry, others in trade. While other families, the so-called 'nouveau riche' only more recently became wealthy. Given these differences, it is sometimes advantageous for certain groups within the economic elite to side with the new cultural elite. Therefore, it should not be surprising that a (growing) minority of private collectors buys contemporary art.

3 The same argument applies to corporations. The minority of corporations that collect contemporary art continues to grow. Collections, such as the Peter Stuyvesant collection, for instance, draw its share of attention. Shareholders may not always agree with the choices of the art purchased, but shareholders' influence is limited. Within these corporations the higher-ups, primarily a new well-educated cultural elite, have a considerable amount of leeway when it comes to purchasing art more to their tastes.

4 Most importantly, however, is the fact that in many countries, governmental bodies and institutions (partly) financed by the government, purchase contemporary art or subsidize contemporary art.

This means that governments with their large art budgets can certainly harm the economic hegemony of the wealthy. If government spending on visual art is added to private and corporate spending, the average taste of art consumers shifts considerably. This way governments, willingly or unwillingly, are also players in the arena of cultural strife.

In the Netherlands, this latter phenomenon is of particular importance. In 1996, between one quarter and one third of all sales in the visual art market were financed with public money.[40] The money came from the central government, local governments, museums and other institutions that spent public money buying visual art. Not much traditional (modern) art was bought and commissioned with this government money. Therefore, if it is true that the traditional (modern) art market is about the same size as the contemporary (avant-garde) art market, government spending accounts for sixty percent or more of the sales of con-

temporary art. This implies that *in the Netherlands, not unlike in other mainland Western European countries, the avant-garde visual art market is above all a government market* (thesis 20).[41]

Extensive government involvement in mainland Western Europe has become possible with the emergence of the new cultural elite in and around government bureaucracies. Its members occupy important positions in the various government administrations. Therefore, it is only natural that in the conflict between avant-garde and traditional visual art, governments in a number of European countries have sided with the cultural elite.

At the same time, most governments are not supposed to have a taste of their own. They are only supposed to be promoting 'quality' in the arts. The question of what quality is, is left up to the experts. Nevertheless, most government-appointed experts come from the new cultural elite. Therefore, by spending money on contemporary art, the government not only follows in the footsteps of the new cultural elite, it also gives credence to the cultural elite's notion of quality. In this manner, governments increase the value of the new cultural elite's cultural capital.

Because of government intervention, contemporary art has emerged as the only relevant area in the visual arts in the Netherlands. The victory of contemporary art is almost complete. In the market, traditional (modern) art is still important, but the aesthetic value battle has been lost. Those working in the traditional (modern) sphere tend to implicitly acknowledge the superiority of contemporary (avant-garde) art. The deviations between market value and aesthetic value has not quite disappeared yet, but the social strife is largely over.

Compared to mainland Western Europe, British government involvement is quite modest. That is why the struggle in Britain is still largely undecided. It is tempting to compare the British situation with that of mainland Western Europe with respect to the effects of government involvement on the development of the visual arts. It is my personal opinion that because there is less governmental intervention and because traditional (modern) art is still militant in Britain, the artistic level in both the traditional and the contemporary art worlds is higher in Britain than in mainland Western Europe.

Viewing the works of artists like Freud, Auerbach, and Kitaj, or the modern portraits featured in the National Portrait Gallery in London, it is not difficult to see that the artistic level is high in the modern (traditional) arena. In my view, contemporary (avant-garde) art in Britain is also far livelier and more inventive than mainland Western Europe's. Contemporary art in for instance the Netherlands and even more in France suffers under its easy victory: it is complacent.[42] Because the

British avant-garde is still being challenged, it remains competitive and alert; it observes its opponents and appropriates the most interesting aspects of its opponents' art. Unlike in the Netherlands, this results in an exiting and interesting cultural climat in Britain's visual arts.[43] It is inevitable that even despite the paucity of government intervention, contemporary art will ultimately triumph in Britain as well, but the resulting cultural climate will be enriched rather than impoverished.

To return to the main issue of this paragraph: *in buying art and giving to art, governments use their economic power to increase the market value of art which the reigning experts have judged to be of high aesthetic value* (thesis 21).

11 Donors and Governments Know Best

Why is the gift sphere in the arts relatively large? Is it because governments and donors side with the new cultural elite and subsidize its art? If this is true, it cannot be the whole story. After all, the government and donors also fund classical music, which is a favorite of the economic elite. Moreover, the market value of classical music would go down without subsidies and donations, while the market value of contemporary visual art continues to rise regardless. A broader argument may apply here. Whenever market value is lower than aesthetic value according to leading experts, governments and donors tend to step in. They use their economic power through purchases and gifts to protect 'quality'. By giving, they support 'quality' and so they bring the market value closer to the aesthetic value.

As noted in the beginning of the chapter, governments generally subsidize arts activities that experts believe to be aesthetically valuable and could not thrive or perhaps even survive without government support. This applies to young unknown visual artists receiving grants as well as to prestigious orchestras and opera companies.

In the case of mass markets – books or films, for instance – government and funding organization intervention is limited. They give 'quality' a chance to survive, but any attempt to substantially increase the relative share of 'quality art' in these markets is too costly. But on the other hand, in the intermediate markets of say live music and theatre, for instance, and in the deep-pocket visual art market, donors and governments often manage to increase the relative market value of 'quality art'. (In the case of the visual arts they do this not only through subsidies and donations but also through purchases.)

Government subsidies to the arts can be explained in more than one

way, as will be shown in the course of this book. One explanation, suggested above, has been that leading experts and the social groups they belong to have an influence on the government. (This would be a form of so-called rent seeking.) But when you hear the arguments of governments and donors, another explanation comes to the fore. Donors and governments care about people and therefore they worry about 'high quality' art. They believe average people show too little interest in 'quality art' and buy less 'quality art' to their own detriment. They believe that average consumers underestimate the benefits of 'quality art'. Therefore, they use their economic resources to buy art and support the arts. This is certainly one possible reason why the gift sphere is so large. It is a so-called *merit good* argument. Art has special merits that people are insufficiently aware of and therefore donors and governments support art. Donors and governments know what is 'best' for two reasons: they know what art is 'best' and they know what is 'best' for the people.[44]

This chapter's provisionary thesis on the recurring issue of the large size of the gift sphere reads as follows: *The gift sphere in the arts is large because governments and donors believe people underestimate the value of 'quality art'. Therefore, they protect and stimulate 'quality art' through donations and subsidies* (thesis 22). Their support helps bridge the gap between high aesthetic value and low market value.

12 Market Value and Aesthetic Value Tend to Converge in the Long Run

When the government and donors bridge this gap between aesthetic and market value, the correspondence between these values increases. And as the conflict between modern and contemporary visual art groups gradually disappears, the correspondence between aesthetic value and market value in the visual arts also increases. Is there a long-term tendency towards convergence then? If that is indeed the case then the economist is correct after all. A number of factors point in that direction.

1 Consumers care about the opinions of experts, while experts are influenced by consumer behavior, whether they are aware of it or not. When the Saatchi brothers boosted the prices of Damian Hirst's work and devalued Sandro Chia's work, experts largely heeded the Saatchi's behavior and changed their aesthetic judgments. On the other hand, art collectors heed expert opinion, for instance by consulting publicized ratings, which show that the prices of the works of certain artists are out of line with the experts' assessments. This is how they discover whose work is on the rise and whose value is collapsing. By buying or selling the works of these artists they consequently draw the market

value closer to that of aesthetic value.[45]

2 As noted above, government tastes can be at odds with those of the average consumer. This implies that government subsidies and purchases bend market value towards aesthetic value, which is the case in the Netherlands. Government subsidies and purchases can also indirectly bend market value towards aesthetic value because they have a signaling effect. They alert buyers that what they support is 'high quality art' and consequently consumers start to purchase more of it.

3 In the long run, artworks with much aesthetic value can earn artists high symbolic rewards as well as market income. Bourdieu observed that publishers of serious literature and dealers of avant-garde visual art are less interested in immediate returns than their 'lower'-end colleagues are.[46] They make long-term investments. And when, perhaps decades later, it turns out that they were instrumental in launching important artists, they and the artists may be rewarded with everlasting recognition, fame, and money.

4 As noted, in the long run the two social groups – one with economic capital and the other with cultural capital[47] – will probably begin to resemble one another more and more until they fuse and aesthetic and market value correspond.

Although these forces may bring aesthetic and economic values together in the long run, they can just as easily be thrown off balance again. When the higher echelons become more alike, chances are that new social groups will emerge in the struggle for social supremacy. They are bound to bring along new forms of cultural capital that will influence aesthetic value and thus lead to fresh offshoots. If this is a cyclical process, long-term convergence is doubtful.

All these forces also apply to mass markets but less firmly. For instance, in the case of films, it is possible that in one hundred years, Herzog may be better remembered and more honored than Spielberg. But even then, it is unlikely that over that period of time, his movies would have earned more money than Spielberg's. (This does not contradict Bourdieu's argument, because his approach is based on symbolic rewards. Therefore, in Bourdieu's view, Herzog's work could, in the long run, generate most symbolic returns, but not necessarily more monetary rewards.) Donations and government spending probably can't bridge the gap between aesthetic and market value in the mass markets because it would just be too costly.

Another difference between mass and deep-pocket markets is that the gap in values in deep-pocket markets disappears when *large* artistic areas are set apart. If one looks only at traditional or only at contemporary

visual art, for instance, the gap all but disappears. Both areas have leading experts whose judgment on aesthetic value does not deviate much from the market value. On the other hand, agreement between market value and expert judgment exists only in *small* artistic areas, or *subcultures* when we are dealing with technically reproduced pop music. Because of the ever-decreasing price of the technical reproduction of sound, images, and words on CD, video, CD-ROM and DVD, the purchasing power of large subgroups breeds all sorts of subcultures with separate aesthetics of their own.

Are pop music and new media art forms the precursors of a postmodern era in which many different values with relatively little coherence coexist? And will the other arts follow suit? Asymmetrical assessment would then become a thing of the past. Formulated differently: is it possible that over time the arts will splinter into more and more subcultures, which peacefully coexist? Will the thesis of convergence break down altogether in a postmodern era? The Epilogue will deal with these questions.

13 Conclusion

Why do Alex's colleagues, in the illustration earlier in this chapter, publicly ridicule market values, and yet, appear to be fascinated by them? And why – to Alex's relief – is it that *on average* an artwork's aesthetic value doesn't remain constant, but diminishes over time, as well as market value?

Apparently, artists are aware that market value and aesthetic value sometimes correspond. Publicly they nevertheless reject market value because they want to believe in the independence of aesthetic value or in a negative relationship between quality and price. But aesthetic value cannot be independent; it cannot rest on the intrinsic qualities of a work of art. Instead aesthetic value is a social value, that is influenced by social circumstances including market value. Because aesthetic value is a social value, it can diminish when works of art gradually become less useful.

Economic and aesthetic value are interdependent. However, this interdependence does not necessarily imply the correspondence the economist predicted; nor does it necessarily imply a negative relationship like the artist predicted. In this respect, both artist and economist are wrong. When the power to buy and the power to tell what is good and what is bad art rests with one group, market and aesthetic value may correspond. When these powers are in the hands of different social groups, low quality can have a high market value as well as vice versa.

In markets where expensive art products are sold, like paintings, the

latter situation is relatively rare. If it does occur, it is a sign of social strife: groups moving up the social ladder challenge the groups above them. When, however, art products are cheap, like books, a negative relationship is more often the rule than the exception. Social stratification assures that the purchasing power of large groups is not related to the cultural power of experts who point out good and bad art.

Both artist and economist are wrong about the relationship between price and quality. General statements about the relationship between market value and quality are not possible. However, it appears that the economist's view is more often right when it comes to analyzing deep-pocket markets, while the artist's view is more often right when it comes to mass markets.

Donors and governments interfere in the development of market and aesthetic value. For instance, in the recent strife for supremacy between traditional and avant-garde visual art, governments in most mainland Western European countries have sided with the avant-garde favored by the new cultural elite.

The general interference via donations and subsidies in the arts increases the size of the gift sphere. The answer to the recurring question of why the gift sphere is so large in the arts, lies with the desire by donors and governments to protect 'quality art' from the market, because of its special merits, even if other interests lie hidden behind this desire.

Artists, art lovers and donors want to believe that economic value devalues and corrupts art and that only aesthetic value should matter. Whether or not deliberately they side with one form of power, the cultural power of the well educated, while dismissing the economic power of not only the well-to-do but also the general masses. But both values are revealing. While many people consider it a struggle between art and money, between aesthetic and economic value, between good and evil, the sacred and the worldly, the spiritual and the vulgar, it is basically the fight between different forms of power. The power to tell what is good and what is bad in the arts competes with purchasing power.

Discussion

1 Is it true that aesthetic value cannot rest on the intrinsic qualities of art alone?
2 Can you provide some arguments against the thesis that aesthetic value and economic value tend to converge over time?
3 Can you provide some examples that show your own appreciation of art having been influenced by price or market success?

Chapter 4

The Selflessly Devoted Artist

Are Artists Reward-Oriented?

Former Teachers and Experts Looking over the Artist's Shoulder

Alex considers himself a selfless and autonomous fine artist, but some years ago something happened that made him rethink his position.

Alex always works with a model. He asks the model to look him in the eyes while the model is sitting. This is an intense experience for both of them. Alex does his best to record the experience in his drawings. While he is drawing, the model's feelings and judgments seem to be reflected in the model's eyes. However, Alex gradually discovered that he was also projecting his own feelings onto his model. The model's eyes can turn into the eyes of people Alex has known. Quite often, it's his father looking at him through the model's eyes. What is brought into the drawing is a mixture of the model, Alex and the people Alex carries inside him. In this short-term symbiotic relationship the model and Alex fuse. There is nothing peculiar about this symbiosis. It is Alex's little artistic trick; other artists have their own tricks.

However, a few years ago, while Alex was drawing in this way, he had a unique experience that relates to the present topic. Alex was drawing a model who was also an art student. Before they began, they chatted awhile and it turned out that the model knew a lot about drawing. Alex also got the impression that this model was not pleased with Alex's intuitive drawing style. His interests were more conceptual. Alex started to draw him. The model's eyes gradually changed into those of Alex's condemning father. And then something unexpected happened. Alex realized that it was no longer his father looking at him but Rudi Fuchs, the director of the Stedelijk, the most prestigious museum of modern art in the Netherlands. His eyes certainly were not approving of what Alex had drawn thus far. (Alex cannot remember what became of this particular drawing, which probably means it did not turn out to his liking.)

This was a shock to Alex. It gave him an uncanny awareness of his limited autonomy. Since then he has come to the realization that all the time he thought he was alone in his studio with his model, there were actually many people present looking over his shoulder. Apart from Mr. Fuchs, there were

colleagues, critics, several art school teachers, a few of Alex's students, some important buyers and some members of committees who decided on Alex's applications for government subsidies. For about a year after this experience, his studio actually felt like a crowded place. After a year, these same people were still around, but Alex's awareness of their presence had been reduced to what it had been before. Nevertheless, Alex was sure that they were continuing to influence him just as much. Or maybe they influenced him even more, because he was less aware of their power. Once again, Alex had internalized these influences.

Concessions in Order to Guard One's reputation

Shortly after leaving art school, Alex began concentrating on drawing heads using live models. At the same time, he was doing commissions for portraits as well. These portraits were like his heads, except that Alex thought the commissioned work never reached the quality level of the autonomous artwork. The portraits were in his own style, but consistently less bold. Alex sometimes wished the two sides of his work were more distinct from one another, so as not to confuse people and potentially damage his young reputation as a draughtsman with a distinctive style. So he began to reduce the number of commissions and Alex currently does not accept commissions anymore. This was not a conscious choice of his. Alex just began to realize that he enjoyed commissioned work less and less. But he was sure that his displeasure was due to worries about his reputation. By just about cutting out commissions altogether Alex lost some income, but his reputation began developing the way he wanted it to.

Recently Alex started to apply more energy to his photography at the expense of his drawing. This was a conscious choice he made. He just wants to be an avant-garde artist. Even though his drawings are not considered traditional, they never really earned him an established position in the avant-garde. Alex expects that his photography has more of a chance of gaining some recognition in the avant-garde. If that happens it is much easier to have his drawings considered as avant-garde as well. Therefore, although Alex enjoys drawing more and considers his drawings as artistically interesting, he spends most of his time on photography now.

No Bargaining with Autonomy – The Audi Deal

Recently the German car manufacturer Audi offered the most important modern art museum in the Netherlands, Amsterdam's Stedelijk Museum, an interest-free loan to finance the building of a new wing. In return, Audi put one of its cars on display in a space next to the new restaurant. In another adjoining space, separate from the general exhibition halls, exhibitions that refer indirectly to Dutch-German relations would occasionally be

organized. Audi would possibly serve in an advisory capacity for these exhibitions. A squabble developed, first in the daily newspapers and later in the city council. Critics thought that the director of the museum, Rudi Fuchs, was compromising their museum's autonomy. They also thought that, issues of autonomy aside, it was a bad deal – Audi was getting too much for too little.

This kind of deal is unique and there is no set price. And so it is only natural that city council and other interested parties evaluate the deal. One evening Alex went to a forum about the proposed deal at the Erasmus University. The main faculties here are business administration and economics. So, Alex expected the members on the panel and the audience to have few objections based on principle against the deal. This turned out to be true, as three out of four members of the panel were fervently in favor of this kind of deal. 'If museums can sell attractive tie-in products to firms, like advertisement space or by letting firms connect their brand name to the name of the museum, it would be stupid not to seize the opportunity.'

What amazed Alex however was that these business-minded panel members and many member of the audience all had one condition. 'The director of the museum must maintain his autonomy.' They were adamant, this was an all or nothing affair. If Audi gets even the least bit of say in the curating process, the deal cannot go through. 'You can't bargain autonomy.' Alex proposed that the director could have 'more or less' autonomy and that his autonomy could also increase by the extra funds he would have at his disposal after the deal. However, Alex's notion did not appeal to them. In fact, it was members of the university business department who were the most adamant about the notion that autonomy is all-or-nothing and that money should have no influence in the matter. Alex could not help thinking that the resolve of these 'money-people' clearly demonstrated the importance of the denial of the economy in the arts.

The Audi deal fell through. It failed at a point in time when there was increased public discussion in the Netherlands about the autonomy of the arts. It was during this time that the State Secretary for Culture proposed to financially reward performing art companies if they would actively work toward increasing the attendance figures among the young. The rest would be penalized by having their subsidies cutback. Parliament blocked the proposed legislation, even going so far as to pass a resolution ordering the minister to respect the autonomy of art institutions. This example as well, proved that autonomy is considered an all-or-nothing affair.

Artists are supposed to be selflessly devoted to their art. Are artists immune to rewards? How immune is Alex when he feels people gazing over his shoulder, who either praise his work or condemn it? And when

Alex decides to concentrate more on his photography, is it for the praise or is it merely to 'serve art'? A similar question can be posed to the museum director who is seeking to close a sponsorship deal with the Audi automobile manufacturer. Does he in turn lose his autonomy?

As an artist, I believe that artists are selflessly devoted to art. They serve art, not Mammon. If artists should emphasize anything, it should be the artwork, not profits. I see myself as a selfless and autonomous fine artist. My friends also see me that way. They note how I stubbornly do my own thing year after year, ignoring customers and the art world at large. (However, I must admit, that on occasion, I catch myself showing off this selfless devotion when I'm among friends. Why do I do it? It worries me, but I try not to think about it.)

As an economist, I believe that artists, like everybody else, are selfish; they try to 'better themselves', whether they are conscious of it or not. This is the only way that I can explain the behavior of artists. Alex, for instance, admitted that he now concentrates on photography in order to be more successful. Therefore, I see no reason to make an exception for artists.

1 The Selfless Artist is Intrinsically Motivated

Why is this total dedication to one's art so important for artists and the art world? Why are the demands placed on artists so much higher than for the rest of society (save perhaps those who join the church)? This is because art is sacred. This high status must be protected. If artists were not totally dedicated to art and would make commercial compromises, as ordinary mortals do, it would diminish the status of art. The mythology surrounding the arts is at stake. Therefore artists, the art world and society must condemn 'self-interested' or 'commercial' artists, or rather, artists they judge to be 'self-interested' or 'commercial'.

The question, however, should be whether artists are really all that selflessly devoted to art or whether it's not part self-interest that motivates them. Is making art an aim in itself or is it a means of achieving personal gain? Are artists then 'selfless' or 'self-interested'? The most common interpretation of the term 'commercial' is that 'commercial' artists are 'self-interested' in the sense that they choose the most profitable activities inside and outside the art world, not for the sake of art but for their own sake. If, at some stage, photography offers higher gains than drawing, the 'commercial' artist competent in both fields, will give up drawing for photography or acting to consultancy. The attraction can be monetary as well as non-monetary. Other than pure monetary gain,

the commercial artist can also be seeking rewards like recognition and fame. (Although the artist who seeks monetary gain is usually much more likely to be labeled 'commercial' than the artist who seeks recognition, I prefer to use the term in a broader sense.)

The well-being of a commercial artist depends on *external rewards* like money, recognition, fame and not on the 'making of art'. A non-commercial artist, one 'selflessly' devoted to art, on the other hand, is only concerned with the 'making of art'. There are no external rewards. Some will argue that the selfless artist does not exist. (In standard economic theory, people are selfish by definition.[1]) It seems that even totally 'selfless' artists profit from (derive 'utility' from) their 'selfless' behavior. They receive 'internal rewards' or 'self-rewards' in the form of 'private satisfaction', as economists say.[2] Their behavior, in fact, betrays that they seek internal rewards. Therefore artists can be said to be intrinsically motivated, and in the strictest sense, there is no such thing as a selfless artist. Nevertheless, I prefer to interpret selflessness as being exclusively intrinsically motivated, and therefore artists can be 'selfless'. Because I prefer a broader interpretation, I place the term 'selfless' in quotations. The commercial artist, on the other hand, is exclusively extrinsically motivated and therefore 'self-interested'.

Economists seldom pay much attention to inner gratification or private satisfaction through *internal rewards*. (An exception is Bruno Frey, who recently introduced the concept of *intrinsic motivation* in economics. He uses the concept in broader sense than I do.[3]) Intrinsic motivation can play a role in any profession. However, it is very likely that internal rewards are even more important for artists than for other professionals.[4] This would mean that *artists are relatively more 'selfless' in the sense that artists are more intrinsically motivated than other professionals* (thesis 23). If this is true, it implies that external rewards are less important for artists. They are more likely to be byproducts of making art than ends.[5] This does not mean that the executive and the commercial artist, who are both in it for the money, don't receive any private satisfaction, but it is more likely to be less important and more of a byproduct.

Most of the time artists are viewed as either selfless or commercial. It appears to be an all-or-nothing affair. This is the way society and the art world tend to employ these concepts. One false step and the artist becomes once and for all a commercial artist. Nevertheless, it is more appropriate to see these concepts as extreme positions on a scale with many positions in between. Being devoted or commercial is a matter of degree. For instance, Alex's choice to concentrate more on photography than on drawing was probably more of a compromise: this choice partly

'serves art' and internal rewards and partly 'serves money and recognition'.[6] Either way, it adds to the artist's state of well-being. Most artists are constantly making compromises; their actions simultaneously serving both purposes, although some of these actions primarily serve 'art' while others primarily serve 'money and recognition'. It follows that most artists are situated in-between; they are neither totally commercial nor totally selfless. Nevertheless, I shall continue to confront the notion of the totally 'selfless' artist with the totally 'commercial' or 'self-interested' artist, not because I think these extremes exist but because the confrontation tells us something about the intermediate positions.

It should be noted that usually only behavior counts in the economic approach; intentions are irrelevant.[7] In practice, the common assumption in the economist's approach is that people are 'self-interested', not by definition but because their behavior shows it: they apparently try to become better off. Therefore the next assumption is that people are after external rewards like money and status. I go along with the first assumption, but in this chapter I am trying to demonstrate that when it comes to the arts, internal rewards also matter. The chapter explores the border between intrinsic and extrinsic motivation.

Economists often further narrow down these assumptions by assuming that 'self-interested' people are only interested in money, i.e., their well-being depends solely on monetary gain. For economists this is a 'shortcut'. They don't deny that recognition and other forms of non-monetary rewards can matter to people, but in terms of explaining behavior, they think money can represent and therefore replace other forms of rewards. In the next chapter, I shall demonstrate that they are wrong when it comes to the arts. Non-monetary rewards play a significant role and cannot be ignored.

2 Rewards Serve as Inputs

When I observe young artists, I am tempted to think that economists are right in assuming that artists seek monetary gain. Young artists are often obsessed with money. Take the models I work with; most of them are young dancers and I notice that money is extremely important to them – far more than others their age. This is the last thing you'd expect from artists who are supposedly devoted to art. However, the instant my models earn some money dancing, they are suddenly unavailable for modeling – not even if I offer them far above the normal wage. This implies that the pursuit of money does not necessarily negate one's devotion to art. On the contrary, young artists are moneygrubbers precisely

because they want to 'serve art'. In general, they earn very little as artists. The only way to survive as an artist is to have a second job. These jobs are often non-arts related jobs such as cleaning, waiting tables, modeling, etc. But sometimes they are indeed arts-related jobs such as teaching or producing minor forms of art, such as portrait painting or acting in commercials.

For the economist this is an example of roundabout production. In order to cut down a tree one first has to produce an axe. Waiting tables in a restaurant and modeling are both means toward the end of 'serving art'. The incomes these types of indirect employment produce serve as *inputs* in a production process, the production of a contribution to art. *Rewards can be means.*

Not all of an artist's rewards are necessarily employed as a means towards artistic ends. These rewards can also lead to personal advancement. For instance, when an actor over acts, she's probably doing so more because she loves applause than the fact that it suits the play. Nevertheless, it is often difficult, if not impossible, to determine whether certain types of behavior serve art, the artist, or both.

In the illustration above, Alex considered the aesthetic value of his photography to be less than that of his drawing, but nevertheless began to spend more time on his photography. He figured this move would help his reputation and that people would eventually come around to pay more attention to his drawings. Or was Alex just disguising his quest for praise? Or is it precisely the other way around so that his well-being does not dependent on praise but only on his contribution to art? In order to contribute to art, his works of art must be seen. And Alex could be right in believing that to make people notice his drawings he needs to enhance his artistic career and reputation via a detour into photography. It is most likely, however, that 'serving art' and receiving praise both contribute to Alex's well-being. Money and recognition serve both as input and as end.[8] The same probably applies to artists with teaching jobs. These kinds of jobs offer artists the means to go on producing art, while at the same time they usually offer some form of immediate private satisfaction as well.

In theory, if one were privy to an artist's alternatives, one could then determine which alternatives best serve art and which lead to the most personal gain. Depending on the circumstances, these alternatives may coincide, but that is probably rare. One could then tell whether artist's behavior is selfless or commercial. In reality however, it's never possible to know the full range of possibilities artists have and how they serve art and artist. The conclusion then, is that *it is often impossible to distinguish 'selfless' devotion to art from personal advancement and to distin-*

guish artists who are primarily selfless from artists who are primarily commercial (thesis 24).

3 Artists are Faced with a Survival Constraint

Why is it that when my models earn some money, they suddenly quit modeling and lose further interest in earning money? The answer is that for them money is not an end but a means. As soon as they earn enough money to survive, they prefer to 'serve art' by spending more time making art instead of earning money through modeling. (This could be proof of 'selfless' devotion, as was the case in the previous section. And, like in the previous section, a cynic could very well argue the opposite; that these youngsters don't care about art at all, and are only interested in wealth and fame. It is probably a combination of both scenarios. In this section however, for the sake of the argument, I assume they're only after non-monetary rewards.)

The economist would characterize the choice these youngsters face as a maximization problem. What combination of time spent on art versus time spent earning an income outside the arts serves their artistic goals best? Time and money are not infinite and they are dependent on one another. More artistic time means less income; and more income means less time for art.[9] Usually there are many choices and alternatives. Take, for example, a visual artist who has received a considerable raise at her second job and now earns more than she needs to just get by. She can now either reduce her work hours to spend more time on her art, or she can continue to work the same hours in order to save money so she can purchase the video equipment she needs to make the videos she wants to use in her installations. There are obviously an infinite number of possibilities.

So we see how individual artists who increase their incomes beyond what they need for mere survival can still be devoted to art, as long as they put extra income toward artistic aims. However, empirical evidence reveals that when artists' incomes increase, artists generally prefer to spend more time making art, and less time working in a second job.[10] In the trade-off between more money for art and more time for art, the choice is usually time for art.[11] This is certainly true for performers, like actors and musicians, who need relatively less money for equipment.

When artists start earning less, they have little choice. They are usually forced to find a second job or increase their hours at a second job, in order to live and survive as artists. *A survival constraint,* as Throsby has coined it, exists for artists.[12]

These kinds of constraints can vary with time and can also vary between artists and between nations. First of all, artists are never totally devoted to art; and so there are varying degrees to which they forsake money. There is no specific income level where an artist suddenly loses interest in money, but there is a range. Second, artists have different monetary needs when it comes to the purchase of art supplies. And third, the notion of what constitutes a decent minimum income varies from community to community. In Europe, having a subscription to a daily newspaper is generally regarded as necessary for a decent lifestyle, while in the US, owning a car is essential. It thus follows that the survival constraint is an average that varies between countries. Generally, the survival constraint for artists can best be interpreted as a *minimum income zone*, an area in which money rapidly loses its importance.[13]

The phenomenon that a non-arts job or a job that involves the production of commercial art almost exclusively serves the 'real' art job is an extreme case of so-called *internal subsidization.* (In internal subsidization or cross-financing, income from one activity is used to subsidize a loss-making activity within the same enterprise.) This extreme case of internal subsidization is not limited to just artists. Young art companies are sometimes also forced to produce minor forms of art in order to survive. (Or they pay their artists such low hourly incomes that the latter are forced to earn extra income in second non-arts or art-related jobs.) The same applies to many small or fringe art institutions that mediate and distribute art, including alternative exhibition spaces, alternative movie theatres, small alternative festivals, small-scale film and video producers and distributors etc. The employees these organizations hire are almost always young and their attitudes are similar to those of young artists. By being underpaid they, in fact, subsidize the loss-making art institution.

Is it possible that it's not just money, but also other rewards, like recognition, that serve as artistic inputs? And if so, is there a survival constraint for recognition like there is for money? Alex decided to turn to photography to boost his reputation, because he thought that in order to 'serve art' he should be more well-known. Being fairly unknown or having an inappropriate reputation limits artists in their abilities to get their art across and properly 'serve art'. In this scenario, recognition becomes a means rather than an end. It is quite possible, then, that artists need some recognition to be able to make art. But this minimum might differ considerably depending on an artist's personal background. Moreover, with immaterial rewards like recognition it's even more difficult than with money to tell whether they represent a constraint in 'serving art' or serve 'selfish' aims. (Who can tell for sure whether the overly dramatic actor is a pompous ass who is fishing for as much applause as he

can get, or whether he needs a minimum of applause just to be able to perform?)

Applause and other immaterial rewards can also serve as inputs or as constraints. Although this view might alter the way we look at artists, its practical significance is limited. In the case of material or monetary rewards on the other hand, the notion of inputs and a (largely fixed) monetary survival constraint is useful, as will be shown in the analysis of incomes in the arts in the next two chapters. *In the arts, there is a largely fixed survival constraint for artists. As long as artists earn less than a minimum level of money, artists seek money in order to make art, but when funds are sufficient they quickly lose interest in earning money* (thesis 25).

4 Autonomy is Always Relative

Was Alex autonomous when he was painting commissioned portraits to finance his true art? And how autonomous is the young writer who washes dishes in a restaurant forty hours a week? Or does Mr. Fuchs, director of the Stedelijk Museum, relinquish his autonomy by allowing Audi to sponsor the museum's new wing?

The main question in this chapter is whether artists are 'selflessly' devoted to art or 'self-interested'. It is a relevant question in a book about the economy of the arts. The question is related to a more general question: *are artists autonomous or dependent?* Because people easily confuse the two questions, I will now make a few comments on autonomy.[14]

Autonomy refers to the liberty people have to follow their own will independent of others. In the arts, this is primarily seen as a matter of artistic freedom. If an artist *chooses* to make an artistic compromise in exchange for more rewards, he or she ends up with less artistic freedom. But the same applies to an artist *forced* to work long hours in a restaurant.

Autonomy in the arts is an emotionally charged concept. 'True artists must be autonomous.' 'The autonomy of the arts needs to be protected at all costs.' Because the notion of autonomy is charged, people tend to see autonomy as an all-or-nothing affair. 'If Mr. Fuchs closes the deal with Audi, he will relinquish his autonomy.'

But autonomy is clearly a relative concept. For Mr. Fuchs, one sponsorship contract might mean a sacrifice of more autonomy than another one. This is not much different from the issue of relativity as applied to the notion of a 'selfless' devotion to art. Both autonomy and selflessness consist of a large range of intermediate positions between the two extremes.

(Theoretically it's possible that there is a generally accepted point between complete autonomy and complete dependence where autonomy or artistic liberty is supposed to end.[15] But in practice, the cut-off point is continuously shifting depending on the prevailing rhetoric.)

When proposals that will reduce autonomy are suggested, people will consistently warn of future forfeitures of artistic autonomy. These all-or-nothing doomsday arguments concerning the loss of autonomy serve opportunistic purposes. They basically thwart discussions about degrees of autonomy. This happened at an Amsterdam city council meeting where politicians successfully argued that Rudi Fuchs would relinquish his autonomy, if the Stedelijk and Audi were to close a sponsorship deal. In so doing they managed to stifle skeptics or render them suspect by making the skeptics look like they were against autonomy in the arts.

Because autonomy is relative, the advantages and disadvantages of the various options surrounding autonomy can be compared. The Audi deal would have reduced autonomy in a number of ways. For instance, the new wing would be called the Audi Wing but more importantly, the director would be required to occasionally produce an exhibition that referred to Dutch-German relations, with Audi representatives serving in advisory capacity. On the other hand, the extra money would also enhance the director's autonomy. More exhibition space would mean more liberty in the curating of exhibitions. Suppose Mercedes presented a deal involving less money, but also fewer conditions. Suppose that the only condition was that the new wing would be named the Mercedes Wing. Even then, some would argue, the director is compromising his artistic freedom. Exhibitions in the Mercedes Wing would be 'colored' by this namebrand. As we noted earlier, social circumstances necessarily influence art and its aesthetic value. These examples clarify the notion that *autonomy is always relative* (thesis 26).[16]

5 Intrinsic Motivation Stems from Internalization

The average fine artist responds to rewards and is thus never totally autonomous. Artists reward and punish themselves and so does society. There are considerable rewards for artists who appear to be autonomous and 'selflessly' devoted to art, just as there are reprimands for those who are plainly commercial artists.

On the one hand, by making art, artists receive *private satisfaction*. Creating art is fulfilling in itself. The 'joy of self-expression', as Tyler Cowen calls it, is one form of private satisfaction.[17] The satifaction comes from the 'labor of love' and stems from an 'intrinsic drive'.[18] The

awareness of 'serving art' also gives an artist private satisfaction. But compromising one's artistic goals can lead to uneasiness, for instance in the form of guilt feelings. The notions of rewarding and punishing oneself are important if one is to understand an artist's behavior. It puts the notion of the 'selfless' artist in perspective and also explains the stubbornness of artists who continue to 'serve art' with few external rewards.

At first glance, self- or internal rewards appear to be inevitable byproducts of making art. But they are more than mere byproducts; they also motivate artists. Artists reward or punish themselves with every stroke of the brush, every written line, every musical note set to paper as they try to 'serve art' and produce high art that matters. The entire notion of suffering may have been exaggerated in the old romantic view of the arts, but famous artists in their diaries accurately describe the ups and downs caused by the doubts they have about their own work.[19] These diaries also reveal that there were always alternatives. Because of internal rewards and punishments, artists often choose one course over another. Artists can therefore be said to be intrinsically motivated.

Because internal rewards like private satisfaction and external rewards like the pleasure derived from recognition are hard to separate, it is difficult to measure precisely how important intrinsic motivation is. Nevertheless, in the popular image, the 'selfless' artist is largely intrinsically motivated and the 'commercial artist' is primarily externally motivated. To exaggerate this popular view, heroic, 'selfless', and totally intrinsically motivated artists for whom external rewards are only a means for them to 'serve art' stand on one side, while extrinsically motivated 'artists' motivated solely by external gain – money, fame, and recognition – stand on the other. These notions are part of the mythology of the arts.

But if one were to search for the origin of internal and external rewards one would discover that they are not at all distinct notions.[20] The internal rewards or private satisfaction artists 'give' themselves stem from rewards that originally came from outside. In their youth, people internalized the rewards and punishments they received from their parents, schools, neighborhoods and various other environments. Despite differences in personal histories, many of these internalized values are social values. For instance, would-be artists learn and internalize the existing social values applied to art and artists. They learn at an early age that culture expects fine artists to be 'selfless' and autonomous. Art for art's sake and artists being 'selfless', caring only for art, are important notions in our culture, to the point that they are part of our general education. Children notice that the 'selfless' artist is esteemed and is seen as the standard for other artists. The commercial artist is scolded. He serves

as a warning to other artists. Young potential artists internalize these values.

Later on during the period of education and training, the values of the profession get internalized.[21] Rewards and punishments contribute to the internalization of the more detailed values the profession embraces. And so it is institutions – from family through art school – that play an important role in the *internalization* process.[22] The fact that in the illustration former teachers are peering over Alex's shoulder demonstrates that he internalized earlier rewards and punishments.

Intrinsic motivation and internal rewards derive from the accumulation of past external rewards and punishments. Because internal rewards stem from earlier external rewards, they can deviate from present external rewards and even go off in a totally different direction. There are artists for instance who have plenty of chances to earn money or become celebrities without punishment by the art world, but prefer to disregard these opportunities. This is not a congenital defect. This kind of behavior can be best explained through how an artist is trained. In the case of these artists the internalization process assures that earning money or becoming a celebrity are not valid options.[23] Because the commercial artist also harbors internalized values, it is impossible to say whether the selfless artist is more intrinsically motivated than the commercial artist or vice versa.

Internalization is not a random process. Not all past advice, praise, reward, or condemnation is of equal importance. Rules that make sense in relation to each other form clusters and become more important. The result is a more or less coherent system of rules in the form of orders and bans that refer to a wide variety of actions. This result can be referred to as the personal value system or conscience of the artist.[24] It is related to the sociological notion of habitus.

6 Habitus and Field

The economic approach we have employed thus far has not been very subtle. Concepts like reward and constraint coincide well with the economist's preference for logical, closed reasoning, but outcomes tend to be discrete and no intermediate positions are recognized. It is either free choice or determinism.[25] On the one hand, the most common view in economics is that individuals are free; they make rational choices and maximize rewards. On the other hand, in an attempt to 'socialize' economics behavior can easily become totally socially determined. If all internal rewards were reduced to internalized external rewards, as we

implied in the previous section, the outside world would completely determine behavior. Individuals would have no choice. (And so we must conclude that in both these views the terms 'selfish' and 'selfless' are basically meaningless.)

In order to develop a better understanding of the relation between intrinsic and extrinsic values, between subjective individuals and their objective surroundings, it is useful to look at socialization in terms of sociology. Among the major socialization theories, Pierre Bourdieu's habitus-field theory is presently used most often. Moreover, Bourdieu and his followers have applied it extensively to the arts. Because of its subtlety and complexity this theory requires extensive explanation, which is not possible within the scope of this book. Instead, this slightly abstract section only briefly treats some of its main concepts.[26]

The *habitus* is the principal component of this theory. It is related to the terms 'conscience' and 'attitude' that we used earlier. The habitus is the subjective counterpart of the objective forces surrounding the individual. The habitus, allows individuals to believe that they understand their social surroundings. There is no calculation of behavior; it's intuitive.

The habitus is more than just a set of (internalized) values and rules. It can be seen as a collection of incorporated dispositions such as the inclinations to think, perceive, value, and act.[27] These dispositions are linked to a person's position in a particular field. As a mental structure, the habitus connects the objective outside world with the subjective self. It is a complicated process that excludes the two opposing conclusions named earlier: man is certainly not totally free, but on the other hand, the notion that the individual is totally socially and biologically determined, is also not justified. The habitus 'leaves room to move'.

The inclinations to think, perceive, value, and act have become incorporated over time. The habitus accommodates past experiences in a cumulative form. And because no two people have exactly the same history, the habitus differs from one person to another. But at the same time, people often share a common background and environment. Therefore the notion of a modal habitus that is shared by a group makes sense.[28] The higher order values discussed in the previous chapter are part of such a modal habitus; they connect people. But it's not just values, the inclination to see, think, and act can also be shared. A habitus gives people a practical sense, a feel for the game. It doesn't prescribe actions in specific situations, but instead, the habitus allows people to find common solutions.

A modal habitus allows people in a group to work together without being supervised, i.e., without the impetus of external punishment or

reward. (They arrive at a natural solution to the so-called free-rider problem.) That people play the game without being aware of it becomes evident when people with a different habitus try to work together. Then there can be a conflict and things go wrong as they did in the illustration on page 36 where Alex and his dealer failed to come to terms, because they 'spoke different languages'.

The habitus is associated with one's position in a *field*. The term 'field' has almost the same meaning as the term 'world', as in art world. Fields are chosen so that dispositions within a field depend on one another while remaining relatively independent from the dispositions in other fields. Therefore, fields have a degree of *relative autonomy*. Medicine, the arts, banking, and politics are examples of such fields. The modal habitus among these fields is quite different. A banker's disposition has little to do with that of a musician's, while musicians have more in common with writers. Nevertheless, because the *positions* of writers and musicians are different within the arts field, their habitus is different as well.

A field can be viewed as a topological map of positions that differ socially. It is primarily a topology of stratification. In the arts, positions connected with high and low art, for instance, say, literary fiction and science fiction, have different locations within the field of literature. High and low positions apply not only to artists, but also to art mediators, art critics, art consumers, government officials in charge of arts policies etc. These positions become more meaningful with respect to social stratification, the further they are divided according to the various genres and sub-genres of art.

By occupying different, i.e., higher and lower positions within a field, groups necessarily relate to one another. Their habitus simultaneously differs and corresponds. Dominance and submission depend on one's position in a particular field. The existing order is reproduced via the habitus. In a simplified version, the habitus among the low arts 'allows' an artist to operate commercially; while the habitus among the high arts 'forces' the artist to forget commerce. But these positions are interconnected because the habitus of either field inclines the artist to view high art as superior to low art. This was discussed earlier as the phenomenon of cultural asymmetry.[29]

7 Selfless Devotion and the Pursuit of Gain Coincide

Are artists who are devoted to art selfless or at least unmotivated by external rewards? Conversely, are commercial artists self-interested and only motivated by external rewards? In terms of the habitus-field theory,

these two groups do not differ in terms of selflessness and motivation. Selflessness and selfishness usually coincide with one another. (Nevertheless, as concepts they are not meaningless, unlike they tend to be in pure economics.) Translating these outcomes into economic terminology, selflessness is usually no more or no less intrinsically and extrinsically motivated than an orientation on external rewards, such as money and recognition. Dispositions in either direction are 'built' into the same habitus.

Looking at the habitus, it is impossible to say whether artists have only one goal (or one consistent welfare function) like 'serving art', while other objectives remain secondary and only represent conditions that must be met to 'serve art'. Within their habitus, artists have a range of dispositions, which cannot be reduced to one goal. Artists are players in complicated games with many prizes. A special 'sense of the game' enables artists to make moves that enable them to remain devoted to art and other moves that serve other goals.[30]

Not all artists play the same game. The games and their stakes differ depending on the artist's particular habitus and on their specific position in the field. Sometimes people from a variety of positions meet for a collective game. For instance, dealers and artists are players in a collective game. And because they share a 'sense of the game', they play their game in an intuitive manner. However, as we noted earlier, when a player has a habitus that deviates from the rest, this player will tend to break the rules, which leads to frustration and problems. This happened to Alex in the illustration on page 36 when because of Alex's profoundly internalized habitus as an economist, he did not play the dealer's game according to the rules.[31]

In this respect my economist's habitus is also different from a sociologist's and this puts limits on the multidisciplinary approach of this book. A bird is known by its song and a man by his language. Therefore, I tend to use the language of economics to explain sociological insights. Because the economist's language was developed for other purposes, this is clearly not the best solution. So in the remainder of this chapter and in the following chapters I will actually take a step back. By primarily arguing in the language of economics and employing terms like 'interest', 'strategy', 'reward', and 'the pursuit of gain' I necessarily simplify. And although I will continue to keep the habitus-field theory of sociology in the back of my mind, part of its richness will be lost. Nevertheless, I hope to prove that the present approach is more useful for the study of the economics of the arts than a mono-disciplinary approach.[32 33]

By claiming that artists are rewards oriented and by using the term 'reward' I now return to the economic approach. (However, by referring to a rewards orientation, i.e., a term that is related to 'inclination', I reveal how the habitus-field theory is at the back of my mind.) In the earlier sections, the analysis revealed that all artists are oriented towards rewards; they need rewards in order to make art and to 'better themselves'. Currently I am wondering why artists have different reward orientations. For instance, why do certain artists seek recognition from the government, while others prefer market rewards? As noted before, it's these kinds of inclinations that gradually became part of the habitus of artists. To understand the variations in reward orientation I will, once more, take a look at the formation of the habitus.

In their development as artists, artists acquire the appropriate cultural capital, which is not just some automatic process, but a social experience as well.[34] Much of the discussion that goes on between students involves a collective assessment of the teachers' values, including their thoughts on rewards. Groups of artists with common backgrounds and educations basically develop the same artistic conscience or habitus and the same reward orientation.

In this respect, it should be noted that the habitus encompasses many areas. No aspect of culture is excluded beforehand. The habitus deals with 'technical' matters such as how artists use their paint; how musicians play the piano, sing, use their bodies, etc. Artists also adopt inclinations to employ certain styles while ignoring others or treat certain subjects and not others.

The habitus also 'tells' which exceptions to basic values are allowed. For instance, it's not so taboo these days for certain 'avant-garde' visual artists to make an occasional commercial wink, resulting in a more accessible piece, but only if they prove somehow that it's not coming 'from the heart' and that they are 'above it all'. Or older artists can pursue external rewards to improve their position, but only within limits.

Differences in the reward orientation of artists come about in the various styles of upbringing, their educations, and their formal arts training. Fine arts colleges prepare their students for other positions in the art world than low arts or applied arts colleges. Moreover, no student starts his or her education as a tabula rasa. Schooling augments the foundations laid during childhood given various socio-economic backgrounds.[35]

Limiting the discussion to orientations on rewards, it should be noted

that in the fine arts students are more often trained to pursue internal rewards. Art must be considered a labor of love based on an intrinsic drive. Therefore external rewards can only be inputs enabling the artist to make art. The latter is a 'leisurely' attitude. Students usually come from above-average social backgrounds. Thus, these avant-garde artists tend to carry along a relatively high amount of economic and social capital. They come from well-to-do families more often than in other fields and professions. Because there is money in the family, they can afford to earn less. Social capital gives them flair, self-assurance, and a sense of audacity.[36]

Although students in the better fine arts colleges are encouraged to 'serve art' by 'doing their own thing', these schools also encourage artists to seek external rewards in the form of 'recognition from peers'. Moreover, in some countries, students learn that accepting government money is less objectionable than accepting money from a corporation or earning money in the market.[37]

The reward orientation taught in lesser fine arts and in applied arts schools is less anomalous. As in most technical and vocational training, commercial success is encouraged and thus to make products that sell. However, part of this education system encourages a submissive attitude towards the fine arts.

Existing inclinations result in various mixtures of products and rewards. In order to analyze these mixes, I found it useful to chart inclinations on the basis of three characteristics or dimensions:
1 the product mix,
2 the types of rewards, and
3 the sources of the rewards.

First, most artists are inclined to choose a certain combination of products. Their product mix leads to rewards.[38] (Painter A specializes in commissioned portraits and still-lifes rather than landscapes and composer B specializes in music for choirs rather than instrumental music.) Second, artists are inclined to choose a certain combination of types of rewards such as private satisfaction, money, status, recognition, etc. Finally, artists are inclined to prefer a certain combination of reward sources, such as governmental, corporate, private buyers or donors.[39] I call the combination of sources and types of rewards that artists seek the *motivational mix* of artists.

Artists necessarily position themselves in respect to these three dimensions. Due to their inclinations, they take positions in an imaginary *three-dimensional space of products, rewards, and reward sources*. For instance, artist C specializes in installations (dimension 1). This gives her

private satisfaction, recognition, and some monetary gain (dimension 2). The recognition she receives comes from peers and the government, while most of the little money she earns comes from the government (dimension 3). This position, with respect to the three dimensions, reflects her present specialization on products and rewards.[40]

Specialization largely follows from the phenomenon explained earlier, that rewards are also means. For instance, for the development of her career, governmental recognition is an essential input for artist D, while for artist E it is almost worthless.

In this three-dimensional space, endless combinations of productive activities and types and sources of rewards are theoretically possible. Nevertheless, because of the habitus, most artists have little room to maneuver in. Artists are not likely to leap to positions further away, and when they try, they usually end up worse off. (Economists call this phenomenon *path dependency*. Once people are on a certain track, they tend to continue, because alternatives become less and less attractive.)

(By assuming that the artist does not want to 'end up worse off', I go back to the common assumption of standard economics that entrepreneurs choose the mix of products and rewards that maximizes their goal, and so I return to the economic metaphor of maximizing individuals. The notion of the habitus certainly was not meant to be connected to this metaphor, but in the present context and with the present restraints I see no harm in it.[41])

It follows that artists position themselves in the three-dimensional space so they can maximize their goals, whether this is to serve art, serve oneself, or both. Because rewards like money and recognition always serve as inputs as well, and because one type and source of reward is more valuable as an input than another, artists care about the source and type of rewards. They weigh one form of reward against another when choosing their positions.

Because artists differ in their habitus, they also differ in their orientation concerning products, types and sources of rewards (thesis 27).

9 Types and Sources of Rewards Matter to Artists

For me as an artist it is of the utmost importance that I receive recognition from my peers. Feeling ignored by my colleagues is the worst thing that can happen to me. The second worst thing is not selling; not so much because I need the money, but because I need it as a form of legitimization. Therefore, in my motivational mix, I am oriented toward recognition from peers and from consumers in the market. Another artist who

truly beliefs in art for art's sake, is only interested in private satisfaction. Meanwhile, a third artist is considered commercial because he seeks monetary gain in the market and fame amongst the general public. A fourth is primarily concerned with money and recognition gained from the government.

Various types and sources of rewards are not independent. For instance, certain artists consider the government money they earn from selling a painting to the government as more 'valuable' than the same amount money earned from a corporation for the sale of the same painting. Because there is no difference in the money itself, the example shows that the sale of the painting also provides recognition, which for these particular artists is higher in the case of selling to governments.

In the fine arts, the 'value' of money earned in the market is often low. It can even damage reputations and consequently, recognition by one's peers. Although in the fine arts as well money is earned in the market, the orientation towards money from the market is usually veiled. However, in this respect age matters. The habitus of older artists sometimes 'allows' them to be more openly oriented towards money and fame. Colleagues and commentators often stress that these artists have put in many years and have thus clearly demonstrated their selfless devotion to art. Therefore, they 'deserve' these types of rewards. Although these older artists may actively seek the rewards, the rewards are seen as accidental gifts bestowed on artists with impeccable reputations. (However, if older artists become too straightforwardly interested in money and fame, their art world will expel them. In the visual arts in the Netherlands, the internationally known Cobra painter Corneille is a good example. The musician André Rieu and the composer Henryk Gorecki are other examples. Such 'defectors' have, for one reason or another, developed a deviant habitus.)

As can be expected, artists in the lesser fine arts are generally more openly money-oriented than those in high fine arts positions. It would be incorrect however, to assume that in their motivational mix money is the only thing that counts. Take for example artists who paint the kind of art that can be bought in 'the store around the corner'. These painters see themselves as artists and present themselves as such.[42] In their circle, the taboo on openly earning money is less strong than among other artists. Nevertheless, the habitus of these artists is not independent of the habitus in higher cultural fields, and therefore, they sometimes exhibit anti-money behavior as well, which serves to compensate for their commercial demeanor. And even though in their motivational mix money figures more heavily than in the case of artists in the high arts, private satisfaction and recognition by one's peers are almost just as important. The

painters I met, who make paintings that sell in the 'stores around the corner', all displayed a strong sense of pride in their technical abilities and a zeal to perfect these abilities, which is hard to explain from an orientation that focuses exclusively on money.

In a specific reward mix rewards from certain sources and types tend to arrive in specific proportions. Usually when one type and source of reward increases, other sources and types increase as well. For instance, when certain artists receive more money from the government their recognition among their peers also increases and vice versa. Therefore, artists tend to remain in more or less the same position in the three-dimensional space of orientation with regard to products and rewards or they follow a fixed route that fits in with their careers. This is again a matter of path dependency.[43] Successful careers often gradually evolve from a one-sided orientation into a broader orientation. The initial specialization can lead to a winner-take-all situation. For instance, later on successful government artists tend to also become successful in the market.[44]

When something unexpected happens however, artists are sometimes forced to leap to another position. For instance, a young avant-garde writer unexpectedly receives an extremely important award early in her career.[45] In this case, she jumps to a new position and thus the balance in her rewards is lost. Her reputation takes a turn that she can neither correct nor adapt to. If the award comes too early in one's career, one is likely to 'lose' or end up worse off.

The effect that a substantial and prestigious sale has can be significant. However, continuous small rewards can also be of the wrong type and not fit a particular artist's reputation. Therefore, as they shape their long-term careers, artists often respond to such outside interventions with counteractions, which will hopefully correct or neutralize the unwanted 'rewards'. These actions are generally subtle. They range from changes in the group of people an artist hangs out with, to small changes in their product style to prevent a recurrence of the undesired effect. One has to develop an eye for this kind of corrective behavior in order to spot it. I think I see it all the time both in my own actions and in those of my colleagues. It also applies to Alex's behavior in the illustration where Alex decides to concentrate on photography because he wants to correct what he considered was a growing misunderstanding about his reputation.

In all these cases, path dependency is involved. If an artist has been on a 'wrong' track for too long, it is difficult to correct. The rewards received have accumulated in a specific combination of monetary, cultural, and social capital, which cannot easily be altered.[46] Writers who evolved into popular television presenters and whose books then, conse-

quently, started selling extremely well, are good examples. They are rich and famous, but often lack literary recognition. Sometimes with some enormous effort, they can manage to gain some respect in literary circles, but they seldom become fully recognized. Many successful new media artists find themselves in a similar situation.

As they try to guide the development of their careers, artists attempt to control the rewards and products. If necessary, they adapt their products and their *marketing activities* (which are part of the production process). Various orientations towards sources and types of income correspond with various marketing activities. For instance, certain commercial talents are more effective in dealing with gallery owners or impresarios than they are with government institutions. Different attitudes and social networks or, in other words, different forms of cultural and social capital are involved.

In practice, artists specialize in certain marketing activities and attitudes. Therefore, artists can be classified accordingly. For instance, artists who specialize in government recognition and money can be called *government artists*, while others can be referred to as *market artists*, *business artists*, *television artists*, etc. Once the corresponding inclinations have been internalized and have become part of the habitus, it is hard to change one's position. For instance, when the average government artist loses his government income, it becomes difficult for him or her to find a way into the private market, and vice versa.

10 Three Examples of Orientation Towards Government Rewards in the Netherlands

The following three examples show the effects on the behavior of artists oriented toward government rewards.

1 In Dutch subsidized theatre, the number of opening nights is large in relation to the total number of people who attend. Although companies appear to be better off, if plays ran longer with fewer opening nights, and therefore lower cost per seat, they prefer to have more opening nights.

 This can only be understood by taking into account an extreme orientation toward government rewards, both in terms of money and recognition. On average, these companies depend on the government for about 85% of their income. Therefore, they naturally orient themselves almost exclusively towards the government. Of course, they seek recognition from peers and experts as well, but primarily from among those peers and experts whose judgment matters to the govern-

ment committee members who ultimately decide on subsidies. And, in general, these committees are impressed by many opening nights and consider them as a sign of quality.⁴⁶

2 In the late seventies and early eighties a 'palace-revolution' took place at the better Dutch visual art academies. In a relatively short period of time most of the older teachers were forced to leave and were replaced by young teachers.

On average, teachers at these schools are also relatively successful artists. Building on their own experiences they help show potential artists the way. These older teachers had been fairly successful in the private market with a style that in Chapter 3 we called traditional (modern) art. Their main source of income was the private market. However, in the seventies, a new avant-garde (contemporary) market began to open up, and this is where the younger generation of teachers were most successful. This market was heavily dependent on government subsidy.

Between 1950 and 1996, the government considerably increased its purchases of visual art as well as the subsidization of visual artists. In the Netherlands, the part of the visual artist's professional income that comes from public sources increased from almost nothing to 45% or even more.⁴⁷ The national government, in alliance with the younger artists and the new cultural elite, was almost exclusively interested in avant-garde visual art and hardly any money went for traditional visual art. (Only local governments spend relatively small amounts of money on the latter.)

Due to the new and substantial government demand for avant-garde visual art, the cultural capital of the older teachers, who were primarily engaged in traditional visual art, declined rapidly. The younger teachers' experience, who sold their work mostly to the government and received government subsidies, had suddenly become more valuable than the older teachers' experiences in the private market. The 'palace-revolution' led to a purge of the older teachers from the principal schools.⁴⁸ Students consequently developed a more government-oriented habitus as well.

Of course, these kinds of conflicts are fought in almost exclusively artistic terms, but viewed from the tenth floor, the changes in income sources and the corresponding changes in career paths clearly show the importance of rewards. The example also reveals that, although the average habitus is not immune to market forces, a fundamental change in reward orientation is usually accompanied by a change in personnel.

3 The gradual abolition in the eighties of an extremely generous subsidy

scheme for visual artists in the Netherlands shows that a considerable reduction in subsidies affects artists' behavior.[50] The scheme was originally created to reduce the hardships of visual artists. It was replaced by a less generous system of subsidies. As a consequence, a relatively large number of those who had profited from the previous subsidy system left the arts because they were unable to successfully adapt their reward orientation. They had specialized in government orientation. Their earlier successful dealings with the government had colored their habitus, which left it unfit for the private sector.[51] Younger colleagues, who had no experience with this scheme, naturally developed a different orientation.

11 Conclusion

Artists are supposed to be selflessly devoted to art, but it is hard to tell if they are selfless or to what degree they are selfless as opposed to commercial. If artists seek rewards, this can imply that they are more or less commercially oriented, but the rewards can also be means to selflessly 'serve art'. Therefore Alex's claim that by concentrating more on photography he serves art may very well be true, but it's also possible that he's merely after applause or both. Moreover, if Alex is exclusively intrinsically motivated his motivation nevertheless stems from earlier external rewards. After all, he has admitted that while drawing in his studio he is sometimes influenced by the imagined reactions of former teachers. Nevertheless, selflessly devoted or not, it is likely that artists are more intrinsically motivated than other professionals.

The example of Alex imagining the presence of former teachers while he is drawing also demonstrates that internal rewards have a social origin; they stem from past external rewards. This notion has been developed in a more elaborate form, in the sociological notion of the habitus. Some of the peculiar inclinations, as well as the limited 'choice' artists often have, become more comprehensible when the notion of the habitus is kept in mind. Selflessness and selfishness are not meaningless concepts, but they often coincide. The habitus approach can be illuminative and helpful to the economist, even when he decides to continue with the traditional economic approach, employing the traditional terminology.

Artists who occupy different social positions within the arts have different orientations towards external rewards. Some artists choose recognition, while others prefer fame or money. Some concentrate on peers, others on governments and still others on the market. Given their habitus, individual artists do not easily change their orientation. For

instance, many European artists have a predominant orientation on governmental rewards, and when governments change or reduce rewards, artists are often at a loss.

Although an orientation towards rewards can explain the behavior of artists, this does not imply that artists can freely choose other artistic activities and other types and sources of rewards. If they choose other combinations, they usually end up worse off because their habitus and capital does not make a good fit for these positions. What often appears to be a noble lack of interest in rewards and an admirable perseverance in one's artistic choice can also be interpreted as the result of the limitations of one's social position.

Artists are relatively highly intrinsically motivated. As far as they are also extrinsically motivated, recognition is often more important than money. It follows then, that the belief in the economic approach, that an interest in money can sufficiently explain behavior, is inadequate when it comes to the arts (as well as most other professions). The fact that money is relatively unimportant in the arts is further corroborated by the existence of a survival constraint for artists. When a certain amount of money comes in, artists suddenly lose interest in earning more money. Together with a strong intrinsic motivation, this phenomenon serves as our first explanation of why incomes are relatively low in the arts, as will be discussed in greater depth in the following chapter.

Discussion

1 'If Alex does such and such he loses his autonomy'. How should a sentence like this be interpreted? Is the difference between autonomy and non-autonomy an absolute or a relative difference?
2 Can you explain why artists who seek fame, are more likely to become suspect than artists who seek recognition from among their peers?
3 To some artists money represents a constraint rather than a goal. Could this also apply to other rewards like, recognition from peers and experts?

Chapter 5

Money for the Artist

Are Artists Just Ill-Informed Gamblers?

Taking the Reckless Decision to Enter the Arts

At the age of thirty, Alex decided to stop working as an economist. At that time, Alex unintentionally joined a life drawing class, and three months later, he was admitted to art school. Alex had decided to become an artist. It was a sudden and reckless decision. Alex felt relieved. It felt like he had finally discovered his destiny. He was not worried about his chances. On the contrary, Alex tried not to think about it. In the back of his mind, he must have known that the odds were against him, as they are against any average art student. Therefore, Alex told himself that he had no choice. If he wasn't going to pursue a life in the arts, he might as well just die. Alex was also convinced that anybody as confident as he was about becoming an artist, was bound to be a success one way or another. He stuck to a simple belief: the more dedicated he was, the more inevitable his chances of success.

Looking back at that time, Alex realizes that, now as back then, he had numerous choices. Becoming an artist was only one. Therefore, by not pondering the odds, Alex tried to convince himself of the reasonability of being unreasonable. As he now realizes, someone who makes it in the arts is so unusual, that the desire to become an artist is little more than leaping off a cliff with one's eyes closed.

The life drawing class that Alex presently teaches is made up of artists, art students, and some extremely talented amateurs. The work of some of these amateurs is better than that of the artists and would-be artists. Alex has initiated some discussions between the amateurs and artists. In the course of the conversations, it turns out that some of these amateurs are aware of their talent. Some had even contemplated going to art school, but decided not to in the end. One of the reasons they hesitated to enter the art world was the many uncertainties involved in an arts career. They seem less reckless than the artists. Moreover, they demonstrate that almost anyone can find out that one's chances of success in the art world are low. Nevertheless, they are often apologetic about their decisions.

Making Jokes about Becoming Rich and Famous

Alex remembers that in his last two years at art school he and his class-mates used to make a lot of jokes about becoming rich and famous. There was something obligatory about it. Alex was at the stage when the cards were being shuffled, when teachers select certain students to launch into the art world – usually one or two per class. Naturally, everyone was nervous. The chances of success of those who go unselected are not quite zero, but certainly diminish considerably. For the majority their dreams of a career in the arts are over, even though it will take some ten years to admit it. The jokes serve a magical purpose. Their ironic jokes about fame and fortune exorcised their fears about their own futures.

The jokes are double-edged because, on the one hand, students begin to realize that most of them probably won't be rich and famous any time soon. On the other hand, by jokingly exaggerating their chances of fame and for-tune, they are effectively mocking fame and wealth and are implicitly expressing their faith in the notions of the selfless artist and the denial of the economy. But above all, the jokes demonstrate their reluctance to face real-ity and that fame and fortune was on their minds all along. Alex is sure that back in those days they all fantasized about money and fame. Occasionally Alex still catches himself fantasizing about fame and fortune, even though his chances are no better now than they were back then.

Dropouts Who Become Artists

Alex believes these days that the seeds of his decision to go to art school were planted much earlier than when he ultimately decided to change pro-fessions. Looking back, Alex now realizes that the dice were cast in his family at an early age. His older brother was set to receive the bulk of the family inheritance, which consisted mostly of cultural capital. His brother is currently a professor like his father before him. In this kind of family, there just isn't much chance to share the cultural inheritance. And so Alex chal-lenged fate by pursuing an academic career in economics even though economics is a subject alien to the general interests of his family. Needless to say, his decision did not pan out, and at age thirty Alex decided to go to art school. Alex felt relieved because he no longer had to fight destiny. But he was also titillated by the possibility of actually succeeding and thus wreaking revenge on the rest of the family.

Although this appears to be an extremely private story, Alex doesn't think so. A historian told him about the roles that are assigned to the various chil-dren in well-to-do families. For several centuries, up until around the First World War, the eldest son in these families was destined to carry on the family business, while the younger males often ended up serving in the army or joining the church. (Meanwhile, not all women in the family married;

some became nuns or spinsters.) This was how family capital remained undivided and vigorous. Alex thinks that today the arts among the higher echelons of society, sometimes serve a purpose similar to what the army and church once did, albeit less convincingly. (Even today first-born sons are underrepresented at fine arts colleges.[1])

Given the odds in the arts, becoming an artist is basically a form of degradation especially when one compares it to the far more lucrative possibilities of those who take over the family business, or their traditions in the sciences or politics. But then again, these 'drop-outs' are not necessarily always worse off being artists. Even if they're unsuccessful as artists they can still maintain some ambiguous hint of status. Moreover, successful family members often end up looking after their artist siblings. And most importantly, by choosing another path, the 'drop-outs' do have a little more chance to recover ground on successful family members, even a slight chance of actually surpassing them. In the past, some exceptional sons end up becoming bishops or generals. And today, an artist at least has a small chance of attaining a kind of fame and fortune the rest of the family never even dreamt of.[2]

Why is it that prospective artists like Alex seem so reckless? Are the arts a kind of lottery system where prizes are high, but the odds on success very small? And, is it true that artists ignore available information about these bad odds? This chapter attempts to address these questions. Above all, it attempts to explain why a low-income existence is the destiny for the vast majority of artists. It also looks at why only a small minority of artists will earn a high income from their art.

It goes without saying that people are impressed by the high incomes that famous artists earn. Not only do these incredible incomes go hand-in-hand with the glitter of stardom; these incomes also confirm the sacred status of the arts and the genius of the particular artist. Strangely enough, the obverse, the notion of the starving artist, also confirms the special status of art. But the phenomenon of the starving artists must remain an exceptional image. Because to learn that the phenomenon of low income is not just isolated to a few individual artists who happen to be poor, and affects the large majority of artists is an unpleasant and therefore readily overlooked view.

In the previous chapter, we were concerned with the selfless or reward-oriented artist and the boundary between intrinsic and extrinsic motivation. Because this chapter tries to clarify the issue of an artist's income in terms of money, we now focus on the boundary between the orientations on monetary and non-monetary rewards.[3]

As an artist, I am convinced that high incomes are well-deserved gifts

for talented artists and *poverty is caused by a general lack of public interest in the arts*. In other words, the general public and the government spend too little on the arts. As an economist, however, I disagree. I do not believe in permanent under-consumption. Yet, I certainly find it hard to believe in permanent overproduction either. Therefore as an economist I am at a loss. I don't understand why artists put up with such low incomes. *As an economist, I prefer to think of poverty in the arts as a temporary phenomenon*. Because if incomes are low enough, it should mean fewer people will want to enter the art world, which means that the sector should shrink and that incomes will subsequently rise to a normal level. I notice however, that so far this has still not happened.

1 Incomes in the Arts are Exceptionally High

Using the term 'artist' in a broad sense and, at the same time, disregarding the difference between high and low art, it turns out that an extremely small group of artists earns astronomical amounts of money. Movie actors and pop musicians belong to the group of professionals who annually top the lists of the highest professional incomes. Actor Leonardo DiCaprio earned $37 million in 1998, film director Steven Spielberg $175 million and the singer Robbie Williams $56 million. After taking into account potential earnings *Forbes* constructs its annual celebrity top 100 for the US. The three mentioned above appear in the top ten. So do the Spice Girls, Harrison Ford, Celine Dion, and the Rolling Stones. In 1998, there are only two non-artists in the top ten: Oprah Winfrey and sports superstar, Michael Jordan. No other professional, whether surgeon, lawyer, scientist or accountant, has a remotely comparable annual income.[4] [5]

The annual celebrity top 100 that *Forbes* publishes every year includes 40 athletes and 40 so-called 'entertainers'. (Apart from a few television personalities like Oprah Winfrey, the 'entertainers' group consists only of artists.) The average income of 'artists and other entertainers' on the list turns out to be five times higher than that of the athletes. It should be noted however, that the income gap between artists and athletes was larger 10 years ago and may well eventually disappear in the years to come. Also, *Forbes* points out that it is becoming more and more difficult to distinguish athletes from artists. Successful athletes, like Michael Jordan, boost their incomes even more by launching acting or singing careers.

Although it's the entertainment or 'low' arts that dominate the celebrity top 100 – followed by sports – this does not mean that there are

no lofty incomes among the 'serious' artists.[6] Moreover, because the careers of many top pop artists are relatively short-lived, the picture would look much different, if one considered lifetime earnings. In that case, a singer like Pavarotti and a writer like John Irving are likely to move much closer to the top.

In this respect, it is instructive to look at the monetary value of a body of work rather than on single works of art. For instance, the present value of Van Gogh's total output could well exceed the lifetime income of any modern superstar, given the price paid for individual works. (In 1990, Van Gogh's portrait of Dr. Gachets sold for $82.5 million.) The same applies to the hypothetical value of the oeuvre of certain writers and composers, if copyrights would last forever. The value of the collective works of Shakespeare, Dostoyevsky, Bach, Beethoven, or Mozart would be astronomical. Not that these works are so 'serious' that they have no entertainment value. In their own time, these works were considered entertaining. Exactly because certain kinds of art are relatively 'rich' in meanings, it can serve different functions for successive generations. Therefore, their life cycle is long and their hypothetical all-time market value can be extremely high. Nevertheless, in this chapter I shall concentrate on actual incomes and not hypothetical incomes.

Top incomes in the arts (broadly defined) are considerably higher than in all other professions that require similar levels of training (thesis 28).

2 Art Markets are Winner-Takes-All Markets

There exists a number of markets where a large and often increasing part of consumer spending ends up in the pockets of a small number of producers, while the majority of the producers earn little or nothing.[7] Those near the top secure a disproportionate share of the particular market's income. Although there is usually more than one winner, figuratively speaking 'winner takes all', as Robert Frank and Philip Cook wrote. For instance, professional tennis players operate in a 'winner-takes-all' market. There are thousands of tennis players all over the world offering high quality performances, but only a select few earns the big incomes, while the vast majority cannot even earn a basic living from playing tennis.

In normal markets, remuneration depends mostly on absolute performance. The seasonal worker who picks tomatoes is paid for the number of boxes he fills. If A fills 100 boxes and B 99, A receives 1% more income. Most remuneration in production is directly or indirectly based on absolute performance as well. In winner-takes-all markets how-

ever, reward depends more on *relative performance* than on absolute performance.[8] If athlete A runs 1% faster than B and wins, she may very well take all the prize money and so earn infinitely more than B. Frank and Cook present the example of Steffi Graf who became the world's number one female tennis player, after Monica Seles, who had been number one for years, was forced to withdraw after she was stabbed by a lunatic. Within a few months, Graf's income doubled even though her absolute performance probably had not changed during this period. After Seles' withdrew, Graf's relative performance increased however.

A feature of winner-takes-all markets is, as Sherwin Rosen noticed earlier, that small differences in quality, talent, or effort often lead to enormous differences in income.[9] The objective differences in the absolute performance of top athletes are small and yet income differences are enormous. The same applies, for instance, to soloists in classical music.[10] *In the arts, remuneration rests largely on relative performance. Slight differences in performance can lead to large income differentials* (thesis 29).

Winner-takes-all markets are not just limited to arts mass markets such as mechanically or electronically reproduced music and literature. In the current visual art world as well, the value of the 'star's' signature is related to relative performance. Old art is sold in a winner-takes-all market as well. Otherwise, there would be no significant drop in value of a painting formerly thought to be painted by Rembrandt when experts finally prove that one of Rembrandt's student painted it. After all, the difference in quality between this painting and a real Rembrandt was very difficult to discern; and yet the difference in value is immense.[11]

Even though the winner-takes-all perspective is not limited to mass markets of mostly technically produced and distributed goods, due to economies of scale, the effects are the most pronounced in these kinds of markets. The services offered by the top performers can be reproduced, or 'cloned', at very little additional cost.[12] Copies of a master recording cost no more for a top singer than for a second-rate singer. The same applies in the case of a television broadcast of a particular concert. International stars control these markets and there is little room for talents of less renown. Along with the ever-increasing impact of *technical reproduction*, extreme winner-takes-all markets also become more and more important.

Other than the influence of economies of scale, 'natural limits on the size of the agenda', or as Frank and Cook have termed it, 'mental-shelf-space limitations', also contribute to the emergence of winner-takes-all markets.[13] Earlier I spoke of a 'limited star capacity'.[14] This means that people tend to remember the relevant details of only a limited number of

products such as product names or the names of its authors. Otherwise, a consumer's life becomes unnecessarily complicated and unpleasant. It generally pays to remember the names of artists who are already renowned. By listening to others one can save on so-called search costs. Moreover, being familiar with the same artists adds to the pleasure of communicating about them with others.[15] *For the average art consumer it makes sense to limit one's energies to a small number of already famous artists. This 'limited star capacity' of consumers helps to explain the astronomical incomes that some artists fetch* (thesis 30).

People are clearly different in mental-shelf-space. Some people recognize more artists' names than others. There are many different ways to use one's shelf space. One jazz aficionado might specialize in international jazz musicians. He might be familiar with all the big names past and present, but he might be totally unfamiliar with the local jazz scene or musicians in other genres. Meanwhile, someone else might know a few international jazz musicians, some local jazz musicians and some musicians in world music. The first one is probably an international jazz specialist, while the latter is probably more of a generalist. (Some people who don't care about pop music may still be familiar with the names and tunes of a few international or local stars, because pop music is a pervasive part of general culture.)

Just because people want to save time and money researching various artists and athletes, while still being able to carry on a conversation about famous athletes or artists does not mean that everybody everywhere has the same list of preferred athletes and artists. There might be a somewhat homogenous character to lists of international stars but when it comes to local 'stars', the lists will vary because various social groups seek distinction. This continual need for distinction clearly puts a limit on the homogenizing aspect in the winner-takes-all markets. The extreme of one single winning star serving all of the consumers and attracting all of their spending cannot exist. Therefore, *the centralizing power in winner-takes-all markets is balanced by the need for distinction* (thesis 31). The significance of that need appears to be increasing in modern society. Therefore, a variation in styles and artists is bound to endure. Pop music, for instance, clearly exhibits both aspects. On the one hand with its cult of stardom the centralizing power is strong, but on the other hand this power is balanced by the need for distinction of all sorts of subcultures causing continuous change and innovation at local levels.

One way to compete with the stars in any particular genre is to copy their formula. Sometimes formulas, as for instance in so-called boybands, last a while and copyists can hit the charts be it usually for a short time only. But for more lasting recognition and financial success imita-

tion is not enough. For instance, many musicians have chosen to imitate George Michael (who himself started of copying others). But these 'plagiarists' hardly made a dent in his share of the market. The only way to compete with the star is to find a way around the star's relative monopoly by offering a different product in order to attract unsatisfied and new groups of consumers. Therefore, contrary to Frank and Cook's thesis, *the increasing importance of winner-takes-all markets does not necessarily impoverish cultural life* (thesis 32).[16] Both imitation and constant diversification are part of the system.[17]

3 People Prefer Authenticity and are Willing to Pay for It

Because the arts operate in winner-takes-all markets, some artists' incomes are high. But this does not explain why top incomes in the arts are higher than incomes in other winner-takes-all professions. Why do successful pop musicians and top film actors earn more than lawyers and athletes?

Artists, lawyers, and athletes are alike in the sense that small differences in talent can mean significant differences in income, even though their absolute performances may be nearly equal. The slightly better lawyer wins the case and ends up earning far more than her counterpart. The same goes for the athlete who runs just a little bit faster than the rest of the pack. In both cases, the difference is small, but clear. But the case involving the arts is not the same. Performance among athletes and lawyers can be measured, while in the arts essential differences cannot be measured exactly.[18]

Relative performance in the arts is not so much about quantities that can be measured objectively, like with lawyers and athletes, but also on authenticity.[19] For the art consumer authenticity is important; art represents authenticity.[20] An artist's unmistakable fingerprint can be detected in the work of art. The personal touch or the artist's signature testifies to this authenticity.

Why are the artist's personal identity and signature so valuable in our culture? In the Middle Ages, people didn't care about an artist's identity. In contemporary Thailand as well, the artist's identity hardly matters. As was noted earlier however, the West has an insatiable desire for goods and services produced by unique individuals, by artists. It's as if artists have injected their individuality into their artwork. Even though everybody is probably authentic, it's only artists who produce public proof of their individuality.[21] If the CEO of Sony dies today, someone will take his place tomorrow. But if Karel Appel dies no more 'Appels' will be pro-

duced; or if Pavarotti dies, no new Pavarotti recordings will be released. Unlike other professions, artists are *irreplaceable*.

People admire artists and envy their ability to prove their distinctive individuality. And so it's my hypothesis that the general public wants to be like the artist; they want to be the artist. Because this is impossible, people magically connect with the artist through his or her artwork. People believe the artist is 'in' the artwork. For instance, the soul of Brahms (long dead) or Robbie Williams (still alive) is 'in' their music; by listening to them people connect with these artists. Often there is a degree of symbiosis involved whereby the 'fan' temporarily becomes the adored artist and shares in his or her individuality.[22]

Although it may be easier to identify with living artists, I believe that people also identify with dead artists. Take the case of an Inca mask; its attraction is not just its rarity but also the assumed individuality of its creator. In comparison in the world of stamp and coin collectors, rarity is the primary quality.

Indirect proof of authenticity's importance in explaining high incomes comes from professions in which performance is generally not based on authenticity. If we look at the list of the richest athletes it turns out that they are not just known for their athletic abilities but also for their TV appearances and their endorsement of products. They're not anonymous athletes who happen to excel in a particular sport, but distinct characters with distinct circumstances and distinct histories. So it's not so amazing that the basketball player, Michael Jordan, not only appears in ads but also in movies. Even the highest paid lawyers and CEOs often become public figures. Although their time is extremely valuable, they still manage to appear in all kinds of, often less than intelligent, television shows. Whether these are strategic moves or merely stem from vanity, their contribution to entertainment certainly contributes to their income.[23]

In chapter 1, it was stated that art's authenticity contributes to art's sacredness but also depends on it. It follows then, that *top incomes in the arts are exceptionally high, because of art's sacredness and authenticity, which the public values and is prepared to pay for* (thesis 33).

4 Incomes in the Arts are Exceptionally Low

Just because top incomes in the arts exceed those in other professions does not mean that the average income of artists is also higher. On the contrary, evidence indicates that the average income among artists is lower than in comparable professions.[24] Therefore, by going into the

arts, artists endure an *income penalty*. If they were to choose another occupation, they would earn more money. According to an early US census report, only employees of the church faced larger income penalties than artists.[25] In the context of this book, this is an interesting result; it again suggests that there is a parallel between art and religion. Both invite employees to make sacrifices.

In earlier studies, the measured income penalty is somewhere between 7 and 15%.[26] The penalty was probably underestimated, because then, even more than now, many poor artists could not be traced and were therefore not included. Moreover, artists' incomes were usually compared with the average income of the work force as a whole. In current surveys, artists are polled using more sophisticated methods, and they are compared to people in occupations with similar 'educational and professional standings'.[27] Consequently, the income penalty for going into the arts turns out to be considerably higher.[28] For instance in 1990, the average income of a full-time artist in the US was 30% lower than that of all other full-time managerial and professional employees, 'a group broadly comparable with artists in term of educational attainment'.[29] Moreover, according to existing standards, US poverty rates for artists are higher than for any other group in professional or technical occupations.[30]

There is evidence that real incomes in the arts have gone down considerably over the last decades. Throsby estimates that in Australia between 1982 and 1993, the real creative incomes of artists have decreased by approximately 30%.[31] According to Pierre-Michel Menger, a similar trend exists in Europe.[32] Even though the amount of work in the arts has increased this is more than offset by the increase in the number of artists. The increased competition between artists for the available work continues the trend toward lower incomes.[33]

In Europe, creative artists, like visual artists, composers and writers, earn the least, whereas in the US and Australia it's performers, like dancers actors and musicians.[34] In the Netherlands, there is relatively a lot of information on the incomes of visual artists. According to a detailed survey, 40% of Dutch visual artists earned less than zero from their profession in 1998.[35] Therefore, the income penalty for the average visual artist in the Netherlands is almost 100%. (If 50% had earned less than zero, the penalty would have been 100%.)

(So far we discussed annual incomes, while it would have been more relevant to compare hourly wages in and outside the arts. Suppose artists with very low annual incomes only work a few hours each week in the arts. The result would be a large difference in annual incomes between the arts and elsewhere, while the difference in hourly income will be less

dramatic.[36] Estimating hourly wages instead of annual incomes doesn't make much difference in the case of Dutch visual artists however, because they spend an average of 36 hours per week making art.[37] On average, performers in the Netherlands only spend 18 hours per week working in the arts, however.[38] Because figures regarding hourly incomes are still inadequate, for the time being it is necessary to compare annual incomes.)

It is useful to note that, if average incomes in the arts are low or even negative, this does not necessarily mean that artists are always poor. Artists are, in fact, often not poor because they have other sources of income, usually from second jobs. But as long as still only a few can make a living from their art, the arts must nevertheless be called a low-income profession.

Despite some exceptionally high incomes in the arts, *the average (and median) incomes in the arts are consistently lower than in comparable professions* (thesis 34)[39]. This implies that *a highly unequal distribution of income exists in the arts. It is more skewed than in comparable professions* (thesis 35).

5 Five Explanations for the Low Incomes Earned in the Arts

Why are incomes in the arts so low? As an artist, I surmised that low incomes in the arts are due to under consumption, people are not interested enough in art. As an economist, however, I pointed out that the notion of under consumption is difficult to maintain when increased consumption figures are taken into account. It's not just that real per capita expenditure on art increases, but also an increasing proportion of income is devoted to art. The fine arts are no exception.[40] Therefore, what puzzles me as an economist is not that the volume of consumption is not higher, but that the number of artists does not decrease in response to demand, so that eventually more normal incomes could be earned. Instead, there are so many artists wanting to work, that only at the present low level of income supply and demand meet.

Therefore, in terms of monetary income, it does not pay to become an artist. Average incomes are low or extremely low. Nevertheless, the *willingness to work for low incomes* is high. How can this be explained? A number of explanations can be offered, which complement one another.

TABLE 3 EXPLANATIONS FOR WHY INCOMES ARE LOW IN THE ARTS

1	The winner-takes-all principle: Winner-takes-all markets are important in the arts. They attract many competitors.
2	Unfitness for non-arts professions: Because artists believe they are unfit for other, non-art professions, they believe they are better off in the arts despite the prospect of a low income.
3	An orientation towards non-monetary rewards: (a) The average artist is more interested in non-monetary rewards than other professionals, while (b) such rewards are (thought to be) available in abundance in the arts.
4	An inclination to take risks: (a) the average artist is less risk-aversive than other professionals, while (b) high stakes, in the form of both non-monetary and monetary income, are (thought to be) available in abundance in the arts.
5	Overconfidence and self-deceit: more than other professionals, the average artist is inclined to overestimate his or her skills and luck and at the same time, ignore available information; therefore they overestimate the rewards available to them in the arts.
6	Wrong information: the average artist is less well informed than other professionals; therefore they overestimate the rewards available to them in the arts.

These explanations for low incomes among artists are based on the assumption discussed in the preceding chapter, that artists are oriented towards rewards, whether as a means to 'serve art' or to serve themselves. First, low incomes in the arts can partly be explained from the winner-takes-all perspective. Even though artists may be just as ill-informed, overconfident, risk-taking, and interested in money as other professionals, the winner-takes-all principle should tempt more people to enter the arts than other occupations with a weaker winner-takes-all market. Due to the market structure, extreme monetary rewards and renown lure people into the arts.[41] Therefore, many youngsters become artists and supply many art products. It follows that average incomes are low.[42]

But average (and median) incomes in the arts are not just lower than in comparable normal markets, but also lower than in comparable winner-takes-all markets. So the question of low incomes also demands other explanations that are more fundamental than the explanation already offered by the winner-takes-all perspective and that complement it.[43]

6 Artists are Unfit for 'Normal' Jobs

In choosing a career, people naturally take into account their skills as well as their deficiencies. Consciously or unconsciously, they assess their chances in various careers. And so it should hardly seem amazing that a youngster who early on exhibited exceptional talent on the piano and ended up winning prizes in various competitions decides to go to the conservatory. Talented people simply have an above average chance in the arts. This explains how a small group of gifted youngsters might end up choosing the arts. But because this group is small, it does not explain why average incomes are so low.

However, it's not just proven skills that determine whether someone becomes an artist; a candidate's inadequacies can be just as important. It's possible that a lot of average artists chose to become artists not because of their superior talents, but because they believe they are unfit to do anything else on a professional level. In the seventies, many of my fellow students decried bourgeois society and stressed that they could not function in 'normal' jobs. Either they felt they were too 'weird' or society was 'deviant' and 'sick'. Either way, the arts offered them a sanctuary. This kind of extreme view is out of fashion nowadays, but many artists still believe the arts offer a (romantic) alternative to a dull and sometimes even disgusting existence in an ordinary job.

If someone has the ability to become an artist and considers all other professions as a recipe for disaster, the choice becomes clear. It is so clear that there appears to be no choice at all, as Alex dramatically emphasizes in the illustration where the only alternative to becoming an artist is death. Less dramatically, many artists just assume they would not perform satisfactorily in a non-arts profession. They would be unhappy and therefore private satisfaction or non-monetary income would be less than zero. Moreover, if they never learned to deal with standard office conduct, and so their work performance would never be up to industry standards anyway, their financial income would also be low. And so they just figure that they'll either end up unemployed, disabled, or working in poorly paid non-arts jobs. Considering the prospect of low incomes in non-art jobs – both in terms of money and satisfaction – it is understandable why these people choose art careers. By choosing an art career they figure that their lower incomes will at least be compensated by a higher level of personal satisfaction. Thus they calculate that their net arts incomes are actually higher than they would be elsewhere.

The important issue in this respect is that prospective artists *believe* they lack the ordinary skills to perform effectively at 'normal' jobs in a society where normality is the norm. This is not necessarily always the

case, but as long as artists believe it is true, it goes a long way toward explaining their acceptance of low incomes. *The low incomes that characterize many arts careers is partly explained by artists' beliefs that they lack the ordinary skills necessary for non-arts professions* (thesis 36).

It is difficult to gauge precisely how important this thesis will be in the scheme of things. Many artists would probably have no problem performing well in non-art jobs. This is also revealed by the fact that an increasing number of artists have second jobs outside the arts. The relative ease with which many of them adjust to these non-art-related employment opportunities goes a long way toward proving just how wrong they are about their non-arts skills. Therefore it is likely that these misconceptions will be corrected over time. But by then it might be too late for some of them to change careers. But then again, it could be that there are other factors still that need to be discussed that are even more important in choosing art as a career.

7 Artists are Willing to Forsake Monetary Rewards

Considering the preceding explanation of why incomes are low, non-monetary rewards must be important to most artists. Is it possible that these kinds of rewards are more important to artists than they are to average professionals? The reasons why incomes are so low in the arts could then in part be explained by the fact that artists are less concerned about money than they are about personal satisfaction and status.[44] Status means non-monetary external rewards such as recognition and fame. (The combination of private satisfaction as a non-monetary internal reward and status as a non-monetary external reward has also been called *psychic income*.[45] Because the term 'psychic income' has become somewhat suspicious among economists, I shall use the more neutral 'non-monetary rewards' to describe the combination of private satisfaction and status.[46])

The previous chapter argued that an orientation towards private satisfaction is built into the habitus of many artists. Moreover, a strong orientation towards non-monetary rewards generally agrees with the notion of denying the economy in the arts. By forsaking money, artists appear to deny the economy.

It should be noted that a particular artist's inclination to forsake monetary rewards is not fixed.[47] It depends on the amount of monetary and non-monetary rewards the artist is already receiving. It is understandable that when artists earn not enough money to make a living, their willingness to exchange money for private satisfaction is almost zero. Only

after some money becomes available and the aforementioned survival constraint is satisfied, the inclination of artists to exchange money for immaterial rewards begins to increase.[48] It follows that the inclination to forsake monetary rewards depends on the artists' individual circumstances. It is strongest when non-monetary rewards are readily available. This is the case in the arts. Compared to monetary rewards, the arts are believed to offer more status as well as more other non-monetary rewards. This belief is probably only partially true, but when young artists believe it to be true it does influence their decisions.

In my view, the main reason why the arts are so attractive and why people are willing to forsake monetary income is because of the presumed sacredness of the arts, the high esteem others have for artists, and in the personal satisfaction expected. Chapters 1 and 2 pointed out that the arts are sacred and bestow significant amounts of status on the artists, who as its priests share in the high esteem of the arts. Beginning artists probably receive a lot of personal satisfaction and, even though they are just starting out, they share in the general esteem of the arts; they acquire a mysterious status that other beginning professionals lack. As mentioned earlier, the arts offer a *romantic alternative*. Again, there is of course the question of whether beginning artists over-estimate the non-monetary rewards, and, consequently, have a rude awakening some years later. But for the explanation of their behavior this is irrelevant. Therefore *a high inclination to forsake monetary rewards together with the presence of relatively many non-monetary rewards contributes to the explanation of low incomes in the arts* (thesis 37).

8 Artists are Over-Confident and Inclined to Take Risks

If average artists would have an above average inclination to take risks, the big prizes in the winner-takes-all art market make the arts even more attractive.[49] Even more youngsters enter the art world and consequently the average income is lower than if these same youngsters had had a more normal inclination to take (or avert) risks. (An above average inclination to take risks can well go together with the before-mentioned above-average inclination to exchange monetary for other forms of income. The artist then seeks high prizes in the form of fame and recognition to pursue.)

People have different attitudes when it comes to taking risks. Some spend far more money on insurance than others. They are relatively risk-aversive, while others prefer to take risks. So considering the art world's extremely high prizes it is only natural that youngsters with some artistic

talent and with an above-average inclination to take risks will be more likely to enter the arts than other similarly talented candidates who are more risk-aversive.[50]

Thus far, there is no empirical research that compares the artist's inclination to take risks to the inclinations among other professionals.[51] However, because I know many artists as well as talented people who decided not to become artists, I find it plausible that an above-average inclination to take risks helps contribute to someone's decision to become an artist. The artists in this chapter's illustrations all exhibited a degree of recklessness. Meanwhile, an extremely talented musician (in the illustration on page 280), who decided not to go into the arts, admitted that he attached too much value to security. (The artist as someone attracted to risk is a generalization that refers to an *average* artist. The arts are not just about adventurous people. There are also many risk-aversive artists. Moreover, there are also other professions and enterprises that attract daring people.) Artists certainly do not consider themselves as (irresponsible) gamblers. But they probably would not protest about being characterized as adventurous, daring, or restless. And the latter may well imply an above-average inclination to take risks.

As noted earlier, the effect of risk-taking is not independent of the availability of rewards. High stakes amplify the effect. The same applies to the absence of stakes outside the arts. People in society who have less to lose, because they miss the capabilities needed in non-arts jobs as discussed above in 5.6., a situation that also applies to ex-psychiatric patients and to the dropouts of the third illustration, sooner take the risk of turning to the arts.

Most youngsters embarking on a career in the arts have only the vaguest notion about the stakes, the number of competitors, their own abilities, etc. And even if they did know, it's unlikely that they would assess their odds correctly.[52] If that were the case then certainly fewer people would choose a career in the arts. *Over-confidence* keeps them from thinking clearly. Many risk-takers are also over-confident. Gamblers consistently and magically overestimate their ability to pick the right number. And youngsters are inclined to overestimate their abilities and luck more than, for instance, seasoned veterans.[53] They are often encouraged to do so in the art world. 'In order to stand a chance in the arts one should really believe in oneself.' As an artist, this is what I was told, and I notice that this is what I tell my students. It is an appeal to a magical belief in one's own abilities, which occasionally turns into a self-fulfilling prophecy, but most of the time turns into a rude awakening.

The available information about the arts is often extremely incomplete and this state of affairs only adds to over-confidence. By contrast,

eighteen-year-old would-be football professionals have a reasonably fair picture of their abilities. The same cannot be said of the eighteen-year-old would-be composer and visual artist with an interest in contemporary art. Because they possess far less clear information about the arts and their own abilities, it is easy to see how they become over-confident. And while football players have learned more about their chances after four years of training, the information that young composers or visual artists have about their abilities in the same period of time is not much greater than when they began. So they can go on being over-confident for a considerable amount of time.

The difference in the sports world is revealing. Here it's not so difficult to make a reasonably rational decision about whether to become a professional or not and when to leave the profession. One's own talents and development compared to those of competitors can be measured. Sports markets are just like art markets – extreme winner-takes-all markets with few winners and many losers. But because there is more available information, there is less excess and ultimately the losers pay, on average, a lower price than someone involved in the arts.

Available information can be incorrectly interpreted, but it can also be ignored. The latter is a form of *self-deceit*. Self-deceit, like over-confidence, contributes to overcrowding and low incomes. For instance, if youngsters are unwilling to turn to available sources of information in order to check their performance, they will probably just end up deceiving themselves. If they don't go to auditions or contact galleries, they do not assess their abilities to help them decide whether to stay or leave the market. Often they refuse to go to auditions or interviews because they fear the outcome will not correspond with their own view of their abilities. Thus they prefer not to know. Because young artists have already invested so much into their careers, they find it difficult to accept that the game is already over. Thus evasive behavior is relatively strong in the arts.

Because artists are more inclined to take risks than others while the stakes in the arts are high, and because artists are more than others inclined to self-confidence and self-deceit, more people enter the arts and, consequently, the average income is lower than it would have been otherwise (thesis 38).

9 Artists are Ill-Informed

Self-deceit often goes hand-in-hand with misinformation. For instance, it is a popular belief among artists that 'doing art is a learning process

without end', meaning that those who persevere will win out in the end. This kind of 'information' encourages them to interpret negative feedback as a stimulus to go on learning. And in doing so, they can continue to deceive themselves till they are eighty. Failed artists give up later than other professionals.[54] On top of that, success late in one's artistic career is extremely rare. Therefore, the myth that 'the loser will eventually win out' sends the wrong signals to artists. Nevertheless, this myth explains "why many artists maintain for so long the hope that they will eventually become famous, even after their deaths".[55]

The decision to enter the arts, to stay in the arts, or to leave the arts is always based on information, however poor it may be. Given the artists' orientation on rewards, whether as a means to the end of making art or for personal advancement, information on possible future rewards – both monetary and non-monetary – inevitably influences one's decision to enter. If this information presents too rosy a picture regarding money, status, and private satisfaction, then obviously more people will be compelled to enter the arts than would have otherwise done so. The consequence of this is that the average artist's income is low, lower than anticipated. But why is that kind of misinformation not eventually corrected, as the economist would predict? If misinformation became corrected after a while fewer people would enter the art world. And eventually, an income situation comparable with that of other professions would emerge.[56] There are two reasons why this doesn't happen.

In the first place, newcomers' expectations can be extremely high, almost to the point of expecting some kind of salvation. Consequently, when these neophytes become disappointed, they hide their disappointments and so the next generation is again misinformed. There is a parallel regarding the situation of immigrants. Immigrants often send a far too rosy image of the Promised Land back to their homelands and therefore the migrations continue. These kinds of images continue to go uncorrected as long as underwhelmed immigrants continue to send these positive messages. They do so because they are afraid to admit that their decisions to emigrate may have been a mistake after all. Many failed artists show similar kinds of behavior.

In the second place, misinformation in the arts more often refers to immaterial rather than monetary rewards. Therefore, verification is difficult and beliefs (or delusions) continue to be justified. In principal, immigrants can correct false information, while in the arts, there are fundamental beliefs that resist verification. (These fundamental beliefs or myths were listed in table 1 in section 1.8.) Due to these myths *everybody in our society tends to be ill-informed about the arts* (thesis 39).

The main (mis)informing myths that surround the arts are *the myth of*

the sacredness of the arts and the related myth of the possibility of relating to a sacred world through the arts. Most of the other myths or popular beliefs emanate from the sacredness of art. Five interrelated myths are particularly misleading when it comes to deciding whether to become an artist.

1 *Making authentic art will be endlessly rewarding.* Even when no other rewards are forthcoming, artists receive ample private satisfaction.
2 *Talent in the arts is natural or God-given.*
3 *Certain talents in the arts will only appear at a later point in someone's career.*
4 *Success in the arts depends exclusively on talent and commitment.*
5 *Everyone has an equal chance in the arts.*
 And so the myths and delusions about the kinds of chances artists have in the arts, chances that are unthinkable in any other field with its diplomas, old-boys-networks etc, continue to beguile the would-be artists.

These myths promise young artists ample internal rewards. And the myth that perpetrates the notion that artists could very well be discovered later in their careers, only prolongs the false promises. As noted earlier, this last myth is false not because late-career discoveries never happen, but because they happen so seldomly.

It is difficult to resist these myths. They have an air of *righteousness* about them, which fits in well with the presumed sacredness of art. This is certainly the case with the equality myth and the myth that a commitment to the arts will eventually pay off. Many artists continue to believe the latter myth. If my fellow colleagues are unhappy with their careers, they often blame themselves for not being committed enough. And most of the time, after some initial grumbling, in the end the success of other artists is often seen as justified because these artists deserve their success because of their total commitment. Therefore, the arts is a righteous order.

Looking down from the tenth floor, these myths certainly appear misleading and misinformational because it's not just talent that matters. Artists do not step onto the playing field with the same talents. Artistic talent is only partly inherited, and it has more to do with the social and cultural capital that artists acquire through upbringings and educations. (Because self-taught artists seem to prove the contrary the art world often puts them on a pedestal. But in most art forms it's usually only a very small percentage of artists who are self-taught.[57]) Capital is unevenly distributed among social groups. The fact that artists, even more than other professionals, come from the higher strata of society demon-

strates that this type of capital is important in the arts.[58] Moreover, artists believe the arts to be free and open to everyone, while newcomers face many informal barriers, as I shall demonstrate in chapter 11. If the newcomers had only known beforehand about these barriers, they might not have attempted to enter the world of art.

Irrespective of talent, chances among those who choose to become artists are unequally distributed. The myth that talent is all that counts prevents the gathering of accurate information about what is required in this profession in order to stand a chance. Instead, it creates a misleading image of prospects in the arts.

Society produces and reproduces an image of the arts that is far too optimistic (thesis 40). Due to misinformation, more people choose the arts, more artists offer their services in the market, and more art is produced than would have been the case had this information been more accurate. Misinformation contributes to the low incomes in the arts (thesis 41).

10 Conclusion

Why do prospective artists like Alex in this chapter's illustrations, seem to be so reckless? Is the art world just some kind of lottery with very slim chances of winning the grand prize? And is it true that artists ignore available information about their slim chances in the art world?

Exceptionally grand prizes, both in terms of money and status, can be won in the arts. These prizes are larger than in comparable professions. It is also true that the average artist earns less than other professionals. Many artists earn low incomes. Despite the high stakes, the average chances are low. In this respect, the arts are like a lottery.

The high incomes of a small number of artists can be explained by the tendency of consumers to attach much value to small differences in the relative performance of top artists, while at the same time they can handle only a limited number of stars. Also the consumers' desire for authenticity explains the high incomes in the arts.

It is more difficult to explain why the income of the majority of artists is so low. This chapter gave six reasons why people continue to want to become artists, despite the fact that the average income is low.

1 Many people are attracted to the arts because the top incomes are extremely high.
2 Artists think they are unfit for non-arts jobs.
3 Artists are less interested in monetary rewards than other profession-als and more in private satisfaction and status. Therefore, they are pre-

pared to work for low wages.

4 The average artist is relatively more daring or reckless. With its high prices the arts are attractive to daring people.

5 The suggestion in the illustrations that artists sometimes ignore information is plausible. Over-confidence and self-deceit add to art world overcrowding. And finally, an important explanation for low incomes is

6 Misinformation. In this case, the cause of low incomes is not sought in the artist's character, but in how society deceives potential artists. Persistent myths continue to lure talented youngsters into the arts. All these factors make the arts more attractive than they would otherwise be. Therefore many people enter the arts and income is low.

In the introduction to this chapter, in my capacity as an economist I could not explain the permanent state of poverty in the arts. I expected poverty to be more temporary. Due to the prospect of low incomes, I thought that fewer people would choose to enter the arts, that consequently the sector would shrink and that incomes would adjust to a normal level. Nevertheless, I noticed that this is not the case. Taking into account the analysis put forth in this chapter, I now understand that in the exceptional economy of the arts, income can remain permanently low.

The six reasons for the low incomes of artists presented in this chapter contribute to the solution of the recurring quandary of this book 'why are incomes so low in the arts'. The relative impact of each of these five explanations is important when it comes to interpreting 'poverty' in the arts. If the first five explanations are the most significant, then artists, in fact, do have little money, but because of other rewards they are not really poor in other respects. To a certain degree, then, poverty is a choice. However, in the point about misinformation, society is to 'blame' and artists are its 'victims'. More will be said about these two contradictory assessments of the economic situation of artists in the next chapter.

Discussion

1 Can you offer some alternative explanations for the high incomes and low incomes in the arts from those already presented in this chapter?

2 Which of the six explanations of low incomes in table 3 do you think is the most important, and least important?

Chapter 6

Structural Poverty

Do Subsidies and Donations Increase Poverty?

Subsidies Make Artists Lose Interest in Selling

Nicole draws in Alex's life drawing class. She has recently left art school. Although she is a good artist, she has yet to find a gallery. The following weekend she is going to join an annual 'open studios exhibition' in her neighborhood and she asks Alex for advice about pricing her work. Alex asks her what kind of prices she has in mind. Alex thinks they're much too high. He asks her if she really wants to sell. Nicole says she's desperate to sell. If she doesn't earn some money soon, she may have to stop making art. So Alex suggests that Nicole lowers her prices by approximately forty percent. (Couching his words, he advises her to set prices so as to maximize sales.) Nicole is shocked and objects, but in the end she lowers her prices. That weekend she ends up selling some etchings and three drawings.

Alex has come to the realization that after art school, most students tend to price their work too high. They determine their prices based on the costs it took to make a particular work including a fair remuneration for their labor. Gallery owners usually inform them that with these kinds of prices they won't sell a thing and in the end recoup none of their costs. Low prices seem unfair. Nevertheless, gallery owners demand lower prices from starting artists.

Robin is an ex-student of Alex's. He left art school a year ago. He recently received a government grant for promising young visual artists. He has been offered a show in an alternative space. As there is no dealer involved, he has asked Alex to help select the work for the show. Alex casually asks about the prices he intends to ask. Predictably, his prices are far too high. In a long argument, Alex tries to convince Robin to lower his prices, unsuccessfully.

At some stage in their discussion, Alex tells Robin that like other young artists the prices he is asking are way too high for his work. Robin furiously objects that he cannot be compared with other novices. To be subsidized by the government means that he is a 'promising young artist'. Only then does Alex begin to realize, that the foolish behavior of Robin has been

caused by the government grant. Government grants give young artists like Robin the freedom to make 'real' art that in their eyes 'deserves' to fetch high prices. Moreover, they not only feel superior; they can also afford not to sell. Since receiving the grant, Robin has quit his second job in a restaurant because he receives enough money to live off of. And so now he is insisting on asking 'fair' prices, even though he knows there is little chance that his work will sell. For the time being, Robin and his subsidized colleagues can feel special.

When Alex visits Robin's exhibition on the last day, he is amazed to see that Robin has sold one of the thirty exhibited paintings. It's one more than Alex had expected. Later, in talking to Robin, Alex discovers the painting was sold to his uncle, who is a well-to-do professor.

Alex likes Robin's work and is sure that, if Robin cut his price by half, he would have sold at least four paintings, maybe enough to propel him into the thick of the art market. Of course, Alex believes that talented artists like Nicole and Robin deserve to sell most of the work they exhibit. Alex realizes however, that even when they do price their artworks more reasonably, this still doesn't happen. There are just far too many Robins and Nicoles anyway. And all these artists produce far too much art.

Now that Robin is receiving a subsidy, he has enough to live off of and so has overcome his survival constraint. He quits his second job and concentrates on making art, not selling it. In doing so, Robin reveals himself to be more oriented towards the government than towards the market. This kind of attitude affects the economy of the arts. This chapter sets out to investigate the general effects that income decreases and increases via subsidies, donations, and spending have on the average artist's income and on the number of artists in the arts. Do subsidies that are intended to raise income levels in the arts really increase income, or do they only increase the numbers of artists? Is it possible that they even lower the average artist's income?

Many donations and subsidies rest on the premise of fighting poverty among artists. Therefore this chapter also attempts to explain the immensity of the gift sphere in the arts.

Finally, how should one interpret low incomes in the arts? This chapter poses and discusses the question of whether poverty is uncompensated and therefore 'real', or whether it is compensated through other forms of rewards.

As an artist, it is my opinion that low incomes are unjust. They do not befit a modern and just society. Therefore, *as an artist I think that the government and donors are obliged to raise the income levels in the arts through subsidies and donations, but also through social security and*

affordable arts training. As an economist, I may go along with the artist's moral judgment that low incomes are unjust. But at the same time, I believe that the remedies proposed will probably only exacerbate the disease: *as an economist I think that the effect of more subsidies, and more donations, social security and subsidized education, is that more people will become artists and more people will end up earning low incomes.*

1 Artists Have Not Always Been Poor

Were comparable incomes in the arts always as low as they are now? There are a number of stories in circulation about famous artists who died extremely poor. People tend to remember these stories, because they fit the present mythology of the arts. Nevertheless, the biographies of famous artists from the past are stories of wealth far more frequently than stories of poverty. Such stories do not need to be representative, but they offer relevant information as long as they are not used as exemplary proof, but instead serve as pieces of a puzzle.[1]

Sometimes information on art prices and the lifestyles of artists from the past offer insight into the incomes of not only famous artists but also of average artists. In the seventeenth century for instance, along with the fluctuations in general economic welfare, the number of Dutch painters fluctuated as well, but incomes were not lower than in comparable professions.[2] Also in the nineteenth century, the average painter probably received higher prices for his work than an average contemporary painter. Research has shown that at that time, prices in the primary visual art market, the market where artists sell paintings for the first time, were higher than those in the secondary market, which is devoted to the reselling of paintings.[3] At present, it's the other way around. It was common for professional artists in the nineteenth century to hold established positions and people were prepared to pay considerable prices for their most recent paintings. Given primary market prices, the average income of nineteenth century artists was not particularly low. (Buying new work was not considered much of a risk. Meanwhile today, the primary market is overflowing with artists selling their work at low prices – that is apart from newcomers like Robin who ask higher prices and do not sell at all. Only a few artists' work ever reaches the secondary market, where prices rise briskly; there prices are sometimes many times higher than the artists themselves fetched earlier for these same works in the primary market. Although reputations were not unimportant in the nineteenth century, price and income differences were not as pronounced.)

The general picture I get from discussions with art historians is that the phenomenon of artists living in poverty found its beginnings in some corners of the nineteenth-century art world. But poverty as a widespread phenomenon belongs to the twentieth century, particularly to the second half of the twentieth century.

Although artists were generally not poor in the nineteenth century, the type of artist that made poverty in the arts more likely was already emerging. An increasing number of bohemian artists were entering the scene at that time. They sold little and when they did sell a piece, they did not use the customary channels. Most of these artists were technically not poor because many of them had other sources of income, such as their families, but their hourly art wages were low.[4] Nevertheless, bohemian artists in the nineteenth century were still decidedly a minority.

The bohemian artist represents two developments that occurred during the twentieth century. First, art becomes increasingly attractive because of the sacred status it has garnered. And second, because the autonomy of the artist is increasingly venerated, established regulations begin to be rejected and vanish. Prior to the twentieth century, the arts were not as attractive an alternative, and regulations assured a higher average income.

Not only were the arts less attractive, there were union-like organizations that helped regulate the profession and protect artists' incomes. They protected quality, drew up strict rules for admission and sometimes even set prices. This long period in the history of the arts commenced with the guilds and ended with the prestigious academies. All the while however, organizations existed that managed to keep incomes reasonably high by keeping the numbers of artists to a necessary minimum. In other words, only people who met certain qualifications were admitted into the profession.[5]

In the course of the nineteenth century however, the academies and similar organizations gradually lost their omnipotence. In the end most of them closed down or became unimportant. In today's world, almost every profession formally controls the size of their membership in one way or another – except for the arts. In the late nineteenth and twentieth century, artists became more or less autonomous. Both artists and the art world at large regarded artistic autonomy as a step forward. Autonomy in the arts was incompatible with membership requirements based on diplomas or ballot. Anyone could become an artist. The number of artists increased and income went down. (Chapter 11 discusses the absence of regulation in the modern arts in more detail.)

Artists are nowadays more willing to accept lower paying jobs. One important reason that we mentioned in the previous chapter is that as the

arts became increasingly perceived as sacred, artists were accorded a special status. Therefore, the reason why incomes remain low can be found in the exceptionally high status of the arts.

The opposite perspective can also be instructive. This implies that incomes used to be more reasonable in earlier times and that the arts did not have the level of status then that it has now. And so, while monetary incomes may have been higher back then, the other rewards were less attractive. Because the monetary incomes in the arts probably began decreasing somewhere between one hundred and one hundred fifty years ago, it is likely that at that time, around the 1850s, the internal structure of the arts – including its much vaunted beliefs and myths – began to change drastically. Artists who began to reject the economy became more and more common in the arts. The worship of authenticity – which had its roots in the Renaissance and gained momentum during Romanticism – fully appropriated the arts and vice versa. The regulations that controlled membership and prices became taboo and the arts as a profession became more and more attractive. *The current exceptional economy of the arts is rooted in the changes that were initiated during the course of the nineteenth century. This change is most evident in the reduction of the average incomes of artists* (thesis 42).

2 The Desire to Relieve Poverty in the Arts Led to the Emergence of Large-Scale Subsidization

It is fairly evident that most rich and civilized societies find it intolerable that some of their citizens live below the accepted poverty level. Especially in Europe governments see it as their first responsibility that people have enough money to lead a decent life. Although in the thirties the US were the first to subsidize the arts for social reasons, it was in Europe that substantial aid for the arts emerged after the Second World War.[6] After the war, European governments embarked on a general mission of social justice, which focused on eliminating poverty altogether. Their efforts in the arts were particularly resolute.

During the first post-war decades, arts subsidies in Europe were mostly based on social arguments. The desire to improve the financial straits of artists was the most important reason for the substantial increase in the subsidization of the arts. It was only later that other arguments began to come to the fore. The social justice issue however, continues to complement other subsidization arguments in most of Europe.[7]

It appears that governments, as well as foundations, corporations, and private donors are particularly sensitive about poverty in the arts. The

image of the starving artist appeals to benefactors. Helping a poor artist is more rewarding than helping other kinds of poor people. Financial assistance is not only a gift to a needy artist; it can also be seen as a gift to mankind. After all, there is a small chance that the artist receiving assistance will eventually become a great artist. This kind of romantic notion is always present when it comes to the various forms of financial assistance available to artists.

The following sections address the question of whether subsidies and donations really raise artists' low incomes. But regardless of the answer, the present conclusion is that *the desire to raise the low incomes of artists partly explains the existence of a large gift sphere in the arts* (thesis 43).

3 Low Incomes are Inherent to the Arts

Before discussing the question of whether financial assistance can effectively increase the low incomes in the arts, it is important to note that low incomes do not necessarily imply that artists are starving. If we look at relative hourly incomes, we see poverty in the arts and poor artists. But artists are not necessarily poor in an absolute sense or when we compare them with manual laborers from a hundred years ago. Moreover, some artists hold down lucrative second jobs or have access to other sources of income, such as trust funds and inheritances. These artists then, are relatively well off, but not as a result of art. If they were to work full-time as artists with no outside income, they would have a very hard time surviving. So *when artists earn too little in the arts to be able to work full-time in the arts, they can be labeled as poor. It's in this sense that poverty exists in the arts.*

Based on the existing income studies mentioned in the previous chapter, there does not appear to be a relationship between developments in spending on art and the income of artists. The total amount of financial assistance for artists has no effect on artists' incomes. The same applies to social benefits. Irrespective of developments in spending, donations, subsidies and social benefits, the incomes of artists have remained relatively low throughout the West for more than a century now, and most pronouncedly since the Second World War. If there is a trend in the second half of the twentieth century, it is a downward one. Countries become wealthier and more money per capita ends up in the arts, and yet income in the arts remains about the same or actually decreases.[8] In countries like the Netherlands where there is extensive subsidization of the arts, the artist's average income is the same or lower than of artists in countries like the US and England, where subsidization levels are lower.

It appears then, that the current phenomenon of poverty in the art is largely a structural issue; poverty is built into the arts.

How can structural poverty be explained? Apparently, it's because artists seem to be quite willing to work for low hourly wages. Table 3 in section 5.5 listed six explanations for the permanent willingness of artists to work for low hourly wages: Artists are unfit for non-art jobs, artists prefer non-monetary rewards, artists seek risks, artists are over-confident and self-deceiving, and artists are ill-informed.[9] The bigger the role any of these explanations plays, the stronger the willingness of artists to work for low incomes. Because artists must survive, however, a minimum income constraint exists. Given this constraint and a large willingness to work for low incomes, an increase in average hourly income is almost completely nullified by a corresponding increase in the number of artists.[10]

External forces, like increased spending, donations, or subsidies, lead to more money being pumped into the arts, which fail to effectively increase average incomes, and instead lead to artists working more hours at their art. (It leads to more people entering the arts. It also allows artists with second jobs to start to cut down on these jobs and begin working longer hours at their art. But because young artists earn the least and usually work more hours in second jobs, the average number of hours artists work in the arts is not really affected.) In theory the extra money leads almost exclusively to more artists. It follows that on average, extra funding affects employment figures more than it affects the artist's average income.

In theory, then, extra funding will never increase income levels but merely increase the number of practicing artists. This is true only if the inclinations discussed in the previous chapter are very strong: artists want to exchange all extra money for non-monetary rewards (or they very much want to take risks, are totally over-confident, or see no possibilities at all outside the arts). However, it is safe to assume that the average artist who earns more than the minimum income level is *mainly* interested in non-monetary rewards, but is not totally immune to extra financial income.[11] Therefore, it must be stressed that the notion of structural poverty applies *broadly* to *large groups* of artists.

The main evidence that bolsters this chapter's theses – structural poverty and that financial assistance for the arts only leads to more artists – is an indirect corroboration. Because as more money is pumped into the art world, the artist's average income does not as a consequence increase, and because the number of hours average artists spend every week making art remains the same, there is only one possible outcome: an increase in the number of artists. This is what happened. The amount

of art subsidies per inhabitant, and to a lesser degree, the amount of money spent on the arts per inhabitant, has risen substantially in all of the western countries during the second half of the twentieth century. Meanwhile, artists' incomes have remained relatively low or have even gone down (in real terms). This means that the total number of artists must have risen.

This theory implies that increased subsidization and other types of incomes to the arts have led to a corresponding growth in the number of artists. As we shall see, measuring the numbers of actual artists over time is problematic. Nevertheless, researchers generally assume that in the West the number of artists has risen spectacularly since the Second World War and that there is currently an 'oversupply' of artists.[12] The conclusion is that the arts are like a bottomless pit. *In general, more money spent on the arts per capita – whether its from consumers, donors, or governments – does not raise the average incomes of artists; instead it just increases the number of artists, including a larger number of poor artists per hundred thousand inhabitants, and therefore to more poverty* (thesis 44).[13] *Poverty in the arts is structural* (thesis 45).[14]

4 The Number of Artists Adjusts to Subsidy Levels

It is important to realize that the thesis that more money leads to more artists and not higher incomes, doesn't only mean subsidies but all forms of income. (Take two imaginary countries where the number of artists is higher than in other countries. This fact can be due to above-average per capita subsidization in one country and above-average spending on the arts in the second.) Nevertheless, in the following sections I shall concentrate on subsidization (including social welfare), rather than on spending and donations, because the goal of subsidization is often the raising of incomes in the arts and because subsidization expenditures are more easily influenced by politics than either spending or donations.[15]

More arts subsidies doesn't increase artists' average incomes; it only leads to more work hours spent on art.[16] The main evidence for this thesis is the indirect proof presented in the previous section. What is the impact of specific subsidies in specific countries?

Refutable hypotheses based on the thesis can either be synchronic or diachronic. On the one hand, geographical (synchronic) comparisons could be produced. In the previous section, I produced a rough synchronic comparison by stating that in countries with ample subsidization artists' incomes are the same or lower than in countries with less subsidization.[17] A more detailed analysis would compare numbers of artists

working in different art forms in, say, the US and one or more European countries. This would test the prediction that in a country like the Netherlands with large subsidy levels, the number of artists per hundred thousand inhabitants is higher than in the US.[18]

Or one can attempt to produce (diachronic) comparisons over time in one country. If the level of subsidization (or social welfare or donations or spending) in a particular country suddenly increased (or decreased) the total number of artists would have to increase (or decrease), as well, while income remained largely the same. Because the conclusion regarding the relation between arts, money and numbers of artists refers to long-term employment, the change had to be drastic, with other circumstances remaining unchanged or changing at a steady rate.

This latter situation is rare. The main problem is however, how to count the artists. This remains extremely difficult because a) diplomas do not reveal who is a professional artist, b) many professional artists are self-employed and unaffiliated, and c) many artists earn most of their income from second jobs and thus often do not appear in statistics. Therefore if countries count artists at all, the strategies vary greatly from country to country.[19] So a conclusive test of our thesis remains outside the realm of possibility. Nevertheless, on the basis of personal observations and discussions with other observers, it is possible to gather some initial data, inconclusive as this evidence must remain, but at least it lends our thesis some plausibility. For instance, in comparing the US and the Netherlands, few observers would disagree with the observation that subsidy levels in the US are lower than they are in the Netherlands and so is the number of artists per hundred thousand inhabitants.

But making a diachronic comparison within one country is almost as problematic. One could try to study the effects over time of drastic changes in subsidization on numbers of artists. In this case, one would need to take consistent counts of artists over a sufficiently long period of time.[20] These kinds of figures are very difficult to come by. Nevertheless, I will examine a few instances when drastic changes occurred in the Dutch art-subsidization 'landscape' since the Second World War, in relation to available data on numbers of artists.

5 Subsidies in the Netherlands Have Increased the Number of Artists Without Reducing Poverty

In order to demonstrate the plausibility of the thesis that more subsidies leads to more artists and vice versa, I will first discuss the effects of the introduction and growth of a particular Dutch subsidy plan of the visual

arts, the so-called BKR, which existed from 1949 to 1987. It is a well-documented case of a major overhaul in the subsidization of visual artists in the Netherlands.

Gradually between 1949 and 1956, the Dutch government developed an extremely generous subsidy plan for visual artists, the so-called BKR. The primary aim of the BKR plan was to offer temporary help to impoverished visual artists.[21] This was emphasized by the fact that the money came from the ministry of social welfare and not from the ministry of culture. Professional visual artists earning less than a certain minimum income were allowed to sell art to local governments in order to supplement their income. If their work met certain rather low criteria, local governments were obliged to buy the art offered to them.

According to this book's theory, this kind of financial assistance plan should encourage more people to remain or become visual arts. Because no consistent figures on numbers of Dutch visual artists exist for this period, it is impossible to appraise whether this is indeed what happened. The fact however, is that the number of participating artists increased from 200 in 1960 to 3800 in 1983, which means it is highly likely that the total number of visual artists increased far more than the demand for art work in this same period.[22] The main evidence is indirect, however: during the same period figures of students enrolled in the fine or 'autonomous' departments at the Dutch art academies grew strongly. In fact, the growth rate was 60% higher than the average growth rate for technical and vocational training enrollments during that same period.[23] This implies that the arts became more attractive and this led to increases in the total number of artists.[24] Therefore, even without strong evidence, almost everybody concerned admits that the BKR plan was (partly) responsible for the huge increases in the number of visual artists in the Netherlands during that period of time.

The effect of the termination of the BKR plan represents our second example. Because the number of artists increased and more and more artists began to utilize the BKR plan, it eventually became too expensive. This led to the gradual termination of the plan between 1983 and 1987. During this period, overall government spending on the visual arts went down approximately 20%. (Visual artists were partly compensated via other newer subsidies. Otherwise, the reductions would have been even larger.[25]) The change over was relatively abrupt, taking place over a much shorter period of time than the earlier expansion of the program. And so, if our thesis is correct, the reductions should have caused, with some delay, a decrease or at least a deceleration of growth in the total number of visual artists.

Most significantly the strong growth in enrollment figures to fine arts

departments at art schools stopped in the years around the conclusion of the program. The yearly increase in enrollment figures began to normalize and resemble those of other technical and vocational training schools. Moreover, more of the artists who utilized the BKR plan, left the arts within ten years after the program's termination than would have left if the plan had been continued.[26] Therefore, the numbers of visual artists not only increased less rapidly because fewer people were enrolling in the visual arts, but also because more people departed. (As one might expect, given the analysis in chapter 4, most of the ex-users of the WIK plan who remained artists found their way to other government subsidies, while only a small minority among them adopted a new strategy by orienting themselves more towards the market.[27])

The third example involves the 1999 introduction of a new program for all Dutch artists, the so-called WIK plan. In the Netherlands as well as other countries, many artists have managed to continue to work as artists thanks to social benefits. For a long time the Dutch authorities closed their eyes to this abuse of social benefits. Nevertheless, the authorities felt that this kind of illegal abuse of the welfare system could not continue forever. Therefore, they made it more difficult for artists to continue receiving social benefits, while simultaneously offering an attractive alternative to artists in the form of the WIK plan. It applies to all artists, writers, performers, visual artists, etc. Basically the participants in the WIK plan receive social benefit legally for a limited number of years without ever having to apply for other jobs. However they must earn at least a minimum income in the arts. In this manner, artists are encouraged to begin to acclimate themselves to the realities of the market. If after the end of the WIK years artists still can't earn a living from their art, they are not allowed to re-register for social benefits and have to find employment outside the realm of the arts. (The artists I know who make use of this program are not particularly concerned about the limited time period. They assume that by then Parliament will have amended or extended the program or have come up with something else to keep them going in the arts.)

Although the new plan is supposed to lead to net savings, the opposite is more likely to occur. Because of a number of amendments that were added by the Dutch Parliament, the new plan has become quite attractive for artists. In the future, a diachronic comparison of money flows and numbers of artists will hopefully determine whether this program actually encourages or discourages people from entering the arts. At the time of writing this book, the only data that exists is for the first year of the program, 1999.[28] In that first year, some 4000 Dutch artists had already made use of this program. It turns out that 58% of the applicants had

previously received social benefits, while 19% were recent graduates of art schools, while 23% did not fit into either of these categories.

It is too early to reach firm conclusions based solely on the results of the first year, but in my view, the latter two percentages are exceptionally high. It is hard to believe that without the WIK plan all of those who finished school would have made their way to the social security office. Some probably would have quit the arts, while others may have been able to make it without the WIK plan. This applies even more emphatically to the 23% who were already artists but who were not receiving social benefits at the time they applied for the WIK. It's hard to believe that all these artists had unexpected downturns in earnings and therefore would have been candidates for social benefits.

In talking to colleagues in the arts who currently receive WIK benefits and had not been receiving social benefits prior to applying for the WIK, it seems that most of them had not suffered any dramatic decreases in income. Instead they quite strategically applied for this new program because it was the best choice among their alternatives. To them the WIK is helpful because it enables artists to reduce their hours spent working second jobs or producing 'commercial' artwork. In short, it enables them to spend their time making fine art. This also applies to certain groups of artists like writers and cabaret performers in the Netherlands who could not qualify for this kind of subsidies before. Therefore it seems likely that the new program will only lead to more overcrowding.

The fourth example rests on a rough synchronic comparison. Although performing artists in the Netherlands earn the same or less than in comparable countries, many foreign artists work in the Netherlands. Naturally this is most applicable for art forms that do not require language, such as dance, mime, and instrumental music. In dance – both at art colleges and in Dutch production companies – the percentage of foreign performers is often greater than 90%, in mime it can be more than 50%, while it is relatively high in a number of music areas. Although foreigners in art schools pay higher tuition fees than Dutch residents, their education is still subsidized. More importantly, art companies receive generous subsidies in the Netherlands. Therefore, when foreign students are good (and most of these students are motivated and talented, otherwise they wouldn't have risked coming to the Netherlands), upon graduation, they stand more of a chance of finding paid employment in the Netherlands than they would in their own countries. (In Germany, for instance, subsidies are also generous, but foreigners are not allowed to work in subsidized companies.) Therefore, the unusually large presence of foreign artists in the Netherlands also adds to the plausibility of the thesis that subsidies only leads to more artists.

The conclusion of section 6.3 that poverty is built into the arts and that any extra money for the arts has little effect on income and only leads to increased numbers of artists refers to the long term and to the sum of all subsidies, donations, and spending. It does not necessarily apply to any specific subsidy or donation. Although it probably applies most strongly to the Dutch subsidy plans discussed in the previous section, it may not apply or hardly apply to certain other subsidies. In order to examine the different short-term effects of changes in specific subsidies and donations on the number of artists, it is useful to distinguish between the direct effects and the indirect signaling effects of subsidization and donation.

First of all, changes have *direct effects*. For instance, if it is mainly successful writers who benefit from a certain type of subsidy or private grant and if more money is made available for this grant or subsidy, the direct effect would be that the income distribution among writers becomes more skewed, while the number of writers hardly increases. It follows that average incomes must rise, at least a little. If, however, another subsidy or grant is instituted to relieve poverty, and mainly poor and unsuccessful writers profit from this program, then the direct effect is that the number of artists increases, while average incomes remain the same.

In the second place however, changes that become common knowledge can often have a *signaling effect*. Such indirect effects of subsidies and grants can easily outdo the direct effects. When a new award is instituted that might confer honor, fame and money on recipients, the direct effect in the form of a raise in average income can be small, while the indirect effect can be significant due to so-called signaling. Because would-be artists begin to believe that they can win these awards it encourages more people to enter the arts and so the net effect is that average incomes decline. This applies to prestigious awards that are won mostly by internationally successful artists such as the Booker Prize for literature, as well as to numerous, more modest, and local rewards in all areas of the arts. The latter awards are less lucrative, but are more appealing because they seem to be less unattainable. In either case, the stakes – both in terms of money and recognition – increase, therefore the arts become more attractive, the number of artists increases and incomes decline.[29] The winner-takes-all principle and the inclination of artists to take risks, further increase the impact of such awards systems on the numbers and incomes of artists.

Most subsidies have both direct and signaling effects. As soon as Robin in the illustration received his government grant, he decided to

spend more time on his art and quit his restaurant job. This is a direct effect. But Robin's grant also indicated that he might be better than other artists and he mistakenly expected that the government would continue to reward him. Any interest he may have had in the market receded even further than would have been the case without the signal. So, because of the signaling effects of certain subsidies artists' average incomes can actually decline.[30]

As has been previously noted, subsidies can increase levels of poverty because the numbers of artists increase and thus lead to a condition where there are more poor artists per hundred thousand inhabitants. The signaling effect can even further exacerbate the effect of subsidies on incomes because instead of the situation where there are more people earning the same low income, incomes may actually decline.

7 Subsidies and Donations Intended to Alleviate Poverty Actually Exacerbate Poverty

As was noted earlier, the desire to raise artists' incomes is the intended function of many arts subsidies. Even when it isn't the subsidy's primary function, it continues to play a secondary role. Policymakers who want to eradicate artists' low incomes usually turn to subsidies that offer direct help to the target group. This implies that government intervention tends to be supply-oriented; subsidies go to the poorer artists and art institutions rather than to art consumers. And yet, because of their signaling effects, these types of subsidies are more counterproductive than other subsidies.

I will first take another look at the direct effects. Contrary to the desire of raising income levels, the direct effect of supply-oriented subsidies for the average artist is an increase in the number of artists and not an increase in average income.[31] When Robin receives his subsidy and consequently totally stops thinking about selling in the market, newcomers immediately take his place. Thus the income distribution and average incomes remain the same, but the number of poor artists increases and so does poverty.

Supply and demand subsidies are not that different when it comes to their direct effects. For instance, a tax deduction on art purchases, a demand subsidy commonly employed in the us, also has the direct effect of primarily increasing the number of artists, while leaving income distribution and average income untouched.[32]

In this context, the signaling effect that subsidies have on art students is important. When education is subsidized, this seems to imply that

society takes some responsibility for the schools and its students. Therefore, subsidized education indirectly suggests – at least somewhat – that would-be students expect to find some form of employment in their chosen fields after graduation. Or, if there are in fact no employment opportunities, students expect their government to take care of them upon graduation. (This expectation is probably not altogether wrong considering the sums of money governments and government-related institutions provide for programs that are created to deal with the poor financial prospects of many artists. Some examples of these programs are: the WIK in the Netherlands, the French 'Intermittent de Spectacle' and the 'Künstler Social Kasse' in Germany.)

Subsidized art education also insinuates that the arts, like other professions, are now more 'democratized' and that almost anybody can become an artist and earn a living as an artist. But whereas in other professions most of the time the large majority of graduates can make a living as a professional, in the arts only a small minority of those who graduate will make it as a professional artist. And so it's hardly amazing to note that the arts are still less 'democratized' than other professions. The parents of art students are still wealthier than the parents of students in other comparable professions. Because these wealthier parents can later assist their sons or daughters, the risks of going into a high-risk occupation like the arts are reduced.

If we observe the signaling effect of supply and demand subsidies they tend to vary however. Supply subsidies are usually part of well- publicized nation-wide programs that artists can apply for and usually raise artists' general expectations. Well-publicized programs aimed directly at artists broadcast the message that the government offers hope for fledgling artists. Subsidies for agents and brokers also tend to send a message of hope albeit not as forcefully. The message coming from demand subsidies such as tax deductions is least clear.[33] Whereas artists and prospective artists are hardly aware of tax deductions for art consumers, they are very aware of the nation-wide generous subsidy programs available to artists. They include the aforementioned WIK plan and other Dutch subsidy programs, the French 'Intermittent de Spectacle',[34] the heavily subsidized 'Künstler Social Kasse' in Germany, the American NEA grants system[35] and, to a lesser degree, also the plans of the Regional Arts Boards in Britain.[36]

Many artists are aware of these programs, because they personally take advantage of them. Plus, these subsidy programs are constantly discussed inside and outside the art world. Regardless of the programs' intentions, they spread the message that society looks after its artists whatever their number. Becoming an artist is a risky endeavor, but subsi-

dies (and social benefits) make it seem less risky. 'The government will always be there to come to the artist's rescue.'

Because subsidization does not boost incomes, this signal is nothing but misinformation. Moreover, no government is capable or willing to go on supporting ever-increasing numbers of artists. *The signaling effect of generally known artists' subsidy programs just adds to the existing misinformation and in doing so, make the arts seem even more attractive. Subsidies for artists lead to more artists, lower incomes, and more poverty.* (Thesis 46).

The present analysis leads us to expect that the total government arts subsidies program in the US with its emphasis on tax deduction leads to less overcrowding, and higher average incomes for artists than in Europe, notwithstanding the intentions of European governments to reduce poverty among artists.

The goals of most subsidies however, is not only to raise artists' income, but to serve a variety of functions. Thus an analysis of costs and benefits could help with the selection process of different types of supply and demand subsidies as well as the over-all package of subsidies. In that context, an inventory and assessment of possible signaling effects is essential. (Subsidies can produce many unintended side-effects.[37])

Governments can choose from a variety of subsidies. They can also choose whether to provide more subsidies and less spending on art or less subsidies and more spending. A cost-benefit analysis could perhaps provide a more informed choice in this matter. For instance, a government could begin by purchasing more visual art as an alternative to more subsidies for visual artists. Demand subsidies, such as tax deductions, can serve as another alternative. (It may turn out that demand subsidies, are actually less attractive than they appear to be on the basis of the previous analysis. The effect on demand is probably small, while there are important negative effects, most notably on the general distribution of income.)

Finally, it is doubtful however, whether there is any specific subsidy strategy that can have much of an impact on average income in the long run. In the exceptional economy of the arts, the basic variable is not income but numbers. If art spending per capita is the same in two countries but country one provides more in art subsidies, then this country will also have more artists, and among them, more poor artists. Poverty is built into the arts. It follows then, that *if the sole aim is to reduce poverty in the arts then the best policy is to reduce overall subsidization of the arts* (thesis 47).

8 Low-priced Education Signals that it is Safe to Become an Artist

Subsidized education, state employment programs, and social benefits all have a different effect on income and employment in the arts than subsidies do. That is because these programs serve a broader range of groups. While subsidies for the arts make the arts more attractive and therefore other professions slightly less attractive, subsidized higher education and social benefits affect all professions. Nevertheless, it appears that the effects of these broader-based programs on the arts are more conspicuous.

I will first look at higher education. In Europe, due to grants for students or subsidies for educational institutions, the relative price of higher education has dropped considerably in the twentieth century, and most dramatically in the decades after the Second World War. The financial aspect of a higher education has become less significant for parents. And thus, less affluent social groups began entering the higher education system and the total number of students increased. In other words, higher education was 'democratized'. In the immediate post-war period, there were plenty of employment opportunities for the increasing numbers of graduates. When on occasion, employment opportunities declined in a certain profession – for instance, the 1970s was a decade of low employment opportunities for graduating sociologists – enrollment figures quickly declined in response. In this sense the market worked well. And if the system worked less successfully, authorities seldom hesitated to redirect students to other fields. When giving information had too little effect, a *numerus clausus* has been utilized regularly in most European countries.

The fine arts case was different however. Here enrollments of arts students just continued rising. No government tried to deter students from studying art, even though it was clear that only a few graduates would ever be able to make a living in the arts.[38] There was also no pressure from professional artists to reduce enrollments to art colleges. Admissions restrictions other than those based on talent were taboo because these would be contrary to the spirit of autonomy in the arts. Therefore, in the short run, admissions adjusted to a particular schools' capacities. And in the long run, the size and number of schools adapted to the number of talented youngsters who were willing to pay the (limited) tuition fees.[39]

In this context, the signaling effect that subsidies have on art students is important. When education is subsidized, this seems to imply that society takes some responsibility for the schools and its students. Therefore subsidized education indirectly suggests, at least a little, that would-

be students can expect to find employment after graduation in their chosen fields. Or, if there are no employment opportunities after all, students expect that the government will still take care of them upon graduation. (This expectation is not altogether wrong given the sums of money governments and government-related institutions spend on programs aimed at relieving the bad financial situation of artists, like the WIK in the Netherlands, the French 'Intermittent de Spectacle' and 'Künstler Social Kasse' in Germany.)

Subsidized art education also suggests that the art profession, like other professions, is now 'democratized' and that anybody can become an artist and make a living as an artist. But whereas in other professions most of the time the large majority of graduates can make a living as a professional, in the arts only a small minority of those who graduate will make it as a professional artist. And so it's hardly amazing to note that the arts are still less 'democratized' than other professions. The parents of art students are still wealthier than the parents of students in comparable professions.[40] Because these wealthy parents can later assist their sons or daughters the risks of going into a high-risk occupation as the arts is reduced.

The presence of highly subsidized art education regardless of future employment sends the wrong signals to potential artists. It contributes to an overcrowded field and low incomes for many artists (thesis 48.)

9 Social Benefits Signal that it is Safe to Become an Artist

During this same period, when higher education became affordable and thus made the arts more attractive, the growth of *employment benefits* and *social security benefits* affected artists more than other professionals. This was caused by the inclination of artists to forsake money in combination with the artist's survival constraint. Generally speaking, the social security or unemployment benefit allowance is sufficient to overcome the survival constraint. These benefits allow artists to work full time in the arts even without other outside income. That means that if artists can count on social benefits, art as a profession becomes a much less risky proposition. *More social benefits induces more people to enter the arts and as a consequence, more people earn lower incomes and poverty in the arts increases.* (Thesis 49)

Many artists use social benefits, unemployment benefits, or related government money to finance their activities. The government often turns a blind eye to these activities or artists manage to mislead administrators. In the 1980s in the Netherlands, social benefits money was gen-

erous and the rules were flexible. Thousands of artists, from dancers to poets, could make art thanks to the generous social benefits program. Presently the benefits program is more restrictive. It is more common now that artists be required to seek alternative forms of employment. However, new programs like the aforementioned WIK plan have replaced more conventional social benefits in the Netherlands. Moreover, in the Netherlands as well as in other countries, many artists continue to find new ways to go on receiving social benefits.[41]

Unemployment benefits is a form of indirect subsidization that is widely used by performing artists and performing arts institutions in the US and a number of European countries. Benefits are given for a limited period, for instance six months. The use of these benefits is legal. Authorities sometimes devise attractive programs (such as the aforementioned 'Intermittent de Spectacle' program in France) geared toward performing artists. These programs have a powerful impact on the behavior of artists and art companies. For instance, since the institution of the 'Intermittent de Spectacle' employment contracts have become much shorter in France, which means that performers receive unemployment benefits for a larger part of the year and companies can pay them less.[42] This is not unlike the situation in the US. (Britain approached the situation from a different angle, which made it more attractive for performing artists to become self-employed.)

This doesn't only involve social security benefits. It's amazing to see how eventually a disproportionately large share of almost any subsidy or benefit, aiming to reduce general poverty or unemployment, starts to pour into the arts. For instance, many countries have developed programs to use money from benefits to finance the wages of employees who were unemployed for a relatively long period. Thanks to subsidization, they receive low subsidized wages, while employers end up paying little or nothing. The wages are often so low that the jobs remain unattractive for unemployed non-artists, who know the prevailing wages for these kinds of jobs. But in the arts incomes are low anyway and a subsidized poorly paid job is more attractive than doing the same arts-related job as a volunteer. And so that's why art companies and art institutions are the first to apply for these kinds of subsidies and how a relatively large proportion of these subsidies ends up going to the arts.[43]

In most of the wealthier countries, disproportionately many artists receive social benefits and unemployment benefits and a disproportionately large share of social assistance ends up going to the arts (thesis 50).

10 Artists Supplement Incomes with Family Wealth and Second Jobs

Even when artists receive subsidies, they often earn so little that one has to wonder how they manage to survive. For instance, the average visual artist in the Netherlands earns (including subsidies!) barely enough to cover costs, with almost nothing left to live off of. The median income (including subsidies, after costs) is close to zero.[44] More than 40% of Dutch artists don't earn enough from their art to cover the cost of making the art itself. This means that at bottom these artists are actually paying to be an artist. On top of that, more than 75% do not earn enough to earn a basic living.[45] How can they go on being artists if, despite donations and subsidies, they cannot make a living? In other words, how can such poverty continue to exist?

The superficial answer is simple: Poverty among artists is only possible if they manage to find other sources of income to make up the deficit in their budgets. What other sources exist? Mainly, the financial aid comes from the artists themselves and from families and friends. Artists transfer non-arts income or arts-related earnings into their art production budgets. This may include savings from previous employment, benefits, or an inheritance.

Although the role of families funding the arts was probably more pervasive in the past, its current role should not be underestimated.[46] First of all, inherited money enables a number of artists to work full-time (or at least more hours) on their art. And, although family members seldom supply regular financial assistance anymore, they do still come to the artist's rescue in emergency situations. Probably the most important source of financial assistance is the artist's partner, however. Often this kind of assistance is built right into a couple's budget. For instance, the partner who holds down an 'ordinary' job, naturally pays most of the recurring bills.

Inheritances and other types of family assistance make the art profession a slightly less risky endeavor. This helps explain the fact that at least 40% more arts students have parents with a higher than average education than other students do.[47] Parents with higher educations earn more and are more able to assist their sons and daughters in their artistic pursuits when they can't make ends meet.[48]

But the majority of artists who cannot earn a living off their art and who have no family wealth to fall back on have to find a second job if they hope to continue making their art. Evidence reveals that the extent of multiple jobholding in the arts is large and increasing.[49] A survey of American artists in New England reveals that in 1981 76% of all artists had a non-arts second job.[50] In 1993, among Australian performing

artists, almost 90% had an arts-related or non-arts second job.[51] Due to the comparatively higher level of subsidization, these percentages are lower in a country like the Netherlands. Nevertheless, in 1998 around 33% of Dutch visual artists had an arts-related second job and spent 10 hours a week doing arts-related work. Moreover 29% of Dutch visual artists worked at a non-arts job on which they spent an average of 17 hours a week.[52] According to another poll, 60% of Dutch visual artists who were still employed in the arts a year and a half after graduation had a non-arts second job.[53]

Artists teaching art has been common practice for a long time, but the fact that so many artists are now supplementing their art-generated incomes with second jobs appears to be a phenomenon of the last quarter century. To some extent, second jobs seem to have replaced family-related financial assistance. Nevertheless, it is even more the present large number of artists who consequently earn too little from their art that has forced artists into seeking out second jobs.

The majority of artists have non-arts related second jobs out of necessity; they no doubt would prefer to work more hours on their own art.[54] The common types of employment such as restaurant work, cleaning, and other forms of menial labor neither offer much satisfaction nor pay very well. As we have already noted, as soon as their income rises and exceeds their survival constraint, they reduce their hours on these second jobs in order to work more hours on their art.

Because second jobs are often regular jobs, they offer some security. Thus, they're attractive because of the income but also because they reduce the risks involved in choosing a career in the arts a little. In this respect, it is worth noting that the risks involved in the arts profession have increased even more over the past thirty years, because the number of regular jobs became smaller in the performing arts and artists had little choice but to become self-employed.[55] Many performing artists lost steady jobs and now find themselves working freelance.

11 Artists Reduce Risks by Multiple Jobholding

Arts-related jobs such as teaching art differ in a number of respects from non-arts jobs. Teaching art usually pays better and offers more satisfaction than, for instance, cleaning.[56] Therefore, it is understandable that when artists start to earn more they sooner give up non-arts jobs than arts related jobs. The difference is also evidenced by the fact that art students sometimes try get a teaching degree as well.[57] These students intend to work as full-time artists if things work out, but if they don't,

they are assured of a pleasant second job as an art teacher. Moreover, part-time artists who hold down teaching positions for a number of years usually make less of an effort in order to pursue their career in art. This means that artists do not always cut back their hours on interesting second jobs when their financial prospects suddenly improve. (Whereas internal subsidization is an unintended by-product of regular teaching jobs in Europe, at American universities teaching jobs for artists are designed to enable such cross-finance.)

By making certain occupational choices artists learn to diversify their risks.[58] They reduce their risks by multiple jobholding outside the arts, as well as inside the arts. They do so by choosing a certain product-mix or combination of activities. For instance, a musician maintains a regular job as a studio musician and earns some extra income by playing in a band. Because these activities demand different skills, she maintains these skills and consequently increases her own chances of continuing her work as an artist. When this band ultimately becomes successful, she learns some managerial skills. She then gets a job teaching, as well, and ultimately ends up sitting on a government committee which decides on grants for young musicians. This is a form of hybridization: artists combine various artistic skills with arts-related skills or perhaps even non-arts skills.[59] Modern artists have grown versatile. Sometimes versatility is more than just some survival strategy. Some artists, in fact, find this kind of diversity rewarding in and of itself.

The number of arts-related jobs that are government-financed or subsidized, has grown. Over the past 25 years, many new jobs emerged in the world of art-mediation. Meanwhile, the number of teaching positions has also increased. It's plausible that the urgency of self-employed artists seeking more stable forms of employment has contributed to the emergence of a so-called 'experts regime' in the arts.[60] These developments may have indirectly exacerbated the already large burgeoning artist population or 'the self-congesting spiral of oversupply' as Menger calls it.[61]

A kind of hybrid artist is now emerging on the scene. These artists have attractive and well-paid non-arts and arts-related jobs. Sometimes they have managed to pursue an altogether different profession as well. These hybrid artists are multiple jobholders by choice. They are definitely not the self-sacrificing artist of old, who considered a restaurant job as a necessary evil. Hybrid artists instead choose a sensible portfolio of activities. This kind of artist is still in the minority, but their numbers are growing.

Suppose that this new type of artist were to eventually become more common. Then the hourly income earned from art would decline even further because these artists would have even less of a need to earn a

living from their art. But because these artists earn good wages in attractive non-arts jobs and, at the same time, don't reduce the numbers of hours they spend working in their non-arts jobs as they begin earning more, the average incomes of artists will begin to look almost normal.[62] Modern multiple jobholding artists are relatively well off and can afford to make art; as artists they can afford to be 'selfless' and to dedicate themselves to their art. They usually earn very little directly from their own art, but because they have well paid second jobs they don't need to. If this form of multiple jobholding becomes the trend, then the arts will again become an occupation for those who can afford it – the wealthy, in other words.

12 Artists Could be Consumers rather than Producers

Judging from the figures showing average income, the arts are an unprofitable production sector. Many artists grow old without ever having been able to make a living from their art. Others leave later in their careers than they would have had they been unsuccessful in another profession.[63] Artists are then, generally speaking, poor. The notion of multiple jobholding however, suggests an alternative interpretation of low incomes. It can be argued that the arts are not as unprofitable as it may seem. This is the case if many artists were not tabulated as producers but as consumers. Such artists are producers in their arts-related and non-arts 'second' jobs, but in making art they are consumers. Part of what they earn as producers in the other jobs they end up spending on their 'hobby', making art. Sometimes they get lucky and they earn a little extra income from this hobby but on the whole they remain consumers.

In this alternative interpretation of the economy of the arts, failed artists, or artists who cannot make a living from their art, are 'happy' amateurs instead of 'poor' and 'miserable' professionals. They are in actuality then, part of the huge army of amateurs – people who *spend* their time and money making art.

This interpretation is in line with the way standard economics draws a boundary between producers and consumers and between professionals and amateurs. Producers *earn* money and consumers *spend* money.[64] Artists, who against their better judgment, go on spending money on their profession, end up being mercilessly categorized as consumers. (Even when they argue to be investing in future success, economists would still consider them consumers, as long as their rates of return are considerable lower than corresponds with normal business practice.) Therefore a large number of artists would stop being producers and

could be dismissed from the analysis. The resulting economy of the arts would be decidedly less unprofitable and less exceptional.

However, the existing distinction between professionals and amateurs in the arts cannot be dismissed this easily. This distinction is socially constructed; it has a long history. It certainly does not conform to the theoretical division offered by economics. At present, in order for somebody to be called an artist, one's professional skills are more important than the specifics of one's education or income. The professionalism of artists depends primarily on how well they relate to the work of peers and predecessors. When they strive for peer recognition this is seen as a positive characteristic of being a professional. An artist's education can also help influence one's professional status, but it is not a sine qua non. Economic qualifications are not totally irrelevant, but their importance is relatively insignificant. Earning one's livelihood from one's art (or having that intention) adds very little to a particular artist's professional status. It's not uncommon in the profession that colleagues consider commercially successful artists as amateurs, while conversely they view certain commercially unsuccessful artists as highly honored professionals.

Although the distinction between professionals and amateurs offered by economists is unsuitable for this study, it does help put other distinctions into perspective and may ultimately lead to a different assessment of the artist's situation. Because there are artists who hold down lucrative second jobs and can thus afford to make art without making money, *poverty in the arts is less severe than it appears to be* (thesis 51).

13 Is there an Artist 'Oversupply' or are Low Incomes Compensated For?

The use of an old accounting trick of turning artists into amateurs will not solve the financial problems that continue to plague the arts. Nevertheless, it's possible that, despite the fact that poverty literally does exist, artists are not necessarily worse off than people in other professions. Artists may be poor in financial terms but rich in terms of alternative income sources. Are there still 'too many' artists, when overall income is taken into account? In this respect, can one still refer to an art and artist 'oversupply' or to the notion that the arts are just too attractive for their own good?

In connection with low income, it is common to point out the 'oversupply' or 'excess-supply' of art and artists. This means that if there were far less artists, producing far less art, hourly wages could attain parity with other professions.[65] But the entire notion of oversupply is probably a faulty one.

As was made clear in previous chapters, professional artists don't just earn incomes, but are also compensated via non-monetary rewards, and they probably receive more of these kinds of rewards than others in comparable professions. So, on the one hand, it can be argued that low incomes are compensated by non-monetary rewards. Through personal satisfaction, recognition, or status gained from their artwork and through the 'kicks' that one gets from taking chances, artists can be said to exchange money for other rewards. Artists would then compensate themselves for their own 'poverty'. On the other hand, it could be that artists are less well-informed than other professionals. The mythology of the arts leads to the proliferations of misinformation. Due to this misinformation artists are 'lured' into the arts and a life of poverty that goes uncompensated.

Both of these interpretations of poverty in the arts are undoubtedly valid. The question is whether one is more relevant. As far as I can see, there is no way of producing a satisfactorily objective answer. People can only argue in behalf of the plausibility of their own particular opinion. Personal attitudes and experiences inevitably color people's opinions. For instance, people who idealize artists see only free and happy artists and tend to overlook the details of actual poverty. The existence of non-monetary rewards assures that the art world remains a harmonious world and perpetrates the notion that there is no such thing as an artist oversupply. Other people however, who are easily impressed by the sight of artistic frustration and suffering, will probably be more attuned to actual poverty. Because of misinformation there are too many artists.

The picture people have of the art world also depends on the artists they happen to know. Successful artists send a general message that they are in fact totally well-informed about the matters at hand. Their success can be viewed as the result of their hard work and dedication. They perpetuate the belief that before their success, it was personal satisfaction that kept them going as compensation for their low incomes. Failed artists however send out a different signal, but, strangely enough, they stick to the same myths. These 'losers' cannot avoid exhibiting their bitterness, but they seldom blame the art world for their failure. They never conclude that maybe there are just too many artists. Instead they blame themselves for a lack of dedication.

Large segments of the poor artist population continue to express extreme indignation regarding any developments that may possibly hinder their already pathetic position in the art world. Even genuine concern is often viewed with great suspicion. Many artists' lives are given over to a permanent state of indignation. These are the artists who feel profoundly cheated and continue to work too hard for too little remuner-

ation. It suggests that misinformation plays a significant role in the arts. For me this phenomenon of permanent indignation based on misinformation makes the notion of real poverty the more convincing one. Therefore I attach more importance to the many myths surrounding the arts and the misinformation they produce. (In the chapters to come I shall continue to stress how the myths surrounding the arts contribute to its general attractiveness.)

Nevertheless, even if the poverty of a majority of poor artists is real, this does not apply to all poor artists. It certainly does not apply to the new type of hybrid artists whose low hourly income in the arts is supplemented by income from attractive other jobs. The hybrid artist chooses his or her portfolio of job options more or less deliberately and certainly not from a lack of alternatives. These artists appear to be less prone to the effects of misinformation. If they ever become a majority of the 'poor' artists, the notion of uncompensated poverty would lose its significance. However, for the time being, many artists continue to have a difficult time supplementing their art income with boring second jobs. As long as their art income remains too meager to earn a living from, low incomes are not fully compensated by other rewards.

Whether a low monetary income in the arts implies that artists are worse off than others, whether there is an oversupply of art and artists and whether the arts are just too attractive, depends on the notion of whether poverty is due to misinformation and therefore real, or is compensated for by non-monetary rewards (thesis 52).

14 Conclusion

Because artists are inclined to forsake money and because of the presence of misinformation, poverty in the sense of low hourly incomes is built into the arts, at least into the arts as we know them. And so is the oversupply of art and artists, which the economist in the previous chapter found difficult to comprehend. To a lesser degree, this also applies to other arts-related professions. For instance, in many European and American cities there are so many commercial galleries that average sales are far too low to provide dealers with a normal income.

Many governments make it a priority to try to reduce poverty in the arts through a variety of subsidy programs. This leads to the emergence of a large gift sphere in the arts, and therefore low income in the arts partly explain the large gift sphere. The economist, however, is correct in claiming that government financial assistance does not solve the problem of poverty in the arts. On the contrary, subsidies actually attract more

would-be artists, and as a consequence, average incomes remain low and the relative number of poor artists increases as does poverty.

Subsidies encourage artists to orient their activities towards the government instead of the market. For instance, Robin received a handsome grant from the government, which allowed him to quit his second job. He also decided to curtail his income-generating efforts in the market. Because younger artists quickly take up whatever position he could have occupied in the market, the number of poor artists actually increases.

Subsidies also convey the message that governments actually provide for their artists, and so any increase in subsidies can stimulate a proportionately larger increase in the total numbers of practicing artists as well as lower their average income and ultimately cause more poverty. This is more often the case with supply subsidies than with subsidies aimed at intermediaries or consumers, for instance, in the form of tax deductions.[66]

The losses produced by the arts have to be financed somehow. Housing, musical instruments, paint, canvases, and other art supplies all have to be paid for. These losses are defrayed through gifts from partners, relatives, and friends and through the process of internal subsidization by artists themselves. Without this kind of support, the arts could not continue to survive in their current form. Presently the most important form of internal subsidization or cross-financing is derived from income generated by second jobs.

It could be argued that many artists are more active as consumers than as producers of art. Their on-going endeavors cannot be interpreted as sound investments. They are amateurs and consumers because they are spending time and money on this hobby called art. Although this view gives the entire notion of artistic activity a new spin, it's a line of thinking that is based too much on an unrealistic distinction between professional and amateur. In practice, the distinction is socially constructed. And because regulating the numbers of artists is anathema to the arts, there are more people working as professional artists than the market can support.

For artists to actually earn decent hourly wages, the number of artists would have to go down considerably. This implies a current state of overproduction in the arts and an oversupply of artists. A career in the arts remains just too attractive for its own good. However, low incomes in the arts can also be seen from an entirely different angle. The hardships of financial poverty may be compensated by non-monetary rewards – such as private satisfaction and status. Personally, however, I'm convinced that a considerable part of poverty is not compensated for, and is exacerbated by the presence of misinformation; which, consequently, leads to an oversupply of both art and artists.

The economy of the arts as we have portrayed it here does not leave much room for the influence of governments and donors. The high status accorded the arts, which affects both artists' inclinations and the nature of the misinformation, prevents change. Whether one emphasizes real poverty or compensated poverty, the arts are unusually attractive. This peculiar attribute makes the economy of the arts exceptional.

Discussion

1 What is your opinion: is poverty in the arts largely compensated through non-monetary rewards or is this poverty real?
2 Where would you draw the line that distinguishes the passionate amateur artist from the professional artist?
3 Do you think that the number of fine artists with second jobs will continue to increase or will there be a return to a reality of full-time artists?
4 If the government wants to spend more money to ultimately raise the average income of artists, how would you advise the government?

Chapter 7

The Cost Disease

Do Rising Costs in the Arts Make Subsidization Necessary?

No Cost is too High When it Comes to High Quality

Ruth Towse told Alex the following story from the opera world. When Samson and Delilah by Saint Saëns was staged by the Royal Opera House in London it included a large chorus. All chorus members had expensive fitted silk dresses. The woman playing Delilah at one point complained that her silk dress did not stand out enough from the other dresses. So they put the expensive dresses with the exception of Delilah's in a washing machine. The effect of washing silk in a washing machine was as expected. The point of whether Delilah was unreasonably demanding or right wasn't the issue; a small improvement had been bought at great expense. The expense was unnecessary because, according to Ruth, cheap dresses could have been made for the chorus members and the silk dresses could have been saved for a later occasion. The problem could have been solved for a lot less money. Plus had the designers been more cost-minded, they would have thought twice about having all the silk dresses looking exactly alike. What shocked Ruth was the total disregard for costs.

Costs are Irrelevant; Artistic Justification is All that Matters

Alex's friend, Gerald, is a composer of contemporary classical music. When Gerald graduated from the conservatory, Alex heard the composition he'd written for his final exam, as performed by a large student orchestra. Alex enjoyed it a lot. Since then, Gerald has written three more pieces for a large orchestra. None of them have been performed yet. After that he has also written eight pieces for small ensembles, of which seven have been performed; some of them several times. So, compared to other young composers he is relatively successful. Alex observes that part of the trick must have been writing compositions that are less costly to perform. Gerald is furious, and begins a long involved story explaining how his reasons for writing for small ensembles were purely artistic. It was a 'natural' step in his artistic development and it had absolutely nothing to do with lower expenses perhaps increasing the chances of getting his work performed.

Alex tries to explain to Gerald about all those visual artists who right after they graduate start right off painting huge museum-sized canvases only to later reduce them to more consumable sizes, sizes more appropriate for the homes of the well-to-do. These artists also deny that there's any relationship between expenses and marketability. Is all this just coincidental? Gerald says he doesn't know about visual art, but in his case the adjustments have certainly not been coincidental. They are based on his own deliberate and purely artistic decisions.

Some weeks ago, Alex heard the performance of his latest work, which he had written especially for a unique concert of contemporary music in the Queen Elizabeth Hall in London. It was a work for harp, cello, violin, and celeste. Alex noticed that the celeste was the sole electronically amplified instrument among them. Alex asked Gerald about this afterwards. Gerald felt really embarrassed. During the final rehearsal, they discovered that they were just not getting the right balance. The sound of the celeste was not loud enough. He said that in writing the piece he had overestimated the hall's acoustic qualities. He at first wanted to cancel his performance, but the director convinced him that electronically amplifying the celeste could provide a makeshift solution to the acoustic problem. The director assured him the audience would have no problem with it. Gerald reluctantly agreed. Speaking with Alex Gerald emphasized that he was not against electronic amplification in contemporary music, as long as the decision rests solely on artistic considerations. In other words, amplification should never be used to cover up compositional defects, or to play in a larger hall with more people present. Gerald still believes that he should have withdrawn his contribution. By not doing so, he feels he has failed as an artist.

Why is it so important for artists to insist that cost considerations don't influence their work? Why does Gerald agree to allow his work to be electronically amplified when it serves artistic purposes, but opposes its use if the aim is to serve more people in a larger hall? Come to think of it, is it possible to make purely artistic decisions independent of cost considerations?

Costs in the arts rise faster than in most other production sectors. Do rising costs help explain the high level of donations and subsidies, i.e., the large gift sphere in the arts? And do rising costs also help explain the relatively low average incomes of artists? Many art donations and subsidies stem from a desire to preserve the high quality of art and the desire to help poor artists. And so can we argue that because rising costs endanger artistic quality and further reduce artists' incomes, rising costs can be used as an additional argument for subsidization? Or is it more an excuse than an argument for subsidization? In order to answer these

questions, this chapter will attempt to put the notion of rising costs in the arts in perspective.

As an artist, I believe that the existence of high quality art is essential, essential for the well-being of individuals as well as society in general. If rising costs begins to threaten the integrity and survival of art then subsidies and donations are essential. Moreover, subsidies and donations are also necessary to assure artistic freedom. *As an artist, I insist that artists must be free, and costs should not impinge on artistic freedoms.* As an economist, I point to the fact that in the past many art and non-art products have disappeared or became largely obsolete because of increased expenses. Some examples include domestic servants, lady companions or a shave at the barber. Subsidizing these kinds of activities has never been seriously proposed. But if it were proposed, it would anyway have been too expensive. Plus it would have been inefficient to maintain these kinds of activities through subsidization. I see no reason why the arts should be any exception. *As an economist, I think it's best to let people decide for themselves whether they still want to keep buying more expensive art products or prefer to buy other products.* Moreover, with respect to artistic freedom I believe that all production, including artistic, ultimately takes place within constraints because resources are limited. There is no freedom without constraints.

1 'Artistic Quality Should Remain the Aspiration, Regardless of the Costs'

Many artists are easily insulted and reveal their indignation whenever anyone suggests they cut their expenses or adjust their artistic choices because of limited funds. "We're not business people, we're artists." The lack of concern about expenses is most prevalent in performing art institutions. The silk dress story occurred some twenty years ago, but it could just as easily have happened today. The artists at an art institution often feel superior to the non-artistic personnel. Worrying about expenses and searching for funding is something let for others to deal with. This attitude is somewhat understandable, as artists in art institutions do not deal as directly with cost and revenue issues as, say, self-employed artists do. Producers and financial directors are positioned between the artist and the market or between artists and donors. Instead of blaming themselves or the consumers, artists can always blame the administrators for the lack of funds or for impinging on their artistic aspirations or, even worse, for 'killing art' as if it were the personal fault of the administrators that funds are not infinite.

Although self-employed artists are more familiar with costs, they also daydream about unlimited funds. They too can get pretty upset about the 'enormous injustice' of not having sufficient funds to make the art they want to make. (People in the arts expend a lot of 'artistic' energy on being indignant. Actually this is a natural response for people who feel they work too hard for too little remuneration. In this sense, poverty in the arts is not compensated but real, as we suggested in Chapter 6.)

Producers, financial directors, and consumers are all blamed for the lack of sufficient funds, but none more so than donors and governments. In the Netherlands, most of the indignation is naturally aimed at the primary donor, the government. Despite, or rather because of, the fact that the Dutch government spends comparatively large sums on the arts, it is continuously attacked for not giving more. It's 'stinginess' is said to be impinging on the autonomy of the arts.

To many people, many of them artists, the autonomy of the artist means that any artwork is worth producing, regardless of expenses or demand. The artist alone should decide the artwork's quality. Financial restraints violate the autonomy of the artist. *The attitude that 'sacred art has no price, and that costs are therefore irrelevant' is a prevailing notion in the art world* (thesis 53). This attitude is also exhibited in the above illustrations. For the composer, even insignificant compromises in quality remain taboo, even if they effectively cut costs. And no cost is too high if it means an increase, however small, in an opera's quality.

But quality is always relative. In poor countries, the food, housing, clothing, or household appliances are usually of a lower quality than in wealthier countries. People there cannot afford high quality goods. And also in rich countries not everything is available. Many quality products, from superior blenders to advanced building materials, remain on the drawing table because they are (still) too expensive to produce.

In art as well, technical restrictions and cost limits are present. Take the extreme example of an artist who, in the context of an artistically interesting project, wants to reclaim the Atlantic Ocean. Due to limitations, this kind of project can only exist on the conceptual level and in the form of sketches. And even in the cases of more modest projects the realization of a work still depends on an examination of benefits in relation to costs. Usually this examination is left to the market. The final decision then is dependent on market variables. But if it looks like consumers won't be able to foot the bill, donors and governments can always step in and make their own appraisal of costs and benefits. For instance, after many years of discussion, German officials decided that the benefits of Christo wrapping the Reichstag were worth the costs. (In this case, benefits and costs were clearly interdependent: the initial resistance of

German politicians actually increased the aesthetic value of the project. This confirms the conclusion of chapter 3 that aesthetic value is a social value.)

2 'The Arts are Stricken by a Cost Disease'

Due to a general sustained increase in productivity, people in the West have far more purchasing power than they had one hundred years ago. Because people earn more, labor costs are higher. The impact however, of higher wages in the industrial and agricultural sectors, has been more than offset by the increase in productivity. Corrected for inflation, due to the savings on labor costs, most products became cheaper. In other words, labor productivity has risen considerably.

However, as far as labor in the art world goes, this is an entirely different story. If developments in the arts were comparable to those in agriculture, we wouldn't have four musicians perform a Haydn string quartet, but only one musician playing at twice the speed. This is not what happened in the world of art. Because Haydn's instructions and specifications are respected, still four musicians appear on stage, who take the same amount of time to play the piece as in the days of Haydn.

It seems that there is just no way to save on labor in the arts and that labor productivity has not increased. And although the incomes of artists have not risen as dramatically as elsewhere and are presently relatively low, they have nevertheless risen considerably. Thus, without the support of subsidies or other non-market revenues, art products should be considerably more expensive in relation to other consumer goods. Due to rising costs the arts have gradually lost their competitiveness and they may not survive without subsidies and donations. Baumol and Bowen, who first used the example of the string quartet, have called this phenomenon *cost disease*.[1] It is a disease, because like a cancer it grows and threatens the infected.

In its pure form, the cost disease is first found in relation to a real-time personal service. Because this service is in real time, it establishes natural limits to possible technical progress. This is the case when it comes to performing a Haydn string quartet or Beethoven's Fifth Symphony, or Shakespeare's *Hamlet*. The real-time service offered by actors, musicians, dancers, etc. is comparable to the services offered by female companions (or prostitutes). If female companions, prostitutes, actors, dancers, musicians, etc. are not present *in person* that specific service does not exist.

(The same does not necessarily apply to surgeons, nurses, teachers, or

hairdressers. In their cases, it is usually the result that counts and not the human presence itself. Their activities can be accelerated or even replaced by technology. Nevertheless, they represent mixed cases, as their presence and conversation may actually involve an essential additional service, which involves real time. Thus, we can say that the pure cost disease also applies to these sectors as well, albeit to varying degrees.)

There is a tendency to widen the concept of cost disease to more labor-intensive areas of production where the chances of net savings on labor costs are small.[2] This most commonly applies to the service sector, which includes retail trade, banking, insurance, and civil service. It also applies to certain areas in the arts, where the final product is not a real-time service. For instance, most creative artists do not offer real-time services, but their products, paintings, manuscripts, scores, etc., involve much personal labor, which usually offers little opportunity for reductions. After all, authentic works of art necessarily depend on personal services.

Economists tend to agree that over the past fifty years labor productivity figures in much of the arts has risen less than elsewhere. Even though artists' incomes have lagged behind, labor costs have risen more than elsewhere. These findings confirm the presence of a cost disease in the arts.[3] In smaller areas of the arts such as classical music, where quality has been largely constant, the rise in relative costs has been the most pronounced. Costs for live pop music concerts have also risen, although less dramatically because attendance figures have risen as well. The intensity of the cost disease therefore varies depending on the art form.

The presence and intensity of the cost disease depends on three circumstances or assumptions:
1 quality is constant,[4]
2 there is no technological progress, and
3 labor costs are high.

Moreover, just because the cost disease is found in an area of the arts, doesn't necessarily mean it is malicious. Whether it is virulent depends on two additional assumptions:
4 increasing costs are not compensated by increased revenues and
5 tastes are constant.

I shall examine these assumptions in the following sections. They apply to specific cultural fields in varying degrees. Therefore, the presence and the particular virulence of the disease is more a matter of degree than an all-or-nothing affair.

Is quality constant and isn't there any technical progress in the arts? The two assumptions are related: constant quality usually implies the absence of technical progress, while technical progress implies a change in quality. Art consumers often demand that quality is constant; this is especially true in the performing arts. A constant quality must be maintained regardless of rising costs. This is in keeping with the general art world attitude that sacred art has no price, and that expenses must never interfere with quality. Therefore, its not so amazing that quality is a constant in Baumol and Bowen's cost disease model developed for the performing arts.[5] As art lovers these economists had thoroughly internalized the art world's dogmas. Nevertheless, it is strange that a basic aspect of any developing society, that of changing quality, is assumed to be invalid when it comes to the arts.

Or maybe it is not so strange. For if we limit our attention to the traditional performing arts of the past one hundred years, one may get the impression that quality has remained constant and that there have been no noticeable increases in productivity. Looking at the rest of culture however, one notices considerable productivity increases. For instance, over the past fifty years, 'commercial' (pop music) performances have not been hampered by demands for constant quality and has introduced numerous technological advances that have increased productivity.

Technological change in the arts is nothing new. Art products have continued to change with the times thanks to technological advances. This also applies to the predecessors of present-day traditional art forms. For instance, the works of renowned classical composers were allowed to change during their times and after. New performance formats and new musical instruments were consistently being introduced. Generally, audiences applauded the changes in quality.

The arts not only applied but also initiated and invented new techniques. People we now consider artists introduced notational systems for music. This led to enormous increases in productivity. The written music of Bach, for instance, has been performed for literally millions of audiences worldwide. The audiences reached by medieval minstrels during an entire lifetime were nothing by comparison.[6] Sheet music did not just serve professional musicians; the published scores allowed this music to enter middle class homes. (Composers like Telemann and Mozart were all for the dissemination of their music in this manner. This is how they earned extra money, while their fame grew as well.[7]) Visual artists, meanwhile, developed oil paint and the technique of lithography. Oil paints were the backbone of all manufactured paint for at least three cen-

turies, while the most used present day commercial printing technique is still based on the principle of lithography.

Although new techniques inevitably led to changes in existing products, these changes did not prevent them from being used. Not only did new techniques alter existing products, they also opened up new artistic possibilities which consequently led to new types of artworks being developed. A more recent example is the computer: word-processing, musical notation programs (Finale and Cubase), electronic music programs, drawing programs, photo-manipulation programs (PhotoShop), etc., not only save time, they change existing products and encourage the development of new products.

In the performing arts, new sound and visual amplification techniques – through so-called video-walls – have gained widespread use. This technology allows for smaller ensembles and casts to perform for larger audiences. Using these techniques, existing products necessarily change while new products are introduced into the scene.

Technological advances also affect the arts indirectly. For instance, ticket reservations and sales for performances have become far more efficient over the past few decades with the introduction of computerized systems. Theatre lighting technology has also been vastly improved, and now requires less labor.

The technical reproduction of art is not only interesting because it demonstrates the possibility of increases in productivity in the arts, but also because it's a good example of the extremely relative nature of the cost disease. The reproduction of performances on CD, radio, film, television, videotape, and now DVD, and the reproduction of paintings in art books, clearly shows how technological advances has allowed the arts to reach increasingly larger audiences, more so, in fact, than any other mechanisms or gadgets discussed thus far. One-hour live performed art is easily more than hundred times as expensive than one-hour of art at home, on television, listening to a CD or viewing a rented videotape or DVD at home.[8] Due to technical reproduction the technically reproduced art product moves out of the realm of personal service and into the domain of cheap industrial good.

Cowen, who presents numerous other examples of technical progress in the arts, considers increased diversity as an easily ignored form of increased productivity. Not only are performers more versatile than they were two hundred years ago, the diversity in musical styles available to consumers is also larger. Increased diversity suggests more quality and consequently, a higher output. Productivity in the arts, it is safe to say, has increased.[9]

There are many possibilities for the introduction of labor-saving tech-

niques, which lead to productivity increases in the arts. This is not to say that there is no limit to the labor-saving techniques. The arts and unquestionably the live performance sector, need to provide personal services in one form or another. Because live performances require personal service in the form of living people on stage, this aspect establishes a final limit on possible changes in existing products and the introduction of new products. (It should be noted, however, that the processes used for the production of industrial consumer goods also "rely on some irreducible quantity of creative labor".[10] Therefore, it's not just the arts that faces limits on labor-saving techniques; ultimately every production process faces this kind of limit.)

When we observe the immense variety of types of technological innovation in the arts we can make some initial comments regarding the cost disease. *Because quality is never constant, the cost disease does not rule out labor saving and productivity increases in the arts* (thesis 54). Moreover, *the notion that the arts in general have not experienced much in the way of technological advances and productivity increases is false* (thesis 55).

4 There is no True Performance

When costs rise the natural response is to look for ways to cut expenses. For instance, when the prices of studio spaces go up some painters will start to work at home. This way they can 'stay in business'.

In the performing arts as well, simple methods exist to cut expenses when costs are rising. One of them is performing for larger audiences; another is having fewer performers on stage. If both are altered simultaneously productivity can be considerably increased. For instance, the music of Jacques Brel can either be performed by a 70-piece orchestra performing for two hundred people or by a solo artist like Mike Almond for an audience of three thousand. In the first instance, the cost per consumer (or unit of consumption) is approximately three thousand times higher.[11] In other words, in this case the solo performer increases productivity by approximately three thousand times. (Because audience size and the number of performances may vary, it is better to count units of consumption and not units of production like performances or productions.[12])

If people are not prepared to pay for larger ensembles, the natural solution would be fewer performers and larger audiences. This is what can be observed, although less so in the more heavily subsidized traditional arts. Nevertheless, even in some traditional areas the number of performers has become smaller. For instance, the average cast size over a

30-year period in American theatres dropped from 16.8 to 9.3, a reduction of almost 50 percent.[13] Contemporary classical music performances have also reduced their numbers of performing musicians. Even if composers like Gerald claim they base their decisions solely on artistic considerations, it is hard to believe that expenses don't have some indirect influence on decisions. (Baumol, who brought the phenomenon of reduced cast sizes in the US to light was doing so to influence increases in subsidies. He felt that cutbacks had a detrimental effect on the arts.[14] Therefore, it's fairly obvious that Baumol does not believe that these kinds of decreases stem from artistic decisions.)

When quality is constant reductions in labor are generally impossible. In the traditional performing arts the true or authentic performance, in which the artist's original intent is approximated as accurately as possible, is a goal that is pursued with almost religious zeal. This is particularly true for classical music. (But because the composer's intent is not always obvious, small differences in quality or interpretation do occur and these interpretations spark endless debates about a particular performance's fidelity to the original).

But when is a performance an authentic copy of an original? In the theoretical approach of Nelson Goodman performances are considered accurate *copies* of a work only if all the artist's directions are carried out. Wrong notes, altered lines of dialogue, characters or musical instruments not prescribed in the original, means the performance is not an authentic copy: but an *adaptation*.[15] (If performers claim they are true to the original, the performance is both a falsification and an adaptation.) However, these are formal distinctions. On the one hand, in music, certain 'adaptations' can still be considered as genuine performances.[16] On the other hand, theatre performances can be 'true copies' although they tell completely new stories through the use of scenery and the ways of acting.[17] What is, in essence, considered true or an adaptation depends on conventions.

Moreover, it's unlikely that the accuracy of a performance is solely dependent on what is happening on stage. Chapter 3 argued that modes of consumption are an integral part of a work of art. Also an alteration in the way a work is consumed changes that work of art. If one evening there are only five people in the audience, while another evening there are five thousand, these are essentially two very different aesthetic experiences.

Even if the conditions of the performances of old masterpieces were copied down to the slightest detail – instruments, the performing space, clothing, and audience size, all being exactly like they were in the days of the first performances – the works would still never be exactly the same, simply because we are totally different people now. We feel and perceive

things differently from the way audiences did in the castles and mansions of the times. These changes plus those in production techniques affect the consumption of art and consequently the work of art itself. Constant quality is an illusion. The truly accurate performance does not exist.

The same goes for art objects. Even though some paintings may have been hanging in museums since they first opened their doors, their ambience is continually changing. This is evident from lithographs and etchings that depict the halls of museums in the past. A museum's appearance changes drastically, it seems, about every fifty years. Thus, today's museum visitors cannot possibly have the same aesthetic experience as spectators from long ago had. Again, a work of art has no independent existence. Circumstances influence a work of art.

The obsession with an authentic performance, especially in classical music, is itself a product of the times. It is related to the aforementioned romantic 19-century notion, which continues to remain the dominant attitude in the art world. In this view, artists, especially the old masters, are worshiped as geniuses and their works should be 'respected' at any cost.

5 The Taboo on Technical Innovation in Classical Music is a Product of the Times

The authentic performance is not some objective given; it is based on conventions. The attitudes towards change and innovation in the arts are certainly not etched in stone. The notion that change is unacceptable in some of the arts is steeped in the social attitudes of a particular time and place. Nevertheless, these attitudes can become a particular period's dictum. For instance, for more than a century now consumers and producers of classical music continue to insist on a particular constant quality and continue to resist new products.

Unlike jazz and pop music, there's an almost universal taboo against any electronic amplification of classical music. It is only quite recently that this taboo in the case of outdoor concerts at least has lost some of its bite. For indoor concerts, this restrictive taboo continues to hold. Nevertheless, differences between various countries do exist. In the Royal Festival Hall in London, the orchestra is allowed to perform before an audience of three thousand using electronic amplification in parts of the hall. (In the Netherlands, there have been and continue to be electronic amplification experiments, but the results are not allowed to be used to lower the prices of seats; the experiments are strictly focused on improving sound quality.[18])

The change in attitudes over time is striking. Between around 1750 to

1850 new and louder musical instruments began replacing many of the musical instruments used in the ensembles for which Bach and Mozart wrote their music. Many new and louder instruments were introduced, while for instance the violin had its numbers increased. In either case the timbre changed; the sound of an orchestra changed far more than presently by electronic amplification. This is particularly true regarding the replacement of the harpsichord by the piano. Louder newer instruments kept replacing the original instruments, a trend that was appreciated by most audiences. The innovations that went into creating the concert hall, with its acoustically sensitive design, added to overall amplification and also dramatically altered timbre.

The developments in louder instruments for symphony orchestra ceased about halfway through the nineteenth century.[19] (Developments continued however, in brass and jazz orchestras. It can be argued that already by the nineteenth century the romantic notion of the artist-genius, whose work must be respected at any price, was already severely hampering technical innovation in classical music. Nevertheless, it is more likely that once the halls were built, the demand for live music could be met for the decades to come. This dampened the spark for technical innovation.)

In the twentieth century, the classical music audience grew even though labor costs were starting to rise. But this time there were no new technical advances to offset the expenses.[20] The art world had changed. The status of the arts had risen and the romantic veneration of the old masters had established a steadfast performance routine and with it, a taboo on technical change.

Because a taboo on change did not always exist in classical music, it must be a product of the age. It's not just artists, however, but the entire art world that contributes to the prolongation of the taboo. If the directors of concert halls had started using electronic amplification twenty years ago, their efforts would not have attracted larger audiences. On the contrary, many would have actually stayed home because they would have considered the altered product inferior.

Whether substitutes are considered inferior depends on the type of consumers being considered. In theory, the gradual losing one type of audience can be compensated for by attracting a new perhaps, younger, audience. Until quite recently, this was apparently not an option in classical music. The taboo on change is so strong that audiences and producers castigate anyone even contemplating reaching new audiences via the introduction of new formats or innovations. It is only now that the classical music world seems to be opening up a little. This is most clearly evident with the growth of electronically amplified outdoor concerts and in

proposals for changes in the repertoire.

The time bomb that classical music directors have to take into account is that their audience is dramatically aging and so they need to consider drastic and risky action. For instance, Simon Rattle of the Berlin Philharmonic Orchestra recently announced that he will include the schmaltzy ('*schlager*') repertoire with singers like Udo Jürgens in his concerts. (One has to wonder if there aren't more creative alternatives that would make for an artistically more interesting event and that in time would also attract a wider audience.)

The comparative integrity of the performances discussed in the previous section and the relative nature of attitudes towards cost-saving innovations discussed in this section lead us to another observations regarding cost disease. The cost disease does not simply emerge from intrinsic qualities in the artwork. Works of art are man-made and so is the cost disease. *The gravity of the cost disease is not fixed. The more reluctant the art world is in substituting particular art products for less costly ones, the more severe the cost disease will be and vice versa* (thesis 56).

The first two rudimentary assumptions of the cost disease, that quality is constant and that there is no technical progress, are largely untrue. On the contrary, *quality changes are common in the arts and the arts have always profited and continue to profit from technical progress* (thesis 57).

6 The Cost Disease Contributes to Low Incomes while Internal Subsidization Contains the Cost Disease

In Chapter 5 we noted that hourly wages in the arts are relatively low. How can the cost disease be caused by high labor costs, when average hourly wages are low? First, the labor requirements may be so great that relative labor costs remain high despite low incomes. Second, incomes vary in the arts and so does the cost disease.

The first point lies at the heart of the cost disease. What matters for the severity of the cost disease is the total labor costs per unit of consumption and not hourly incomes. Hourly income affects labor costs but so does the number of hours required for one hour of consumption. Generally in the arts, labor requirements per hour of consumption are higher than in other sectors. In other words, the labor-intensity of production is high. This means that labor costs can be relatively high, even if the hourly wages are relatively low. For instance fringe production, which depends on low wages, usually involves a high level of labor intensity and is thus also susceptible to the cost disease.

Second, labor costs as a proportion of total costs are higher in the arts than in other sectors, but they also vary among the various art forms. Labor costs are often very high in the established and often structurally subsidized performing arts. Labor costs are lower, but usually still far above average in those areas of the arts where artists in part subsidize themselves or assist in a volunteer capacity. Labor costs are normal or even low, however, in the areas that involve the technical reproduction of the arts.

This means that the severity of the cost disease varies throughout the arts. For instance, because most dancers do not work for the established companies and thus earn very little, the average income of dancers is low. Nevertheless, a small percentage of dancers who work for structurally funded companies earns less but not that much less than comparable professionals do.[21] Therefore, in this respect the cost disease hits established companies more than the less official companies.

In the opera world as well as some other areas of the arts, the stars earn many times the average income. Here labor costs can be a much larger portion of total costs than in other art sectors that don't have super stars, and so the effects of the cost disease are particularly intense. Moreover, the incomes of the stars rise faster than average incomes.[22] Because there is usually only room for a few stars (due to the before mentioned limited star capacity of consumers) their relative incomes can be extremely high. Therefore, the proportion of labor costs per unit of consumption rises as well. This means that the cost disease dramatically affects the traditional performing arts where there is a star system in place, particularly opera.

In the case of structurally subsidized companies, donations and subsidies, on the one hand, aggravate the disease, but on the other hand, soften its effects. Because of the extra proceeds that come in from donations and subsidies, structurally subsidized companies can afford to pay higher wages, while keeping their prices relatively low. Moreover, governments usually only subsidize these kinds of companies on the condition that they pay 'decent' wages. For instance, governments demand collective bargaining agreements between employers and employees.[23] This means that labor costs are usually higher than in comparable 'commercial' or alternative companies. Therefore, on the one hand, the cost disease is more severe in the case of structurally subsidized companies. On the other hand, however, the government usually compensates the annual wage increases in the form of higher subsidies. Therefore, although the disease is unmistakably present its effects are felt less. *The malice of the cost disease is contained by ever-increasing subsidies* (thesis 58).

Whereas the income from governments and donors renders the disease

less malicious, in the case of established companies, low incomes, thanks to internal subsidization by artists and relatives, helps contain the cost disease in unofficial and alternative artistic sectors.

If the amount of labor per unit of consumption continues to go down in the industrial and agricultural sectors while it remains high in the arts, relative incomes would have to continue to go down year after year in order to contain the cost disease permanently. And, as noted earlier, incomes have gone down considerably and continue to do so.[24] Moreover, the growing significance of second jobs suggests that the limits of internal subsidization by artists and therefore of a further lowering of incomes from art have yet to be reached. Because artists are willing to work for low incomes, the cost disease has less effect on the arts than it otherwise would have. With normal incomes prices of art products would be higher and therefore the sector would be smaller. Only because of their willingness to work for lower wages artists can keep their jobs. It follows that the cost disease indirectly contributes to low incomes in the arts.[25]

When average economic productivity rises, certain sectors of the arts that depend more on volunteers and amateurs are less vulnerable. One has to wonder whether over time the rise of the amateur sector and breakdown of barriers that divide amateurs and professionals are going to emerge as some of society's answers to the cost disease. For instance, many professional classical music choirs and professional jazz big bands have already been replaced by amateur groups where only the director is paid. The existence of the cost disease has necessitated the slashing of labor costs, which has enabled these forms of music production to survive.

The basic remedy against the cost disease is by replacing labor with capital. This happened in the areas of technical reproduction in the arts. In the production of literature, of music on CD or the Internet, and of visual media like video, DVD, and television, relative labor costs are much lower than elsewhere, sometimes even lower than in the industrial and agricultural sectors. Therefore at present, there is no cost disease in these media. (And yet, the Hollywood mega-movie productions with their elaborate superstar system have experienced an increase in labor costs. It can be argued that eventually relative labor costs will rise in all other media as well. However, even if they rise, it doesn't necessarily represent an example of the cost disease.[26])

The analysis in this section leads to the following observations. On the one hand, *the cost disease contributes to the already low incomes in the arts* (thesis 59). On the other hand, *internal subsidization by artists relieves some of the effects of the cost disease* (thesis 60). *The star system among artists only aggravates the disease* (thesis 61).

7 There is no Limit to the Demand for Works of Art

Even if the three assumptions on which the existence of a cost disease rests apply, the disease is not always malicious. It's only malicious when *revenues grow insufficiently* to cover rising costs. In other words, if labor costs rise, but consumers are willing to pay higher prices to offset these costs, there may be a disease but it's not malicious. The arts can then continue to flourish despite rising costs.

The general notion is that consumers are not prepared to pay higher prices for live performance arts that cover costs. Consumers may instead prefer to spend their money on industrial consumer goods, which have become relatively cheaper over the years. Without subsidies, prices become too high and the live performance arts are threatened with extinction. It seems that these days real-time services in- and outside the arts have fewer chances of surviving in the market.

Nevertheless, not all real-time services have become extinct. Although there may be fewer house servants now than one hundred years ago, the willingness to pay for a prostitutes services has kept pace with rising prices. Psychiatrists, among other professions, have also managed to discover new markets in real-time services. Evidently rising costs do not necessarily lead to a decline in demand.

Available figures show that with rising income, per capita spending on the arts per head has steadily increased since the Second World War.[27] An increasing percentage of national income and the workforce is devoted to art.[28] This applies to both the fine arts and to art in a broader sense. Spending on live performances is no exception. For instance in the US, per capita expenditures on the performing arts as a percentage of disposable income has more than doubled in the period from 1975 to 1997. In Britain, in the relatively short period of 1980 to 1988 spending both on live art events and on cultural goods and services more than doubled in real terms. As a percentage of all consumer expenditure, the two categories both increased by 30%. In the Netherlands, per capita expenditures on the live performance arts rose faster than expenditures for other forms of culture, from television equipment to CDs. This means that increasingly prosperous consumers spend increasingly large sums on the arts.

In most countries, increased expenditures more then compensated for rising prices. Therefore, on average, the turnout per capita increased as well, but this doesn't apply to all forms of art. Whereas consumers attended pop-concerts more often, they went a little less often to classical music concerts, and attended the theatre considerably less frequently.

At first glance, this is not such an amazing result. When income levels

rise, one expects more spending for live performance arts. After all, art is considered a luxury and so when people have more disposable income they are likely to spend more on luxury goods. On second thought however, this does not apply equally to all luxury goods. Most art products – from performing art to literature – demand a certain amount of time from consumers.[29] And although well-to-do consumers may have more money to spend, they often have less leisure time to spend it in, because they usually put in long workdays. Therefore, it is more likely that consumers will be attracted to expensive luxuries that offer more satisfaction in less time. If this is true, rising income levels should lead to less rather than more demand for performing art. (The income effect then is negative.) But thus far, this has not been the case with the performing arts, although it is partly true in the case of literature. After all, in Europe the group of people working extremely long workweeks is relatively small, while increasingly many average income earners start to work part time and so exchange income for a shorter working week.[30] And even if consumers attend live performances less often because they have less free time, they tend to spend more per event and thus total spending can still increase.

The demand for art and other services like health care could well be infinite. Whereas consumers need only a limited amount of cars or television sets, there seems to be no limit to their demands for art and other entertainment. In terms of employment, this could be beneficial. Even though lower costs in the industrial and agricultural sectors continue to make products cheaper and cheaper, increasing public prosperity, they also offer fewer and fewer employment opportunities. This does not create unemployment however, because more laborers drift over to the labor-intensive service sector, which includes the arts. (Less than a quarter of the American workforce is still employed in the industrial and agricultural sectors. Therefore, what has been called a disease could just as well be considered a healthy development.

But the transition to a service economy does not always proceed smoothly. Many consumers in the 1950s and 60s must have found the variety and choice of inexpensive manufactured goods overwhelming if not downright disorienting. This rapid and sudden shift from service goods (including live art) to manufactured goods may have been a form of 'over-compensation'. Since then it took decades to come to a more balanced choice between services and manufactured goods again. (It can be argued that arts subsidies were needed to survive this difficult period.)

From this section we can conclude that costs in the arts rise but that revenues from sales rise as well. *In some areas of the arts the cost disease is not malicious because market revenues rise at a rate that is equal to costs* (thesis 62).

8 Changing Tastes Can Also Cause Financial Problems

People spend more money on art, but not on all art forms. In certain areas of the arts sales do not increase at the rate as elsewhere. The cost disease can cause the lower spending – higher costs causing higher prices and less demand – but changing tastes can also be responsible. In the first case, the cost disease causes a loss in competitiveness. In the second, consumer preferences have changed and so the art products that are no longer favored generate less revenue. It is only when lost revenues follow from higher costs and not from changing tastes, that the cost disease is malicious.

An example can illustrate the not-always-clear distinction between changing costs and changing tastes. Over the past fifty years, realistic portrait paintings that necessarily take a long time to finish have become far more expensive. Labor costs have risen considerably. During this same period, high quality professional photographic portraits have become much cheaper than painted portraits. Presently consumers purchase far more photographic portraits than painted portraits. This can, first of all, be explained by the increasing difference in costs and prices: photographs are generally cheaper. But it can also be explained in terms of a change in consumer taste. Consumers gradually began preferring the new product – photographs. The third explanation is that it is a combination of the two. In this context, it is important to note that costs and taste are not independent from one another. For instance, consumers may have been originally attracted to the lower prices of photographs even though they may have still preferred the painted portraits. Then with the ascendancy of photography consumers gradually became accustomed to the new products and began appreciating its artistic qualities. In the end, many consumers ended up preferring the photographic portraits. Tastes had changed. Therefore, changing tastes are probably more responsible for the present small size of the market for painted portraits than rising costs.

A *change in taste* can be interpreted in various ways, as the following example shows. Suppose people increase their consumption of recorded music and reduce their consumption of live performances. (1) The narrow interpretation is that *the existing consumers have changed their tastes with respect to existing products*. People gradually began going out less in the 1970s, and as a consequence attended live concerts less often while increasing their home consumption of music. In a broader interpretation, (2) *existing consumers change their tastes because of the introduction of new products*. Because CD quality was regarded as much higher than that of LPs, home consumption of CDs became more attrac-

tive and took the place of attending live concerts. Finally, in an even broader interpretation, (3) *average taste has changed because new consumers with new tastes have entered the market*. In this respect, thirty-year-old consumers, who attended classical music concerts in the 1950s, clearly had a different taste than today's thirty-year-olds. Today's thirty-year-olds certainly attend classical music concerts less often and pop concerts more often. Over time, the tastes of young people have changed. Because total spending is what counts for the success of any particular art product, it is the last interpretation of changing tastes that concerns us here.

Although people in the art world might see the cost disease as a natural disaster, it should be noted that the same technological progress blamed for the cost disease enabled many of the latest attractive art products. For many people CDs are a continuous source of pleasure. The same applies to art as seen on television, videotape or DVDs. These products have important qualities, which provoke changes in taste.

Because costs, prices, product quality and tastes change at the same times, it is impossible to delineate precisely the cost disease effects from the effects caused by changes in taste. Nevertheless, it is sometimes possible to arrive at a rough idea of the impact of changing tastes. From 1960 to 1985, most European governments helped maintain competitive prices for the performing fine arts broadly in line with those of other forms of live entertainment and the cinema. This was possible because governments used subsidies to compensate for increasing losses caused by the cost disease. Nevertheless, despite subsidization spending per capita on classical music concerts and theatre went down, while spending on pop concerts and other forms of live entertainment increased. Therefore, *it is plausible that the drop in spending on live classical music and theatre and their loss of market share is caused by changes in taste and not by the cost disease* (thesis 63).

Because, both arts-sector workers and politicians believe it's more just to subsidize the arts because of financial problems caused by rising costs than because of changing tastes, the distinction between financial problems caused by the cost disease and by changing tastes is more than just academic. In this respect, it should be noted that the presence of the cost disease itself does not necessarily legitimize subsidization. Even though house servants, prostitutes, or barbers continue to have to deal with rising labor costs, nobody would argue for their subsidization. This implies that only when other reasons for subsidizing the arts are already in place, the presence of the cost disease adds to these reasons. For instance, if governments want to raise income in the arts because low incomes are judged to be unfair, and the cost disease is perceived as the

cause of low incomes, then the need to subsidize artists' incomes becomes more convincing. The same applies when art has special merits that people underestimate and these merits are endangered by rising costs. Therefore, for politicians the cost disease strengthens equity and paternalistic arguments for subsidization.

On the other hand, if people visibly change their tastes and lose interest in certain art products, politicians are more likely to leave it up to the market. In this case, they probably consider subsidies as particularly meddlesome, more so than in the case of rising costs endangering the special merits of art. If the producers of traditional art products can't maintain consumer interest then too bad.

Therefore, it is understandable why rising costs are emphasized by the art world, while changes in taste are often played down. For instance, people working in classical music often prefer to ignore the fact that tastes have changed and that most people under fifty nowadays prefer other styles of music. They beg for assistance and get it because they have framed themselves as victims of rising costs. Evidently *the cost disease frequently serves as a panacea* (thesis 64).

Culture is never fixed and neither is taste. Art changes. Styles come and go. Therefore, changes in tastes cannot be ignored. *Financial problems in the arts seldom stem exclusively from rising costs; changes in taste are often more important* (thesis 65).

9 Pop Music has Attractive Qualities that Classical Music Lacks

In order for the cost disease to be malicious, tastes must be constant. In practice however, neither taste nor quality is constant. Moreover, they depend on one another. Because changes in taste are almost always accompanied by changing production techniques as well as new products with different qualities, changing tastes not only *cause* financial problems in the arts, but they also offer *remedies* to these problems. When new art products replace old art products, some art forms may fall into decline, but the arts as a whole survive.

The false notion of a constant quality in the arts rests on the view that there is no room for substitution in the arts; if new art products emerge they only add to the existing stock of art products. This notion is false. The proportion of total artistic output that society places in its archives is relatively small. The large majority of artworks, from visual art to pop music, have a short life span: meaning that it often ends up in the garbage between ten years and one hundred years after its creation. As shown in the illustration on page 53, of all the paintings that were displayed in the

Netherlands during the Golden Age, less than one percent have survived to the present day.[31] Even art that is relatively easy to archive, such as manuscripts, scores, plays, etc., has been forgotten or will slowly begin to fade in relevance. For instance, most of the music dating from the 1930s is seldom performed anymore. *For the majority of art, the demand withers over time; it is replaced by new art with different qualities* (thesis 66).

Often artistic areas initially regarded as low art, have gradually turned out to be innovative and are more competitive than older art forms. They threaten older art forms, through both artistic innovations and technical innovations. With new art forms comes new strategies in tackling the cost disease and thus costs per unit of consumption is lower, and so is the price. Therefore a lower price accompanies an altered and more attractive art product. In this respect, technical and artistic innovations are not independent of one another. This becomes particularly clear when we compare pop and classical music.

The introduction of electronic instruments and amplification has made pop music versatile. Live pop music is not dependent on a certain design of music hall nor on an audience with a particular taste. Instead, it can accommodate the tastes of the wealthy through performances in small venues as well as the average consumer through performances held in extremely large venues such as stadiums. Electronic amplification was probably introduced in much the same way as louder instruments were in classical music a few centuries earlier. Classical musicians had to make themselves heard at noisy gatherings, just as the first jazz and pop combos had to rise above the noise of the patrons of bars. Electronic amplification was the obvious solution. When electronic instruments were introduced, they inevitably led to new sounds and interesting new products. Artistic developments and technical developments, which were introduced to increase productivity, have stimulated one another.

The notion of artistic innovation accompanying technical innovation is particularly clear in the case of the human voice. Singers in noisy pubs could not rely on classical training. Amplification, however, obviated the need to develop a booming voice. On the contrary, the softest and most intimate sounds became part of the new musical styles. Individual styles of singing based on 'natural' voices could be retained and developed not only in small venues, but also in halls with ever-larger audiences. Thanks to amplification the personal characteristics of each singer's voice remained intact and could be appreciated by audiences. In this respect, a classical singer's options are far more limited because their voices have to fill the hall without any aid. A trained listener can certainly hear differences between Pavarotti's voice and Placido Domingo's, but these are incremental when compared to the differences between for instance Tom

Waits's voice and Stevie Wonder's. I believe that the individual voice, which, because of the innovations of electronic amplification, can also be heard in front of large audiences, is a major artistic innovation. It is probably the most important attraction of the new and successful musical styles.

The changes in the use of the human voice are part of a general shift away from composition-based genres in music to, as Tyler Cowen calls them, performer-based genres. At present, the most popular musical genres are all performer-based. "A performer-based genre, like rock and roll or country and western, transmits musical and aesthetic visions through specific music-makers. The specific interpretation is paramount."[32] When different musicians perform the same compositions the interpretations differ a great deal, much more so than in classical music. Singers with individual voices as well as musicians, who respond to their audiences in an original way, inspire their audiences. These kinds of performers best serve the need of consumers when we consider authenticity (discussed in chapters 2 and 5). These performers often also have a charismatic stage presence.[33]

From Romanticism onwards art consumers longed for authenticity. This makes the success of the new performer-based musical genres understandable. Even though these new genres are often viewed as 'commercial', in emphasizing authenticity they are more closely connected with the modern romantic notion of art with its belief in the autonomous artist than the classical genres. Personalities are essential to pop music; both on the provincial level of countless bohemian artists and on the level of the stars. Who could be more different than Robbie Williams and Kurt Cobain or Madonna and Lauryn Hill. (It is not amazing that even in classical music, although it's basically composition-based, performers increasingly become stars. More than before soloists and above all directors try to 'steal the show'. This is probably essential if live classical music is to survive at all.)

In pop music seeing one's favorite artist perform live contributes to a sense of being in tune with the artist. Therefore, it often feels like a unique and 'priceless' experience. Because many artists improvise while performing, their live performances have unique qualities of their own that often get lost on CD and even on television. Impressive visual effects add to this feeling. In classical music, on the other hand, the visual quality of a live performance is even more limited than it was one hundred years ago. It is not so difficult to understand why so many modern audiences prefer the more vivacious live performances of performers in new musical genres.

Since classical music not only has to compete with other live perform-

ances, but with superb CDs of the same classical music, audiences are increasingly disappointed with the performances, which pale in comparison to the same music on CD they can listen to at home. These CDs, in fact, are often command performances by world-famous orchestras that the average local orchestra cannot possibly compete with.[34]

Important people in the established art world often have problems with new products, new formats, and new tastes. According to them: 'Music loses complexity'; 'Watching television is not an aesthetic experience.' 'Culture and cultural tastes are becoming more and more superficial.' 'These new cultural products signify the gradual decay of culture.' For many people in the cultural establishment indulging in cultural pessimism appears to be attractive in itself.[35] These people also often have an interest in the status quo. Moreover, a person's artistic taste usually doesn't change very much after the age of twenty-five; when it becomes more difficult to get enthusiastic about new cultural trends. This explains why it sometimes takes a changing of the guards to get established aesthetic views replaced.

The arguments for and against cultural pessimism is a subjective matter. The increased variety of art products may or may not be viewed as a good thing or even as a manifestation of progress, but for many people, it is a blow against cultural impoverishment and cultural pessimism.[36] Less complex art works however, could be a sign of cultural impoverishment. Nevertheless, it must be noted that the intensity of an aesthetic experience seldom rests on an artwork's complexity.[37]

Quality is not constant in the arts. *The natural remedy of the cost disease in the arts comes from new art products and changing tastes* (thesis 67).

10 Subsidies and Donations Exacerbate the Cost Disease

Advocates of subsidies for the fine arts like to pose the rhetorical question what will happen when the government stops subsidizing the arts. The inevitable answer for them is that the arts will simply disappear. No sensible person could ever want this to happen. Therefore, the government must subsidize the arts. The arts, of course, stand for the fine arts, especially the traditional performing arts.

Fear of decimation or extinction is what contributed to the large-scale subsidization of the traditional performing arts that commenced shortly after the Second World War. Apparently rising costs made subsidization inevitable. Although the cost disease does not legitimize subsidization, it does strengthen the paternalistic arguments and equity arguments for the subsidization of art as well as the social justice argument, which

states that artists whose income is endangered by the cost disease need assistance.[38] This implies that *rising costs partly explain why the gift sphere is large in the arts* (thesis 68).

If politicians subsidize art because they are convinced that rising costs lead to low incomes and that rising costs threaten the special merits they believe art embodies, this does not imply that the underlying logic, that subsidies remedy the cost disease, is correct. It can be argued that donations and subsidies do not remedy the cost disease, but actually aggravate it.[39]

The natural effect of subsidies and donations is the partial replacement of an orientation towards the market by an orientation towards the government or donors. Whereas cost reductions straightforwardly contribute to one's market success, they often have little or no effect on being successful with government committees or funding organizations. Instead, contributions to 'quality' – as defined by government committees or funding organizations – are more important in assuring success. As noted before, often, the more opening nights a Dutch theatre production has the more successful it is deemed by government committees. Therefore, subsidization and donations can easily lead to a careless attitude regarding costs and can further hinder the development of new formats and products.

The orientation on government instead of the market is particularly strong when subsidies as a percentage of total income are very high. In that case the orientation on the government is simply a matter of survival. If the government subsidies suddenly stop coming, there are few alternatives but to give it up. Thus all attention remains focused on the issue of 'quality' because it's only when organizations manage to keep their product interesting in the eyes of government committees, that subsidies will continue to help offset rising costs. So there is little impetus to employ new strategies or develop new products to offset rising expenses.[40]

In this respect the *signaling effect* of financial assistance, whether it be in the form of donations or subsidies, cannot be ignored.[41] It reinforces the persistent notion in the art world that the quality of artworks must never be beholden to market forces and must always be solely based on aesthetic considerations. Because 'art is sacred and costs should not be an influence' assistance is demanded and given. In practice, financial assistance can be a license to ignore costs.

So, the scenario of an organization having to survive on less assistance should stimulate innovations that will cut costs, and subsequently should lead to more energy invested in the development of new products that might appeal to new audiences.

To assess whether this expectation might be accurate and to examine other long-term effects of subsidization on costs it is possible to compare countries with moderate levels of subsidization – Britain and the US – with countries with higher levels of subsidization, such as the countries of mainland Western Europe. In the Netherlands, Germany, and France, for instance, structural subsidized traditional performing art companies such as opera, theatre, music, and dance companies, receive approximately 85% of their annual income from subsidies. In Britain, comparable companies receive 45% of their income from subsidization while in the US it's less than 10%. When one factors in private and corporate donations the differences are less dramatic, but still substantial. The figure for the Netherlands, France, and Germany is still around 85 % (donations are negligible), for Britain approximately 50% and for the US approximately 40 %.[42]

On the basis of this analysis one would expect three types of differences between the US on the one hand, and mainland Western Europe on the other.

1 In the US and Britain lower subsidies, which are only partly compensated by higher donations, means a) higher ticket prices, and thus b) fewer people go to the traditional performing arts, and that c) the people that do go are wealthier.
2 There is more impetus to apply new cost-cutting techniques and product innovations in the subsidized companies in the US and Britain to keep them competitive in the market.
3 Mainland Western Europe's performing arts generally, including little and unsubsidized performing art as pop-music, is less competitive and that cultural imports are high, because unfair competition ultimately leads to a low level of innovation unsubsidized areas as pop-music.

Let's first look at prices as they relate to attendance levels. Given the relatively low level of subsidies and donations, one would have expected much higher prices for performances in the US than in Europe. But there is evidence that prices are not that much higher in the US. Because prices differ not that much and because in the US, spending per capita on the live performing arts is approximately 20 percent lower than in Europe, attendance figures per capita to the traditional performing arts in the US and Britain are also lower than in Europe. But this has more to do with taste than with higher prices. (After all, Americans spend less on the performing arts but also spend correspondingly less on art and culture in general. Americans prefer to spend more of their disposable income on other forms of consumption.)

Because the average ticket prices are not that much higher in the US the

average incomes of audiences are also not that much higher. In fact, it is safe to say that it is basically the same social class that regularly attends the performing arts in the US, Britain, and Europe. But because prices are slightly higher in the US and Britain, the same social class is prepared to pay higher prices. As has been demonstrated again and again, attendance figures of the traditional performing arts have little relationship to ticket prices; if necessary the audience is prepared to pay more. There is evidence that this attitude is not just limited to the US and Britain, but that so-called price elasticity is relatively low in other European countries as well.[43]

Therefore it is probably true that, in the long run, the effect of lower subsidies on prices, audience sizes, and audience composition is not that great. These kinds of results send out a caution signal against hasty and dramatic prophecies about the arts collapsing if governments gradually decrease their subsidy outlays. The degree of subsidization seems to have little effect on the demand for art products that are adversely affected by the cost disease.

The second prediction, that subsidies encourage rising costs by discouraging cost saving and the introduction of cost-saving techniques and innovations, is at least partly true. Direct subsidization in Europe is much higher than in the US and Britain. Higher American private and corporate donations only partly cover the difference.[44] Therefore, market-generated earnings of structurally subsidized companies comprise about 50% of total income in the US and Britain and approximately 15% in countries like France, Germany, the Netherlands, and Sweden.[45] A large disparity in subsidization incomes coupled with small differences in total per capita attendance figures and prices can only be explained by the fact that costs are higher in Europe. Performing art companies in Britain and the US are more successful in keeping costs down. Costs per visitor are lower because the average audience size per performance is larger and also because, on average, the same program is performed more often.[46] (In mainland Western Europe, performances of a successful opera, musical, play or concert held over for a longer stint are regarded with suspicion. 'When they come in droves, quality cannot be high.' Moreover, in countries where many performers still have permanent contracts such as the Netherlands and Germany costs due to higher labor costs are also higher than in the US.)

One would also expect more innovation in staging-techniques and products in Britain and the US, but this is not borne out by the evidence. In general, the introduction of new techniques like electronic amplification and video screens in the traditional performing arts, is seldom any more prevalent than it is in Europe. This goes for the introduction of

innovative new products as well. To Europeans, the theatre, classical music and opera repertoire in the US is considered relatively conservative. American production companies seem to be even more locked into a clichéd repertoire of reliable fare than they are in Europe. Whether this is true or not is open to debate, but in general, American innovation is no greater than it is in Europe.[47]

Our third prediction proposes that subsidies should inflate industry costs because of unfair competition within the industry. Innovation in unsubsidized areas is indirectly discouraged. Subsidies cause unfair competition and so increase industry costs. This is because some of the arts receive high levels of subsidies and thus increase their status, while monetary reward and even more status in the unsubsidized arts remains low, lower than in countries, for instance with a lot less subsidization. Therefore the incentive to innovate is also less in the unsubsidized sectors than in the corresponding sectors in countries with less subsidization. Pop music in general is more innovative in the Anglo-Saxon countries. Most of the contemporary innovations come from these countries. As far as costs and quality are concerned Europe in general cannot compete with the Anglo-Saxon countries. Europe, for instance, imports far more pop music than it exports. (More will be said about this subject in section 9.9)

The conclusion of this section is that, contrary to the belief in the art world that subsidies are the answer to the cost disease, *subsidization exacerbates the cost disease in the long run. Therefore, decreasing subsidies is the best remedy against the cost disease* (thesis 69).

11 Conclusion

Labor costs in the arts have increased more dramatically than in the general economy. A cost disease exists in the arts. Nevertheless, in most of the arts the cost disease is relatively unimportant or benign, because quality is not constant, technical progress is substantial, incomes are relatively low, demand continues to increase, and tastes change.

Among artists and in the art world in general, the notion of artistic quality being autonomous from cost and demand considerations is important. Gerald believes that the issue of electronic amplification should remain an artistic consideration and not one of how to increase your audience size. In other areas of the arts a taboo rests on quality changes. The space to experiment with new techniques and formats is limited and costs continue to increase almost without constraint. This implies that labor cost increases in the arts do not depend on the technical

qualities of art products; they are based on social attitudes that change over time. For instance, the current taboo on technical innovation in classical music and the obsession with authentic performance is a product of the times. In the past there were no such taboos and obsessions. These taboos certainly don't exist in pop music where new techniques not only produce cheaper live performances, but also performances attractive to a broader audience. Interesting new art products spawn new tastes.

Rising costs does not necessarily imply that the cost disease is malicious. With increased prosperity comes a willingness to pay higher prices for attractive art products. And regardless of whether this is a good or a bad development, artists are apparently prepared to work for lower wages, which in turn makes the cost disease less malicious.

At the same time, the growth of subsidization and donations was stimulated by fears that otherwise the cost disease would lead to unacceptably low artists' incomes. Moreover, if the cost disease were to decimate the established arts, their special merits, which people presumably underestimate, would also disappear. The desire to avoid this kind of scenario further fueled the growth of subsidies and donations. It follows that rising costs are part of the reason why the gift sphere in the arts is so large.

The art world's experiences with rising labor costs are not unlike those experienced by other service sectors, such as education and healthcare. The latter two sectors demonstrate that increased consumer demand can effectively render the cost disease benign. Consumers, who have enough of everything else choose to maintain an interest in education, healthcare, and art. Thanks to the productivity increases in the agricultural and industrial sectors, consumers have more disposable income to spend and are evidently prepared to spend it on educational and healthcare products, as well as on art. Thus, as long as art manages to change along with prevailing tastes and vice versa, the cost disease does not necessarily have to be a terminal disease.

Discussion

1 Nowadays outdoors classical concerts for larger audiences are increasingly electronically amplified. Can you explain why there are no electronically amplified classical concerts in halls that are much larger than the average traditional concert-hall.

2 This chapter suggested that a higher utilization of amateurs and a more flexible distinction between amateurs and professionals may in

the long run be one of society's answers to the cost disease in the arts. What is your opinion?

3 In the US, the performing arts receive fewer subsidies. More donations only partly cover the difference. Therefore market-generated income is more essential. Nevertheless, the performing arts tend to be just as conservative in the US as in Europe. Does this necessarily refute the theory that subsidization hinders innovation?

Chapter 8

The Power and the Duty to Give

Why Give to the Arts?

Serving Art

The other day Alex had a discussion with Robert. Robert makes installations. As far as their reputation in the art world is concerned, Alex and Robert are more or less on the same level. But as far as his career goes, Robert has chosen a different path from the one Alex has chosen. Robert has chosen a path with fewer financial rewards. He operates on the periphery of the 'avant-garde' circuit. Every so often an artist from this circuit is invited into the established avant-garde circuit and gains renown in the general art world as well. Although this happens only to a select few, Robert, without ever admitting as much, seems to be waiting for the call.

When they talk, Robert justifies his actions by personifying art. He 'gives his time to art'. He 'serves art'. He sets himself apart from other artists, whom in his view are 'betraying art'. 'Their solutions are superficial and cheap. They're not interested in art, so much as pleasing the art world.' (In Robert's circle pleasing the art world is an even bigger sin than pursuing money.) Alex asks him if art has interests. Robert says it does. Alex believes he is being sincere. According to Robert the interests stem from the legacy of art. Robert mentions some famous artists from the past he admires and who inspire him. At this stage in their discussions Alex always begins to feel a bit inferior and guilty, because he's not as familiar with the works of these famous artists as Robert is. Moreover, Alex has a difficult time seeing the relationship between these artists' works and Robert's work. But Robert thinks the relationship is evident. (Robert makes installations and sculptures primarily out of mud.) Nevertheless, Alex is impressed by Robert's willingness to sacrifice himself to art.

Earning Less by Spending More Time Working as an Artist

When Alex is employed as an economist, he earns about four times as much per hour as he does working as an artist. If he wanted to, he could easily spend more time working in economics, but he usually doesn't. And so it can be said that he gives to art what he could have earned had he spent more time in economics.

Although Alex would love to see himself as a selfless donor to the arts, Alex cannot deceive himself. He knows that if he spent more work hours in economics, he'd start feeling forlorn and end up paying up a price that outweighs the extra income. Moreover, sometimes Alex notices something else that shocks him. A reward he seems to get out of earning so little stems from how he exploits the very fact of his low income in relation to others. He casually makes people aware of his difficult financial situation and they usually respond with something like 'Gee, he must be a real artist; he seems to sacrifice everything for his art.'

Alex realizes that his gift to the arts is certainly not a pure selfless gift.

Helping the Poor Artist

Alex likes selling his work out of his studio. (Of course, whenever he does he makes sure to tell his gallery owner about it – well, most of the time, anyway.) Alex likes doing it even though some buyers seem to need endless amounts of time to make a choice, they drink too much tea, discuss their personal problems, and insult him by wickedly praising his work to the sky, etc. There is only one kind of situation Alex can't stand. That's when well-meaning friends and family members come to his studio. He usually does not sell a thing, and afterwards he feels depressed.

Personal feelings not only matter in dealing with family and friends but also with other buyers. For instance, Mr. R. is gay and he likes certain kinds of drawings of male nudes that Alex makes. Alex suspects that Mr. R. likes him as well. Meanwhile, Mrs. V. likes Alex's photographs, but she likes supporting artists like Alex even more. These types of situations are easy to handle. Both parties know the unwritten rules. Therefore, it's not difficult to close a deal.

With family members and friends it's quite different. Within Alex's social group there are no established rules for combining commerce and support. The old rules have disappeared and no new ones have taken their place yet. And this is why they get stuck.

Most of Alex's friends and relatives think that openly supporting him would be insulting – and in the back of his mind Alex agrees. Moreover, an open acknowledgement of the fact that they earn a lot more money than Alex does would only lead to unpleasant feelings of guilt. Both parties want to avert this situation at all costs. And so whenever they want to support him, Alex is not supposed to notice it or he has to pretend not to notice. This puts Alex and his family and friends in an impossible situation. Family and friends think that Alex will misinterpret any hesitance about buying an artwork as a sign that they're not really interested in his work and more interested in supporting him, which is patronizing and an insult. Therefore, they try to play a complicated game of charades that almost always goes wrong. In the end,

no deal is closed and family and friends leave Alex's studio frustrated, while Alex is left behind feeling just as miserable.

Why is it that Alex's family and friends, but also private citizens, corporations, foundations, and government agencies feel so compelled to support art and artists? And why do artists like Robert and Alex give so much to art? Do they make sacrifices? Or is it more proper to say that they pay dues (or duties) and are ultimately sacrificed?

In order to answer these questions it might be useful to look at gift-giving in the arts from the perspective of power and duty. I use the term 'duty' to emphasize that many 'gifts' are not free, but imposed by the own conscience, or by conventions. This chapter tries to establish the notion that donations and subsidies primarily rest on issues of power. But we will also look into the phenomenon that the obligation to give can restrict a donor's power to the point that donors can even begin to be perceived as victims. A continuum exists that extends from pure gift to pure duty. The gift is freely offered while the latter implies an obligation to pay, not unlike duties paid at national borders. Because the term 'duty' has a number of nuances such as one's 'duty to help', I shall apply this term to situations where the giving is not totally a matter of free choice.

Chapter 2 already made the point that the art world relies heavily on gifts. Gifts, including subsidies, are as important in the US as in Europe.[1] The present chapter's analysis of the gift, including an analysis of the benefits of gift-giving and the obligations to give, goes a long way toward explaining why there is such a large gift-sphere in the arts.

As an artist I believe that gifts to the arts are selfless and spontaneous. This applies not only to the sacrifices made by artists, but also to the gifts from donors. *As a social scientist, however, I emphasize the interests that are involved in the process of gift-giving. Generally, gifts are not all that selfless. They are a complex transaction characterized by various conventions through which the donors receive various benefits.*

1 Donors Receive Respect

There is extensive available literature regarding the gift.[2] By formulating and then answering some questions about gift-giving in the arts, I try to apply some of this literature's findings to the arts. I begin with some preliminary questions.

Who are the main beneficiaries of gifts to the arts? It seems apparent that art consumers and art producers both profit from these gifts. When an orchestra survives because of certain donations or subsidies, it's con-

sidered a gift to those who can now continue to enjoy the concerts as well as to the musicians who can hold on to their jobs. But by calling it 'gifts to the arts' I also suggest that art itself can be a beneficiary. Thanks to particular gifts art can continue to flourish. As noted earlier, art itself cannot actually receive gifts; only people can. But in line with the way people think and speak metaphorically, these donations can also be considered gifts to art.

Who are the benefactors of the gifts? Government agencies, foundations and corporations, private donors, the families and friends of artists, and last but not least artists themselves give substantially to art.

How important are gifts in the arts? Earlier, in chapter 2, I estimated that the arts receive approximately half of their income in the form of gifts, which includes subsidies. The contributions from artists, their families and their friends was not included in that estimate. When these gifts are added, the percentage is probably much higher. Gifts are anyway very important in the arts.

Do gifts replace one another? Gifts from various sources usually substitute and sometimes complement one another. In the US, government gifts comprise a much smaller proportion of overall gifts than they do in Europe. But private gift-giving is much more prevalent. This means that private gift-giving is a substitute for government gift-giving or vice versa. This also applies to gift-giving by artists. Artists' gifts are often a substitute for government subsidies and other donations. The average income of artists working in alternative sectors that receive little or no subsidies or donations tends to be much lower than in sectors that receive ample donations and subsidies.[3] By working for low incomes artists subsidize themselves and so give to art. This implies that government subsidies not only replace market income and donations, but also so-called 'self-subsidies'.

Sometimes, however, gifts tend to complement one another. This is the case, at least in the short term, in the so-called matching schemes. For instance, the government agrees to give to artistic endeavors by matching the funds that corporations and private donors agree to give. Or, in certain countries, subsidies from the central government depend on subsidies pledged by local governments or vice versa.

Is there a sharp line between gifts, market exchange, and forced transfers? These three forms of transfer, which were discussed in chapter 2, can be said to represent the corners of an imaginary triangle. Many of these transfers appear somewhere in between the three corners. For instance, a continuum exists between gifts and forced transfers. Donors are often compelled to give. When there is a distinct feeling of obligation, a donation stops being a gift and turns into a duty.[4]

A similar continuum exists between gifts and market exchange. Although gift-giving and trade are both voluntary, they differ in other aspects. Of the differences mentioned in chapter 2 the following are relevant in the present context.

1 Gift-giving is less of a quid pro quo than commerce.
2 Gifts are not based on a contract.
3 The benefits of gifts often derive from third parties rather than from the recipient of the gift.
4 There is usually more personal contact between donor and recipient.[5]

These are relative differences. None of the above characteristics is condition enough to warrant gift-giving or commerce. Only when the characteristics are combined can a transaction be seen as either closer to the gift-corner of the triangle or the market-exchange corner.

For instance, the presence of personal contact does not necessarily convert a transaction into a gift. On the one hand, when merchants make deals, personal contact sometimes plays a vital role. On the other hand, when large foundations give small grants to individual artists, it is usually based on details supplied on an application and there is often no personal contact involved. The aforementioned foundation grants are nevertheless gifts, because the gift characteristics on the whole are more evident than the market-exchange characteristics.[6]

Are gifts selfless? The existing literature on gift-giving generally emphasizes the element of reciprocity.[7] Gifts generate returns. In this respect, it should be noted that gifts do ultimately change the world. Without the gift the world would be a little bit different. For instance, when a rich patron donates an important painting to a museum it's character is altered. First, the patron usually enjoys the new situation and thus it represents a return for the gift-giver. Second, because of the gift people often have more respect for the donor which means another important return to the donor.

In the existing literature on the gift it is a common assumption that a gift's benefits sufficiently explain gift-giving. In this sense then, gift-giving is selfish rather than selfless. Therefore, viewed from the tenth floor, the behavior of donors can to some purpose be analyzed from the assumption that they seek rewards. This is the approach taken in this chapter. (If we look more closely however, many donors do not seem to be deliberately seeking rewards. Because of the habitus of donors, selfless and selfish behavior cannot be easily separated. According to the conclusions in chapter 4, the same can be said about artists.)

2 Donors Have Influence and are Necessarily Paternalistic

Do gifts depend on power? Just as everyone's purchasing power is not the same, there are also a variety of capacities to give or 'powers to give'. Some people simply have more resources and thus effectively wield more power to influence the world around them through their buying and donating patterns than others have. (Because the term 'power' is often associated with the abuse of power, the term probably carries a negative connotation for some readers. But wherever people differ, in sex, physical strength, wealth, cultural or social capital, power-differentials necessarily exist as well. This means that the possession of power is not necessarily a good or bad thing, and so the term 'power' can also be used in a neutral sense.)

Trading and giving both presume the possession of the means or power to trade or give and therefore. Somebody, who has nothing, has nothing to give and therefore no means to influence the world. This does not imply that all donors in the art world are rich. On the contrary, sometimes donors do not need much to be able to give part of it away. For instance, poor volunteers and poor artists evidently have enough time to give some of it to art.

Like consumers operating in the marketplace, donors can choose whether to give or not, how much to give and to whom. What they give to one, they do not give to another. If Bill Gates had decided to donate large sums of money to arts training instead of to an IT education program, it would have had dramatic repercussions for many people. Therefore, the wealthy donor's influence is much larger than a poor donor's. Metaphorically speaking, the former has far more votes than the latter. The same applies to the wealthy consumer who has more influence in the market than a poor consumer does.

Nevertheless, *the cumulative power of the masses to give* can be just as influential as *the power of the rich* to give, not unlike the purchasing power of the many can be more influential than the purchasing power of the rich as discussed in Chapter 3. In the US, the bulk of classical music and theatre donations comes from a broad cross-section of not particularly wealthy private donors. Similarly, the impact of the cumulative gifts of many artists with extraordinarily low incomes may well exceed the total received from other private sources. In other words, large numbers of small donors add up.

Donors in the arts can be said to have influence. Among other things, they influence the outcome of the various art world disputes. This becomes particularly obvious in the case of large donors. One example is how the Dutch government influenced the outcome of the dispute

between the traditional and avant-garde branches of the visual arts.[8] Meanwhile, in the US, the CIA has used its power in the past to promote American abstract art abroad as a symbol of American freedom.[9]

Both trade and gifts have an effect on the state of the world. For instance, in the production of concerts, orchestras manage to 'change the world' by 'buying' a certain kind of behavior from their musicians. Or art consumers can 'change the world', by purchasing certain CDs and not others or by purchasing tickets to specific events. Moreover, conspicuous consumption also changes the world by evoking respect in onlookers. Nevertheless, donations often garners more respect than consumption does. And so when donors enable musicians to go on performing or enable a local museum to purchase a certain painting, they not only directly change the world, but they also indirectly change the world by generating a certain amount of respect for their generous behavior. Donors receive attention, respect, and distinction.[10] The act of gift-giving makes people behave slightly differently towards the 'Maecenas'; they pay a little more attention and show a little more respect toward the donor. But attention, respect, and distinction are not qualities one can just buy directly. It is an indirect result of conspicuous consumption and even more so of conspicuous gift-giving.

Do gifts involve display? Respect for donors is a possible result but not necessarily a definite manifestation of gift-giving. In this respect, gift-giving sometimes resembles advertising. Advertising also supposedly alters behavior. Someone buys advertising with the hope that consumers will buy more of the advertised product. The way that advertising influences the competition between products and firms is not unlike how donors compete with one another, albeit in a less obvious and deliberate manner.

Gift-giving, like advertising, often depends on display. Whether a gift is displayed intentionally or not, gifts usually gets noticed, by the beneficiary but also by various observers. Therefore, gifts produce so-called external effects, just like advertising does. Observers cannot ignore the outward signs of gifts whether they be large or small. Observers respond to gift-giving like they respond to advertising. I call this a reciprocal effect because the effect is returned to the producer of the external effect.[11] The response to an advert is most likely increased sales, while the response to a gift is attention, respect, and distinction.

Both advertising and public gifts involve a certain degree of compulsion. People cannot always avoid their effects. (From the observer's point of view, some effects of both advertising and gift-giving are involuntary and thus more like forced transfers than like gifts. They can also be seen as compulsory collective goods, comparable to a sculpture in a public

space that cannot be ignored by the passersby.)

Are gifts paternalistic? Donors choose the destinations of their donations. In the arts, donors never spread their donations around evenly over the full spectrum of artistic endeavors. They pick and choose. Private donors in the US, for instance, give far more to traditional classical music and traditional theatre than they do to modern music and modern theatre. They have the power to do as they wish and it is in this way that these donors express their influence on American culture.

Sometimes the influence of a single donor has broad implications. The example of the Dutchman Joop van den Ende demonstrates the influence that a single donor can have. After Van den Ende sold off his television production company in 1999, he started to use the profits to support both 'serious' and 'popular' unsubsidized theatre in the Netherlands. The incomes of the lead actors and directors immediately began to rise, which consequently meant that the costs of publicly financed theatre also began to rise. Because the funds of public corporations did not rise, it became more difficult for them to pay lead actors and to continue to make fine theatre. Naturally, theatre makers began to think in terms of accommodating Van den Ende's wishes at the expense of heeding to government influence. Gift-giving had changed the Dutch theatre world.

Because of their selective influence, donors are necessarily paternalistic. Sometimes paternalism takes the form of a concern for groups of people who are thought to be unable to adequately take care of themselves.[12] For instance, some donors are convinced that certain people underestimate the beneficial effects of fine art consumption. As such, fine art is a so-called 'merit good', a good whose merits are supposedly underestimated. By gift-giving art prices are lowered, and so donors attempt to persuade people to consume more art. If their paternalistic strategy manages to successfully alter the public's tastes then this is a another return for the donors.

Donors receive returns in the form of influence; they influence other people's artistic taste or their influence leads to respect and distinction (thesis 70). *Donations and subsidies to the arts are necessarily paternalistic* (thesis 71). *The more powerful donors are the more chance they have of influencing other people's artistic tastes* (thesis 72).

3 Art Sublimates Power and Legitimizes the Donor's Activities

The respect that recipients and onlookers can offer donors is not without its limits. Therefore, whether donors are aware of it or not, they compete for a finite amount of attention, respect, and distinction, not unlike the

way firms compete for consumer demand. Sooner or later more distinction for one donor means less distinction for other donors. Therefore, by giving, but also by buying and other forms of public behavior, people with power display their symbols of power hoping to contribute to the maintenance and improvement of their position on the social ladder.

The sailor shows off his strong arms, the business executive drives a fast car, and the government parades its army. These are symbols, which refer to possible uses; the sailor can actually punch out an opponent while a government can kill its enemies. The messages are easy to comprehend. Most of the time however, power is symbolized in more indirect ways. Apparently, indirect messages are often more effective than direct messages. This applies particularly to gift-giving. More respect is usually accorded the more indirectly a gift displays the donor's power. Usually the indirect display of power is well served by art.

Art has always been a useful vehicle for the indirect symbolization of messages. This applies most obviously to the visual arts. The murals in palaces, churches, and town halls as well as the paintings in the mansions of the wealthy, which now inhabit our museums, all indirectly convey the power of the Maecenas who often commissioned them to donate to the church. These paintings often do so by alluding to situations from the past, to sagas or to myths. (Our modern art is thought to contain fewer messages, but I expect that in fifty years time people will have discovered that our modern art contained far more messages than we are aware of at present.)

Usually art does not symbolize power directly. Most of the time it symbolizes power in a sublimated form. Power is sublimated and the desire to wield power is often totally denied. In Christian iconography, a beggar may well refer to the powerful commissioner who donated the painting. Moreover, art itself – including modern art – is often an expression of sublimated power. On the one hand, it reflects power, because only wealthy individuals and institutions can afford to commission this kind of work and then donate it. On the other hand, art transcends power. Music, theatre, architecture and visual art will certainly not win any war, or dominate any stock market. Therefore, it is the ultimate expression of power, when the high and mighty can afford to say: 'I do not need to exhibit my army or my fast car; I have art.' Through art, patron, sponsor, and government can associate themselves with the sacred. Art's halo of sacredness shines upon them and, paradoxically, reveals their invincibility. Art merely suggests actual power like military power, taxation power, or financial power.

The fact that art is perceived as superfluous and useless serves to enhance this sublimation of power, which is not only manifested through

gifts to the arts, but also through art purchases and the conspicuous consumption of art products.[13] For instance, banks buy considerable amounts of visual art. The Dutch government spends almost as much money on the buying visual art as on subsidies for the visual arts.[14] (There appears to be a large difference between buying and donating. When governments or corporations buy art, capital is not spent, however, when they donate art they become poorer, at least in the short run. But the status of art can be so exalted that in the long run gifts may well contribute more to the prestige of the donor, therefore increasing rather than decreasing the donor's capital.)

Chapter 2 argued that the arts, in the form of objects, manuscripts, scores, etc., function as bearers of some of society's most important beliefs and values. Modern people worship the artwork made by their ancestors, the way other people worship their ancestors. Art stands for the accumulated past. It stands for the nation and for civilization.[15] Through art, donors can associate with the world of art and culture. It gives them prestige.

Art not only offers prestige; it also legitimizes. Consumers legitimize firms and voters legitimize governments, but only to a limited extent. A true proof of legitimacy often comes from a higher authority. Emperors and kings needed God's blessing. Since art has to some extent superseded religion, monarchies, governments, and corporations increasingly need art to legitimize their own existence.

Institutions facing little competition derive relatively little legitimization from buyers or voters. Therefore, they're often the ones trying the hardest to get legitimized by a 'higher' institution. The remaining royal families, state organizations, nationalized corporations, and private (near) monopoly corporations, all spend a relatively large amount of money purchasing and supporting art.[16] For instance, in 1998 the Dutch central bank paid an extremely high price for a Mondrian painting that was to be a gift to the Dutch people.[17] The extravagance of this gift corresponds with the notion of a monopolist who is seeking legitimization.

In the search for legitimacy, size and continuity seem to be of some importance. Older and bigger corporations do relatively more for art than new and smaller corporations. Usually the latter only recently gained their right to exist in the market and they therefore have less need for supplementary legitimization. In this respect, it would not surprise me if people who inherit money do considerably more for the arts than people who worked hard to reach their present level of wealth.[18] The first, who are born into wealth, need to legitimize their money more.

Also corporations, whose policies are criticized, are continuously searching for ways to strengthen their integrity. The fact that most major

tobacco corporations are larger collectors and supporters of art than other food industry corporations confirms the notion that art can strengthen legitimacy. Even well established banks, which do not appear to lack integrity, compensate for their involvement in the 'vulgar money business' by affiliating themselves with the fine arts.

Giving to the arts and giving art constitutes a display of power. This display often appears in a sublimated form (thesis 73.) *Moreover, gifts to the arts legitimize donors* (thesis 74).

4 Gifts Turn into Duties

In the preceding sections, I have emphasized the power of donors. Nevertheless, the power of donors can be limited by obligations, as I intend to show in this and the next section. Donors often feel obliged to give. When the power of donors becomes limited, beneficiaries often gain some power in exchange. This means that beneficiaries can then apply pressure on the donor. If this pressure is persuasive, then transfers can evolve into something totally involuntary; they stop being gifts and turn into forced transfer like duties, taxes, or even bribes. This type of forced transfer is quite rare in the arts. Nevertheless, gifts that are rooted in obligations are common. These obligations to give can either be weak or strong. Where gifts appear on the continuum that runs from free gifts to forced transfers depends on the degree of obligation.

When gifts are exchanged between people of equal power, customs usually prescribe giving. People have a duty to give. In this context, it is worth noting that the largest percentage of private giving does not flow from rich to poor, but occurs between people from the same income brackets.[19] Within these groups, the continuous giving of presents and assistance is rooted in important conventions that fuse gifts with duties. The donor, like the beneficiary, in this case, is neither powerful nor powerless.

In the arts, individual beneficiaries have seldom wielded much power, especially when compared to that of large donors. Nevertheless, the conventions of giving can be an effective force and the obligation to give can significantly limit a donor's power.

In the cases of duties and obligations, the threat of retribution always looms in the background, but actual punishment is rare. If any punishment is meted out, it usually originates with the donors themselves. In other words, they are self-imposed as shows from the following example. Often representatives of a local elite may feel personally responsible for the course of society and thus feel compelled to give to local art institu-

tions. The benefits they receive in return, like prestige, are usually not reserved exclusively for the donors, however. A community of donors, and non-donors among the elite all share in the benefits in the form of respect. Therefore, at first sight, it seems as if individual donors would be better off if they just stopped supporting the arts, and save their money, because they could still easily benefit from the continued donations by others. Nevertheless, considering prevailing social conventions, not giving can often end up being more expensive than giving. These conventions do not offer much leeway for those who prefer not to donate.

Conventions result from the collective internalization of values and rules with respect to giving. When conventions are effective, negative internal rewards – a bad conscience, for instance – are usually enough to control behavior. It's only in exceptional situations where social control and external penalties, such as ostracism from one's social class, come into play. This mechanism not only applies to private donors but also to administrators at corporations and government agencies.

Internalized rules are often passed on within a particular institution. Because the process of internalization at each organization and institution acquires its own character, each institution can be said to have a specific 'culture' or 'identity'. For instance, the character of a financial institution is quite different from that of a construction company. Unlike construction companies, banks have developed a predilection of generous giving to the arts. At the same time however, individual banks have each developed their own specific preferences in who they give money to based on subtle differences in their corporate identities. For instance, while most banks in the Netherlands collect so-called avant-garde visual art, the ING Bank (part of the ING Group) has for a long time now preferred to collect figurative modern art, even during a period when the bank received nothing but gripes for the choices it was making. To a degree, the collection reflects the identity of the bank and vice versa.

The situation of private individual and government agency giving in the US and in Europe is that in the US private individuals give more generously to the arts than they do in Europe. In Europe, government agencies 'give' more in the form of direct subsidies than in the US. The difference is an enduring one. Thus, we have the existence of different effective conventions and traditions of giving. Recent attempts in Europe to boost private and corporate giving have not been very successful at bridging the difference with the US.

Gifts to the arts can be duties, because failing to give can be punished (thesis 75). *Conventions explain an attitude of giving among private individuals, corporations and government agencies. Such attitudes can be contrary to individual interests* (thesis 76). *Conventions explain the*

differences in giving between corporations as well as between countries (thesis 77).

5 Donations and Subsidies are Embedded in Rituals

Conventions serve a purpose. Collective experience helps establish the notion that the benefits of certain conventions outweigh their costs. Therefore, when behavior stems from such conventions, costs and benefits are taken for granted. They do not need to be pointed out or verified. For instance: 'giving to art is good for banks and not giving is bad'. Moreover, this kind of conviction can turn into a self-fulfilling prophecy, producing its own benefits and penalties.

Why is it that in the Netherlands all the major banks support art and maintain substantial collections of modern and contemporary art? Does a bank undermine its standing in the industry by not collecting art? From the tenth floor, a bank's behavior can be explained in terms of a fear of appearing contrary, or as particularly uninterested in culture. This could be detrimental because all banks must compete and try to lure qualified higher personnel. An uncultivated identity that comes with not supporting the arts might make it an uphill battle to attract the proper personnel. Costs would certainly rise as a consequence of this image. Government agencies engage in similar competitive behavior. But it is doubtful whether bank management and government decision-makers really think this way. Meaning that it's much more likely that conventions regarding simple notions of good and bad are internalized, which basically compels managers and decision-maker to promote art as a necessity.

When costs and benefits are taken for granted and when it's considered taboo to question the rationale of donating to the arts or the rationale of punishing defectors, then donations and subsidies represent a form of ritual giving, accompanied by ritual punishment of defectors. In primitive societies, rituals almost always govern giving, and our society may not be that different.

In both primitive and modern society, those who do not abide by the rituals and conventions face inevitable social ostracism. In modern society, offenders are usually punished in a discreet manner within their own circle. When public figures 'go astray' however, they may face public pillorying and humiliation. In the seventies, there was the case of mr. Drees Jr., a slightly naïve Dutch economist and politician, who managed to draw some attention to himself.[20] He was an intense and sincere art lover. He was also a man of integrity with strong principals. He thought

that the poor were paying too much for the cultural consumption of the rich. When, as a politician he had made it clear that he meant to do something about this, no open discussion, but a kind of gossip with the description of him as some kind of 'cultural barbarian' arose. This not only killed his plans for cutting subsidies it also killed his political career. What is striking here is the power of just one phrase. No arguments were employed; his opponents used only this one phrase. In rituals, words often represent or conjure up basic irrational powers. This man was portrayed as cultural pariah, an enemy of art, comparable to being against Christianity in previous centuries.

Nevertheless, donors and governments do not support the arts out of fear of punishment. Giving comes naturally. Donors feel a sense of responsibility; gift and duty fuse. Giving is rooted in conventions and embedded in rituals. Although individual beneficiaries do not possess the power to extract 'gifts', they ride the waves of conventions and rituals. In this sense, the art world is often less defenseless and at the mercy of the givers than it presents itself. People believe that the sacred world, which art represents, is extremely vulnerable, that it needs protection and gifts to survive. But without any deliberate organization a lot of power has been invested in the conventions and rituals surrounding the arts.

Giving to the arts often follows from conventions and is embedded in rituals (thesis 78). *Because the arts are fostered by the power of conventions and rituals, they are not as vulnerable as they sometimes appear to be. Society gives to art and art 'takes' from society* (thesis 79).

6 Artists Give and Pay Tribute

Thus far, I have only treated some general aspects of giving in the arts. I have thus far ignored the essential differences in giving of the various types of donors. In the remaining sections, I will look at the distinguishing characteristics of giving to the arts by the various groups such as artists, family and friends of artists, other private donors, corporations, and private foundations respectively. I will discuss giving by governments in chapters 9 and 10.

Artists subsidize the arts. They do so by being prepared to work for low incomes and by transferring money from savings, inheritances, social benefits, social insurance payments, or non-arts or arts-related incomes to their 'art-business'. This scenario is comparable to a publisher who shuffles money from a profitable science fiction imprint into its unprofitable fine literature department.

Self-subsidization or internal subsidization can be substantial ele-

ments of the total subsidy picture. For example, non-applied visual artists in the Netherlands earn some 27% of their income from government subsidies and 73% from the market.[21] Subsidization therefore appears to be less than in the case of an actor who works in a structurally subsidized theatre company that receives 85% of its income from the government. But the picture changes however, if one acknowledges that Dutch visual artists supplement their (very low) average annual net incomes of 1200 Euro (in 1998) via self-subsidization.[22] If they supplemented it to the level earned in comparable professions, the 'gift' part of the income of visual artists could be as much as 95% or more and the market portion less than 5%.

It is doubtful however, whether all self-subsidies can be considered 'gifts'. In the common notion of giving, self-subsidies would not be considered gifts. Gifts involve an exchange between distinct entities, whether it be individuals or institutions, which basically means that artists cannot give to themselves, even if it is for the purpose of 'serving art'. The concept of the gift, then, needs to be broadened. On the one hand, this notion of expanding the definition would seem logical considering that the motivation of self-employed artists subsidizing themselves through low hourly incomes is basically identical to the artists who indisputably give to art companies through volunteering their time or working for low wages. On the other hand, because self-subsidies by self-employed artists are sometimes sound investments in future successes, it is more logical to treat them like any other business investment.

In order to resolve this issue, I follow the logic previously expressed in chapter 6 and divide self-subsidies into compensated and uncompensated categories. The compensated portion is an investment, not a gift. The portion not immediately compensated by non-monetary rewards and whose future monetary and non-monetary compensation is more uncertain than is common practice in business investments, I call 'donations' and I characterize as gifts. (After all, many undisputed gifts also generate uncertain future returns.) In my approach, these gifts remain part of the gift sphere and are added to the already large gift sphere in the arts. At the same time, it must be acknowledged that the line between donations and compensated self-subsidization is extremely unclear in the case of artists. Therefore, it is hard to assess the relative importance of these artist donations. As I made clear in section 6.13, I believe that an important part of internal subsidization, however, is not compensated and can be treated as gift giving.

When artists give, they influence the outside world, be it ever so slightly. As I've already noted, even poor artists have some capacity to give. Their talents, training, and experience enable them to make sacri-

fices, most essential of which is, of course, the sacrifice of becoming an artist. In this context, 'being poor' may in itself represent a form of power. Their very poverty enables poor artists to make relatively large sacrifices in order to continue their work as artists. Moreover, whether it's intentional or not, when they display this gift, as Alex does in the second illustration, they end up impressing people with their self-sacrificing behavior. As is the case with any gift that is not totally hidden, its display can lead to respect.

In the case of poor artists who have been unsuccessful for a long time, however, such returns are limited and often gradually vanish. Pity – a negative reward to most people – begins complementing and eventually replacing respect. Successful artists obviously have a greater capacity to give. And although most successful artists do not sacrifice themselves, they usually continue to give to art. Their gifts, in fact, generate respect and self-esteem.

It is likely that in making sacrifices artists have some vague notion of future returns in the back of their minds. Meaning that their sacrifices might eventually reap returns in terms of money, fame, recognition and personal satisfaction. The majority of artists, who possess little chance of ever being compensated, continue to nurture these expectations. Future compensation however, is so uncertain that the donations or sacrifices by the majority of artists cannot possibly be considered normal business investments. Moreover, because of the prevailing myths about the arts that continue to operate in our society, artists are for the most part, ill-informed. Artists give on the basis of misinformation. If this available information wasn't so misleading, artists would probably give less.

Looking at all this from the tenth floor, misinformation has the effect of turning donations into duties. By allowing themselves to be misled, artists do not end up sacrificing themselves, so much as being sacrificed at the altar of art. Nevertheless, given the habitus of artists, it is safe to say that sacrifice and being sacrificed amount to about the same thing. In this respect, the term 'tribute' is more fitting than 'duty'; artists pay tribute. Tribute implies the fusion of donation and duty and is experienced simultaneously as an homage and an obligation. By giving their time and money to art, artists pay tribute to art and more specifically to the accumulated body of work of their predecessors in the arts – the collective cultural capital of their profession. Because of their habitus, paying respect, as well as donating time and money, represent a 'gift' that comes naturally for most artists. (All this does not apply to the occasional rebel, however. For the rebel paying respect represents a clear duty.)

Most monitoring of donors in the arts occurs extremely indirectly.

This certainly is the case with artists paying tributes. Formal codes are unimportant.[23] Given their habitus, artists just 'naturally' stay in line. Behavior is based on a mythology that has become part of the habitus. Because of the myths mentioned in table 1 in section 1.8, behavior takes on ritualistic characteristics. For instance, the continuous sacrifice of the unsuccessful artist looks a lot like a ritual sacrifice. Viewed from the outside, it seems to be irrational. The ritual, however, imbues the sacrifice with a 'natural' rationale, which does not need to be verified. Moreover, when an artist becomes derelict in her duties to art, it seldom leads to punishment, because defectors are already so effective at punishing themselves.

This analysis of donating by artists also applies to art entrepreneurs and what I call semi-artistic personnel. For instance, small art book publishers are renowned for their internal subsidization; the same can be said of many of the other art intermediaries such as small impresarios, dealers, people who run alternative theatres, art spaces, etc. A whole world of people exists who spend an unreasonable amount of time and money on the arts, and in doing so, give to art in much the same way as artists do.

Self-subsidies and gifts by artists, semi-artistic personnel and small art companies help contribute to the already large gift sphere in the arts (thesis 80).

7 Family and Friends Subsidize Artists

Although the legal ties between artists and their partners, relatives, and friends have become less stringent, the presence of a personal union still matters when it comes to giving, and therefore it is useful to distinguish them from other private donors.[24] When partners, relatives, or friends give to artists, idiosyncrasy usually plays a role. The returns these people expect from giving often depend more on the relationship they have with the artist than on their relationship to art. Meaning that they support their partner, friend, son or daughter, and probably would not support another artist whom they didn't have close personal ties to.

As we observed earlier, a surprising number of artists still come from well-to-do families.[25] Parents, brothers or sisters support them, just like Theo supported Vincent Van Gogh. In the first place, family money can serve as a form of insurance. Youngsters are more likely to choose art and the prospect of extreme uncertainty, if they know in the back of their minds that there will always be someone with the means to rescue them if things go wrong. Moreover, many artists live off an inheritance. Or they

have parents who ended up paying far more for their children's art education than they would have paid for another kind of education. And after their children graduate, they often continue to cover their offspring's losses for many years thereafter.

Nowadays an immense amount of the total subsidies comes from partners. The practice of the well-to-do husband who pays for his wife's arts activities, which oscillates somewhere between career and hobby, has not altogether disappeared, but other arrangements have become even more important. Breadwinners, both male and female, now often finance the serious art careers of their partners. These include not just artists, but gallery owners, impresarios, and other intermediaries as well. Because in today's world direct financial assistance is sometimes a humiliating experience, as seen in the last illustration above, artists' partners often find less conspicuous ways of supporting them. For instance, they often basically institutionalize their assistance by automatically paying certain shared costs such as rent or holiday costs.

Friends and colleagues, along with family members and partners, also give to art by buying art and going to performances, which they would not have done had they not had a personal relationship with the artist in question. As everyone familiar with the major Western art scenes knows, there are huge areas of unprofitable art activities, which are primarily frequented by colleagues and prospective artists and even more so by friends, partners, and families. Of the, say, twenty people present at any particular contemporary or experimental art performance or opening, most are certainly personally related to the artist in some way. The social costs and benefits of this circus of self-fertilization do not concern us in this chapter, but one way or another the bills do get paid. The deficit, after official subsidies have been incorporated, is paid by internal sources. Friends, colleagues, partners, and family members pay a considerable part of it.

The assistance offered by family and friends represents a clear case of how gifts are based on power as well as on duty. On the one hand, it's a matter of power, like in the past when powerful families had the resources to support artist family members, which, in turn, enhanced the family's prestige.[26] On the other hand, giving can also be seen as obligatory, because there are conventions in well-to-do families that convert support into a duty. While donors remain the more powerful party, beneficiaries are not powerless.

Although there are no accurate estimates, because of the large number of people involved it is plausible that *giving by families and friends to artists contributes considerably to the large size of the gift sphere in the arts* (thesis 81).

8 Private Donors Give to Street Artists as well as to Prestigious Art Institutions

Private donors operate on all levels and in all areas of the arts. For instance, a donor gives a nickel to a street artist as he or she walks by. Another donor works as a volunteer in a local theater. And a third donates an entire new wing to a museum. It is a pity that there are no accurate estimates of how much people give to street artists, but if we take into account the number of street artists who can make a living from their art, the total amount must be substantial. The same applies to volunteerism as a gift.[27] Even when we omit these two forms of giving, private American and European giving is far more important than corporate and private foundation giving.[28] (That is if we ignore corporate sponsorship, which is more of a market transaction than a gift.) *The gift of private donors to the arts adds substantially to the importance of the gift sphere in the arts* (thesis 82).

For the person who gives to the street artist the main return is probably the artistic product itself.[29] If donors like the product, they appear to give 'spontaneously' to support that product. Nevertheless, it is more appropriate to say that conventions help dictate that they give naturally.[30] Gifts to street artists bring returns but so does any private gift to the arts. This does not mean that individuals or corporations are deliberately seeking returns. Just like artists, donors are neither selfless nor totally selfishly interested in reaping rewards. (The sections in Chapter 4 that dealt with 'selfless' artists and their habitus also apply to 'selfless' donors.) Nevertheless, to simplify and reiterate a little, the behavior of donors, like that of artists, is oriented towards returns, which includes internal rewards.

For rich donors the rationale of giving to the arts is often embedded in philanthropy as a social institution.[31] Philanthropy often plays a role in more general notions of how society should be organized. In the US, one notion is that the government should not be overly influential, which means that citizens should assume as much responsibility as possible, which includes the act of giving. Moreover, philanthropy can be a way of life. It binds group members together and differentiates them from other social groups.[32] Having a group identity leads to distinction.

Anonymous philanthropy remains a rarity. Low profile giving is more common. The fact of one's donations to art are sometimes selectively announced.[33] This often adds more to one's esteem than a messy display of one's wealth.

The returns for small donors are usually not limited to themselves. Small donors share many returns to their gifts with non-donors. But a

small part of the returns is usually exclusive. As in a market transaction, donors often 'buy' some exclusive rights, like special mentions, free seats, VIP treatment during performances, a journal only for donors, all benefits that are all especially geared toward 'The Friends of the opera, museum etc.'. Therefore the donation plan contains some aspect of market exchange and the largely symbolic exclusive returns seduce donors into continuing to give.[34]

Conventions that make gifts partly obligatory exist on all levels of assistance relationships. This applies as much to giving to street artists as to the philanthropy of the wealthy. 'People should do their share' is a convincing argument, in- and outside the arts. Therefore conventions make gifts fuse with duties.[35]

9 Corporations and Private Foundations Support Art

The corporate financing of the arts receives a lot of publicity, to the point that it looks like the arts are almost totally beholden to it. In the US, however, corporations give less than foundations and they in turn give considerably less than private individuals and far less than local, state and federal governments. In Europe these differences are even more extreme because corporate philanthropy is negligible.[36] In Europe, government giving as well as private giving are most important. Given the publicity their generosity receives, corporations and foundations have managed to spotlight their generosity. This is hardly amazing. Because they are the most clearly oriented towards returns, they display or advertise their generosity more than other categories of donors.

As is the case with small private donors, corporate donations are a combination of market exchange and gift. Market exchange occurs when the donor receives exclusive returns, as stipulated in a contract. Sometimes the contractual returns – as in, free tickets or other perks, for instance, – are so important and so little of the donation remains that 'donors' are more consumers than they are gift-givers. This applies to almost all aspects of today's corporate sponsorship plans. Sponsorship means basically trading advertisement rights which makes the gift part inconsequential.[37] In other words, there is no actual philanthropy involved. Nevertheless, because of the attractive status that is accorded the gift, such terms as 'sponsorship' and 'donation' are applied to veil the true nature of these commercial transactions.[38]

Corporate philanthropy is common in the US; in Europe it is almost nonexistent.[39] Nevertheless, the motivation of corporations to give to the arts, to sponsor art or to buy art appears to be largely the same.[40] The

success of the promotion of the name or corporate logo is the most important return.[41] Non-monetary rewards are also significant factors for the various CEOs and upper levels of management. Surprisingly, personal contact with the artists involved is often an important aspect of these rewards. The face lift of a bad corporate image was mentioned in an earlier section as a reward. The same applies to the goal of increasing the legitimacy of one's organization through its association with the arts.

In the case of private foundations or funding agencies it seems that imago and prestige cannot be a driving force for financial support as the main benefactors, who could benefit from them are long dead. But, as in corporations, prestige also goes to the present management and the higher employees. Moreover, foundations need the legitimization art donations can offer them, exactly because there are no living heirs (or shareholders or consumers) who these foundations can report to.

Most donors find advertising their generosity an essential ingredient of gift-giving. The details may be disseminated in a muted or dignified manner or they can be ostentatiously publicized on television and billboards. Either way corporations, foundations, and government agencies enhance their identity and increase self-esteem and respect. In other words, it improves both their internal and the external imago.

The majority of rewards reaped by corporations or foundations do not come directly from the artist or art company beneficiaries but, as was noted earlier, from an elaborate tangle of vague and indirect sources. Corporations, foundations, and government agencies, increase their status and image via their connection with sacred art. Moreover, in capitalizing on the 'higher authority' aspect of art they also legitimize their own existence.

At the same time, as we showed in the first half of this chapter, corporations can also feel compelled to give because of existing conventions and public pressure. It is often difficult to tell where gifts that reap profits end and costly duties begin.

10 Conclusion

Giving to the arts is an attractive feature for most donors; otherwise they would not do it. The aura of the arts shines upon them. Donors like corporations and government agencies, get attention and respect and their association with the arts legitimizes their power.

Although donations usually produce rewards, not-giving can also produce negative rewards. The giving is then more or less obligatory where not-giving is a punishable offense. Because obligations are rooted in con-

ventions, giving usually comes naturally. Otherwise, one's lack of generosity is often a matter that is self-punishable through appropriate guilt tripping and having to deal with a bad conscience. Only very rarely punishment comes from outside, as has been the case with politicians who after openly challenging the rationale of art subsidies have been stigmatized as philistines. The taboo against publicly challenging the wisdom of subsidies demonstrates that giving to the arts is embedded in rituals.

Gifts are primarily associated with donations that come from outside the arts, but a large part of giving in the arts takes the form of internal subsidization. Artists continuously donate money to their art careers. The money usually comes from a second job, savings, an inheritance, social benefits, insurance payments, or just living a Spartan lifestyle.

When artists, like Robert and Alex in the first two illustrations of this chapter, give to art, do they sacrifice themselves or are they sacrificed at the altar of art? Robert and Alex do receive certain rewards for their gifts. At the same time they are obliged to give. Not giving is a punishable offense. However, given their habitus it is more accurate to note that artists are inclined to give. Existing myths maintain this status quo. In the case of artists like Robert and Alex, gift and a sense of duty, sacrifice and being sacrificed, all blend together.

The analysis of gift and duty in this chapter plausibly explains why there is this inclination among various social groups and institutions to give to the arts, which in turn, helps explain why there is such a substantial gift sphere in the arts. Of these groups, governments certainly have a very strong inclination to give to the arts. Why however, governments give so much, is not immediately clear. The next two chapters will attempt to explain government subsidization from the power-duty perspective.

Discussion

1 Could you defend the statement that donors are more selfless and less oriented towards rewards than we have suggested in this chapter?
2 On the one hand, it can be said that the support of art by a bank serves to enhance the bank's identity and imago. In this sense, giving is an expression of power that may eventually lead to a competitive advantage. On the other hand, it can be said that competition forces a bank to support art. Support is evidently an obligation or a duty. A failure to support art can result in severe punishments as it may ultimately endanger the very existence of the bank. How should this apparent contradiction between power and powerlessness be interpreted?

Chapter 9

The Government Serves Art

Do Art Subsidies Serve the Public Interest or Group Interests?

Opinions on Government Support for the Arts

Alex asked some friends why they think the government supports the arts. Paul, a composer of contemporary 'classical' music, observes "I don't think there would be modern music without government aid". When I remind him of the existence of pop music he is embarrassed. He probably wanted to say that pop music is not real music, but he doesn't. Instead he talks about the great classical tradition. "I think it is absolutely necessary that it continues. And consistent renewal is the only way. I strongly believe that in the long run innovation is in everybody's interest. But even those who love classical music do not seem to be that interested. I hate to say this, but people don't even know what's good for them. And so the government has to take responsibility. And not supporting or not supporting music enough is not only shortsighted; it's also extremely unfair. Even with subsidies I earn very little and so bear a large part of the costs of my own artistic work. Without any support, artists like me would carry the full burden of the costs of the little innovation that still remains. I think it would be very unfair to stop subsidization."

Peter is a visual artist who works in the 'fringe' avant-garde circuit. He just manages to eke out a living and continues to make his art because of the availability of all sorts of small subsidies. As long as he can do his own thing, he doesn't consider his low income as unfair. "It is the price I pay. But I do think society should also pay a price. Art comments on society and has values that are independent of market value. I think it's the duty of artists to offer critical commentaries through their art – also on the influence of the market and the role of money in society. But one cannot expect people to pay for painful comments. Therefore, society should furnish a free haven for art outside the market." For Peter this is the raison d'être of subsidization. "If subsidization were stopped, art would become overwhelmingly commercial and lose its sting. In the end, society would emerge as the real loser."

Anna is an art administrator. As a civil servant she worked for a government body that issues subsidies to artists. Now she is running an art festival,

which is almost solely funded by the government. "I must stress how disastrous stopping subsidization would be for the arts and for society at large. Entire aspects of culture would just disappear. I think there would be no serious theatre and music left. This must never happen. It is in the interest of society that the arts flourish. This applies to traditional art just as much as to modern art. It is my viewpoint that society's willingness to let the government support the arts reflects the degree of it's civilization. And talking about civilized people, I must add two things. Firstly, the government has a duty to help poor artists, and, secondly, it must see to it that art is accessible to the poorest of its citizens. High prices for performances and museums are an assault on humanity. I really want to emphasize that subsidies should keep art affordable for everybody." Alex objects at this juncture and points out that low prices do not stimulate the attendance of low-income groups. "You are absolutely wrong," she says. "I personally know several people with little education and very little money, who attend classical theatre and music. And above all, it is the principle that counts."

Martin owned a number of factories that produced a certain brand of dairy products. He retired early. Now he collects art and he goes to concerts. He loves the opera above all. "It's a pity I did not discover art earlier. I would loved to have set up a visual art collection owned by my company and bearing the company name. Modern art, of course. But paintings that could be appreciated by my employees. It is not impossible, you know. About your question: I've changed my mind about subsidies. I'm now on this committee to recruit donors for the National Opera. Do you know how much a visit to the opera costs? At first I could not believe it myself. It's about twenty Euros per ticket. But actual costs would make the price around four hundred Euros.[1] It could be even more if you consider the many free tickets – I get free tickets, of course. So you can work it out; without subsidies, prices would have to be raised by about two thousand percent. Nobody, well, hardly anybody could pay those kinds of prices. We are trying to get more private donations. But it is more difficult than I expected. We will increase our revenues by about one or two percent, but not more. Without subsidies, the opera would disappear or it would become an extremely elitist affair." Alex adds that in his opinion it is already an elitist affair. "Oh no, think of all the students who come. And you know who I saw there last time? Auntie Sien from the Jordaan; she cleans my house." (The Jordaan is a former working class neighborhood in Amsterdam.) "Well of course, she's an exception. In general, people have no idea how much they could benefit from the arts. People must be educated. Therefore, art should be affordable. But I tell you, if I were still in business, I would really hang my Rob Scholte paintings in the canteen. We can't leave everything to the government. We should all contribute to the good cause."

Jonathan – Alex's personal favorite – works in the bakery around the corner. Alex happens to know that he occasionally goes to one of those mega-pop concerts that take place in football stadiums. But other than that, Alex never noticed that he was much interested in art. "Art? That's for rich people," he says. "Well, not for all rich people, of course. Some go in for different stuff. But I think the queen and the people around her like art, and the ministers too. And all those people who live along the canals and in the Concertgebouw area, I am sure that most of them fancy art." (The Concertgebouw area is an upscale neighborhood in Amsterdam next to the well-known concert hall.) "And I can tell you that those people have their ways. Yeah man, they know how to get stuff cheap. Well, maybe not cars and horses, but something like culture; that's easy for them. All these people know each other. And they have friends in the government. Actually I can't blame them. It's only natural. Everybody tries to get the best. They happen to get a little bit more. But I don't care."

According to Paul, Peter, Anna, and Martin, the government supports the arts because it has a duty to do so. Without subsidization, society would be worse off. Art serves the public interest and therefore the government serves art. This is the *public interest explanation* of art subsidization. Jonathan, however, has an alternative explanation. He says that influential groups who profit from the government support of art pressure the government to support the arts. The government serves art because it is forced to do so. This is the *rent seeking explanation* of art subsidization. In the following chapter I will add a third explanation: the government subsidizes the arts because it has an interest in art. Art serves the government. I call this the *government interest explanation* of art subsidization.

These three explanations correspond with different positions on the gift-duty continuum presented in the previous chapter. It involves three different views of the government. In the first explanation, the government is selfless, it has an obligation, but it is not under any pressure to give. Government subsidies are located at intermediate positions on the gift-duty spectrum. In the second explanation, the government is forced to pay duties. Such duties are located at the duty-end of the gift-duty continuum. In the third explanation, the government is a powerful donor; it gives to the arts and it receives rewards for giving. It has an interest in these returns, in other words. This explanation is located at the gift-end of the continuum. In this chapter, I will examine the first two explanations. Both fall under the heading 'the government serves art'.

In Europe, approximately half of the registered gifts to the arts comes from the government. In the US it's a quarter, while Britain is somewhere

in-between.[2] (Taking into account tax deductions, government spending on the arts per capita in the US is about half of that of Europe.) Compared to other sectors, the size of the government gift to the arts is extraordinarily large in Europe as well as in the US. The large government gift needs some explanation. Because a substantial part of the total gift for the arts comes from governments, its explanation will also contribute to the answer to one of the main questions of this book: why is the gift-sphere so large in the arts?

In this respect, the present analysis treats many more aspects of government involvement in the arts than direct subsidization. For instance, even though not all of the figures are known, the analysis also applies to tax deductions on gifts to the arts, regulations that channel lottery money towards the arts, and money that flows from public broadcasting and public universities to the arts.[3] These are indirect forms of subsidization. It also comprises government purchases of art, regardless of whether these can be considered gifts or not. For instance, the government buys paintings for public museums as well as for government buildings.

As an artist, I see many reasons why it is in everybody's interest that the government supports the arts. I agree with Paul, Peter, Anna, and Martin that art often contributes to society for free. Without subsidies, these kinds of contributions would become smaller and ultimately just disappear. Moreover, I also believe that art is good for people, even though they might not realize it. Therefore, inexpensive subsidized art is necessary to persuade people to consume art. And the government must keep art affordable for everybody, because it would be unfair if poor people could not consume art. And lastly, the government must subsidize the arts to prevent artists from starving.

As a social scientist, I have no opinion on the artist's reasons why the government should support the arts, but I do not see how they can explain the current high level of government support. I am inclined to think that *art world pressure applied to governments helps increase subsidies.* Moreover, I become increasingly convinced that *the government supports art because it needs art.* This view is examined in the next chapter.

1 Art Subsidies Need Reasons

In answering the question of why the government supports the arts, Paul, Peter, Anna, and Martin, all give reasons as to why the government should support the arts. They evidently think that reasons referring to

the public interest explain why the government supports art. They, and many others, assume that the explanation lies in the legitimization. This is a fallacy, however. There is an extreme and artificial example of this. Even if, with hindsight, one agrees that the construction of the palace of Versailles served the public interest, it is not public interest but the private interest of the Sun King, Louis XIV, that explains why the palace was built. Without the latter there would have been no palace.

Although explanation is not directly attributable to legitimization, the two are often related in modern society. Legitimization is irrelevant only in the cases of two opposite, extreme situations. First, legitimization is irrelevant when all of a government's orders are handed down directly by an absolute ruler like the Sun King or when a single 'lobbying' group completely controls government policy. Legitimization is also irrelevant in another hypothetical situation: when a particular government works like a computer and is able to detect and subsequently carry out all of the populace's demands and is automatically able to convert them into policies that serve the public interest. In reality however, these extreme situations cannot exist. Instead we have situations that fall between the two extremes and here, argumentation and discussion become increasingly important.

In a democratic society, lobbying groups can only get subsidies, when they effectively argue that government subsidies will serve the general public. This is a prerequisite for subsidization. Nowadays, anybody who wants something from the government, whether it be the king, fishermen, truck drivers, surgeons or artists, argues that their plans are in the public interest. However disingenuous these arguments may be, if they are temporarily convincing, they can lead to government support. Therefore, it is not only the pressure of lobbyists that explains subsidization but also their reasons.

Government is not a populist mechanism or a blind machine that automatically serves the general interest. Instead, government officials feel an obligation to serve the public interest and so they listen to the arguments of various groups who try to convince government officials that their particular plans would better serve the public interest than other plans. The arguments involved can come from political parties, social scientists, civil servants, as well as from various lobbying groups. And so, when specific arguments are convincing they contribute to art subsidies, even if these arguments can be proven false. Therefore arguments can, at least partly, explain art subsidization. Nevertheless, in the long run, the explanatory power of sound arguments is larger than that of false arguments. Therefore, in the following sections I will examine some common arguments in favor of art subsidies. If they end up being

predominantly false, it is likely that the rent seeking justification is more important than the public interest justification for art subsidies.

2 'Art Subsidies are Necessary to Offset Market Failures'

Because of art's aura many art lovers feel little need to legitimize art subsidies. A vague legitimization is often enough. Because art is thought to be sacred and 'good for mankind', the government has an obligation to subsidize the arts. And because of the mystique of art both the benefits of the arts for society and of art subsidization are obvious.

Since the sixties, however, the art world has been requested to specify the benefits of art subsidization. The request arose out of the development of a more rational approach to government expenditure that was instituted to control overall budget growth. Since then, a hypocritical morality exists when it comes to legitimization. On the one hand, the art world and the government cultural ministries continue to claim that the benefits of the arts for society are evident and beyond discussion. On the other hand, because bureaucrats in other agencies require more details, the art world and government cultural ministries eagerly welcome any argument that may help justify subsidization.

In response to these art world demands, economists have written numerous articles on the subject of the legitimization of art subsidies.[4] The art world embraced their arguments in favor of art subsidies. Any argument seemed welcome. This eagerness in the art world can arouse suspicions, however. Maybe the numerous new arguments help hide a bad conscience. Maybe Jonathan is right in looking for group interests in art subsidies.

The arguments in favor of art subsidies that economists and others have presented all refer to public interest. As noted earlier, a modern government's expenditure no longer solely serve the interests of a single individual like a monarch, or of a single group like the aristocracy; it must serve the public interest. The notion of public interest represents an important binding element in and around government institutions and in general society. Policy documents on the arts often contain the term 'public interest'. Civil servants and citizens both tend to evaluate government actions in terms of their contributions to the public interest. Meanwhile, art consumers, art companies, and artists seeking subsidies all directly or indirectly refer to the public interest as well.

The meaning of 'public interest' is not given and the 'best' way the government can serve public interest is a matter open to political discussion. Frameworks, however, do exist that structure the discussion. The

framework offered by *welfare economics*, a specialization within economics, makes the effects on welfare visible when it comes to markets without intervention and with intervention. This framework is apparently influential.[5] So the art world has welcomed arguments in favor of art subsidies that derive from welfare economics. Consequently, other arguments for art subsidies are sometimes also worded in welfare-economic terms, or otherwise they can be translated into these terms. Therefore, even though many fundamental objections can be raised against the welfare-economic approach, I shall use this approach to structure the discussion in this chapter.[6]

The fact that subsidies are provided at all implies the assumption that the government can do a better job than the market. Therefore the market is supposed to fail and so-called market failures are present. In the illustration, Paul, Peter, Anna, and Martin implicitly point to market failures in the arts. Their arguments are not unlike the welfare-economic notion that the correction of market failures increases welfare and serves the general interest.

First, the *merit argument* demands a correction because the market is indifferent to tastes. The market ignores the collective desire to correct 'incorrect' tastes and to educate people. Therefore Paul and Martin want the government to educate people through art so that people can develop 'better' tastes

Second, the *equity argument* demands a correction because the market does not produce a fair distribution of income. Paul and Anna's request that the government interferes to raise the low incomes of artists is an indirect reference to this argument. The same applies to Anna and Martin's demand that the government keep the arts accessible for people of fewer means.

Third, the *collective good argument* demands a correction because the market fails to produce goods and effects, like seawalls, that cannot be sold in the market. (This is market failure par excellence.) Paul, Peter, and Anna referred to art's free contributions that would barely exist without government support. They are indirectly referring to collective goods (also called public goods) and external effects, like for instance, an exciting cultural climate. 'See how much society would lose if the government were to stop subsidizing art.'[7]

These three types of arguments have – directly and indirectly – played a role in the political debate on art subsidies. They have often been successfully employed to help increase or at least maintain art subsidy levels.

3 'Art has Special Merits and must be Accessible to Everyone'

In the above illustration, Martin and Paul argue that art must be subsidized because people do not necessarily know what is good for them. People must be educated to become aware of the special merits of art. Martin is a well-to-do art lover while Paul comes from a traditional and a cultural family. They believe in the importance of art not only for themselves, but for others too. They feel responsible for other people and they worry about them. 'Many people don't buy art because they don't realize how good art can be for them. They must be convinced by low prices.'

People who care about other people the way Martin and Paul do often express their responsibility for other people in terms of gifts. (Martin gives to the opera.) But the market and private sector fall short when it comes to some people's desire to educate others. That's why the government steps in, to correct this market failure.[8] (Important donors were often the first ones to petition their governments with requests for art subsidies.[9]) People who don't buy art supposedly underestimate the value of art and so governments subsidize art to persuade these people to consume art. In this case, art is called a merit good. Merit policies are thought to serve the general interest because they eradicate market failures. When merit policies work everybody ends up better off in the long run.[10]

Art is a merit good par excellence. Sacred objects and activities are always thought to have special merits. 'Art has magical powers.' 'It can change people's lives.' 'It turns them into better people.' 'It heals.' These qualities are attributed to art either implicitly or explicitly. This may sound exaggerated, but if one listens to average art lovers discuss art, it is not. These kinds of conversations confirm the mythology of the arts that was presented in table 1, section 1.8.

In the past people were converted to Christianity under duress and in this manner became 'civilized'. Today art is considered a prerequisite for civilized people. *No western government wants to spread the gospel any more; they all prefer to spread art.* Art is a modern form of 'religion'.

As with religion, a necessarily elite point of view is involved. 'We know what is good for the common people better than they do themselves.' One group is enlightened; the other is in need of enlightenment. Some people decide for others. If the first group donates money to enlighten others through art, they do not donate randomly, nor do they support all forms of art. They pick and choose their preferred art forms. As was noted in the previous chapter, they have the power to choose and thus have the power to be paternalistic. This also applies to governments.

Subsidies derived from the merit argument are meant to 'change' people. Civilized tastes should be replacing uncivilized ones. Art with its

miraculous powers can do that. The aim of educating through art is twofold. The first aim is enlightenment for its own sake. Because people don't know what they're missing, they must learn to enjoy art. Art brings enlightenment. In a figurative sense, people are enriched by their exposure to art. The second aim of education through art is emancipation. Through education people increase their cultural capital and thus increase their opportunities. As they reach higher positions in society, they also literally become richer.

With both aims, the equity argument strengthens the merit argument. An unequal distribution of income is unfair, but according to Martin and many others, it is more unfair that poor people cannot afford art than not being able to afford a holiday in the sun, for instance. They see the merits of art as more significant than the merits of a vacation. Because they prefer to offer poor people low priced art and not tax deductions, which they can spend at their own discretion, the desire to change behavior takes precedence. The assumption, that art can improve poor people's chances in society and thus contribute to a more equitable distribution of income in the long run augments the argument.

This view basically states that when art is too expensive and thus unavailable, poor people are basically being denied their rights to an education and to an equal chance at bettering their lot. Art subsidies are both a matter of knowing what's good for others and are rooted in the notion of social justice. Unaffordable art is contrary to the notions of social justice, and so art people like Anna and Martin end up feeling guilty and indignant about high art prices.

4 The Merit Argument has been Used Successfully

The arguments about the educational qualities of art have been around for a long time; first they helped legitimize donations and later they justified subsidies. The specific reasons why people should be educated through the arts have varied however.[11] For instance, at the end of the nineteenth and the beginning of the twentieth centuries, socialists and liberals promoted the betterment of the working class. They were convinced that avant-garde art and 'art with a message' could change the existing taste of the working class who preferred low forms of entertainment.[12] In the period after the Second World War most political parties in western countries prescribed subsidized art to distract people's attention away from the new, successful and supposedly poisonous products of mass culture. Publicly financed broadcasting dedicated to culture was another outcome of this desire to civilize the common man.

After 1968, 'socially relevant' art was supposed to educate people.[13] Art needed to be 'diffused' among common people. These notions gradually became less important, until recently when socially relevant art became relevant again. The same applies to the notion of art education that recently began to reappear in the political debate in many countries including Britain, France, Germany, and the Netherlands as well as the US, where, after his inauguration, President Bush jr. proposed a 7% increase in NEA funding, earmarked for education.

The protagonists of art subsidies who think art should educate people have always been concerned about how accessible art is for the lower classes. Not unlike health care and public education, they have demanded that art be accessible for the lower classes. Centuries of collective action actually did lead to the eventual establishment of 'social rights' to health care, public education and social security.[14] In the 1960s and early 1970s, in a number of European countries, a movement consisting of artists, art administrators, and civil servants demanded a similar social right to art. These attempts failed however.[15]

In the discussion of art policies – in government reports and in parliamentary proceedings – the notion of an art policy that educates or 'civilizes' people has been a recurring theme for at least the past 150 years.[16] Evidently, the notion of art as an educational tool for people who show little interest in art is a common one. Nevertheless, the fact that the right to art never was actually instituted as a social right demonstrates that art is less essential for survival and emancipation than, for instance, health care and public education. However miraculous art may be, it is not an effective instrument for educating people.

In the case of the arts, the merit argument is false. It is false in terms of the argument's objective, in terms of alternatives, and in terms of the effectiveness of the proposed means. First, the objective is dubious. There is little proof that subsidized art enlightens or emancipates anyone who is not interested in art. The assumed benefits of art subsidies may very well be insignificant, nonexistent, or negative. Secondly, there are better alternatives. Spending on public education contributes more to education than art subsidies. Thirdly, subsidies are ineffective in two ways. Lowering prices has a negligible effect in persuading people with limited cultural capital to start to consume fine art.[17] The majority of art subsidies go to people who are already well educated. (So it's not so amazing that Anna and Martin can only come up with a few individual cases of a-cultural people who, because of the artificially low prices, occasionally go to the opera.) If the argument were to be truly analyzed one would have to admit that the already educated become even better educated and relative inequality actually increases; the net effect then is decidedly negative.

The fine arts advance distinction. They enable people from the higher classes to distinguish themselves from people lower on the ladder. Therefore, it is peculiar that the first should want to undermine distinction by desiring to use art to educate people and to promote equality. It could be used to veil other purposes. Even though education may be a genuine goal, its eventual failure is often welcomed just as enthusiastically because it proves that art is not for everybody and thus it reinforces distinction. This kind of double standard may well have contributed to various government art diffusion programs in several European countries in the 1960s and 1970s.[18]

Art subsidies based on the merit argument are, on average, ineffective or counterproductive; they do not serve the public interest (thesis 83). Therefore it is likely that other interests can hide behind the merit argument. Nevertheless, *the merit argument has enabled subsidization* (thesis 84). The argument has been used successfully to solicit art subsidies. Because of high art's mystique people look up to it and believe it has miraculous powers and thus agree that it must be subsidized.

5 'Government Must Help Poor Artists'

However miraculous art may be, it cannot fill an empty stomach. If the sole aim of art subsidies is to correct the income distribution among consumers, then they are in fact counterproductive. In general, poorer consumers are far better off when they receive a 10-Euro tax deduction to spend as they wish, than when through subsidization they – and everybody else – receive a 10-Euro discount on theatre tickets. After all, a cheaper theatre ticket doesn't really do someone who needs food, clothing, or medicine much good. Moreover, because the average theatergoer earns a relatively high income, the subsidy skews the distribution of incomes even more thus exacerbating economic inequity. Therefore, when Anna and Martin say that it is unfair that people with low incomes cannot afford to purchase art or buy performance tickets, they cannot say this just because of inequality, but because they believe art has special merits. They use the argument treated in the two previous sections rather than the equity argument. Existing inequality can only strengthen the merit argument.

Paul, Anna, and many others not only worry about poor people in general, but also about poor artists. (It is possible that they consider low incomes among artists less fair than the low incomes among the general workforce. Artists who make sacred art deserve even less to be poor than other workers. It's an attitude that brings up the merit aspect again.)

Governments are generally concerned about low incomes and thus sometimes aim a specific aid package at a particular group of workers or other social groups. This strategy can be more effective than general measures. For instance, fishermen who were adversely affected by an unexpectedly reduced quota have been aided effectively by temporary subsidies in the past.

After the Second World War, many European governments subsidized art and artists to help relieve their wretched financial situations. They focused their assistance on artists as a group. In the post-war period, the costs of art production, especially in the performing arts, rose quickly and people were worried about artists' incomes. Therefore, as I argued in chapters 5 and 6, the argument that the low incomes of artists must be corrected has played an important role in the growth of art subsidization after the Second World War.

The recent introduction of new strategies to raise artists' incomes shows that the equity argument remains important. Several European countries developed plans to improve artists' financial situations.[19] Sometimes these plans come directly from the ministry of culture. In other cases, governments prefer to keep their culture and subsidy plans separate and so the ministry of social welfare administers the subsidies.[20] (An example of the latter is the WIK plan in the Netherlands, discussed in chapter 6.)

Whereas the equity argument can be justified in the case of other workers, it cannot be in the case of artists. Aid is counterproductive because it actually increases the number of poor artists, as was shown in chapter 6. (In theory, distinct types of aid might work, if it was temporary and the government simultaneously limited the access to the arts through effective information campaigns and, if necessary, through an official limit on the number of people who can become artists. At present, this is not an option.) There are better alternatives in the struggle to alleviate poverty in the arts. For instance, a general income policy involving social security and general tax measures to assist the poor is more effective. Artists benefit more from these measures than other professionals do because they generally earn less and receive social benefits more often than other professionals do.

Art subsidies based on the equity argument that are intended to raise artists' incomes, are ineffective or counterproductive (thesis 85). Because these subsidies don't really raise incomes other interests probably hide behind the equity argument. Nevertheless, *the equity argument has enabled subsidization* (thesis 86). The argument has been used successfully to solicit art subsidies. Because of the mystique of art, people worry more about the low incomes of artists than of other types of work-

ers. Therefore, the public is usually easily won over to the idea that subsidies should be used to raise the income of artists.

6 'Art is Public and the Government Must Intervene to Prevent Underproduction'

In the illustration, Paul, Peter, and Anna point out that the arts provide free contributions to society. Because the arts don't receive adequate reimbursement for these contributions in the market, they count on subsidization as a guarantee against the under-production of art. To prove their case they invite us to imagine a situation without government subsidies. In this scenario, they see the arts as a much smaller sector and they see all the free contributions that art used to provide as largely drying up. Therefore, in their view most people would be worse off.

This is a collective good argument. Paul, Peter, and Anna hit at the core of the welfare approach to public expenditure: markets fail because the free contributions or benefits of the arts cannot be sold in the market. Because contributions are free, art products affect not only the well-being of people who pay for them but also of those who do not pay. Thus because of the free contributions art will be underproduced. This is market failure par excellence. (The implicit logic of the market that 'competition insures survival of the fittest', breaks down.) An obvious example of market failure is that people enjoy public sculpture or the beautiful facades of the mansions along the canals in Amsterdam for free. There is no market for these goods.

In many ways, art is public and free. The arts produce so-called collective goods and external effects.[21] If the view of beautiful sculptures or facades could be somehow marketed, people would be willing to pay for them. Since people cannot buy these goods, they could eventually become under-produced. In that case the government steps in and subsidizes art on behalf of its citizens.[22] This is the collective good argument.

This argument, furnished by economists trained in welfare economics, was employed intensively in the 1970s and 1980s to convince politicians and civil servants about the necessity of subsidies for the arts.[23] It is a 'textbook' argument that indirectly influenced policy-making. The collective good argument confirmed existing views on art deriving from the aura or mystique of the arts. It reinforced the notion of art as having a general beneficial influence in society. It also reinforced the idea that the arts are vulnerable. Without government guardianship the arts would wither. These are the kinds of ideas that have always played a role in public discussions on art subsidization.

Nevertheless, it is questionable whether the collective good argument is sound in the case of the arts. In this respect, two questions must be asked:

1 How important are collective goods and external effects in the arts?
2 Are they underproduced when there is no or less subsidization?

In the case of cultural collective goods and external effects that have a physical presence, like façades, public sculptures, church carillons, and street artists, there is little reason to doubt their existence. The majority of possible relevant collective goods and external effects are, however, not immediately perceivable and hard to pin down. In that case, it's even more difficult to determine their significance. These intangible collective goods and external effects are probably ubiquitous in the arts.[24] Nevertheless, economists tend to be suspicious of arguments based on intangible externalities. I don't agree. After all, the presence and value of these goods can never be determined 'objectively' other than through political debate.[25] Therefore, intangible collective goods in the arts can certainly be relevant, as the next two examples will reveal.

First, both the inhabitants and visitors of a particular town observe and enjoy its artistic or cultural climate. This climate is not for sale; it's a collective good. In this case the collective good is more than the sum of numerous external effects produced by various sources. The number of sources and their effects is so large, that it's impossible to accurately describe the collective good in any detail. Nevertheless, the climate it creates is important for the well-being of many people. It's free, enjoyable, and beneficial for such varied sectors as artistic innovation, design, shopping and tourism, and for the overall economic growth.

Second, the artists' innovations are often free.[26] Unlike most industrial innovations they cannot be patented. Therefore, once they are made public, anybody can use them for free, as long as the artworks are not copied exactly.[27] Both artists and the general society profits from these cost-free innovations in the arts.[28]

These kinds of goods clearly matter, they have value and are important – question 1; but will they necessarily be underproduced – question 2; when they receive much less or even no subsidization? Even if collective goods and external effects are important in the arts, is it possible that without government intervention they might still continue to exist?[29] The fact that collective cultural goods and external effects are ubiquitous suggests that they are not being underproduced. Apparently, non-market rewards exist that contribute to their production. Among others, gifts and internal subsidies represent rewards that keep the production of many collective goods and external effects in the arts going. The works of

street artists are a good example. Although these works are unmistakably collective goods, they are financed exclusively by private gifts from small donors. Moreover, storekeepers' associations, corporations, and large donors also subsidize activities that contribute to the cultural climate in a town. Above all, artists incessantly subsidize their own activities and thus contribute to the artistic innovation and cultural climate of a particular urban area.

When art consumers and art producers 'produce' external effects they often also receive indirect reimbursements. Because the façades of their houses along the canals are so beautiful, many Amsterdam homeowners receive indirect reimbursement in the form of prestige and are therefore happy to keep up their façades. In this context, all the returns of the gift discussed in the previous chapter contribute to the production of collective goods and external effects.[30]

Abolishing subsidies will necessarily alter and, to some extent, reduce the free contributions offered by the arts. But because subsidies are only one among many factors, that promote free contributions, the cutback doesn't have to be all that substantial. The savings may well outweigh the loss in benefits. For the most part there is little reason to assume collective goods and external effects will just disappear, as Anna and Martin suggest. Moreover, as has been noted earlier, donations and subsidies often complement one another. When subsidies go down, donations take up the slack or vice versa.

The dominant situation in the arts is one of overproduction and not underproduction.[31] Above all the willingness of artists to work for low incomes contributes to a considerable excess supply. In my view, the causes of overproduction are much stronger than the causes of underproduction. Therefore, although market failure due to the presence of collective goods and external effects undoubtedly exists in the arts, it is unlikely to cause substantial levels of underproduction.

The collective good argument for art subsidies is usually false (thesis 87). Because subsidies are ineffective, other interests must be involved. Nevertheless, *the collective good argument has sanctioned subsidization* (thesis 88). The argument has been used successfully to solicit art subsidies. Because of art's mystique, people believe that art has a general beneficial effect on society, which would be forfeited if subsidization was significantly decreased. Therefore, society consents to subsidies that are intended to maintain the free benefits that the arts provide.

There is however, one type of cultural collective good that is occasionally underproduced, especially in poorer countries. A nation's cultural heritage is what we hand down from generation to generation.[32] The willingness of future generations to preserve this heritage remains

unknown, while the present generations in the poorer countries often have different priorities. Because cultural destruction is irreversible, the price of 'underproduction' can be extremely high. Therefore, it can be argued that government intervention is often necessary. In wealthier countries, regulations are often sufficient to insure preservation. While most owners and consumers are increasingly willing to financially support their heritage, regulations rather than subsidies often effectively reverse the 'irresponsibility' of some owners. This has already been proved in the case of the mansion owners along Amsterdam's major canals.[33]

In the next two sections, I will examine in greater detail two particularly appealing aspects of the collective good argument.

7 'Art Contributes to Economic Welfare and so Must be Supported'

The argument most commonly employed in favor of art subsidization is that the arts are good for the economy. Even though the protagonists of art subsidies probably try to free ride on the general primacy of economic goals, the argument could be valid. Usually however it's not.

If the arts were to suddenly disappear in a particular city or a country, the economic effects would certainly be substantial. Basically, this is what most so-called impact studies measure.[34] The effects on employment in the arts and in areas related to the arts would be large, but the same could be said about any economic sector that suddenly disappears. Even when a heavily subsidized branch of industry that shows consistent losses is about to be shut down – like coal mining was in several European countries – impressive figures demonstrating their contribution to the economy can be produced. The arts also consistently show losses and are heavily subsidized. Proving that their economic impact therefore does not necessarily justify subsidization.

What needs to be demonstrated is the presence of collective goods and external effects, i.e., a free contribution to the economy derived from a market failure that could not survive without subsidization. It is first of all questionable whether there really are no markets for the contributions in question. For instance, people argue that hotels and restaurants in Amsterdam benefit without cost from the presence of cultural institutions like the Rijksmuseum and the Concertgebouw. But the opposite – cultural institutions profiting from the presence of attractive hotels and restaurants – is also true. Therefore this is basically a market relation in which no external effects are involved.[35] (In the case of unique events, like a festival that is produced every four years, external effects on the

local economy can be important. In this case, however, the economic benefits are relatively clear and some of those who profit are often prepared to sponsor the event.)

Sometimes the existence of assumed economic benefits is difficult to prove. Some decades ago, the expression 'art as a lubricant for the economy' was employed in the Netherlands. All sorts of miraculous national effects were attributed to the arts, from superior industrial design to happy factory workers. Again, these effects, if they do exist, don't need to be external and when they are external they may also develop without subsidies. The lubricant argument in relationships that involve other countries is more convincing. Art can accompany economic diplomacy, which means that foreigners impressed by a nation's culture may be more interested in its non-artistic products as well. In the next chapter, I intend to show, however, that such cultural diplomacy serves interests that go beyond the mere economic.

The argument that government must subsidize the arts because the arts contribute to the economy is usually false (thesis 89). Nevertheless, *the argument that art aids the economy has enabled subsidization* (thesis 90). The argument has been successfully employed to solicit art subsidies.

8 'Society Needs a Reserve Army of Artists and must therefore Support Art'

In order to support extraordinarily gifted performers and creative geniuses, society needs a huge pool of artist recruits and a correspondingly large number who will fail. Maintaining a large pond with many fish is necessary to catch a few big ones. Or, to invoke another metaphor, the higher you want the point of the artist pyramid to be, the broader the base should be. Without a certain high percentage of losers there will be no artistic geniuses.

The presence of large numbers of artists can be considered a common interest or common good. Because there appears to be no market for a large reservoir of unsuccessful artists, the presence of a reservoir is also a collective good.[36] In the view of many people, this collective good is likely to be underproduced if the government does not step in and subsidize the arts. This view has influenced many public debates on art subsidization.

This argument, however, is false. Again the presence of a collective good, in this case a large reserve of artists, does not automatically imply that without subsidies this collective good will be underproduced, i.e.,

that there will be too few artists. Because of forces external to the market, it is possible that the collective good is sufficiently produced without government intervention. If this book's claim that the arts are extremely attractive is correct, then overproduction is a more likely consequence than underproduction. The pond will be big regardless of subsidization.

Frank and Cook have demonstrated that from a welfare point of view, winner-takes-all markets often attract too many candidates rather than too few.[37] This certainly applies to the arts with its extreme winner-takes-all markets. Therefore, subsidies only have the effect of increasing social waste. And so what is really in the interest of society is not a bigger pond that develops naturally, but a smaller one.

(One could argue that it is unfair that at present poor and unemployed artists, who endlessly subsidize themselves, bear most of the pond's costs, but that has nothing to do with the underproduction of a collective good, but with equity. As already noted, there is little the government can do to raise artists' incomes.)

A secondary argument can be added to Frank and Cook's argument. It is possible that the value of a large pond as a major factor in the discovery of extraordinarily talented artists tends to be overestimated. In this respect, the notion of whether artists are born with their talent or whether it is a matter of training becomes more important. If artistic talents are innate, a larger pond will produce a larger number of talented artists. For instance, because men continue to grow taller, finding good male tenors is becoming increasingly difficult. In this case, a big pond will probably produce more good tenors than a small pond. Nevertheless, there is a limit to the amount society is willing to pay for such talents.

Moreover, it is likely that the majority of creative talents are primarily an issue of training, and therefore a bigger pond will usually not produce a larger number of talented artists. In this context, it is revealing that the sciences apparently rarely consider creative talent innate. The sciences are more dependent on training than on a large reserve. Upbringing and training are probably as essential in the arts as it is in the sciences.

The argument that government should subsidize the arts because society needs a large reserve of artists is false (thesis 91). Nevertheless, *the argument of the big pond has helped sanction subsidization* (thesis 92). The mystique of the arts has made this argument appealing.

9 Government Distorts Competition in the Arts

Government intervention sometimes reduces market failure, but it also causes market failure. For instance, when governments subsidize the arts in order to maintain a large reserve of artists, this leads to a waste of resources. When it comes to subsidies, people often believe that it doesn't hurt to try. The fact that art subsidies can actually lead to less welfare is usually ignored. Ultimately, any government intervention in the market has benefits as well as costs. And the creation of market failure through subsidization and the consequent distortion of competition is a cost that cannot be ignored.

Although the discussion in this section does not augment the subsidization explanation, it is nevertheless important because it puts the legitimization of art subsidies into another perspective. In chapter 7, I suggested that the intensive subsidization of certain sectors of the arts in Europe actually hinders innovation in adjacent unsubsidized art forms. The government thus causes unfair competition through subsidization. Subsidies produce artificially low prices for subsidized art. If subsidies were abolished, prices would rise and therefore art that had previously been subsidized would become less attractive and art that had never been subsidized before would become more attractive.

By only lowering the relative prices of certain artists and art forms and not of others, subsidization directly causes unfair competition. Subsidization is, however, also an indirect source of unfair competition because it only provides symbolic advantages to the subsidized parties. Subsidized art often bears the legitimate art label, art that is sanctioned by the government, and this gives it another advantage in the market.

At first glance, unfair competition in the arts due to subsidization seems to be a theoretical notion. After all, unsubsidized European pop music flourishes, while according to this theory it would suffer from the subsidization of classical music. It seems that the artificially low-prices of classical music do not make it more competitive against pop music. (It can also be argued that these art forms are not really in direct competition. This is not really true however, at least not in the long run. Competition can be observed through shifts in consumer behavior. As has already been noted, classical music has lost much of its market share over time to pop music. In the years immediately after the Second World War, thirty-year-olds mostly went to classical music concerts; this same age group now primarily frequents pop concerts.[38] Maybe this shift would have been even larger had prices of live classical music not been kept artificially low, but that is not certain.)

The effects of government intervention do not so much come from low

prices as from indirect advantages for subsidized sectors and indirect disadvantages for unsubsidized sectors. The fact that in the Netherlands, for instance, approximately 70% of all live and recorded pop music comes from abroad would not be a cause for concern if these large imports were offset by equally large pop exports. But even taking into account periodic export hits like presently 'Netherdance', exports are negligible and therefore imports remain much larger than exports.[39] Thus, a large trade deficit exists in pop music and other forms of unsubsidized contemporary art. Pop music demand has boomed, but it has been primarily been answered by imports.

Several explanations can be offered for the fact that local production in the unsubsidized sectors of mainland Western Europe has lagged behind. One reason is that English has become the new Lingua Franca and so Anglo-Saxon countries clearly have competitive advantages. The advantage is particularly large in the production of technically reproduced art that involves language. Here there is an extra advantage because due to the large English-speaking community, scales of production can be larger which reduces costs. But it is questionable if language is that important. Some of the most inventive pop or new music involves less and less vocals. Anyway, it is my conviction that in Europe the most important disadvantage has nothing to do with cost differentials, and more to do with a lack of incentives at home.

Due to the subsidization of the fine arts in Europe, the unsubsidized arts have a relatively lower status. The status difference between high and low art is artificially large. When subsidization of the fine arts is high, there is little respect for other forms of art. The difference is smaller in countries with more moderate rates of subsidization. It is telling that as early as 1965, the British queen received the Beatles in Buckingham Palace, handed them a prestigious reward and praised them for their contribution to music. It is unthinkable that the Dutch could have produced such inventive pop musicians at that time, but if they had, the Dutch queen would never have received the Dutch equivalents of the Beatles. (Even now, almost four decades later, there is little chance that the Dutch queen would be prepared to hand out a reward in pop music.) In mainland Western European countries the establishment tolerates, but does not respect new unsubsidized art forms. Subsidies both confirm and reinforce this attitude.

This is not to say that unsubsidized art does not have its own centers of reward, but these centers primarily serve those involved. They lack general legitimacy and tend to remain provincial or they are primarily media events, like the Dutch TMF rewards. For instance, pop music in the Netherlands remains defensive and insular. Subsidies create a wall

between subsidized and unsubsidized areas. Whereas, the much-respected prizes awarded in the subsidized areas are for instance generally recognized and respected, the attention accorded awards and competitions in unsubsidized art forms is limited to the specialty group of producers and consumers or to the audience of the commercial media.[40] Because the unsubsidized arts have relatively little symbolic income to gain, there is also little incentive to innovate.

Pop music is basically an Anglo-Saxon invention. Currently pop music is consumed and produced all over the world. Nevertheless, the bulk of the innovations continues to come from the US and Britain. Ever since the Second World War, music has continued to be renewed over and over again, but mainland Western Europe has produced a very small share of the innovations. If a similar difference were to exist in the visual arts, it would be less evident. Nevertheless, I think it's no accident that since France and other mainland Western European governments started to seriously subsidize contemporary visual art in the seventies and eighties, London became the center of artistic innovation in the visual arts. Recently Berlin has become a second center of innovation. Due to the recession rents are low, but subsidies for artists are also much scarcer than in, for instance, France.

I do not want to suggest that there is no artistic innovation in unsubsidized areas of the arts in Europe. For instance, Germany is producing innovative Techno. There is also successful (but hardly innovative) Dutch Netherdance, while France produces innovative digital video. Generally these innovative outbursts are short-lived. They do not induce a consistent flow of innovation. The cultural establishment largely ignores these outbursts. Due to government-induced unfair competition, important artistic innovations are left to other countries.

In my opinion, the possibility of *government-induced unfair competition* in the arts hindering innovation is a significant subject that deserves further exploration and more documentation. (Apparently not all evidence points in the same direction. For instance, according to New York artists I know, for the most part New York is not a haven for invention. On the contrary, the survival of the fittest means conforming to whatever is hot and trendy.) Nevertheless my provisional thesis is that *in countries where some art forms are highly subsidized and thus gain more status, there is less innovation in unsubsidized art forms. In countries that spend the most money on art subsidies, unsubsidized art tends to be middle of the road* (thesis 93).

When the effects of a lack of innovation become evident, there are two possible solutions: either the status-difference between the subsidized areas and unsubsidized art forms can be reduced by reducing all subsi-

dies, or subsidies are also funneled to formerly unsubsidized art forms. Mainland Western Europe seems to have opted for the second approach. Increasingly they have begun subsidizing, directly or indirectly, formerly unsubsidized art forms, such as pop music (including hip-hop), film, comics (*bande-dessinée*), break dancing, etc.

Finally, it should be acknowledged that, depending on the circumstances, subsidization can also harm the subsidized art forms themselves by making them complacent, resistant to innovation and thus less competitive with other countries. For instance, French state support is increasingly being blamed for the deplorable state of contemporary visual art in France as compared to England, the US, and Germany.[41] Therefore, these art forms would have been better off with less financial assistance, meaning that subsidization causes market failures.

10 Self-Interest Hides Behind Arguments for Art Subsidies

So far, it seems that art subsidies by and large don't serve the general interest. Therefore, even though false arguments can be influential, it is unlikely that these arguments can fully explain art subsidization in the long run. This brings me to Jonathan's claim that art subsidies are in part the result of the pressure influential parties put on governments. If art subsidies do not serve the general interest, do they instead serve the interests of the protagonists who demand these subsidies? And can the pressure of these protagonists explain government involvement in the arts, as Jonathan has concluded?

If the art world puts organized pressure on a government, it is a matter of so-called *rent seeking*. Groups try to acquire benefits or rents. When the government 'gives' rents to the arts under pressure, the government's 'gift' is positioned at the duty-end of the gift-duty continuum. In the most extreme case, the government is 'blackmailed' so that the government ends up subsidizing the arts as a form of bribe to prevent the repercussions threatened by influential social groups. The art world is thus using and exploiting the government. In order to prevent adverse repercussions, the government decides to serve art instead of the general interest.

Art lovers and artists who use the government for their own interests are obviously not selfless. Therefore, by assuming that artists and art lovers are not necessarily selflessly dedicated to art, the present approach is contrary to the mystique of selfless and sacred art. It distrusts the selfless motives of the art world. There are at least seven reasons why this suspicion might be justified.

(1) Art subsidies do not raise artists' incomes. Subsidies, in fact, are

more likely to increase poverty. (2) Art subsidies designed to educate people, largely end up in the hands of people who already have considerable cultural capital. And (3) if the recipients have little cultural capital and thus little chance, art consumption in itself adds little to their cultural capital. General public education is more effective.[42]

In practice (4) lower prices seldom persuade people to consume (high) art.[43] (Anna and Martin can only point to individual cases.) (5) Lower prices can even be counterproductive when in the eyes of outsiders they signal lower quality. And if, for example, a few of those for whom opera ticket subsidies are intended, actually go to the opera because prices are artificially low, then the cost of their 'conversion' is high. This is because the subsidy ends up in the hands of many more people than those for whom it is intended. Costs are also high because they are contrary to general income policies. In fact, the average taxpayer pays for the consumption of upper-middle class art consumers and therefore (6) income is redistributed in an unwelcome direction.[44]

Suspicion is further raised because the arts employ mainly (7) general art subsidies. These subsidies do not discriminate between rich and poor consumers and therefore, income is redistributed in the wrong direction. Instead, it would have been possible to employ forms of price differentiation or, even more effectively, handed out vouchers. Vouchers can be designed to discriminate, between rich and poor, among other criteria. Thus the undesired effect on income distribution is limited and a larger part of the subsidy's aim is reached.[45]

The fact that art subsidies often have little effect or are counterproductive but are nevertheless maintained, plus the fact that price differentiation measures and vouchers are rarely used, suggests that other interests must be at stake. Paul, Peter, Anna, and Martin's motives in promoting art subsidies may very well be selfish.

Although suspicion seems to be justified, it does not automatically imply that art lovers deliberately use selfless reasons to cover up self-interest. If art lovers behave in a self-interested way, a double standard can be involved, as has been noted above. So, it's questionable whether artists and art lovers deliberately and strategically try to put pressure on the government in order to receive the benefits of art subsidies.

11 The Art world Benefits from Subsidies

Although the majority of economists, who have discussed public expenditure on the arts, have only applied the earlier-discussed welfare approach, some have attempted to also find explanations for the subsi-

dization of the arts that go beyond market failure. These economists always refer to the possibility of art world rent seeking.[46]

From the 1960s onwards, social scientists have become more and more impressed by the influence of lobbyists or so-called 'pressure groups'. At first, the idea was that pressure groups could make the democracy even more democratic. They informed the government on the public's needs and desires. Meanwhile opposing influences would balance each other out.[47] It became clear, however, that there was a considerable difference in various groups' abilities to influence governments. This implies that, when certain groups are relatively influential, it pays to put pressure on the government. Influential groups tend to get more out of government than other groups do. They profit at the expense of others. They manage to hoard a larger share of government spending in the form of subsidies.[48] In many countries, it is assumed that farmers and homeowners are engaged in rent seeking. These groups are organized as lobbies. They succeed in receiving relatively high levels of subsidization, either directly or through tax deductions.

The first characteristic of rent seeking is that members of pressure groups benefit considerably more from subsidies than the general public does. Therefore, it pays for individual members to put their efforts into rent seeking. A second characteristic is that the memberships of these groups are relatively small in comparison to the total number of taxpayers. Because the price each taxpayer pays is relatively inconsequential, it does not pay to protest against certain proposed subsidies. A third characteristic is that these lobbying groups are influential enough to actually harm a particular government.[49]

Art consumers are likely candidates to get involved in rent seeking. First, they comprise a minority among taxpayers. Second, they stand to profit considerably. They profit both financially and symbolically. The financial profits are clear. Although the arts, especially the performing arts, become more and more costly to produce, the prices do not rise correspondingly thanks to subsidization. Without subsidies the protagonists would have been worse off.

If, for instance, the Dutch government were to stop subsidizing the arts and costs remained constant, the average ticket price to a symphony orchestra performance would increase from 14 Euros to 80 Euros. The ticket price to a formerly subsidized theatre performance would increase from 8 Euros to 87 Euros.[50] While the average ticket price to the opera would increase from 34 Euros to 226 Euros.[51] If consumers maintained the same attendance patterns with respect to these formerly structurally subsidized performing arts, this would increase the consumer's expenses by an average of ten-fold. And if consumers were to attend less often,

their average spending would usually still show a considerable increase. Irrespective of how consumers decide to respond, they would consistently lose in terms of money and or attendance. This means that they gain considerably from the current levels of subsidization.[52]

Not only consumers but also arts-related personnel such as art administrators and intermediaries, profit from subsidies and have a clear interest in subsidies. Subsidies help provide for their employment. Moreover, comparatively speaking, their directly or indirectly subsidized incomes are substantially higher than that of artists. Therefore, subsidization has the effect of raising income levels and increasing the number of well-paid positions. It follows that art institutions are obvious candidates for rent seeking.

The position of artists is more complicated. On the one hand, artists with regular jobs in art institutions are comparable to people in arts-related occupations and they are also likely to profit from increased subsidization. In the long run, on the other hand, average artists are unlikely to profit from increased subsidization given the analysis presented in chapter 6. Nevertheless, because most artists perceive themselves as having a large interest in subsidies, they may very well be the first to man the barricades to demand more subsidization or to fight against potential cutbacks.

Besides financial gains there are the symbolic gains, which could very well be far more important. The very fact that the government subsidizes the art consumption of the elite sets this form of consumption apart. The subsidy serves as a sign of approval of elite tastes and so existing elite distinction is either increased or reinforced. The same applies to the phenomenon of asymmetric judgment; the lower classes look up to the subsidized art of the upper classes, meanwhile they look down on the unsubsidized art forms of the lower classes.

Public declarations of a desire to educate people adds to one's prestige. The choice of art of the elite is established as an example to others. When it eventually turns out that despite lower prices the diffusion of their high art has had little effect, it is turned around to prove that not everybody is suited for this level of art. This way, as we have already noted, the eminence of the art lover only increases even further.

12 The Government is under Pressure to Subsidize the Arts

On the basis of the foregoing analysis, one would expect to find considerable amounts of organized rent seeking among the arts. Nevertheless, few cases of this kind of rent seeking actually occur. The economist,

William Grampp, described two cases of organized rent seeking in the arts. In both cases, rent seeking came from large art institutions.[53] Such institutions are better equipped to put pressure on a government. In the Netherlands, there have been some rare incidents of public rallies in support of art subsidies. In these cases, artists' unions but even more so the directors of large art institutions played important roles. Other countries also report some lobbying efforts but no rallies.

So-called art lobbies exist in several countries.[54] For instance, Dutch ministers of culture have been reproached for being unable to change the existing art policies, because they have often had too many personal art world ties.[55] And it would have been strange, if some of the friends and acquaintances of a minister in the art world did not periodically meet in order to discuss strategies that could prevent the minister from making unwanted decisions.

In the arts these 'lobbies' are, however, extremely loosely organized. They can hardly be accused of deliberately seeking rents. Generally, they don't even have a chairperson or an office, unlike farmers or homeowners organizations. This means that the large majority of art world participants are too poorly organized to put any effective pressure on a government. On second thought, this insignificance of organized rent seeking in the arts is hardly amazing. Too much organization and discipline are contrary to the autonomous artist spirit. Organization and discipline are directly contrary to the internalized rules in the habitus of most artists and many art consumers as well. The option of organizing in order to put pressure on a government simply does not arise in the art world.

Most of the people concerned naturally resist organization. Moreover, if a strong organized lobby were to exist, the lobby's efforts could very well end up being counterproductive. If art lobbyists began behaving like farmer or motorist lobbies do, they would betray the disinterestedness of the arts, which would lead to a loss of credibility and further damage their cause. (When occasionally some emotional artists manage to draw media attention to the 'desperate situation' in the arts via some anarchistic, confused and above all boisterous action, almost everybody in the art world feels embarrassed.) Despite the obvious advantages, actual *organized rent seeking is largely absent in the arts* (thesis 94).

This view of art world rent seeking begins to change, however, when one looks down from the tenth floor and interprets rent seeking in a broader sense. Here we see that the government actually appears to be under considerable pressure from the art world. This pressure stems from the individual and non-concerted actions of numerous individuals rather than any one deliberate organized action. Because this kind of behavior is rooted in internalized shared values, actions do not need to be

concerted; they are naturally in tune with one another.

The influence the art world has on the government largely rests on internalized values. Civil servants in charge of art policy often come from the same social group as art consumers and producers and have thus internalized many of the same values. Therefore, if government officials were caught even toying with the idea of substantially reducing art subsidies, they will most likely end up punishing themselves by not being concerned enough about 'vulnerable and sacred art'. This means that most government officials never even contemplate these kinds of cuts. And if they do, a hint of outside pressure is enough to remind officials of the ideals they stand for and the harm they might bring to their own careers, were they to forsake these ideals.

That outside pressure can lead to actual damage was revealed by the example in the previous chapter of the economist-politician whose reputation was seriously undermined when he pleaded for lower levels of art subsidies. Such cases are rare, however. The implicit threat of punishment, the chances of getting a bad reputation, 'he or she is a-cultural', and the possibility of being banished from one's own social circle are sufficient deterrents.

The most common view people have of the arts is one of an extremely vulnerable and impotent sector. 'Everything sacred is vulnerable.'[56] At the same time, however, art has status and the values that underlie this status are widely shared. Therefore, society has invested a lot of energy in the arts. The apparent vulnerability of the sector actually amplifies its influence. Few people will deny that vulnerable art needs protection. Given the vulnerability of art, even rich art consumers who might otherwise be suspect have credibility when they plead for art subsidies.

An unusual relation between lack of organization and ability to inflict damage exists in the arts. There is little visible organization in the arts and there are almost no rent-seekers who might apply direct pressure on the government. But because values are internalized, governments can nevertheless be harmed and thus are continuously under pressure. This pressure is part of a social ritual. The result is a ritualistic paying of duties to a far from powerless art sector.

The fact that the government is under indirect pressure from the art world partly explains art subsidization (thesis 95). This is a provisionary conclusion. Its assessment must wait until the following chapter, in which a third and related explanation will be presented.

13 Conclusion

Are Paul, Peter, Anna, and Martin right in remarking that art subsidies serve the general interest and that this explains why the government subsidizes the arts? Or is Jonathan right when he observes that the government subsidizes the arts because the art world puts pressure on the government?

The arguments that state that art subsidies serve the general interest and those that refer to the special merits of the arts, to equity and to the collective goods and external effects in the arts, are largely false. In this respect, subsidization is unnecessary, ineffective, or counterproductive in the long run. Subsidization is often unnecessary in the case of collective goods and external effects. It is also ineffective in the case of merit goods and counterproductive with respect to artists' incomes. Moreover, instead of correcting market failures subsidies actually induce market failures because they cause unfair competition.

Nevertheless, in one form or another, general interest arguments have been used successfully in public debates to promote subsidies for the arts. For instance, when after the Second World War the costs of the performing arts began to rise rapidly, politicians worried about artists' incomes and about the accessibility of the arts for people with lower incomes. Moreover, a strong desire has always existed to educate people through art. Finally, art subsidies were required to enable a sufficient production of collective goods and external effects in the arts. Due to the mystique of art, the effects of subsidization were seldom checked and so false arguments could continue to influence art policies. Therefore, the arguments of Paul, Peter, Anna, and Martin in part explain subsidization.

The fact that meager arguments can appear convincing demonstrates that the mystique of the arts must be strong. Nevertheless, it is unlikely that the use of weak arguments can fully explain the rapid growth of art subsidization in the US and Europe since the Second World War and the current extensive scale of subsidization especially in mainland Western Europe. Therefore, the phenomenon that groups put indirect pressure on governments to subsidize the arts, i.e., rent seeking, may well offer a supplementary explanation for the larger part of art subsidization.

The analysis broadly confirms Jonathan's view that the government subsidizes the arts because of external pressure, but Jonathan is wrong in assuming that the higher classes deliberately pressure the government into subsidizing the arts. Instead, this pressure stems from internalized values that are shared by people in the art world as well as in the various government agencies. These values depend on the mystique of art, the

same mystique that forms the essence of arguments that refer to the general interest.

In practice the rent seeking and general interest explanations overlap. Sometimes the emphasis lies on rent seeking and sometimes on convincing arguments that refer to the general interest. Depending on an individual's personal experience with the arts, one may judge one explanation as more important than the other.

Because I shall present a third explanation in the following chapter, I postpone the assessment of these two explanations until the end of chapter 10. In that chapter I will examine the possibility that art subsidization serves government interests. Instead of being a blind machine or the victim of the art world, governments can be perceived as an effective donor that receives numerous benefits from subsidizing the arts. In other words, art may very well serve the interests of a government.

Discussion

1 Most classical concertgoers have an above-average income. Subsidization allows some people with more moderate incomes to attend these kinds of concerts. If the aim of subsidization is to assure that concerts remain accessible for people with lower incomes, where would you draw the line? How many people with lower incomes should be attracted to outweigh the fact that an income advantage is given to people with high incomes?
2 Do you agree that the arts do not need support to maintain a big pond of artists in order to produce some extraordinarily talented artists?
3 Can art consumption help people with little cultural capital to increase this very capital?

Chapter 10

Art Serves the Government

How Symbiotic Is the Relationship between Art and the State?

How the Veiled Purchase of a Mondrian Painting became the Center of Public Debate

In 1998 the Dutch National Bank bought a Mondrian painting for 36 million Euros and gave it to the Dutch people. Journalists found out that the purchase had been handled behind closed doors using intermediaries and that a special arrangement had been used because the deal had not been entirely legal. The 'gift' from the bank to the Dutch people came from public money; therefore, parliament should have been asked for permission to spend this money on the purchase of the painting. The elected representatives of the Dutch people must be able to decide what the Dutch are going to give themselves. The Prime Minister, who had known about the deal all along, admitted that he thought that parliament would have never consented to the deal. Therefore, a 'minor' disingenuous procedure and some concealment had been required. The intention of the government and the bank director had only been to do something 'nice' for the country.

While the gift was meant to be public, the deal had to remain veiled. When it finally became public, a row ensued and the public reacted particularly negatively. The people were not happy with the gift because they did not like Mondrian's painting.

Alex remembers that he and his friends had mixed feelings about the affair. They liked the painting very much, although they thought that it had cost far too much money. But that wasn't their main issue.

Alex's colleague Rosa had the most extreme opinion. 'I like this Mondrian, but I could never accept it as a gift. The president of the bank is a thief; he gives away what is not his to give. He is more than just a petty criminal. This so-called gift comes from a theft worth – think of it – eighty million guilders. For that money a thousand visual artists could paint murals on public buildings for the rest of their lives.' This is what Rosa does when she has paid work. Then Peter asked her: "How certain are you that those murals are what the people want?" And Rosa responded, "Of course they'd rather spend their money on bus trips to the Costa Brava, but at least their local board representatives like my murals."

Peter was really disgusted by the sneaky maneuvers of this fraternity of

regents. At the same time, he was aware of the fact that as a heavily subsidized artist he was an accomplice; "It is terrible that we can only make art and have art around us at the expense of others." This is what he hated most of all. Apparently, the whole affair depressed him very much.

Alex, like Peter, was not immune to feelings of guilt, but most of all he was angry with the bank director for such a poor and clumsy cover up job. Alex was pretty sure that the hatred of the Mondrian painting was not terribly profound. The hatred for the painting only became acute because it was so closely associated with highhanded governors who the people resented. Under normal circumstances, people would have just shrugged it off, and a few years later they'd probably be proud of this new 'pearl' in their national collection. Moreover, Alex began to understand that the concealment of a gift serves purposes other than just covering up some semi-illegal affairs. He realized that such a prestigious institution like the Dutch National Bank could never bequeath a national gift in an atmosphere of extravagant celebration with food, drink and entertainment for everybody, nor could it have been the source of an exciting debate in parliament. In order to show their special influential positions both the national bank and the Dutch State needed a 'veiled' presentation.

How the Dutch Made a Favorable Impression in Berlin

In the summer of 1999, Alex visited his friend Adrian in Berlin where he presently has a studio. Sitting in a cafe and reading the newspaper headlines, Alex noticed that the Dutch Dance Theatre had given a number of extremely successful performances in Berlin. That evening he heard from Gerhard, Adrian's new boyfriend, that the performances were part of a combined Dutch political and trade mission to the German capital. It included several cultural highlights from the Netherlands.

Gerhard does stage lighting and he had been involved in the staging of the performances of the Dutch Dance Theatre. Gerhard said he and his colleagues were very impressed by the innovative and high level of the dancing. The style, although international, still had a Dutch touch to it. They noticed that the artistic director and the large majority of the dancers were not even Dutch. But then listening to them speak, they discovered that everybody in the company spoke Dutch very well.

For these German stagehands it was a strange experience to see so many foreigners in this Dutch company because in Germany the members of state-subsidized art companies must be German. Alex noticed that the newspaper critics had also praised the cultural openness of the Dutch.

Gerhard certainly loved the inspiring international charisma of the Dutch. He told Alex that he would like to do stage lighting in the Netherlands. And at this time he is in fact doing so at 'Het Muziektheater' in Amsterdam.

Why do governments bestow art on their citizens? Why did the Dutch government present a Mondrian painting to the Dutch public, when they would have preferred another kind of art or a tax deduction instead? And why did the government not convert the painting deal into a major celebration? How does the Dutch government use art to impress its German neighbors? Finally, what kind of message is the Dutch government trying to convey?

The explanations for government involvement in the arts presented in the previous chapter are probably lacking. They don't explain the extent of the government's involvement. This chapter approaches the subject from a different angle. It looks at the government as if it has its own interests. Supporting art, one can say, is in the interest of the government.

Unlike the previous chapter, this chapter approaches government gifts to the arts from the power end of the gift-duty continuum. The government is not obliged or forced to support art. Instead – like a large corporation – the government has the power to support art and does so in order to profit from it.

As an artist, I am sticking to my earlier opinion: *The government supports art because art is important to society. As a social scientist,* I'm increasingly convinced that *the government supports art because it needs art.*

My thinking on this subject is incomplete. Nevertheless, I like to share what I have.[1]

1 Governments Have Interests and Tastes

"The government is no judge of the sciences and arts." This saying from the 19-century Dutch politician, Thorbecke, has for a long time influenced Dutch art policy. If one interprets it in the strict sense, it means that the government should never interfere in the arts. In a broader sense, it means that the government is 'allowed' to support the arts, but must leave subsidization choices to the art world.[2] The idea that a government could have artistic taste is abhorrent. The autonomy of the arts must be respected at all costs. Government neutrality when it comes to art is particularly important in countries like the US, Britain, and the Netherlands. In Germany and France, for instance, art is more politicized. Nevertheless, these countries also have many advocates of government neutrality with respect to the arts.

This chapter examines a government's interest in supporting art. It demonstrates that when government intervenes in the arts it necessarily

becomes 'a judge of the arts'. Because governments have interests and because not all art serves government interests equally, it is natural for a government to only support certain kinds of art.

My approach to government behavior in this chapter differs from the common economic approach. I am using this rather abstract introductory section to justify my approach. This section may be of more interest to academics than to general readers.

The welfare approach to government expenditure discussed in the previous chapter treats the government as a neutral clearinghouse.[3] What the government gathers from its citizens in the form of taxes, it redistributes among these citizens in the form of goods and benefits. (When some get more and others less than what they paid in taxes this kind of redistribution is supposed to serve income policy.) The government itself is neutral; it doesn't necessarily gain or lose from these transfers. Because the government has no interests of its own, it can be called selfless. When it subsidizes the arts, it selflessly serves public interest by 'serving art'. This view was treated in the public interest explanation in the previous chapter. (Also in the other explanation in that chapter, the rent seeking explanation, the government was selfless; in fact in that explanation, it was seen as a victim of rent seekers.)

But the harmonious and highly abstract view of government pursuing public interest cannot explain the large and persistent involvement of governments in the arts. General interest arguments turn out to be predominantly wrong in the case of the arts. The other, the rent seeking explanation, is in a broader sense more convincing. It nevertheless remains difficult to comprehend how rent seeking by a badly organized art world could lead to persistent large-scale support, whereas other, better-organized pressure groups actually lost much of their earlier support.

The latter scenario could change, if it is acknowledged that civil servants and politicians can also be rent seekers, as the public choice theory in economics assumes. Individual politicians could increase their electoral base, coalition ministers could minimize conflicts, while civil servants could try to maximize their budgets.[4] However, if we really want to explain government behavior in the arts I propose going one step further. I want to look at government interest and the interests of government agencies and not just at the interests of specific government employees.

In order to develop a more satisfactory view of government behavior it is important to look at the government from a different angle. Instead of merely redistributing money and goods, it is more fruitful to view the government give and take as two separate functions. These functions are not carried out by some anonymous machine, but by various government

agencies that operate on different levels and in many configurations. The relationship between taxation and expenditure is often extremely indirect.

A government or a state is not a totally independent 'natural' entity.[5] Nor is it merely the indiscriminate executor of the electorate's desires. In many ways, governments or government agencies are comparable to large firms where a board of directors but also groups of employees have relative autonomy. They have discretionary space.[6] Under constraints, they pursue their own goals. Constraints come primarily from shareholders, but also from laws, conventions, trade unions and, in the case of a department within a firm, from higher authorities within the company. Therefore, boards of directors do not indiscriminately carry out shareholders' wishes. In the same way that government agencies do not automatically carry out the wishes of citizens or their representatives. Within constraints, established by higher government agencies, among others, they also pursue their own goals.

It's often impossible to distinguish actions that proceed from the use of discretionary space from those actions that proceed from the impact of constraints set by official goals and other limiting circumstances. It is equally difficult, if not impossible, to determine which actions of individual civil servants and politicians fully utilize discretionary space. Therefore, it is better to draw the attention to the interests and actions of government agencies instead. Such interests vary from government agency to agency. Therefore, governments and government agencies can be said to have lasting identities or, metaphorically speaking, personalities. By way of metaphor, a government can be said to 'need' art or to 'prefer' art, as if the government was a living organism.

In this context, it should be noted that the use of 'government interest' often serves as a shortcut. When no detailed information is available on the influence of individual persons or groups in and around the government, a discussion in terms of government interests serves as a second-best solution. However, by speaking in terms of government interests I also emphasize that institutions have relative autonomy. The fact that government behavior ultimately rests on the private interests and behavior of individual officials, voters, delegates, and others does not mean that government actions can be reduced to those private interests and behavior patterns. For instance, the satisfaction civil servants and politicians get from supporting art cannot fully explain government support. In the case of institutions like a government, the total is more than the sum of the parts. The institution maintains a state of relative autonomy. Therefore, the parallel with an organism is more than a metaphor. Within government institutions, a modal habitus is reproduced that

newcomers tend to adopt. By participating in the administration, civil servants' and politicians' attitudes change. For instance, if before entering the administration most important bureaucrats and politicians had little respect for the fine arts, they would quickly learn to respect it.

(In this respect, I depart from the methodological individualism of traditional economics and the public choice theory and I side instead with the sociological approach such as the figuration theory of Elias and the habitus-field theory of Bourdieu.[7] Because the total is more than the sum of its parts, it also follows that government interests cannot be equated to the sum of internal pressures applied by bureaucrats and politicians who favor the arts. Therefore, the present approach differs from an approach that only examines magisterial rent seeking, as is the common practice in public choice theory.[8])

In this context, I shall not only speak of government interest, but also of government taste, as if government was a being with certain tastes in art. This is a shortcut for complicated phrases like 'the government enables certain experts to develop tastes that become expressed in government subsidies and purchases.' At the same time, it's more than just a shortcut; I emphasize the relative autonomy of the government in its preference for art.

2 Art Appears to be Less Serviceable than it was during Monarchical Times

Extensive patronage by the courts, the church, and other patrons preceded modern state patronage. It seems that in their relation to the arts, modern governments are the successors of the church and the monarchy. Thus, it would be strange if the interests that modern governments have in supporting the arts bore no relation to the interests of the patrons of earlier periods.

In stylized fashion, a Patron and a Maecenas can be said to have been interested in art in three respects. Firstly, they enjoyed the immediate benefits that followed from their private consumption of art. Paintings hung on the castle walls and music was performed for exclusive circles. Secondly, they enjoyed the indirect benefits of the internal display to subordinates, which led to increased respect, obedience, solidarity, etc. Thirdly, they enjoyed the indirect benefits of external display to competitors in the form of the preservation or improvement of their position in social space. These three dimensions of art utilization depend on one another. Solidarity, respect, worship, awe, or fear of others are just as related to art utilization as enjoyment of the art product itself might be.

One use cannot be separated from the other, as we made clear in chapter 3.

The Patron and Maecenas of old did not hide the fact that art represented an attractive consumption good. The possibility of display was an auxiliary attraction.[9] By conspicuously consuming art products, rich consumers openly fabricated an external effect that gave them returns in the form of more respect.[10] Respect was a reciprocal effect: onlookers responded to the magnificence and splendor of their art.[11] It 'changed' them; in general inspiring respect and awe for the Patron or Maecenas. Not only subordinates or 'friends' were impressed, but also enemies. In the past, the rich used art to mark their position on the social ladder in order to preserve or improve that position.

In my view, the present use and support of art by modern governments can still be analyzed from the perspective of the interests governments have in private consumption and display. Many would argue that this is impossible because modern governments are purportedly disinterested, and also because art is increasingly considered as useless to large donors like governments.

It is true that, unlike modern governments, the Patron and Maecenas of old openly consumed art. They did not perceive their dealings with art as gift giving. Because they were interested in art, these 'benefactors' made deals with artists in which many rights and obligations were specified. Although viewed from the outside, these same deals sometimes looked like gifts the Maecenas basically commissioned artworks, while the Patron employed artists.[12] Even churches were 'consumers' of art rather than donors. Unlike the common people, they could afford the conspicuous consumption of this 'luxury'.

Modern governments on the other hand are donors rather than consumers. They often spend more money on subsidies than on purchases. And because modern governments are supposed to be disinterested, they prefer to present themselves as donors and not as consumers of art.[13] Nevertheless, I shall show that governments have numerous interests in the arts. First of all, governments seek display. And at present conspicuous gifts serve the need to display better than conspicuous consumption does.

It is also true that the arts have changed. Art has lost some of its traditional uses; for instance, art is no longer used as propaganda. Modern advertising strategies are more effective in conveying specific messages. Nevertheless, display through art has not disappeared, but its nature has changed. The messages of most current art are almost always general. This is particularly obvious in the visual arts.

More than 200 years ago visual art was attractive to the Maecenas

because of the artistic symbols that painters employed. People could easily comprehend the meanings of the artworks and could respond to them. (In this respect, it resembles the way modern people 'read' advertisements.) Therefore, in the competitive struggle between churches, kingdoms, aristocrats, and the affluent, the arts were often used for a direct and specific purpose. Specific messages, not easily misunderstood, indoctrinated subordinates to submit to their superiors, be it pope, king, local aristocrat, priest or magistrate. Or they were enlisted in the struggles that would assure their superiors' place on the social ladder. Observing the various scenes depicted in paintings that presently hang on the walls of our museums, one can see that patrons made extensive use of art's capacity to propagate concrete messages in the political strife of the time.

Current art does not tell buyers and observers what to do or believe, at least not in a blatant way. The messages modern art conveys are general, not specific. When the CIA sponsored American abstract painting during the Cold War, it wasn't trying to convey a concrete message, like 'shake off the chains of communist oppression'. The message was extremely oblique and general, more like, 'Look at these paintings and you will see freedom in America'.[14] The CIA evidently believed that modern art could still be used for non-artistic purposes. Right or wrong as they may have been in this case, it is unlikely that art has lost all of this instrumentality.

It is generally only in retrospect that the instrumentality or lack of instrumentality of art can be determined. Impressionist painting for instance, which for a long time stood for a totally disinterested '*l'art pour l'art*', can in retrospect, be viewed as having had a message that served the needs of a new clientele. It effectively marked the newly gained independence and prosperity of those urbanites who could afford to take trips to the countryside. It is this countryside as seen through the eyes of the urban visitor that the Impressionists depicted. By displaying these kinds of paintings, consumers were able to distinguish themselves and develop a new identity.

I still believe that the arts are instrumental. They are used for display and marking someone's position among others in social space. The same applies to towns, regions, and countries. The main difference is that the messages are less literal and more general than before. American abstract painting did not depict liberty; it *is* liberty. The fact that this kind of vague message is short-lived, just as short-lived as most concrete messages, suggests that art can still be used in an instrumental way. (Today, American abstract painting would probably not be used to symbolize American liberty.)

Art has changed and so has its patronage. The new patronage is one of democratic governments and private individuals and to a much smaller degree, of private corporations and private foundations. Most of all modern governments have replaced the courts, churches, nobility, aristocracy and regents of previous generations. (In the US, government involvement since the Second World War has its origins elsewhere.[15] Nevertheless, as I suggest in the Appendix to Chapter 10, the explanation of government involvement in the US does not have to be all that different.)

Three interdependent developments commingle in the transition from old to new patronage. First, the old donors became less relevant in society. Secondly, the arts became more independent or autonomous; the arts were less prepared to serve as conveyors of concrete messages plus they became less fit to convey these concrete messages. Thirdly, the new donors, most of all governments, increasingly needed art to convey their general messages.

At the same time that the former masters of the arts became less important within the existing social order, the arts gradually became less serviceable to the former masters. In the nineteenth century, Bohemian artists entered the scene. Gradually artistic autonomy became an ideal not only of artists but also of the art world and of general society. Therefore, it was not so unusual for a Dutch minister to tell parliament that 'the government is no judge of the arts'. It is a statement that could never have been made by a king or bishop.

It is possible that the obsession with artistic autonomy has delayed the transition to the new patronage. In a number of countries, there appears to have been reluctance on both sides to resume patronage. It is hard to calculate, but it is likely that in these countries the level of overall support of the arts showed a relative downhill slide in the second half of the nineteenth and the first half of the twentieth centuries. This was more likely the case in a country like the Netherlands than in, for instance, France, where the authorities maintained a high level of involvement.[16] Nevertheless, government support increased rapidly after the Second World War in all Western countries, including the US. In the Netherlands, it rose from a very low level to that of a per capita rate equal to that of generous countries like Germany and France.[17]

That the restoration of a substantial patronage system was not begun earlier is probably due to the fact that both the art world and governments were not ready for it. The art world remained reluctant. After art gained more autonomy it had to develop a new and stable habitus before it could once again deal with large donors, who could very well be wolves

in sheep clothing. Political parties were also reluctant to participate. They didn't want modern government to follow in the footsteps of the old royal system by creating a new type of official or state art.

After the Second World War, this reluctance did not altogether disappear, but it became less significant. Gradually the growing advantages of government support started to outweigh the disadvantages. On the one hand, the situation in the fine arts appeared to be degenerating. Art world expenses, most pronounce in the performing arts, were rising quickly and the relative incomes of artists were declining. Unemployment among artists was on the increase. There was a sense of urgency; assistance was called for.

On the other hand, the benefits of involvement in the arts for governments had also increased. Competition with other nations was increasingly based not only on military and economic might, but on cultural influence as well. Moreover, culture was increasingly being seen as essential for creating solidarity and coherence among the citizenry. The arts could perhaps play a significant role in all this. The government needed general messages from unimpeachable sources. As far as artistic messages could be interpreted as expressions of government influence, this had to come in the form of sublimated power. Therefore, the government did not overtly promote its assistance to the arts. Governments often supported the arts in a surreptitious way. And this befitted the arts.

Despite an initial reluctance by both sides, art and government were willing to play their newfound roles. After the Second World War, government expenditures on the arts began to rise quickly. In the Netherlands, government expenditure on the arts, per capita, corrected for inflation, more than tripled from 1950 to 1980. (After 1980 the amount stabilized.) It's impossible to ascertain whether the primary initiative for the new patronage came from governments or from the art world. Government needs were probably the single most decisive factor.[18] Governments needed art for veiled display both internally for their own people, and externally for other nations.

Governments need display their power. As we noted in chapter 8, in 'times of peace' power only exists as a display of power symbols. These symbols keep others informed about the power of their 'superior' or 'competitor' and ultimately make them respect those in power. Modern governments are extremely powerful. Because they manage enormous amounts of collective riches and have a monopoly on the authority to levy taxes and use violence, the power of the state is seen as unrivaled. Today's governments with all their wealth and power are the heirs apparent to kingdoms of earlier times.[19] Like the monarchies of old, they display sublimated power through art and direct it at their own citizens or

at competitors like other nations (or regions or towns). I will first examine internal display.

4 Veiled Display Serves Social Coherence

In 1999, as mentioned earlier, the publicly owned Dutch National Bank spent 36 million Euros on a Mondrian painting. Never before had so much public money been spent on a single painting. As described above, the painting was given to the Dutch people, which meant that it was handed over to 'Het Mauritshuis' museum in The Hague. For the bank, the gift represented a ceremony to mark the eventual transition to the Euro.

Given the celebration and the enormous size of the gift, one would have expected the transfer to occasion a grand celebration to be attended to by ministers, ambassadors, and local magistrates and perhaps marked by a huge fireworks display for the rest of the nation. No such thing happened, however. The queen unveiled the painting in the presence of a small gathering of mostly art world people. If there were any speeches, they were not broadcasted on radio or television. The unveiling went almost unnoticed in the news. Why wasn't this opportunity utilized for a grand display of cultural values? One would have expected as much.

It was never the intention of those concerned to draw much attention to this gift. As noted in the illustration, the way the painting was purchased had already received more attention than had been intended. This may have contributed to the extreme modesty of the ceremony, but the ceremony probably would have been sober anyway. Currently in the Netherlands, a sober display befits the government's cultural efforts. Display is possible and perhaps even necessary, but it must be kept to a minimum, especially with respect to the general public.

Veiled display seems to be a contradiction in terms, but it is not. Veiled display is not overpowering, but nevertheless leaves its traces. In an open display the extravaganza of single buildings, arches, sculptures, paintings, and performances makes audiences gaze in wonder. In a veiled display it is usually not a single item but the combination of many somewhat prestigious 'events' that together 'impress' people. These events need a minimum of openness otherwise they might go unnoticed. In impressive and yet veiled display everybody undergoes the artistic experience and responds accordingly. Moreover, what is displayed in a veiled manner is usually not so much immediate power, but sublimated power. The Dutch government's possession of works of art like a Mondrian painting represents – unlike military hardware – a form of sublimated power. This was

also noted in chapter 8. Veiled display befits the sublimation of power.

Whereas the patrons of old used art in openly majestic ways, in most western countries pompous art presentations are no longer appropriate contributions to national solidarity. Instead of paying respect to the authorities, people would tend to laugh at them. Moreover, nowadays, veiled display keeps art more exclusive than open display. In the past, magnificent castles with barred entrances inspired awe. People today are more aware of the existence of high culture, they are impressed and maybe even proud of it; in theory they might even come to view it, but usually the way it's presented puts them off.

The degree to which governments veil their cultural displays varies over time and varies according to country and artistic endeavor. Amazing new architecture, extravagant operas, and museums of modern art with their cathedral-like exteriors and their collections of precious modern art, are relatively conspicuous manifestations of cultural power. Their presence is displayed both to citizens and foreign visitors alike. France is probably best known for its open display of cultural power (as well as for the personal interest their presidents take in displaying art with a certain grandeur). In the Netherlands on the other hand, cultural power is primarily displayed in a subdued and subtle way. The sober identity of the Dutch government requires a veiled form of display. (Nevertheless displays can vary. More now than in earlier times, the Muziektheater, the Concertgebouw as well as other important art institutions are inscribed as so-called 'figureheads' of Dutch culture. The use of the term 'figurehead' reveals the element of display involved.)

The degree of transparency or veiling involved in the display of power through artistic means also depends on the way government is organized. Lies the emphasis on relatively centralized bodies and is their little room for private initiative or is government largely decentralized and do private organizations have relatively much power? The last situation fairly accurately describes the US. As we shall see, government display in the US through artistic means is not only more subdued but also less important than in Europe.[20] Compared to France, the Dutch government also leaves a relatively large amount of space to local and private organizations.[21] No modern government, however, today still displays cultural power as openly as the kings and emperors of old used to. The art world would be against this type of display and the general population would not be impressed. People were certainly not impressed in the former communist countries, where ostentatious architecture and social realist paintings with precise messages preached the virtues of the administration.

Whereas in the past, internal display served to propagate a sense of

awe or fear for authority to assure obedience of the citizenry, it currently serves to promote a common feeling of cultural identity and consensus with national institutions. It serves the notion of social coherence. Education through art also contributes to social coherence. (In this respect, education through art is part of the promotion of social coherence, even though they are often presented as separate aims of art policy.[22] For instance, immigrants can only begin their compact with state institutions after they have learned about its customs and traditions.)

Only a few decades ago cultural education was still openly employed to contribute to national cultural identity and social coherence. For instance, many governments were prepared to spend large amounts of tax money on public broadcasting. Broadcasting was not used for propaganda purposes as was the case in the communist bloc, but it served public educational purposes and the promotion of social coherence in a direct and transparent fashion. National radio and television stations have lost much of their significance and can no longer count on large sums of public money.[23] A complacent and continuous display of a country's cultural merits no longer serves social coherence.

Nowadays, a subtle and veiled display is generally thought to serve the nation better. The nation remains, however, the binding force par excellence. The oneness and solidarity that hold a community together rests on a cultural identity that differs from the cultural identities of other nations. In this respect, nations do compete.

5 The Cultural Superiority of the Nation Needs Display

Looking back it's easy to see that wealthy and powerful institutions, like churches and kingdoms, competed with one another. The history books are filled with tales of domination, war, victories, and defeats through the centuries. People nowadays tend to think that the competition between nations (and regions as well as towns) has largely disappeared and that their world is pacified. There still is competition but it occurs through trade. This form of competition seems to concern businessmen, not nations (or regions or towns). People tend to consider commercial triumphs and defeats as extremely relative and temporal: one year this company or country wins, next year another. Trade seems to be a gentleman's game, never to be confused with warfare. Appearances, however, are deceiving. The outcome of the commercial competition between towns, regions and above all nations can be as extreme as in the case of warfare. Not just businessmen, but successive generations prosper from commercials victories or suffer from defeats. For long periods of time,

this type of competitive struggle can determine a population's prosperity and poverty, cultural liberty and cultural dependence.

A country can considerably increase its trade rewards, if it is able to determine (some of) the rules of international trade. International prestige, including cultural prestige, adds to this capacity. Moreover, international prestige represents a reward in itself. This reward is especially augmented when a country has the capacity to set (some of) the rules of international culture as well. Economic and cultural success abroad clearly depend on one another, as the much-envied international success of the US demonstrates. Cultural identity is both source and product of cultural superiority. In this respect, a nation's identity differs from that of another nation. It is distinct and more or less authentic. (It should be noted that because cultural prestige is rewarding in itself, art is not necessarily subordinate to the economy in the present approach, as it was in the argument of section 9.7 where the government must subsidize art because art contributes to the economic welfare of a nation.[24])

International cultural prestige, as with trade, is necessarily based on a comparison, in this case between different cultural capabilities and identities.[25] When the outcome of the comparison is favorable, prestige increases. Which means that there is a confrontation, either directly or indirectly, with other nations. This confrontation is largely an automatic process and takes place in the market, among other places. American cultural products like films, television programs and pop music, do well in markets all over the world and thus contribute to America's cultural prestige. Most governments, however, are not satisfied with the results produced by these natural exchanges and thus deliberately display the high standard and superiority of their own culture to the rest of the world.

Countries like Germany and France maintain an expensive network of cultural embassies – 'Das Goethe Institut' and 'Maison Descartes' – in many cities around the world. These embassies produce exhibitions, readings by authors, musical performances, etc. This kind of permanent cultural presence is too expensive for most other countries. Moreover, ad hoc bilateral exchanges are currently not only cheaper but probably also more effective.[26]

Many countries also take examples of their performing or visual art abroad on political junkets, trade missions, and cultural exchanges. And when foreign missions visit another country, the hosts will certainly offer their guests a variety of cultural happenings. They are not just matters of hospitality or ceremony. They are occasions to attract as much publicity for one's own culture in the other country as possible. (The reviews of these cultural events in the foreign press are monitored and

discussed at length in the national newspapers. In this way, these encounters also offer internal evaluations of the strengths and weaknesses of the national culture.)

Because of modern communication technologies people know more about other cultures than they once did. Therefore, the organized cultural activities abroad are above all reminders and catalysts. Periodically extra attention is drawn to the cultural production of the visiting country. The existence of a rich culture is merely suggested. Although culture that is taken abroad on missions sometimes helps to open new markets for one's own cultural productions such as books, CDs or performances, it primarily serves to strengthen and, if necessary, correct one's own cultural identity.

It appears that national cultural identities have become important again. In Europe, unification has led to fears of homogenization with the disappearance of national currencies and laws. Meanwhile, all over the world consumer products have become more and more the same. Present-day consumer goods are international rather than national in origin. Culture however, allows a country to maintain a distinct character, a cultural identity of its own. And art, with its emphasis on authenticity rather than homogeneity, offers the most important long-term contribution to a unique national cultural identity.[27]

Sports are also outstanding cultural products and they certainly contribute to national prestige. But countries usually excel in one sport or another for brief periods of time and thus the relative advantage tends to be temporal. Moreover, sports products are international products and involve relatively little local cultural identity. Art products on the other hand, have long histories of being closely associated with the cultural identity of a particular country.

Because it is impossible to give a detailed description of the cultural identity of any one country, the concept of cultural identity could almost be perceived as an empty concept. It is not impossible however, to approach a cultural identity in more indirect ways. For instance, one can observe the kind of identity a government tries to promote in neighboring countries and how this identity somehow crystallizes in the media. Dutch culture in the context of a combined political and trade mission to Berlin described in the above illustration serves as an example.

The Dutch government took a selection of art products to Berlin. The selection emphasized aspects of Dutch cultural identity that might impress the neighbors. Although the Netherlands is a small country, the art chosen was not nationalistic or folkloristic. Among the highlights of Dutch culture were the Dutch Dance Theatre performances under the direction of the Czech-born Jiri Kylian, which made a strong impression

in the German press. Several newspapers remarked that the dance pieces were modern, international, and Dutch at the same time. The Dutch managed to combine a national and an international identity. What the papers found most striking was the cultural openness of the Dutch; the fact that almost all dancers including the director were not Dutch by birth added to this impression. On top of all that, the director and most of the dancers spoke Dutch well; they apparently felt at home in the Netherlands. (As noted earlier, in Germany only German dancers can dance in state-subsidized dance companies.)

The 'typical' Dutch values exhibited were the values of individual freedom, tolerance, diversity, and cultural relativism. These values are rooted in the striving for democracy, equality, and the sharing and diffusion of culture. Such liberal values befit a small country that depends on free trade. By emphasizing them abroad, they are presented as relative attributes of the Dutch identity. The implicit message is that 'the Netherlands is not just another small country; the Dutch have a special place in social space and their cultural values can serve as an example for others; they deserve to be exported. For instance, other European countries with immigrant problems or strife between various social groups can profit from these Dutch values.'

This does not mean that the Dutch only emphasize the modern aspects of their cultural identity. On other occasions, the Dutch do not hesitate to show off the solidity and seriousness of their cultural identity as it established itself over centuries. 'The Dutch are serious and honorable trading partners. If they are open to the world and to new things, they know what they are doing.' In this setting, the paintings of Rembrandt and Vermeer might be shown to foreign guests. Attention will likely also be drawn to old Dutch architecture – the monumental as well as the everyday. This contributes to the Dutch quality of trustworthiness. Even Van Gogh appears to augment the seriousness and sincerity of the Dutch identity. In this respect, the aforementioned Muziektheater, Concertgebouw, Rijksmuseum and the Van Gogh Museum serve as figureheads of Dutch culture for foreigners.[28]

The present argument also applies to competitiveness at more local levels. Identities at local levels tend to differ more subtly, but they are just as important. The competition between towns is often very visible. Cultural festivals, among other events, play an important role in their rivalry.[29] And in a country like the Netherlands with three major cities close to one another, the distribution between the three cities of the major art institutions, which are predominantly financed by the central government, is a continuous source of rivalry.

6 Government Taste Serves Display

Why did the Dutch National Bank – with government permission – choose a painting by Mondrian and not a painting by, say, Karel Appel? The Mondrian painting was not what one would call the people's choice, and even many members of parliament would not have consented had they been asked. The answer lies in the interest the government has in display. With respect to its own citizenry, this kind of display serves, despite some initial resistance, education and in due course social coherence. Moreover, the presence of the painting in the Mauritshuis in The Hague is bound to impress foreigners and to reconfirm Dutch cultural identity. In this context, the sobriety of Mondrian was preferred to the expressionism of Van Gogh, for instance. The choice was made and it confirms the notion that governments have a taste.

A particular government's taste with respect to art is revealed in the aesthetic choices it actually makes. Central or local governments subsidize and buy art, but not all art. They select art. For instance, the contents of the government's 'shopping basket' of subsidized and purchased art differs from the contents of the basket of art purchased by the average private individual. The contents of these baskets differ simply because selections differ. Therefore, by definition the government has a taste that differs from the taste of others. The same way the taste of local government differs from the taste of the national government. These differences are not accidental. Differences in taste are rooted in government interests.

When a government travels with certain artworks on missions abroad it also makes a selection. Certain artworks are selected because they serve the interests of the government better than other artworks. When it subsidizes the arts domestically, the same applies. A government cannot remain neutral.[30] If governments had to remain neutral and if 'the government is no judge of the arts', this ultimately implies that governments can never subsidize art. The continuous attempts to let governments subsidize neutrally are basically a form of self-deception.[31]

Governments seem to be neutral because they often leave the actual choice up to independent experts. Nevertheless, almost all governments basically decide on the size of the total art budget and on its distribution over the various art forms. Only the distribution within an art form is sometimes left to experts. Moreover, these experts are never totally independent of government scrutiny. Experts, for instance, decide what art is so-called 'quality art', but as was made clear in chapter 3, quality and aesthetics are not independent variables. It depends on cultural power or cultural influence.

When a government supports classical music, for instance, it reinforces the cultural influence of experts who might favor classical music and so the 'quality' of classical music remains high. Thus it would be wrong to say that a government gives money to classical music instead of to pop music because classical music has more 'quality' than pop music. It is more appropriate to say that currently, classical music better serves government interests than pop music.[32] (If subsidization rested on 'quality', then the 'quality' of pop music must have suddenly experienced a rise in the last decade because in that period some European countries have actually begun to subsidize pop music, be it in dribs and drabs. Nevertheless, critics do not agree with this sudden rise over the past decade. It is more plausible that the piecemeal subsidization of pop music increasingly serves government interests.)

In subsidizing the arts, governments are not neutral. Government has a taste (thesis 96). In this respect it must be noted that government involvement in the arts is not only revealed in its purchases and subsidies, but also in what it promotes and pays attention to. For instance, in many countries literature does not receive direct subsidies. But at home, the government still manages to bestow it with distinction by offering prestigious official awards. And meanwhile, when abroad, it assists in promoting literature as a manifestation of its culture by subsidizing translations into foreign languages and by subsidizing the costs of publishers displaying the publications of national authors at foreign book fairs.

Can government interests adequately explain its current selections of art? At first glance it's difficult to comprehend how, for instance, the large investment in classical music can serve the objectives of social coherence. Nevertheless, in order to close ranks, people need only be impressed; they do not necessarily need to participate in (high) art. In this respect, cultural symbols of superior, remote but not altogether inaccessible cultural power often serve a government well. In a case like this, only a mere hint of meaning may actually reach the general public. (Common people assume that privileged insiders fully understand the deeper hidden meanings of the art displayed, while they themselves only have a vague notion of it.) This implies that *governments have a preference for art, which is neither altogether accessible nor extremely inaccessible* (thesis 97).

For instance, on the basis of this analysis, one would expect that if (some of) the subsidized avant-garde visual art had continued to develop into esoteric and inaccessible areas, it would have served the government less well, and the government would have gradually lost interest in it. In a different situation government could just as easily lose interest if, for instance, ever more television contests cheapen mainstream subsidized

classical music, till it totally loses all its mystique.

Because prestige is an important return from the display of art, it is almost always in the interest of the government to select high and sacred art and to ignore less prestigious art. This explains why some art forms dominate government subsidies. In this respect, opera and classical music finish first, followed by the other traditional performing arts. They remain the current big winners. Next comes avant-garde visual art. In terms of attention, literature also does well.

Broadly speaking, *governments do not care whether the art they subsidize is classic, traditional, or contemporary as long as it has high status. Governments prefer prestigious art* (thesis 98). Because of differences in status, governments prefer classical music to contemporary classical, jazz, or pop music; and they prefer contemporary and old visual art to traditional visual art.[33]

Governments do not only select high-status art. They also produce this status. As noted earlier, the very fact that governments select certain artworks over others adds to the prestige of the selected art. By displaying art, governments enhance the prestige of their selection or prevent its decline. In this way, governments have some control over the production of (prestigious) art.

Regarding their behavior governments basically prefer prestigious art. However, this does not exclude experiments. For instance, the French as well as the English (London Arts) have started to subsidize exponents of hip-hop culture, break dancing, rap, comics, etc. and the Dutch support various forms of so-called transgressive art. The budgets are extremely small compared with funds that are given to more established varieties of culture. But as a way of receiving government attention, it cannot be ignored. Through these new endeavors governments influence the cultural identity of a country (or region or town) and they stimulate feelings of oneness and solidarity. (In due time such art may even become prestigious. In the future it may turn out that by their present subsidization these governments contributed to the consecration of these new art forms.)

7 Governments are Willing to Support the Arts

What is the relation between the rent seeking explanation of government involvement in the arts, presented in the previous chapter, and the government-interest explanation presented here? Both depart from interests, but the first stresses pressure put on the government because of the interests of groups outside government, while the second emphasizes

government power and government interest. Although these approaches sit at opposite ends of the gift-duty continuum, they could nevertheless complement one another. Mutual interests could be involved.

After the Second World War, the arts not only knocked on government's door and later on business's door, but government and business also pursued the arts. Art needed government to relieve its bad financial situation. This dreadful situation was due to a large supply of artists and little growth in productivity in the arts. The government, however, needed the arts to enable it to deploy subtle cultural strategies in its rivalry with other countries as well as to promote national coherence among the people, as mentioned earlier.

Given the fact that the arts needed support and that governments appeared to be willing to offer that support, one would have expected considerable rent seeking from the art world. But according to the analysis in Chapter 9, the art world never became organized enough to enable it to put effective pressure on the government. No substantial organized rent seeking developed.

The arts did not effectively organize because this goes against the basic notion of artistic freedom. And, because they were afraid of losing their newfound autonomy, they resisted overbearing government involvement. In the US, the mistrust of government involvement remains particularly strong. The fear of business involvement in the arts has been less pronounced in the US. In Europe, it was the opposite. Because in Europe the fear of business arose first, the arts consented instead to government involvement. Only several decades later would business become an acceptable partner in the arts and vice versa.

The absence of highly organized rent seeking can also be explained by the fact that there was little need for it. Even without rent seeking the annual art budget rose year after year. In other sectors with considerable organized rent seeking support was less persistent. The attitude of governments towards pressure groups, like automobile and homeowners, gradually turned around in the seventies and subsidies were reduced considerably in the decades that followed. Subsidies for the arts represent a notable exception.

In most countries, government arts expenditures per capita, corrected for inflation, has risen steadily since the Second World War until around 1980. Since 1980, art expenditures in most European countries have more or less stabilized.[34] (In some countries, like England, there was actually a slight reduction in spending in the eighties that was corrected again in the nineties.) Contrary to the popular notion in the art world that government is withdrawing from the arts, there has been no net reduction in spending per capita and there are no real signs of a substan-

tial decline in expenditures in the near future. Therefore, given its difference from other sectors it is unlikely that arts expenditures are just some response to organized external pressure; it's far more likely that government interests are involved.

Nevertheless, both explanations enhance one another because as we noted in the previous chapter, external pressure is internalized by government officials. But it's also because a new type of 'mediator' has emerged who harmonizes the sector's interests and the administration's interests, as we will see in the next section.

8 An Arts Experts Regime Harmonizes Government and Art World Interests

Since the Second World War, many professionals gradually found employment in institutions that integrate European governments with the arts. They form an imaginary semi-political body or an 'experts regime' in the arts, as Abram de Swaan has called similar professional 'regimes' in education and health care.[35] Some of these professionals are employed within government agencies, but seem above all committed to the arts. Others work in subsidized art institutions. Still others work in the many institutions that operate in that domain located between government and art and are primarily government funded.[36]

Similar kinds of professional or experts regimes emerged earlier in the health care, social security, and education sectors. Although the background of the arts experts regime differs, it shares certain characteristics with the other three.[37] One common characteristic is that in all four sectors, the interests of many people in the sector run largely parallel with the interests of government agencies. For instance, art's high status serves both the government and the art sector employees. The professional regime in the arts takes care of shared interests. Presently *a professional regime in the arts looks after and harmonizes the interests of the government with those of the art world* (thesis 99).

The experts regime also harmonizes internal interests. Neither the arts nor the government can be treated as a monolithic entity. They consist of many parts, whose interests do not always coincide. And so the regime not only tries to harmonize the interests of the government and the art world, but also of the various governmental departments as well as of parts of the art world.

Because not all of the interests can be reconciled, the regime assists the arts in setting boundaries. In the arts, however, such boundaries cannot be based on regulations or diplomas. For reasons that will become

clearer in the next chapter, this kind of control can only be informal. Instead of deciding on people based on their diplomas, a complicated system of informal barriers exists that calls for many gatekeepers. The professional regime supplies most of these gatekeepers. They are organized by the regime and they often, either directly or indirectly, receive facilities and payment from the government.

With the help of a professional regime in the arts, the government has gradually become a co-producer of art.[38] By indirectly controlling circles of recognition in the arts, it helps co-produce the definition of art. This is in the government's interest as it can thus assure that the art it subsidizes and consumes is defined as the best examples of available art.

At the same time, however, standards of artistic quality are increasingly determined in an international context. Therefore, part of the arts experts regime is in the process of becoming internationally oriented. This applies, for instance, to important avant-garde institutions that exhibit and produce international contemporary visual art. Examples are White Columns in New York, The Serpentine Gallery in London, Witte de With in Rotterdam and The Appel in Amsterdam. Although local and national governments finance these institutions, their directors are part of the board of directors of similar institutions in other countries and vice versa. This way a professional regime acquires an international dimension. On the one hand, it is able to synchronize local interests to international developments. On the other hand, it can show national highlights, not as folklore, but as national innovations within an ongoing international development.

Given the activities of the professional regime the notion of government artistic taste has to be put in perspective. Government taste is not an independent variable that officials can supply at will. By supervising the dialogue between the art world and the government, the regime has an important stake in government taste. This is how the government and the arts depend on one another. Because of the impact of this professional regime in the arts, the relationship has become a complicated knot that's not easily untangled.

It turns out that the government and the cultural sector are engaged in a symbiotic relationship. Art serves the government and the government serves art. The giving of gifts to the arts by a powerful government who seeks display and the extraction of duties from a government who submits to pressure merge into new rituals. On the gift-duty spectrum, power has met duty.

Why did the publicly owned Dutch National Bank in cooperation with the Dutch government purchase a Mondrian painting to give to the Dutch people, while the latter did not really want this painting? This chapter has emphasized government interests. In the case of the Mondrian painting, the government wanted to impress people and not necessarily please them. Moreover, by adding an important piece to the Dutch national collection other countries can now be impressed as well.

At home, art is promoted because it is thought to contribute to education and consequently to social coherence. In its relation with other nations (or regions or towns) art plays a role in the rivalry. That is why the Dutch government chose to have The Dutch Dance Theatre and other exponents of Dutch art accompany its combined state and trade mission to Berlin. Towns, regions, and nations compete with one another. They no longer advance their standing through warfare. Instead, they compete through trade and cultural exchanges. Cultural identities play an important role in this.

Although art is still useful for governments, it no longer conveys concrete messages as it once did in the monarchical past. The newly gained artistic autonomy of the arts no longer tolerates this. Governments also prefer art to assist them in a veiled display of power. Therefore, the purchase of the Mondrian could never have been the occasion for a grand celebration. Nevertheless, art with considerable status is generally most useful for governments. It explains why classical music receives much more money than pop music, for instance.

Gradually since the Second World War a professional regime in the arts emerged which synchronizes government and art world interests. This shows that last chapter's rent seeking explanation supplements the government-interest explanation of this chapter. The third explanation, the general-interest explanation that was treated in the previous chapter, also contributes to the overall explanation of art subsidies and of the large gift sphere in the arts; arguments that are largely false but nevertheless convincing add to subsidization.

I am inclined to attach the most value to this chapter's government-interest explanation, but this does not imply that the other two explanations are unimportant. Moreover, the three explanations are related because they all depend on a common determinant: the mystique of art. However, before I return to the mystique of art in the concluding chapter, I will first take a look at informal monopolization in the arts in the next chapter.

I claim that the present explanation of government involvement in the

arts applies to both Europe and the US. Nevertheless, some important differences exist, which are briefly discussed in the appendix to this chapter.

Discussion

1 Is the explanation of the subsidization of the arts on the basis of a government need for display implausible in countries like the Netherlands where a strong court (monarchical) tradition never existed?
2 It could be argued that because of the growing importance of other forms of display like advertising, television shows, public discussions in the media, sports, etc., the use of art for display is rapidly losing its significance. What is your opinion?
3 Can you think of other examples of art used by governments for (veiled) display other than those already presented in this chapter?

Appendix: Differences between Government Involvement in the Arts in the US and in Europe

Although I claim that the general explanation of government involvement in the arts as presented in chapter 10 applics to both Europe and the US, differences exist. This appendix briefly discusses some differences and correspondences. (In most respects Britain holds an intermediate position between the US and the countries of mainland Western Europe.[39])

Apart from the support for artists in the thirties through the Work's Progress Association (WPA), which was part of Roosevelt's New Deal, before 1965 there had been no large-scale and continuous tradition that was common in Europe of direct support for the arts by the government in the US.[40] Nevertheless, in most European countries there was also very little subsidization before the Second World War. Therefore, the main difference is that substantial subsidization in Europe started sooner after the war and reached higher levels. To a degree however, subsidization was legitimized in similar ways.

In the US, as in mainland Western Europe, the government has been sensitive toward the notion of international competition. For instance, after the war government officials in the US successfully argued for more government expenditure on the arts by emphasizing that the US must not lag behind the European nations. Apparently, these officials thought that art could play a role in international competition.

From 1969 to 1977 Nancy Hanks, chair of the National Endowment for the Arts (NEA), managed to increase the budget of the NEA from $11 to $114 million by alluding to the symbolic effects of government involvement. (In 1972, she persuaded President Nixon and the Congress to double the budget.) The gist of her argument was that more funding would increase the status of the government in the eyes of the public, while at the same time having almost no impact on the federal budget.[41]

These arguments confirm the rationale of Chapter 10. It appears that in the US and in Europe, governments sought to improve their competitive power and to enhance their status by associating themselves with the high status of the arts. (At the moment, the NEA receives only 7% of the total cultural budget of the federal government, but symbolically it remains important. Presently, the NEA is primarily stressing the economic impact of the arts and the number of jobs the cultural economy generates. 'By subsidizing the arts, economic successes are possible at low costs.' It is one of the general interest arguments of Chapter 9. As happens in Europe as well, the art world tries to free ride on the present dominant belief in the necessity and possibility of economic growth.) After coming into office, Bush jr. proposed a 7% increase in the NEA budget to be spent on educational projects. It is the same educational argument that has again come into favor in Europe.

The most important difference between the US and Europe does not lie in the arguments for subsidization, but in the circumstances in which these arguments are applied. In the US, the distrust among artists and others of government intervention is greater than in Europe. American artists, even more than their European colleagues, remain afraid of losing their autonomy. This mistrust is related to the desire, vested in the American identity, to have a government that intervenes as little as possible. As soon as the government does more than necessary, it becomes suspect. While in Europe, the status of governments may increase when they increase spending on the arts, in the US, when the art budget rises, mistrust of the government is likely to get the upper hand. High art budgets therefore don't serve government interests.

In the US, there is less distrust of private giving, however. Through tax deductions of gifts for the arts and of purchases of art the government supports the arts substantially, but does not intervene in the organization of culture. "Government is a minority stockholder in the organization of culture."[42]

Another difference is that in Europe the status of the arts is generally high and undisputed, while in the US the status of the arts is more ambiguous. Whereas in Europe most people share a vague respect for the fine arts, including modern art, in the US upper class people are not

ashamed to admit that modern art means nothing to them. Apparently modern art contributes little to the general sacredness of the arts. In the visual arts, this became particularly clear in the so-called culture wars, in which the sometimes sexually explicit or blasphemous content of modern visual art, such as in the works of Mapplethorpe and Serrano, caused clashes between advocates and adversaries of subsidization. Apparently, art sometimes divides rather than unites. This means that if central or local government agencies in the US support modern art, it is not at all certain whether they will advance their prestige. The gain may very well turn out to be a loss. (As a result of these culture wars the funding of the NEA was cut by almost half again.)

The fact that content is a subject of dispute shows that the status of art is not beyond discussion in the US. In Europe, artistic form is a matter of debate, but content is not. In the US however, most discussions about visual art are not about style, but about content, most of all the permissibility of sexually explicit subject matter. (According to Montias it matters that the evolution of state support for the arts in the US has been more democratic; in his view it did not allow art-loving elites as much opportunity to impose their tastes on the public as in Europe.[43])

It is also telling that corporations in the US appear to have more liberty in their relation with the arts than government agencies have. Many corporations have collections of 'avant-garde' visual art.[44] And some firms that have problems legitimizing their existence, like tobacco companies, spend huge sums on their support of the arts. They correctly believe that this improves their imago. The situation of governments in the US is, however, also different because governments can be controlled by sometimes relatively small but powerful lobbies. (At the time of the above cut in NEA opinion polls showed that 60% of the public vaguely supported the NEA and 20% strongly opposed it. A far more effective lobby in favor of the cuts, however, managed to push the minority opinion through.)

A professional regime in the arts is present in the US as well. The people in the regime, however, do not merely (directly or indirectly) report to the government, but also to other centers of power, most of all, important foundations, companies, and universities. Well-known foundations like the Getty Foundation and the Rockefeller Foundation, corporations as well as music publishing companies, impresarios, dealers, and even critics hold positions that compete with government agencies and are to be reckoned with. Nevertheless, the American artistic regime is less powerful than the European regimes. In the US, no participant is much stronger than another and no one holds a monopoly position in the regime like the European governments do.

The fact that fundamental differences exist between the position of

governments in the US and in Europe is best demonstrated by the way governments use tax deductions and other tax concessions to support the arts. In the US, a relatively large portion of government money to the arts is in the form of tax deductions for foundations, companies and private individuals. Approximately 70% of total funding from the central government comes from tax concessions, mostly as tax deductions on purchases of art and gifts for the arts. In mainland Western Europe, this percentage is less than 20% and it comes mainly from reduced VAT payments for cultural products.[45]

By allowing tax deductions and other tax concessions the government subsidizes art. Because the taxman has set broad interpretations of what art is, the choice of art that gets subsidized is largely left up to the consumer. In practice the recipients consume and support high as well as low art. Therefore, the government cannot derive much distinction from its indirect support for the arts. No superior choice can be displayed. The same applies to the substantial indirect government subsidization of artists through public, but also private universities. In the case of direct subsidization, which is the most popular in Europe, the government narrows its margins considerably. Government taste in purchases and commissions is even more influential. Therefore, these forms of support comply better with a wish to display.

Evidently, and in line with what has been written above, the American government expects less from display than mainland Western European governments do. Instead, the government of the US prefers to empower private institutions and individuals through the indirect mechanism of tax deductions to address the public purpose.[46] This explains its stronger preference for tax deductions and for indirect subsidization through universities. On the other hand, the resistance against tax deductions in Europe, despite some evident advantages, can only be understood, if the aspect of display is taken into account. European governments do not want to cut down on display.

Chapter 11

Informal Barriers Structure the Arts

How Free or Monopolized Are the Arts?

Being Selected by the Government

Shortly after graduating from art school Alex applied for a government grant for visual artists. Everybody does. It would have been unprofessional not to. He applied because of the money. There are three different types of grants.[1] Each of them offers the artist an amount of money, which is equal to a year's income in a comparable profession. For an artist, however, a grant of this sort represents an income for many years to come, given the low average incomes in the visual arts. No wonder these grants are attractive.

When Alex applied he knew his chances were small. All promising graduates applied; there were four times as many applications as there were grants. So, he wasn't counting on getting one. In this respect, he was not too disappointed when he was rejected. In another and unexpected way, the rejection hit him hard. It hit him in a way no statistical calculus could mitigate. He felt rejected as an artist. Secretly he had hoped for recognition. He had hoped that the most significant organization in the Dutch art world, the government, would say: 'All right Alex, we know that nobody is lining up to buy your drawings, but we can tell that you're a real artist. We want you to stay in the field.'

So the grants are not only attractive because of the money. In fact, Alex discovered that the symbolic attractiveness of the grants exceeded their immediate financial attractiveness. Since he did not get the grant, he continued to doubt his right to be an artist. Was he a fraud? He thought (and still thinks) that many unsuccessful artists make bad art. Little would be lost if they just left the arts. Was he one of them? The rejection lowered his self-esteem. He could not hide the doubts he harbored about his own art and that made it all the more difficult for him to find a good gallery. Had he gotten the grant it would have given him wings. The grant is also important in an objective way; for instance, if he could add that to his curriculum vitae it would certainly help convince Dutch gallery owners and collectors of his worth.

After that first attempt, Alex tried two more times, both unsuccessfully.

Then he stopped. He wanted to save himself all the existential doubts associated with a rejection. This is how many artists end up going underground; they often even stop trying to crack the market. Nevertheless, ten years after leaving art school, Alex felt self-assured enough to start a new round of applications. He first applied for the 'werkbeurs' subsidy, which is the most prestigious and most difficult to get, and he got it. And everything else he has applied for since has also been accepted.

Looking back at this first grant, Alex now realizes that it was actually an enormous relief. Experts now took his work seriously. He had a right to be in the field. Alex even suspects that since that initial sign of recognition his artwork has improved – more than it ever did before. He felt more self-assured and he became more daring. Not all of Alex's colleagues react as strongly to this kind of rejection. But all of Alex's colleagues certainly recognize this scenario. To almost all avant-garde artists in the Netherlands government acceptance is the first and most important barrier.

Looking back at the rejections, Alex, now belonging to the group that receives government grants, wonders why his earlier work was rejected. The answer he can live with is that his work at that time was not good enough, but since then his work has improved. In the back of his mind, however, he knows that it could also be merely changes in government taste. Back when he applied for his first grant, the Dutch government was not interested in figurative art. It only developed a taste for figurative art again over the past two decades. And Alex has been producing figurative art all along. Still, he finds it difficult to admit that the government is not just interested in quality, as it claims, but that it has a taste and that it rejects work that doesn't fit in with its preferences. This is how it puts up barriers. Alex prefers not to question the government's authority; he prefers to see the government as an institution that protects the autonomy of the artist, not as one that interferes with it. That is why Alex wants to believe that his work has improved.

Incorrect Associations in the Arts can be Disastrous

Alex has a studio in the same building where Margaret has hers. Margaret is quickly becoming a successful international artist. When Margaret and Alex are working, they might have a cup of tea in Margaret's studio at the end of the day. In a corner of her studio hang four artworks by Margaret's colleagues. Three are by successful friends about her age; the fourth is a small painting by Alfred who is much older. Alfred is Alex's friend and was once Margaret's teacher. Looking at this painting, it is clear that Alfred had a big influence on Margaret. She told Alex that this particular painting is precious to her. The painting hangs there as an homage to Alfred.

Gradually Alex noticed that every now and then during their tea-sessions

this specific painting was missing, while the three other paintings would still be there. After a while he worked out that it was missing on days Margaret received important visitors: dealers, people from galleries, journalists and successful colleagues.

He asked her why she put the painting away. Margaret was extremely embarrassed and almost in tears. She started to apologize. "You know the art world. I must be so careful. It is better not to be influenced by an artist who is little known. To be honest, it is worse when they know Alfred's work. Then they suddenly see my work in a different light. Because of its roots they can more easily dismiss it. Just now I cannot afford to be associated with Alfred. Maybe in twenty years, but not now. But, yes, you are right: it is strange the way I handle this painting. I suppose I should take it home." This is what she did. When Alex told this story to his friend Alfred, it evidently hurt him.

Why does Margaret publicly deny her relationship with an artist-friend whose work she admires? And why is it so important for artists to be favored by the government? In order to answer these questions this chapter investigates the barriers that artists encounter in the arts. Because many of these barriers depend on government involvement, the treatment of this subject was delayed until an analysis of the government's involvement in the arts could be completed.

At first glance, it seems that, unlike other professions, there are few barriers in the arts. The arts are unfettered. Anybody can become an artist. If people couldn't become artists it would violate the autonomy that defines the arts. It would desecrate art. The mythology of the arts demands that success rests solely on one's commitment and talent. Thus, the arts must remain independent sans barriers that might constrain artists.

As an artist, I strongly believe in the importance of freedom and autonomy in the arts. So does the whole art world and therefore *as an artist I do not believe that barriers exist in the arts.* If I end up being less successful than I had hoped, I don't blame my shortcomings on barriers and monopolization. I'd rather blame myself or the consumer for being not committed enough to art. Therefore, as an artist I don't readily acknowledge forms of monopolization. As an economist, I am better equipped to perceive organized barriers in the market that are deliberately constructed to keep certain competitors out. And because I don't believe these barriers exist in the arts, *as an economist I find the arts to be unusually open and competitive.* Therefore economist and artist agree.

1 In other Professions Barriers Inform Consumers, Restrain Producers and Limit Competition

The barriers that mark other non-arts professions do not seem to exist in the arts. To discover if this is really the case, I will first examine barriers in other professions. Anyone who is interested in pursuing a non-arts profession faces a number of barriers. First, candidates pay the fees to their chosen institution of higher education. This gives them access to the profession's certified body of knowledge. Then they have to pass certain standard exams. They are only allowed to practice their profession after they have received their certifications or diplomas. (In some professions candidates are also required to pay fees to colleagues for the right to join an already established practice.) Therefore, anyone who is unable or unwilling to pay or is unable to pass the examinations faces a de jure or de facto *Berufsverbot*: in practice he or she is not allowed to work in the profession.

Professionals who have spent some years pursuing their career face other barriers as well. For instance, if they want to be successful at their chosen profession, they must seek admission to one or more select professional associations in one's field or seek an extra qualification like a Ph.D. These barriers are not situated at the front door of the profession; they mark off privileged inner sanctums. If candidates want 'to move up' in their chosen professions, they must overcome these barriers as well.

In order to pass through any of these barriers one needs a combination of monetary, cultural and social capital as well as some luck. Authorities can limit the membership or number of entrants by increasing entrance fees or raising the qualifications standards and so raise the amount of capital needed. Generally speaking, there is a limit to how high fees can be raised. Modern democratic societies consider exorbitant entrance fees as unfair. Requiring inordinate amounts of extra training that bears little relation to the demands of the profession is not uncommon, however. This is one way of restricting the number of entrants into a particular profession and, as a result, the incomes in the profession remain higher than they would be without the barrier. If the barrier is managed by members of the profession who profit from limited membership, or if they can unduly influence the authority chartered to handle the barrier, the profession is said to be more or less monopolized.

Not all barriers lead to monopolization, however. If producers who meet realistic requirements are allowed to pass and if there is no *Berufsverbot*, competition is not necessarily impaired. Some barriers serve primarily as certificates and information outlets. In this respect, it is useful to examine the signals that barriers emit. First, they produce a

warning signal to other producers who might choose to illegally cross the barrier. Secondly, they produce signals telling customers that the membership has special qualifications not available to those outside the profession. Without signals it is often difficult for consumers to procure information on the quality the member produces. Take, for instance, used car dealers. It is difficult for consumers to determine whether the automobiles being sold are in satisfactory condition or not. They have less information than the used car dealers themselves have and therefore a situation of asymmetric information exists. To overcome this situation, certain used car dealers display certificates, indicating that they are recognized by a certifying organization.[2]

Signaling barriers can be found everywhere. They exist in both monopolized and non-monopolized situations. They can be related to products, like biological milk with a seal of approval or hotels rated by numbers of stars. Or they are related to people, like scholars who have a Ph.D. degree.

I call the barriers in this section, formal barriers because their existence depends on authorities who have the power to institute the barrier and regulate passage through it. This authority is not anonymous; it is in the hands of known institutions or individuals. The authority informs consumers and through the process of installing, raising, lowering, or removing a certain barrier, it often also controls membership figures. Sometimes, and not too uncommonly in non-arts professions, formal barriers may, de jure or de facto, result in a formal control of membership.

2 The Arts Resist a Formal Control of Numbers of Artists

Given the large supply of artworks and artists and their correspondingly low incomes, one would expect a strong tendency in the arts to reduce membership rolls via formal controls. Or, if that's impossible, one would expect various organized attempts to certify artists and art products to better inform consumers. This is, however, not the case. The formal barriers and signals, found in other professions, are either absent or relatively unimportant in the arts.

Unlike in other professions in the arts, the separation between professionals and amateurs does not necessarily have anything to do with formal education. Although most artists have had some formal training, many don't have diplomas and, more importantly, they do not need a diploma to work as artists. This implies that no formal barrier based on a diploma requirement characterizes the arts. The entrance to the profes-

sion is free. Moreover art does not have shielded, certified bodies of knowledge.[3] In most professions, only initiated professionals and graduates have access to these certified bodies of knowledge. In the arts, this body of knowledge, including knowledge of techniques, styles and history, is de facto free; anybody can have access to it.[4]

In general, artists encounter few formal barriers that officially limit who can be a working artist. First, in most countries artists without diplomas can receive government grants and unemployment benefits.[5] The same does not apply to other professions. Second, although certain modern artists associations represent formally closed inner circles, these circles have little impact and they are often counterproductive. Successful artists, for the most part, do not take these associations seriously. Artists associations are basically a thing of the past. Third, although artists can get a masters degree or a Ph.D. in some countries, they do not offer easier access to the art world.[6] They are basically irrelevant for the professional success of an artist. Finally, on average artists with some years of official training or with assorted diplomas do not necessarily earn more working in the arts than artists with no official training.[7]

The actual insignificance of professional education as a barrier is most evident in literature. In other art forms diplomas do exist, but are not obligatory. Nevertheless, although professionally educated artists seem to be no better off than artists with less education, many prospective artists do pursue official training. And because there are so many, quite a few are rejected at the gate of the art colleges. Therefore it appears that academies have a *numerus clauses* and that the most important formal barrier in the arts is situated at the entrance to art schools.

It is however questionable if a significant formal barrier that keeps numbers of artists down really exists at the entrance to the schools. It is true that candidates are selected. Officially, admissions are based purely on talent. (Other criteria remained taboo, as they would contradict arts autonomy.) In practice however, the teachers' assessment of talent is necessarily relative and subjective. Teachers have an interest in keeping enrollment high. Most art teachers are artists who earn little from their art and therefore, they cannot afford to lose an attractive teaching job. (Moreover, they are usually eager to help artist friends get teaching jobs in their schools.) As a result, admissions to particular schools tend to depend on the capacity of the schools rather than on the number of talented would-be students. And in the long run, both teachers and arts administrators have an interest in increasing enrollments and the number of schools to accommodate the ever-increasing number of art students. Therefore what seemed to be an artificial and formal barrier at the gate of art colleges is primarily a normal price barrier.

Where numbers of applicants were large in other professions, not only information campaigns would discourage potential students from entering, also, especially at the technical and vocational training schools for those over 18-years old, a numerus clausus has been commonly employed in most European countries. By and large, the same applies to the US.[8]

After the Second World War in the arts however, art student enrollments only continued to rise. Nevertheless, there was no pressure from professional artists to reduce enrollments, nor did governments try to deter students from studying art.[9] In most European countries, this situation continues on into the present day. For instance in Britain, where students currently pay a fee that largely covers costs, the enrollments in art departments continues to rise at least as fast as in other departments. After winning the 1981 elections, the socialists in France increased the subsidization of art education and ignited a spectacular rise in enrollments. (In the year 2000 in the Netherlands, a new system of financing art schools was instituted to indirectly limit enrollment figures in the fine arts departments at various colleges. Whether this is a sign of changing attitudes with respect to control or an inevitable correction of an earlier excessive growth rate, is at present difficult to tell. There are signs however, that current enrollment figures at the autonomous departments have gone down in the Netherlands.) So far, it is still basically true that barriers that lead to a formal control of numbers of artists are unacceptable because creativity must not be hampered by official regulations.

It is unthinkable that art 'intruders' could simply be scared off – as is the case with other professions – by telling them that, 'We will call the cops if you ever promote yourself as a tenor because you do not have the required qualifications.' Or more generally: 'We will call the cops if you attempt to work as an uncertified artist.' Using coercion to prevent a colleague from painting or making music would violate people's deepest belief with respect to art: that of the autonomy of the arts and artist. The arts would lose its sacred status if the entrance to the arts was formally limited. Even the body of knowledge must remain as unrestricted as possible. *The arts resist a formal control of numbers of artists. Barriers that formally control numbers are taboo* (thesis 100).

3 In the Past Numbers of Artists were Controlled

Because formal barriers are not important in the arts, the arts appear to be relatively open. The entrance fees are low and people with equal amounts of talent appear to have equal chances. Thus far, the analysis

confirms most of the popular images people have of the arts. Looking back at the history of the arts, however, this conclusion could very well be premature.

Before I argued that in the past, until the second half of the nineteenth century, a formal control of numbers or occupational control was common in the arts.[10] For instance, in France until the end of the seventeenth century, painters' guilds regulated sales and the types of materials used, and they also issued licenses to individual painters. Thereafter, the Académie Royale maintained a monopoly and forced all independent painters to join its organization. Moreover, it also defined the 'correct' style; this style was taught in school.[11]

In the nineteenth century, the number of artists grew rapidly. An increasing number of these newcomers were so-called bohemian artists. They opposed the basic bourgeois mentality. Their romantic alternative put autonomy and authenticity first. This idea countered the notions of control and regulation. During the second half of the nineteenth century, a regulated supply came to an end under the pressures imposed by numerous newcomers, by the deviant mentality of these new bohemian artists as well as the success of new distribution channels. The Academy collapsed, along with comparable institutions in other countries and in other art forms.[12] Since that time, both the regulation of supply and the idea of enforcing a correct style are unthinkable because they are contrary to the very essence of art.[13]

It turns out that *both the bohemian ideology of the autonomy of the artist and the pressure of burgeoning numbers of artists forbid the formal control of numbers in the arts* (thesis 101). In the first place, formal regulation would be futile. If certain artists were excluded from the profession, new groups of 'marginal' artists would continuously find ways around officialdom and become more successful than 'qualified' artists. Secondly, given the mystique of the arts, society in general does not approve of a formal regulation of numbers in the arts. (After all, regulations might prevent a genius from being discovered.)

In this respect, the artist's status is ambiguous. On the one hand, artists regard themselves as professionals in a similar way as, say, doctors do. Artists evidently have a long professional history. And as artists they have attained a high level of status. On the other hand, the status of the arts as profession cannot compete with the status of comparable professions.[14] It has experienced its ups and downs, but over the past one hundred years, art as a profession has never had much status.[15] By refusing to regulate the size of the group one ultimately decreases the status of a profession. In medicine and other professions with a high level of professional status, this kind of regulating is an important demonstration of

the power of a particular profession. It shows who is in charge and it keeps income within a particular profession relatively high.

4 Granting Certificates to Commercial Galleries in the Netherlands (An Example)

Even though the arts have changed and barriers that formally control numbers are insignificant in the arts these days, this does not necessarily mean that barriers don't exist and that the arts are totally open. On the contrary, the arts have many barriers, both formal and informal. In order to explain how informal barriers work, it is useful to look at an example.

In 1992 in the Netherlands, a number of galleries were expelled from an attractive subsidy program. In that same year, just about the same group of galleries was excluded from participating in the most prestigious commercial art fair in the Netherlands, the KunstRAI. If this was a coincidence, it was an extraordinary coincidence. If it wasn't, it makes it all even more astounding. After all, it was a public institution that issued the subsidies, while the fair was a private industry event. It's difficult to see how the actions in these two sectors were attuned.

Two formal barriers were involved in the expulsions. Applicants had to meet certain objective criteria, but ultimately admission depended on the decisions of two selection committees.[16] Admission to both the subsidy plan and the trade fair were important for gallery owners because of the financial advantages but even more because of the indirect signaling effect. Participation in both subsidy plan and fair served as symbols of 'quality', which by association means a division between 'good' and 'bad' galleries. Galleries without these two signs were worse off.

The signs were even more attractive because they were not meant to signal quality. If galleries had gotten together to create an institute to certify 'quality' galleries, it wouldn't have worked because it would run contrary to the liberal autonomous spirit in the arts. The same, however, does not apply to free riding on existing classifications. In this case, existing signs serve as 'marks of quality by association', and thus serve as informal barriers.

Both the subsidy plan and the fair had been under pressure to reduce the number of participating galleries.[17] Therefore, the two parties had each created a committee to select participating galleries. Both committees consisted of gallery owners and independent experts. There was no overlap between the two committees. As noted, the fair was a private enterprise, while the subsidies were granted by the Dutch government. Nevertheless, miraculously, the two committees somehow decided on an

almost identical division of galleries to be included and excluded.

Let's examine how this could have happened. In 1992, Dutch government-sponsored avant-garde art was high and the fair's directors were willing to forsake some financial remuneration in return for the prestige that avant-garde art accorded. Therefore, both committees invited independent experts as well as experts from a business organization of government-oriented avant-garde galleries. Although these experts all knew one another, they later denied that they had discussed a common strategy for the selection of galleries beforehand. And this is probably true. There was no need for a conspiracy because the committee-members were already 'in tune'. They already spoke the same language. In the discourse they used all the right words and 'correctly' applied their knowledge of representative galleries and artists to other galleries and artists. Without any conspiratorial intent, they 'naturally' came up with the same selection of galleries. The members of the two committees were gatekeepers of the same informal barrier that surrounds 'quality' galleries.[18]

5 Characteristics of Informal Barriers

In the example above, experts used an implicit definition of 'good' and 'bad' galleries, and thus defined boundaries and barriers. The 'good' galleries that are on the inside belong to a privileged circle; the 'bad' galleries remain on the outside. In the same implicit way, insiders use definitions of 'good' and 'bad' art or 'good' and 'bad' artists. Below are some stylized characteristics of informal barriers. (Sociology offers an extensive literature on related subjects like gatekeepers, classifications, reputations, networks, and the transfer of capital.[19] It's not my intention in this chapter to improve on these findings. I primarily rephrase the findings to explain informal barriers and monopolization in the arts from an economic point of view.)

a The control of an informal barrier does not rest with appointees or any official institution. Instead, the authority is an anonymous entity. It comes from a collective of gatekeepers who may not know one another. By defining forms of recognition, they produce an informal barrier.

b Anybody who takes part in the discourse on the recognition of art and artists and who is able to influence the discourse is a gatekeeper. Artists and other experts like critics, gallery owners, dealers, impresarios, civil servants etc., can all be gatekeepers.

c Inarticulate terms are used in discourses on the arts. Their meanings change rapidly.[20] Gatekeepers know the ins and outs of these shifting

terms. Connotations refer to 'good' and 'bad' artistic styles, trends, attitudes, etc.[21]

d As styles become increasingly difficult to describe, the names of a few key artists rather than of styles are used to denote a circle of recognition.[22] On the basis of these names gatekeepers can tell which artists belong or do not belong to a certain circle.

e The defined selections and circles of recognition are versatile. They change as the process of defining the barrier changes directions. This kind of versatility is possible through the use of container words, such as quality, original, authentic, cutting edge, or innovative, and of names of key artists who represent other related artists as well.

f Gatekeepers have an information advantage that allows them to monopolize the discourse, which in turn enables them to easily exclude both artists and experts who do not understand the discourse well enough.

g For producers and consumers alike, informal barriers are a signal that artists inside the circle have qualities that artists outside the circle do not have.

h In practice there are, within any art form, only a limited number of different circles of recognition that effectively signal quality.

i A formal barrier often becomes temporarily attached to an informal barrier. Its mark stands for the informal barrier. It is a mark of quality by association.

j Certain formal barriers are interconnected because they stand for the same informal barrier.

k Because the government, to a large extent, finances the professional regime in the arts and thus pays the numerous gatekeepers, these gatekeepers take care of the government's interests.

l Informal barriers function as reward systems.[23] By passing through a particular barrier after fulfilling its requirements, artists start to share in the rewards of a privileged circle.

m Informal barriers hinder competition. Memberships within a circle are limited, which means more monetary and non-monetary income for insiders and less for outsiders.

The existence of informal barriers in the arts can usually only be made credible. A first clue in the investigation of informal barriers and circles of recognition can often be found in formal barriers, because these formal barriers sometimes get temporarily attached to informal barriers. Formal barriers offer anchorage and a clearly visible sign of quality as well as an organizational structure for gatekeepers. Formal barriers in the arts are easily discerned. Admission to advanced training, diplomas,

subsidies, prizes and awards, admission to an artist association, museum purchases, invitations to arts fairs, having one's work performed by a well-known orchestra, and receiving a prestigious teaching job are all obvious signs of formal barriers. Many of these barriers employ ballots or forms of cooptation. They are effective however, because they rest on underlying. The link is temporary, however, because formal barriers cannot function as signals of quality in the arts in an official and permanent manner. This would be contrary to the autonomy of art and artists.

An example of temporary anchorage was presented in the first illustration. The type of subsidy Alex received (a 'werkbeurs'), was extremely important because in the Netherlands it was very visible and functioned as a sign of passage into an important informal circle of recognition. As a sign, it was conspicuous. (It is currently less important as a signal.) In the arts these 'marks of quality by association', which were never designed to certify artists, are less objectionable than permanent formal marks like diplomas, which are designed to certify artists. Therefore, when formal barriers gradually becomes rigid and begin to limit artistic freedom, the informal barrier becomes attached to other formal marks.

When government subsidizes artists and when people organize, for instance, a music concourse or an art fair, they create formal barriers and so, deliberately or not, they enable anchorage to take place with one or more informal barriers. Without their intervention, the informal barriers would be less effective. To some degree, the government and those who organize a music concourse or a fair are responsible for the 'good art' versus 'bad art' dichotomy produced by the informal barrier. Nevertheless, because an informal barrier connects different formal barriers, it is sometimes difficult to figure out exactly who is most responsible. In the illustration, the impact of government subsidies was stressed. At the same time however, the aforementioned fair could have been decisive. (Alex's work had been exhibited at the fair and the government committee members could have seen his work there. The phenomenon of the 'joy of recognition' will often mean that committee members will sooner grant subsidies to artists whose work they have already seen than to artists whose work they've never seen before.) Therefore, government barriers in part depend on market barriers and vice versa. Nevertheless, one type of barrier often dominates. In the Netherlands, for instance, the government barrier is usually the more important barrier, as we saw in the first illustration.

Informal barriers contribute to monopolization in the arts. The degree to which a circle of recognition is monopolized depends on how successful a group of gatekeepers is in limiting group size and raising income. In this respect, it does not matter whether or not the monopolization is

intentional and the actions of the gatekeepers are coordinated.

Informal barriers as opposed to formal controls of numbers exist in the arts. They limit the number of artists in a circle of recognition and raise their monetary and non-monetary income. Experts, including artists, sharing a specific discourse function as gatekeepers (thesis 102).

6 Informal Barriers Protect Collective Reputations

Because most art forms already have a huge supply of art and artists, art consumers have plenty of choice. But deciding is not easy. One often needs to be an expert to know the value of a particular artwork among the oversupply of, for instance, pop music and contemporary visual art. Is the work insignificant or does it represent the beginning of a new and important trend? With respect to new art, there is a certain amount of 'uncertainty of taste'.[24] Art moves in many different directions, and even experts find it difficult to predict long-term developments. Nevertheless, experts still have a better idea of what is hot and what is not than the average consumer does. Because information is asymmetric, like in the case of used cars, experts assist consumers in distinguishing 'good' from 'bad' art by granting various marks of quality in the form of reputations.[25]

Reputations in the arts signal quality. Like the certificate on the door of the used car dealership, a reputation promises certain qualities for consumers, which artists without this reputation cannot offer. Nevertheless, a reputation is not a certificate; it is not a piece of paper conferring certain rights on the owner, rights that are guaranteed by some official authority. Instead, a reputation in the arts is part of a discourse in which many reputations are formed, assessed, changed, brought down, or protected.

Reputations have (1) an individual component and (2) a collective component. The individual component is the personal trademark of an artist. Artists are usually known for certain authentic characteristics in their work, which they do not share with other artists. This personal 'trademark' is an essential part of their reputation. Because experts including colleagues are continuously assessing the authentic qualities of artists' works, the reputation of, for instance, Freud is different in many aspects from the reputations of Auerbach and Kitaj even though they all belong to the same group of figurative painters.

The collective component of a reputation rests on similarities within a group of related artists. The collective aspect of the reputation plays an important role as long as artists are not considered the top in their partic-

ular art form. This aspect is an imaginary signal or mark of quality, which is connected to the informal barrier that surrounds the group of related artists. (As noted, nowadays these 'schools' usually do not have names, but are known by the names of one or two key artists.) Gatekeepers decide on who to let in (to attain a certain reputation) and those who are to be kept out. In fact, participants in the discourse occasionally let artists in by granting them a favorable reputation, while others are rejected or are stripped of their favorable reputations. This way the favorable reputation of the insider artists can be protected. Letting artists in is often a matter of cooptation, but cooptation within the limitations set by the discourse.

Although no legal means exist to protect reputations, punishing offenders is apparently possible. Taking the favorable reputation away from offenders is the same as revoking a certificate. Artists get a negative reputation and begin to lose income. This is why Margaret in the illustration is reluctant to show her relationship with Alfred. She is afraid that people will learn about the connection and begin to see her work in a different light. This could eventually harm her reputation.

7 Innovations in the Arts are Protected and Indirectly Rewarded

The acknowledgment of the importance of reputations helps in understanding the extensive presence of innovation in the arts. At first glance, there seems to be little award for innovation in the arts. There are no laws protecting innovation in the arts. Although copyright laws protect actual products such as texts, melodies, dance steps or images, copyright does not protect the innovations in the inherent artistic styles in an artwork. In theory, patent law could protect some of these innovations, as it does in industry, but in practice, patent law is not really applicable in the arts. The law requires unambiguous criteria. In the case of industrial innovations, these criteria are supplied in the form of specifications. Descriptions of styles, however, will always be ambiguous.

For example, anybody can copy Mondrian's style. Not only artists working in the style of Mondrian, but also producers of shower curtains (and Yves Saint Laurent) using Mondrian-like patterns could freely profit from his innovations, as long as they did not directly copy Mondrian's work. In other words, no legal system of appropriation is in place with respect to Mondrian's innovation in style.[26]

At the same time, the costs of innovations are usually high. Sometimes many years of 'research' by one or, numerous artists precede the innovation inherent in a new style. Therefore, without some other system of

remuneration the incentive to innovate in the arts might easily disappear. If governments and other donors didn't finance a large portion of scientific research, the same would happen in the sciences, where patents sometimes are also an unlikely option. Therefore, by analogy, a case can be and has already been made for government subsidies to the arts to help foster innovation.[27]

The necessity of the subsidization of artistic innovation seems logical. It is not however because many creative and performing artists are that eager to innovate. Even though not all art forms value innovation equally, change and development are typical for both the modern creative and the performing arts.[28] Why are so many artists engaged in innovation, if it is, in fact, an unprofitable endeavor?

Although innovators in the arts do not receive rewards by selling patents, they nevertheless do receive rewards. The fact that outside the market gatekeepers give innovative artists a reputation for being innovative contributes to other rewards. Gatekeepers grant a favorable reputation to innovators, which serves as a signal and gives them status and also indirectly increases their market income. Imitators on the other hand, receive an unfavorable reputation and in this way, the reputations of innovators are protected.

This means that while patents serve as formal barriers in the market, important informal barriers replace patents in the arts. The law protects the rights of the patent holders. Only those willing to pay a price are allowed to use patented ideas. Leslie Singer has suggested that the directors of important modern art museums run semi-patent offices because they offer semi-patents to innovating artists by giving them reputations for innovation.[29] By granting these reputations to some and refusing them to others, they manage to control an informal barrier. Therefore, museum directors are experts who play a significant role in creating reputations.

Nevertheless, the influence of museum directors must not be exaggerated. Reputations often begin developing long before these directors become involved. Therefore, the notion of collectives of gatekeepers is more appropriate. They create and assess reputations for innovation.[30]

Science, the twin sister of art, also has to deal with the fact that many innovations cannot be protected by law. The sciences however, have an extremely institutionalized and formal reward system. The sciences employs a system of certified ranks and titles, which is conducted by peers. The arts has no official ranks and titles. Instead, informal barriers based on an ongoing discourse structure the arts. These barriers produce a balance between variety and continuity. The balance shifts over time and varies between art forms. In some art forms, like classical music,

continuity comes first. In others, like the visual arts and pop music, variety and change are more important.[31]

Even though patent laws cannot be applied to most art innovations, these innovations do not go totally unprotected. *Informal barriers controlled by gatekeepers protect reputations for innovation that lead to recognition and indirectly to monetary income* (thesis 103). Since artists are indirectly rewarded for their innovations, a degree of appropriation exists.

8 The Arts are Structured and Developments are Controlled

Discourses change and informal barriers are always evolving. Nevertheless, these barriers confine the economy of the arts; the economy is less open than expected. *Informal barriers* not only confine, but also *structure the economy of the arts* (thesis 104). Therefore, the results of people's activities in the arts are not altogether unpredictable. In this context, I will offer a few remarks on the origin and the mechanism of change in the arts. They may contribute to the understanding of the economy of the arts. (A detailed discussion of the subject falls, however, outside the scope of this book.)

When gatekeepers meet, for instance in committees deciding on grants, they speak the same language because they have been trained in the same discourse. Therefore, they tend to agree easily, sometimes to their own astonishment.[32] Within the process, the discourse changes. New insights gradually creep into the discourse and influence the outcomes of decisions.

In modern art, different schools or styles come and go. By employing the inarticulateness of container terms 'dialects' develop. When a new style survives, the dialect starts to influence the main discourse. And when it becomes more and more noticed, chief experts and peers start to assess the new school or style. At this stage, existing gatekeepers ridicule the new style, fight it, respect it, argue for its recognition, and even start to 'produce' it. This is a give and take between the newcomers and the established experts and peers. In this way, the central discourse changes from within. And so barriers also change.

Usually there is only one dominant discourse. Nevertheless, occasionally a fight between two discourses can go on undecided for a long time, like the fight between avant-garde (contemporary) and traditional (modern) art in Britain discussed in Chapter 3. In this case, two discourses exist side by side which have their own gatekeepers and challengers and that largely change from within.

Although a discourse is flexible, it would be wrong to assume that a discourse can take any form. An art form has a history. Over time cultural capital has been accumulated, which cannot easily be undone. Even when groups disagree, they always have some common ground to stand on. It is above all because of this fixed core that committee members understand one another.[33] By controlling the barriers that new styles face, gatekeepers indirectly define art. They check whether new developments respect the core of the specialization or take it in directions they do not approve off.[34]

The authority or power invested in the informal barriers in the arts rests with groups of insiders, artists, and other experts. In this respect, not everybody who takes part in the discourse surrounding a barrier has the same power. For instance, the director of an important museum of modern art is likely to have a larger say than a critic writing for a local newspaper. This confirms the conclusion in Chapter 3 that not only the power of rich people's money, but also the power of words of those with a lot of cultural capital influences the definition of art, an influence that most others do not have. Because the power to define art is unequally distributed, the arts are not as open and free as they seem to be.

The inaccessible or open nature of the arts also depends on the way the power to define art changes hands. Is it vanquished or is it handed over voluntarily? Is there an element of heredity involved in the sense that important artists and experts hand over power to their own kind rather than to strangers? Viewed from the outside, such a system of cooptation would imply yet another form of monopolization, which further abridges artistic freedom.

In the arts, cultural capital and social capital are important sources of power. They enable experts, including artists, to participate in the relevant discourses. Their capital is found in relationships and a network, in their knowledge of the history of an art form, of its developments, of the names of its relevant artists and of the accurate interpretation of pertinent terminology. However, their power never goes undisputed. If others manage to increase their cultural and social power within the discourse, the value of the cultural and social capital of the first diminishes. Therefore, by controlling the access to circles of recognition, including government funds, the experts and artists concerned have an indirect means to safeguard their cultural capital and pass it on to whomever they choose.

In general, important gatekeepers tend to favor fellow artists or artist friends who belong to the same artistic schools, even the same colleges where the gatekeepers studied or worked as teachers. This means that to be accepted, the cultural capital, as well as the social capital of newcomers, counts. These 'kinfolk' or 'rookies' are likely to respect the cultural

capital of the gatekeepers.[35] (Alfred in the illustration is evidently not an important gatekeeper, but an outsider. Although Alfred may have influenced Margaret, she joined an established circle of recognition with its own leading artists. Because Margaret doesn't take risks and goes to great pains not to offend her colleagues, she is more of a rookie than a rebel. Nevertheless, occasionally gatekeepers invite a 'rebel' in as well. Sometimes the alliance with a young rebel can slow down the devaluation of the gatekeepers' capital.)

At the end of their careers, the old guard's power will necessarily diminish, but their capital can remain valued and respected. Protégés choose their own directions but will refrain from ridiculing the outdated capital of the old guard and continue to pay tribute. In this way the cultural capital of older artists lives on in the work of their younger colleagues and becomes part of the core of the specialization. This is how successful older artists increase their chances of having their art outlive them.

Because informal barriers protect the benefits of a privileged position, allow cooptation, help channel the benefits to 'offspring', and sometimes safeguard privileges beyond the death of the artists concerned, they lead to monopolization (thesis 105).

The largely unintentional mechanism described above is also present in other professions, above all in the sciences. The difference is that newcomers in the arts unjustifiably expect the arts to be open. Therefore, they arrive in droves, are ill-informed and unaware of the extent of informal monopolization in the arts.

9 The Risks of Some are Reduced at the Expense of Others

Due to informal barriers the arts are structured and partly monopolized, but the structuring is informal and difficult to discern. Informal monopolization causes a reduction in risks for artists in privileged areas, while risks are higher for artists outside these areas.[36] In the selected areas, average income, in the form of recognition and usually some money as well, is higher because many are excluded and numbers are relatively small. Therefore, competition is less intense. In these areas, there is a consolidated effort to support the reputations of artists. Artists are also informally protected against theft of the intellectual property inherent in their innovations. Moreover, risk is further reduced as gatekeepers partially control the development in the discourse about art. Therefore the chance that totally unexpected developments will occur is smaller than elsewhere.

Informal structures make some areas in the arts slightly more predictable and therefore less risky for its participants. But it does not turn these areas into a safe haven. Even in these areas, however, artist's careers are in no way comparable with university careers, for instance. Risks remain relatively high. Nevertheless, once an artist drifts outside these areas the risks become even greater. Risk reduction in the inner circles implies increased risks in the unstructured outer zone. In other words, some profit at the expense of others.

When I envision the arts, I picture a large outer zone in which many unsuccessful artists dwell and a small inner zone comprised of a small number of more or less successful artists. In my picture, height stands for recognition. The large outer zone is a plane and the inner zone is a mountain in the middle of the plane with a few peaks. The beginning of the mountain range and the contours at different heights indicate three or four successive circles of recognition. Because newcomers with equal artistic talents seem to have the same small chance of crossing the plain to reach the mountain, they all seem to be as bad off in the unfriendly outer zone. This is not true, however. Due to other differences in social, cultural, and economic capital, newcomers in the arts face different risks. On average, those who manage to cross the first barrier, the plain, have more social, cultural, and economic capital than the rest. And after that, fewer and fewer artists reach the higher mountain peaks, i.e., the higher circles of recognition. Again and again, more and different capital is required to keep going. Some has been gathered along the way; other capital was already there. Most artists, however, never manage to leave the outer zone.

Chapter 5 argued that artists are ill-informed about the arts; because of the myths about freedom and autonomy they can't see the full extent of the barriers. Therefore, many people enter the art world, who would not have entered, had they been able to see the barriers clearly. *Because the control of numbers in the arts is informal rather than formal, people contemplating a career in the arts are usually ill-informed; they think the arts are more open than they really are and they are unaware of the extent to which informal monopolization characterizes the arts* (thesis 106).

10 Conclusion

Why does Margaret, in the earlier illustration, publicly deny her relationship with an artist friend whose work she admires? And why is it so important for artists to be favored by the government? Margaret has

passed through the informal barrier that surrounds an attractive circle of young, successful avant-garde artists. She does not want to jeopardize her position by revealing herself as having too many inappropriate connections. Meanwhile, artists seek government recognition because it represents the informal barrier that distinguishes 'good' from 'bad' artists.

On the one hand, the economy of the arts is exceptional because there is little occupational regulation. No diplomas are required to practice art or to call oneself an artist. Admission to the existing bodies of knowledge in the arts is also not controlled. There is a taboo on both forms of control because the arts need to protect their autonomous imago. The arts must appear to be open. On the other hand, however, the economy of the arts is exceptional because of the existence of many informal barriers that are difficult to ascertain and ultimately reduce the openness of the arts.

Successful artists and other gatekeepers control informal barriers. As was the case with Margaret, only limited numbers of artists are admitted into specific circles of recognition. Versatile rules develop and are applied during discourses among insiders, who don't necessarily know one another. Using this kind of discourse reputations are built, assessed, or destroyed.

Reputations resemble property rights in the market because when experts and peers recognize the style of a particular artist or a group of artists, another artist or group can no longer lay claim to this style. Therefore, although artists cannot acquire patents to protect their work under the law, their innovations are nevertheless informally protected.

It turns out that in the introduction to this chapter both the artist and the economist were wrong in assuming that few barriers exist in the arts. There are more barriers in the arts and the arts are more structured than one would expect in the absence of a formal control of numbers. People entering the arts are often not aware of the numerous barriers. They believe that all that matters is talent and hard work. Many artists will continue to think this way until their dying day. This attitude is part of the artist's habitus. Artists are apparently ill-informed. The importance of barriers is underestimated, and so artists come in droves and their average incomes are low. This means that another explanation for the large numbers who enter the arts and their low incomes is the relative invisibility of barriers in the arts.

The arts appear to be a rough field to enter. It seems that everybody is as bad off as everybody else is. Nevertheless, for reasons nobody quite understands, some find their way while others do not. This chapter has hopefully made it clear that there are underlying structures, which privi-

lege some at the expense of others. In practice, areas of reduced risk in the arts are reserved primarily for those with sufficient amounts of the right kind capital.

Discussion

1 One view has the arts pictured as an extremely anarchistic sector where everybody only looks out for themselves. Another view of the arts is that it's more like a battlefield where successful artists command armies of disciples and together with other gatekeepers they 'organize' the arts in order to leave their mark on art history. What is your view?
2 In this chapter, part of the explanation has been shifted to areas, which are not treated in this book. What is the origin of artistic development? How do informal structures and monopolization emerge and how do they develop? How do differences in capital arise? Can you elaborate on these subjects?

Conclusion: a Cruel Economy

Why Is the Exceptional Economy of the Arts so Persistent?

Apologizing for not Going into the Arts

Alex meets Marco at a classical music concert. When Alex tells Marco he's a visual artist, Marco confides in Alex that a few years earlier he had contemplated about going to a music conservatory to study composition. He explains that he is a good pianist and that he has won some prizes at concourses for young people. During their conversation, he reveals his regrets about going into information technology instead. But his regrets appear to be of the romantic kind; the sort of regrets people can indulge in. Alex is more struck by the fact that Marco is apologetic about his choice not to go into the arts, as if he has done something wrong and now must apologize. Maybe he feels the need to apologize because Alex did manage to go into the arts. In Marco's opinion, Alex has done the right thing.

This has happened to Alex before: people being apologetic for not choosing the arts. Marco is, however, the first who explains why he is apologetic. He notes that by letting the arts go, he feels that he missed out on something special. By not becoming an artist, he has harmed himself, like he has mutilated himself. He could have put himself, his personality, into his compositions, which would have allowed his personality to grow. He would have become a more complete human being. Moreover, he would have belonged, belonged to the world of art. But it's not just he who has lost out – Alex mustn't think him arrogant – but society also lost out because of this regrettable decision. If he had become the composer he wanted to be, he is sure he could have offered something significant to society. He would have joined the group of artists who help shape the history of art, of civilization itself. Yes, he is ashamed of his choice and deep down he feels guilty.

Alex tells him that despite his talents, his chances of actually making it as a professional composer would have been extremely slim. Marco says that this just makes things worse. It demonstrates that he is a coward, somebody who wants to play it safe.

Alex has to admit that Marco doesn't appear to be a very adventurous person. Moreover, Alex notices that he thinks Marco is 'bourgeois', even though Alex knows he should be congratulating Marco in his decision to choose a lucrative career.

Alex has discovered people like Marco everywhere, even in a poor country like Brazil. Alex (the alter ego of the author) wrote this chapter in Recife, Brazil. One day, while he was in an alternative bar in the new part of Recife, Alex met a woman, Maria, who told him that she had always wanted to become a dancer but ultimately decided not to. It struck Alex that she talked about it in exactly the same apologetic tone of voice as Marco. On another night, Maria introduced Alex to a group of dancers. None of them were employed at that time. Nevertheless, some had been working for fringe dance companies in different cities in Brazil, and were hoping to continue to do so. The amazing thing was that their descriptions of the Brazilian fringe dance scene sounded a lot like the fringe dance scene in the Netherlands: the same kind of dedication, the same hardships, the same large groups of dancers working only once in a while. The fundamental beliefs that underlie the arts and the economy of the arts are more international than Alex had thought.

Marco's apologetic behavior lies at the heart of the exceptional economy of the arts. While Marco may have regrettably decided to not pursue art, many others decide precisely the opposite. They enter the art world because the arts are extremely attractive, despite the prospects of low incomes. The arts offer something 'extra' that makes Marco apologetic.

I set out to write this book to explain why incomes are so low in the arts and why the arts remain so attractive as well as the phenomenon of the large amounts of donations and subsidies the arts receive. During the process, it turned out that in many respects the economy of the arts is an exceptional economy. In this concluding chapter, I will list the aspects which makes the economy of the arts exceptional. I will also summarize the book's findings with respect to low incomes and the large gift sphere. On top of that, I will try to analyze the results by attempting to answer, first, whether the economy of the arts can be qualified as a cruel or merciless economy, and secondly, whether artists sacrifice themselves or are sacrificed within this merciless economy.

As an artist, I am aware that the arts did not bestow the romantic alternative upon me I had hoped for. Being an artist is just a lot of hard work and also badly paid work. Nevertheless, I continue to believe that all my struggles will ultimately be worth the effort. I am convinced that in the years to come I will contribute something significant to the history of art. Because the work is hard and badly paid I really need this kind of belief to keep me going. *As a social scientist,* I am now aware that the arts are a tough place for many of those who take the plunge. The economy is merciless. It is also an exceptional economy. Because of all the myths that swaddle art, the economy of the arts is persistently exceptional.

1 The Economy of the Arts is an Exceptional Economy

In the course of this book, I have drawn a picture of the economy of the arts that shows its exceptional nature. The following table lists several exceptional aspects as they appeared in the pages of this book. Taken together they portray an exceptional economy.

TABLE 4 ASPECTS CONTRIBUTING TO THE EXCEPTIONAL NATURE OF THE ECONOMY OF THE ARTS

1	The valuation of art products tends to be asymmetric; one group looks up to the high art of the other group, while the latter looks down on the low art of the former. (Chapter 1)
2	In the arts: (1) the economy is denied; (2) it is profitable to be non-commercial; (3) commercial activities are veiled. (Chapter 2)
3	Art and artists have an exceptionally high status. *(Chapter 1)*
4	Artists overlook or deny their orientation towards rewards. (Chapter 4)
5	Top incomes in the arts are extremely high; higher than in other professions. *(Chapter 5)*
6	The large majority of artists earn less than other professionals do. Hourly income is low or even negative. In the modern welfare state, this is truly exceptional. (Chapter 5)
7	Despite these low incomes, an unusually high number of youngsters still want to become artists. The arts are extremely attractive. (Chapter 5)
8	Beginning artists face far more uncertainty than the average beginning professionals. (Chapter 5)
9	Money represents a constraint rather than a goal for many artists. (Chapter 4)
10	Artists are (more than others) intrinsically motivated. (Chapter 4)
11	Artists are (more than others) oriented towards non-monetary rewards. (Chapter 5)
12	Artists are (more than others) inclined to taking risks. (Chapter 5)
13	Artists are unusually ill-informed. (Chapter 5)
14	A combination of myths reproduces misinformation about the arts. (Chapter 5)
15	Artists more often come from well-to-do families than other professionals. (This is even more exceptional because usually the parents of 'poor' people are also poor.) (Chapter 6)
16	Poverty is built into the arts. Measures to relieve poverty do not work or are counterproductive. (Chapter 6)

17 The arts are characterized by an exceptional high degree of internal subsidization. By using non-artistic income artists make up the losses they incur in the arts. (Chapter 6)
18 The gift sphere in the arts is large; subsidies and donations comprise an unusually large portion of income. (Chapter 2 and 8)
19 Unlike other professions, the arts do not have a protected body of certified knowledge. Anybody can access it. (Chapter 11)
20 Unlike other professions, there is no formal control of numbers in the arts. Anybody can pursue an arts career regardless of their qualifications. (Chapter 11)
21 Many informal barriers exist in the arts. (Chapter 11)

The exceptional nature of the economy of the arts, as it emerged in the chapters of this book, is a relative exceptional phenomenon. The difference between it and other sectors is a matter of degree. Nevertheless, given the combination and intensity of exceptions, the phrase 'exceptional economy of the arts' is justified.

2 Despite the Many Donations and Subsidies Incomes are Low in the Arts

This book has attempted to answer the questions of why income is low in the arts, why the arts are so attractive and why they receive so many donations and subsidies. The main answer to the first two questions was sought in the high status of the arts. It leads to overcrowding and therefore to low incomes. A number of reasons were given for art's high status. The denial of the economy both stems from the high status of the arts and contributes to this very status. Because the average artist cares less about money and more about non-monetary rewards than other professionals do, the high status of the arts causes overcrowding and low incomes. Incomes are also low because artists believe they miss the capabilities needed in 'normal' professions, and because artists tend to be less risk-aversive than others. Moreover, prospective artists are structurally ill-informed, and therefore even more youngsters enter the profession and incomes end up being even lower. The willingness to work for low incomes is so great that, when an artist's art income is too low to earn a basic living, artists often utilize income from second jobs or money donated by partners to continue making art. Finally, this book argued that donations and subsidies designed to relieve poverty in the arts have the opposite effect; they tend to increase the numbers of artists with low

incomes. Moreover, well-known subsidy programs for artists give the signal that the government is willing to take care of artists and thus add to the overall attractiveness of the arts and therefore exacerbates the conditions that produce low incomes.

At first glance, the answer to the third question 'why do the arts receive so many donations and gifts' seems to originate with the answer to the first question. Because incomes are low and because people want to relieve poverty in the arts, private people, corporations, and the government support the arts. To a degree, this book went along with this explanation. The argument that private and public gifts are necessary to counteract poverty in the arts has contributed to the large size of donations and subsidies for the arts, even though the effect has probably been the opposite, namely more poverty. In the long run however, it can't be ignored that donations and subsidies have little or a negative effect. Therefore, it is unlikely that the poverty argument can explain the total dimensions of the large gift sphere in the arts.[1]

Instead, this book has put most emphasis on the explanation of the large gift sphere in terms of the interests that donors and governments have in giving to the arts. In other words, donors and governments receive returns. Both donors and governments use art for display purposes. Therefore they buy art and even more give art. Chapters 8 and 10 analyzed the many purposes this kind of display serves. Donors and governments profit from the high status of the arts, while at the same time they add to this high status. This takes us back to the beginning: the fact that the high status of the arts contributes to the large numbers of artists and low incomes. Therefore, many gifts are more likely to contribute to poverty than to relieve poverty.

3 A Grim Picture has been Drawn

Can the exceptional economy of the arts be characterized as a 'merciless' economy? If it is merciless, this can be revealed in two ways. Firstly, in a subjective sense – the portrait of the arts in this book pretty much debases art. Secondly, in an objective sense – many participants in the arts economy are worse off than they would have been had they chosen other occupations.

People tend to attribute high and admirable qualities to art. In a subjective sense therefore, the economy does not live up to the rosy picture people have of the arts. It is unpleasant to acknowledge that art has two faces and that it is profitable for artists to deny the economy. It is annoying to learn that monetary and aesthetic values often coincide. It is hurt-

ful to learn that donors and artists are not selfless. And it is disappointing to discover that the arts are not open and independent and that there is no such thing as an equal chance. Barriers exist everywhere and winners pass their advantage on to their protégés. Therefore, surviving in the arts is not just a matter of 'natural' talent. The picture remains disappointing, because it contradicts the myths that surround the arts. The insights of this book tend to demystify the mythology of the arts and this can be a painful experience.

When I think in terms of a merciless economy, however, I first think of objective characteristics. The clearest sign of a merciless economy in an objective sense is low average income and the fact that poverty is structural. Some people earn extremely high incomes and yet average income is much lower than in comparable professions. Income is often so low that it doesn't even cover the costs of the profession, like instruments, materials and studio rent. Average incomes are not only low; they are virtually fixed. Higher demand or greater donations and subsidies do not raise income levels, instead they encourage more people to enter the arts. With more money funneled into the arts comes ever-increasing numbers of poor artists per capita and thus rates of poverty increase as well. Built-in poverty is a clear manifestation of a merciless economy.

Because of the mythology that surrounds the arts, youngsters run to the Promised Land, thinking they're going to find a pot of gold once they get there. Many of them leave the profession many years later, disillusioned and too old to start a new career.[2] Because of art's sacredness, beliefs are persistent and are not subject to correction. Losers blame themselves for not having been dedicated enough. They never blame the structure of the arts. Unlike after the gold rush when people start to go home artists do not realize that there are far too many of them seeking their fortunes. Moreover, nobody ever asked to see their diplomas or membership cards. In other sectors, membership is regulated both to the profession and to the inner circles within the profession. This kind of regulation also serves as a deterrent. The numerous informal barriers in the arts, however, remain ambiguous and invisible from a distance. They do not, needless to say, deter newcomers.

Given the fact of low average incomes, artists only manage to survive thanks to internal subsidization. Because the sacredness of the arts is taken for granted, giving to the arts has a ritual aspect and some gifts are more or less obligatory. Huge amounts of money from second jobs, partners, family, and friends, continue to flow into the arts. With its army of superfluous artists, the arts are insatiable; they scrounge off anyone in their path. This ability to extract gifts could be a characteristic of a privileged situation. But because few people appear to profit from the gifts

and most of the money disappears into a bottomless pit of ever more poorly paid artists, the continuous support of the arts exemplifies a grim rather than a privileged state of affairs.

Thus far, the analysis confirms the cruel nature of the economy of the arts. And yet, artists are not necessarily as bad off as other low-paid professionals. As indicated in Section 6.11, they probably receive more than the average amount of private satisfaction and other forms of non-monetary income such as status. These forms of remuneration are probably more available in the arts than elsewhere and artists are more oriented towards these rewards than others. Artists are inclined to exchange money for other types of income. When artists appear to sacrifice themselves and are poor in monetary terms, their poverty is partly compensated. It is however difficult to tell to what degree.

This book has also emphasized that the aura and the mystique of the arts misinform artists. Because of the mystique, many well-trained youngsters enter the arts with high expectations. As noted, some stay, while others leave the arts at a later stage, when it is generally impossible to start a new attractive career. In either case, the subsequent disappointment is an existential disappointment because it concerns all aspects of life. The poverty due to misinformation is not compensated. I therefore personally think that the word suffering can be applied to poor artists, even though they receive some compensation.

In certain respects, the economy of the arts resembles a pre-capitalist economy. The many gift transactions remind us of this. The same applies to the idiosyncrasies inherent in both market and gift exchanges in the arts. As was the case in feudal times, the personalities of the two participants entering into the transaction are essential, as is the notion of dependence. Personal contact and dependence play a decisive role in the many transactions that take place in the art world; between artists and dealers, artists and curators, artists and impresarios, between dealers and customers, between customers and artists, between artists and patrons, and between artists and government officials.

Other aspects of the economy of the arts, however, remind one of the heyday of capitalism. Many toil while few profit. The extreme uncertainty that beginning artists face does not jive with the reality of a modern economy with its general regulation of numbers and regulated markets with built-in securities.

These similarities only exist in a relative sense. Unlike 19th-century workers, modern artists don't starve. There are at least four reasons for this.

1 Artists don't starve because of the support offered by families and partners.

2 Artists manage by benefit of modern social security. While families and partners have played a significant role in the arts for several centuries, the assistance offered by social security is relatively new. Although artists still take relatively high risks, these risks are lower than they would have been in earlier times.

3 However ill informed potential artists may be, they have a choice; they could choose another profession. The old proletariat of the past had no choice. The main reason however, why artists don't starve, is that:

4 Many artists have second jobs. Nonetheless, because these second jobs are usually unskilled, most of them remain underpaid considering their levels of education. (If in the distant future the majority of artists were to have attractive, well-paid second jobs, the economy could no longer be termed merciless.[3])

These four points demonstrate that poverty in the arts and the mercilessness of the economy of the arts are relative concepts that exist in comparison to other modern sectors.

4 Winners Reproduce the Mystique of the Arts

After the gold rush, the vast majority of miners end up leaving to try their luck elsewhere; the gold rush is over. Why has the 'art rush' lasted so long? Why do poor artists stay or leave at a much later point in their careers than one would expect, and why do so many newcomers arrive to take their places? Why is poverty structural? First of all, it should be noted that nothing is permanent. Overcrowding and large-scale poverty in the arts are relatively recent phenomena, becoming widespread only after the Second World War and these conditions could very well disappear over the next fifty years. Nevertheless, this book has tried to show that, for the time being, current conditions help maintain an exceptional economy of the arts and poverty that remains structural.

In this respect, it should be noted that the fact that the economy of the arts produces a host of losers and a few winners, is not exceptional. The same occurs in every other economy as well. For example, the introduction of the mobile phone spawned many telecom outlets. Three years later most of these shops had gone out of business. Those who survived were the apparent winners in the market reward system. Thus, the notion that contestants compete for a market share and that some will lose is not exclusively an arts related phenomenon. What is exceptional however, is that, unlike the cases of the telecom shops or the gold diggers, art economy losers don't necessarily leave and others continue to choose

to enter the art world. The sector continues to be just 'too' attractive. This book has tried to describe the mechanisms that keep the sector attractive and the economy exceptional.

The economy of the arts as depicted in this book represents a relatively closed system. The key is the high status or aura of the arts. Because of the mystique of the arts, most players in the game believe they have an interest in its high status and act in ways that will assure that its high status is maintained. This applies to governments and other donors, successful artists, critics and people working in art institutions, but it also applies to the majority of unsuccessful artists who earn little or nothing from their art. Within the confines of the system, everybody is right because if the arts were to suddenly lose their high status everybody would be worse off – at least in the short run.

Nevertheless, observing this all from the tenth floor, one notices that in the long run not everybody is well off in the present setting. In the previous section, I opined that many artists appear to suffer the consequences of the reality of the economy of the arts. I believe that artists are primarily sacrificed, even though they also sacrifice themselves. Or in other words, artists are exploited. Exploitation implies that there are people who receive unearned income from unequal forms of exchange.[4] Who are the exploiters? It is natural to seek out the 'exploiters' among the winners. Nevertheless, given the importance of myths in the arts, it is difficult to discern who is precisely exploiting whom in the arts. Therefore, I do not concentrate on tracking down those who profit the most from exploitation. Instead, I look for 'social needs' or 'powerful social relations' that induce behavior that reproduces the status quo in the arts. The following needs are particularly important in the process of reproducing the status quo.

1 Because the art world believes it has an interest in sacred art, it needs government assistance to help maintain or raise the status of the arts.[5]
2 Donors, governments, and consumers need art to be sacred for their own status and legitimization.[6]
3 Art consumers believe they need a large stock of potential losers to increase the chances of a few extraordinary talented artists emerging to sustain the myth that artistic talent is indeed scarce.[7]
4 The art world, donors, and governments need countless losers to enhance the high status of the winners.
5 Society needs a sacred domain. The first three items were treated in earlier chapters; the last two I will briefly discuss now.

A notion that has gone unspoken in this book is that the high status of the arts, of its successful artists, of its art institutions, and of its important

donors, is even higher because of the presence of so many failed artists. 'If so many take the plunge and fail, those who succeed must be special indeed.' The more losers, the higher the status of the successful artists will be. But the real winners at the expense of the failed artists are the art institutions and the donors. Art institutions and donors need many people to become artists and many who fail, are disillusioned, but continue to work as artists or abandon the art world. They thrive on the romantic notion of the starving artist. (They legitimize their preference for the large pond by explaining how among all of these struggling artists there will emerge a few unexpected geniuses.)

The winners – both successful artists and donors – profit, but it is unlikely that they can be portrayed as active profiteers. Because the benefits are based on existing beliefs, there is no insidious plan to lure people into the arts. In fact, the contrary seems more likely. Many modern governments go to great pains to improve the deplorable economic conditions of artists. And although government programs sometimes exacerbate the very conditions they are trying to alleviate, there is no indication that governments deliberately do so or have a secret agenda. Moreover, successful artists are more often embarrassed about the general deplorable state of their profession than proud. And so, if the arts go on producing hordes of losers, it is not because there has been some deliberate strategy instituted to abet their failure. Nevertheless, when one observes all this from the tenth floor, it certainly looks like the artist losers enhance the status of the winners. Whether it's deliberate or not, winners reproduce the mystique of art by allowing many losers.

5 Society Needs a Sacred Domain

Marco in our illustration is jealous of artists who dared to pursue their muse. His decision not to go into the arts goes hand in hand with his feelings of guilt. He says it's like he has thrown away his only chance of becoming an authentic human being, a true individual. This means that artists must have 'something special' that other people lack.

Artwork and artists have been accorded a special status for a long time. Even prior to the Renaissance, artists were already becoming less and less the anonymous craftsmen; their names and signatures became more and more significant. Since then art has become 'animated': the artist is 'in' the work of art. In other words, people believe that the spirit or soul of the artist has 'entered' the art work. The personal creativity that goes into the work makes it and the artist authentic. Although being an authentic individual is a general ideal in our civilization, only artists

offer definitive proof of their authenticity. Therefore artists are envied and admired. They offer a romantic alternative to a society of more or less anonymous and replaceable employees – from managers to street sweepers.

This alternative is romantic, 1) because it is unrealistic: not everybody can become an artist, 2) because a false notion of creativity is involved, as we demonstrated in Chapter 2, and 3) because it offers an escape.

The bohemian artist presented a model for those who had a desire to escape the bourgeois lifestyle. Currently, it is seen as an escape from the world of commerce, technology, and science, in which calculation, efficiency, and rationality rule. By belonging to the gift sphere, art stands in opposition to these worlds.

On the one hand, art offers an *alternative*. In a technology and consumption-dominated society, it is not so amazing that many people put the arts on a pedestal as a reminder of another, better world. And it is natural that countless youngsters would want to become artists to escape the dominance of the other professions and to creatively display their individuality. They do so because they hope to share in the mystique of the high status of art, but also because they expect that making art will offer them a personal satisfaction that cannot be found in ordinary occupations.

On the other hand, art also serves as a *counterforce* in a society that is considered by many as too rational, too commercial and too technological. Therefore, art is not some noncommittal alternative to the rational activities in modern society, but a necessary compensation for these activities. It has the potential to counterbalance the unhealthy developments of calculation, rationality, and efficiency in society. Although these opposing spheres of art and rationality are threatening to one another, they also need each other to survive.

Both art and science ultimately contribute to cognition, but it's 'magical' art that relies primarily on dense symbol systems as opposed to 'rational' science, which employs discrete symbol systems.[8] (As noted in the first chapter, in dense systems all variables count: like the color, the width, the impression and the shade of line in the drawing of an artist. In a scientific graph only a limited number of variables matter in a discreet way.)

To gain true knowledge, both approaches are necessary. Art and science are two sides of the same coin. It seems that our society can go a long way in using one side of the coin, while essentially ignoring the other, but there are limits. In everyday practice, the discreet approach typical of science is omnipresent, while the density typical of art is often suppressed. Therefore, artistic expressions are extraordinary. This implies that, as

long as society primarily operates on the rational knowledge of science, the arts will remain special. This societal imbalance contributes to art's sacredness.

The two interests, art as alternative and art as counterforce, merge at a higher level in a more general interest – the need for a sacred domain. Durkheim has suggested that all societies need a sacred domain.[9] Today, religion no longer supplies a satisfactory sacred domain for society. Art has, in this respect, partially replaced religion. If society needs a sacred domain and art offers this domain, society has an interest in maintaining the arts in their present state. For the time being art must remain sacred.

All societies have probably had a sacred domain, which usually involves vital interests. Yet these interests, as they presently exist, do not need to be universal. Every period probably endows the sacred with slightly different values. Durkheim associated the sacred domain with collective and rational values that belong to the soul and that oppose the individual and egoistic desires of the body. Art as bearer of civilization's values in other words.[10] Although the conflict between spirit and body has not disappeared, it is less significant than in Durkheim's time. Contemporary values that are linked with the seemingly irrational or inexplicable are certainly at the core of what we consider the sacred domain; they oppose the rationality of our 'scientific' society.[11] Whether this is true or not, our society maintains a sacred domain, which it endows with significant values. For the time being the arts represent this domain. For this reason, society seems to reproduce the mystique of the arts even though the precise mechanisms employed are not altogether clear.

6 Future Scenarios with More or Less Subsidization

The market is essential to the arts. Approximately half of the arts' income derives from the market. But compared to other sectors, the market remains secondary while the gift sphere continues to be enormous. This gift sphere is both a cause and a result of the exceptional economy of the arts. *The smaller the gift sphere in the arts the less exceptional and cruel the economy of the arts is* (thesis 107). Lower levels of subsidies and donations will turn the arts in a sector that is more like other sectors, which produce fewer victims.

But this doesn't necessarily mean that the amount of donations and subsidies can be changed at will. On the contrary, the findings in this book suggest that the sizes of the gift sphere and market sphere are pretty much fixed. Participants are locked into the exceptional economy of the arts. The epilogue below discusses possible developments that, in due

time, could make the economy less exceptional, but these are not so easily manipulated either.

Nevertheless right or wrong, people tend to see the government as the one player in this complicated game whose behavior can most easily be altered. Therefore, I will briefly try to imagine what the consequences of more and of less subsidization might be.

Let us first envision a situation in which subsidies have been increased. In this situation, the economy of the arts is likely to become even more exceptional and cruel. The emphasis is on a selection of established traditional and modern art that is impressive and has already had its high status for a long time. This selection is continuously celebrated in all sorts of official settings. A portion of this art has clear roots in the past and so it tends to unify the population and to strengthen its cultural identity. Moreover, due to subsidization, part of the fine arts remains affordable for people with lower incomes and is available in towns far from the cultural center of a country. The fine arts retain much prestige, both at home and abroad.

At the same time, there will be more artists and more poor artists and as a consequence a huge oversupply of artists. New art forms will inaugurate relatively little innovation. These art forms and their patrons will receive little respect, while innovators will largely go unheralded. Any significant innovations in these new art forms will most likely come from other countries.[12] Because the barrier between subsidized and unsubsidized art will remain high, younger generations will probably increasingly lose interest in subsidized art.

On the other hand, in a scenario where subsidies have been lowered, art will lose some of its magic and retain less prestige. Because established art will now be considered less sacred, it will be criticized and challenged more strenuously. This causes a lively and innovative cultural climate. Moreover, art, which develops outside of the established art forms, gains more status. There is more praise for innovators. New art forms are less defensive and insular. In the new art forms, many innovations are produced that keep art interesting for new and younger audiences. There is less dependence on foreign countries; the export of new art forms keeps pace with imports or may even exceed import. But art might become less helpful in building a nationwide cultural identity. Moreover, a larger proportion of artistic production will only be affordable for rich people while fewer art products will reach the far-flung peripheries in a country. The oversupply of artists is less dramatic and therefore fewer artists will be impoverished.

Although in the latter scenario there might be fewer artists, average income does not necessarily need to be higher than in the former situa-

tion. But if in the long run art becomes less sacred, fewer people will enlist. In this respect even a moderate formal control on numbers might be introduced. In this case, average incomes would probably rise.

Other characteristics could be included in either scenario. A characteristic judged as advantageous in one scenario may be considered a drawback in the other. Whether it is judged advantageous or not is necessarily subjective. It will probably not surprise the reader that I believe less subsidization has more advantages than more subsidization. Personally, I think that in our current situation, artists and society pay too high a price for art's sacredness. I want to stress that my opinion applies to the arts and not necessarily to other areas of government involvement, like education, heath-care and social security. (I do not belong to the group of economists who generally support the free market-ideology.)

Just because someone prefers a situation of less subsidization in mainland Western Europe, this does not necessarily mean that one wants the European art world to mirror the American art world. In Europe with its own long history of support of the arts, the art world that evolved here has its strong and weak points, but none of it can be changed very easily. Nevertheless, I personally think that the mainland Western European art world while maintaining its strong points, stands to gain by governments, who simultaneously and gradually begin to reduce their art subsidies and involvement in the arts a little, or at least do not further increase art subsidies.

Presently the opposite is happening in Europe however, where after a stagnation period in the 1980s and early 1990s, governments have again begun increasing their involvement. They have also sought to broaden the types of art they now subsidize, including, for instance, pop music and other new art forms. The budgets are currently still small and appear to serve a primarily symbolic function, but once they commence these kinds of subsidies have a tendency to swell fast. If this trend continues, the symbolic competition between established art forms and new art forms will become less unfair. At the same time however, I expect that subsidization will be disastrous for pop music innovations and innovations in other new art forms that compete in an international arena. Moreover, I can envision a nightmare scenario if in the end, all artistic endeavors were dependent on government support and would therefore orient themselves toward bureaucratic committees that necessarily have to draw a line between those who receive subsidies and those who do not. It is doubtful, however, that this scenario will fully develop. After all, the raison d'être of government involvement in the arts lies in the consecration of a selection of art and not in making all artistic endeavors equally valuable by forcing them under one bureaucratic jurisdiction.

Irrespective of one's wishes, it is unlikely that governments will contribute to a less merciless economy of the arts by reducing its level of involvement. Therefore, although the exceptional economy of the arts is certainly not eternal, for the time being many will continue to pay a dear price for the high status of the arts. And artists will continue to bear the brunt of it as they continue to sacrifice themselves and be sacrificed on the altar of the arts.

Discussion

1 What is your opinion on the use of the word suffering in connection with artists? Are artists sacrificed or do they sacrifice themselves?
2 Do you agree that with less government involvement the economy of the arts will be less cruel?
3 Can you offer arguments that can prove that the version of the exceptional and merciless economy of the arts presented in this chapter is outdated?

Epilogue: the Future Economy of the Arts

Is this Book's Representation of the Economy of the Arts Outdated?

In this epilogue, I address the question of whether my representation of the exceptional economy of the arts is an outdated one, or nearly so. Given the notions of postmodernism and commercialization, the answer to this question could well be 'yes'. Therefore, Section 2 and the sections thereafter will examine the forces that promote change in the arts and the economy of the arts. Because a thorough treatment of possible developments is beyond the scope of this book, the remarks in this epilogue are sketchy and necessarily speculative.[1]

1 Signs of a Less Exceptional Economy of the Arts

On the basis of the analysis in this book, one could expect a normalization of the economy of the arts to be accompanied by the following signs.

TABLE 5 SIGNS OF A LESS EXCEPTIONAL ECONOMY OF THE ARTS

Monetary signs

1 There is a downward trend in the incomes of successful artists. (The contrary is currently the case.)

2 There is a downward trend in the prices of old and contemporary art by famous artists. (The contrary is currently the case.)

3 There is an upward trend in the average hourly income of artists. (The contrary is currently the case.)

4 There is an upward trend in the percentage of artists with salaried employment. (The contrary is currently the case.)

5 There is a downward trend in overall donations and subsidies to the arts. (This is currently not the case.[2])

Other 'hard' signs

6 There is a downward trend in enrollment figures of youngsters going to art colleges. (This is currently not the case.[3])

7 There is an increase in formal regulation of numbers of artists. (This is not currently the case.)

8 Governments favor a different, more varied selection of art. (This is true in a formal sense, but not in a material sense. Although other art, like pop-music has come into focus, the money it receives is almost negligibly – see below in this section.)

9 Governments and other donors have become less interested in the distribution of the fine arts. (This is true.)

'Soft' signs, changing attitudes in society and in the art world

10 Art has become less important in symbolizing people's position on the social ladder (This is not true.)

11 High and low in the arts have lost some of their normative connotation of superior and inferior. Instead, they denote different genres and domains. (This could be true – see Section 5 below.)

12 The line between art and non-art is becoming less clear. (This could be true – see Section 5 below.)

13 Asymmetric valuation loses its significance. The phenomenon that elites look down on the artistic preferences of the lower classes, while these classes in turn admire the choice of the elites, becomes less important. (This could be true – see Section 5 below.)

14 Market orientation increases in the arts. Blatantly commercial strategies become less exceptional and more acceptable. (This is partially true – see further down in this section.)

15 The public and the art world lose interest in original and authentic art. (This is not true.)

16 The cult of the genius in the arts becomes less important. (This is not true.)

17 The (relative) autonomy of art and artists is becoming less important for both the public and the art world. (In general, this is not true.)

18 The esteem accorded 'artists' in the applied arts (design, advertisement and fashion) increases. (This is true.)

19 The status of doing commissioned work is rising. (This is true for the upper echelon artists.)

20 Artists have increasingly mixed feelings about art being sacred or 'special'. (This is probably true.)

21 New artists emerge who favor a more down-to-earth approach to art. (This is partly true – see Sections 2 and 3 below.)

22 Non-arts jobs become more personal and authentic, making a romantic alternative less necessary. (This is true in some areas, but not in others.)

If these signs are relevant and if my assessment of them is correct, the 'hard' signs indicate that the picture of the economy of the arts in this book is not outdated. It appears that postmodernist forces have not effected the distribution of funds. Nor have important institutions, such as foundations and governments, lost interest in the arts. The hard signs do not suggest an imminent change in the exceptional economy of the arts. The 'softer' signs, however, are more ambiguous. They seem to suggest that 'change is in the air'. The 'soft' sign I believe is the most important however, that 'art has become less important as a signifier of social position', is almost certainly not true. In order to determine whether change is still likely, I shall discuss some of these signs in more detail below.

The more openly commercial attitudes, as mentioned in sign 14 above, are not limited just to the arts. There are few social circles left where discussing money and financial gain is still 'not done'. In this respect, society's values appear to have changed over the past thirty years. But are they only superficial (temporary) values? Or did a more fundamental attitude towards money and commerce change as well? The current increasing, sometimes even pathetic, interest in non-money values among some business people, not only in new-age circles, suggests that higher order values have not changed much.

It seems that arts attitudes with respect to money and commerce have changed and it appears that the art world has become more commercial over the past two decades.[4] Particularly performing art companies have been flirting with more commercial attitudes. It is however difficult to tell whether the new attitudes are being internalized or are a temporary answer to the present consumer and donor demands. In Germany, for instance, the first decades of the twentieth century saw an increased interest in theatre marketing, but it did not endure.[5] Moreover, the more commercial attitudes that emerged in the visual arts in the 1980s have by and large disappeared again.

Sign 8, which refers to the fact that European governments have begun subsidizing broader areas in the arts, could signal a more fundamental change, however. As I noted in Section 10.6, these governments have started subsidizing areas like pop music and related art forms. For instance, France subsidizes hip-hop and art by immigrants. In monetary terms, these subsidies are fairly negligible compared to those for the more traditional recipients of art subsidization, but they are significant symbolically. The question is whether this could be interpreted as a sign of an inaugural shift in government tastes, for instance away from classical music and towards pop music, or whether governments are simply broadening their base of art forms.

Although a government's selections and tastes are always evolving, I

would be inclined to interpret the present development as a broadening of taste rather than as a shift in taste. Given its goals with respect to education and social coherence, this kind of broadening strategy was to be expected. Moreover, governments are increasingly aware that a taste that has become too partial and unilateral is bad for general artistic developments and narrows the public support for their policies. Therefore, this sign could indicate a significant change. If the new subsidies continue and become substantial, the gap in status between art forms could be reduced and the economy of the arts could ultimately become less exceptional. As has been noted however, it is also a natural tendency of governments to offer distinction and this implies a selection between art forms, at least in the long run. Therefore, it remains to be seen how far this development will go.

2 Artists with New Attitudes Enter the Scene (1)

Sign 21 predicts a possible normalization of the economy of the arts via the emergence of new types of artists with new attitudes. Currently, I notice that artists' attitudes are moving in basically four directions. Each of the four directions has its own type of artist who might be said to exemplify that direction. I discuss the artist-researcher and the postmodern artist in this section and the artist-craftsman and the artist-entertainer in the next. Most modern creative artists embody traits of all four, but with a different emphasis.[6] (I invite readers to view my 'ideal-types' critically and to construct their own.)

Many modern artists have developed an attitude that resembles the scientist's attitude. Most of these artist-researchers are not particularly interested in audiences or buyers. Studios are laboratories, while concert halls, museums, books, and internet sites are lecture rooms for a select and well-informed audience. Their attitude is in line with a contemporary art that has become increasingly self-referential. To follow the discourse one almost needs to be an expert. Like the world of science the audience of these artists consists of insider – colleagues, critics, and trained laymen. John Cage is an example in the world of music. Visual artists like Donald Judd, Dan Flavin and the Dutchman Peter Struycken also fit into this group.

The economy of the arts could eventually become less exceptional if artist-researchers gradually became more important. They are like scientists because they value originality, but not in a romantically hyperbolic sense. They don't mind a little demystification if it contributes to the establishment of a strong professional status comparable to that of a sci-

entist. In Europe, some of them may even be willing to become university employees with a small teaching obligation, an already common scenario in the US. On top of that, they might even go so far as to support some formal regulation of their numbers.

It is doubtful however, whether society is actually prepared to pay these artists in the long run. Because of their research, art is not that entertaining and contributes very little to the aura of art, their art usually doesn't sell well in the market. And without the indispensable aura, it loses part of its utility for donors as well, which includes the government. This means that if the artist-researcher were gradually to become the most common artists, the arts would probably shrink; art could even develop into some kind of marginal phenomenon. Therefore, it seems highly likely that it'll be another type of artist who will be most common in the future.

While the artist-researcher naturally probes and challenges existing rules, conventions and boundaries, postmodern artists do not so much trespass these boundaries of art as ignore them altogether.[7] They do not try to shift the boundaries but prefer to leap over them from one field to another instead. They move freely between art, design, and applied arts, including advertising. For instance, world music composers, samplers, and modern DJs are examples who fit this description, as do VJs and visual artists like Mathew Barney, Pipilotti Rist as well as the Dutch artists Inez van Lamsweerde and Joep van Lieshout.

Postmodern artists could eventually help make the economy of the arts less exceptional, if they were to become more significant in the arts. They challenge the prevailing attitudes in the arts, especially the inclination to deny the economy. Successful postmodern artists jump effortlessly from art to advertising graphic design, for instance, and from relatively autonomous to commissioned work. They often establish a business and might hire a number of employees to assist them. In this sense, they are more like businessmen and they are not ashamed of it. It is this kind of natural commercial attitude that could easily herald a less exceptional economy of the arts for the future.

But exciting as the postmodern artist experiment may seem, in the long run, the arts cannot exist without borders, as I demonstrate in Section 5 below. Therefore, if postmodern 'artists' were to become more significant, art would either cease to exist in the conventional sense or these artists would just leave the art world and concentrate on other professions or, more likely, they would gradually consent to the re-establishment of borders. Anyway, postmodern artists would eventually lose their edge and thus cannot be seriously regarded as a significant force in the normalization of the economy of the arts.

3 Artists with new Attitudes Enter the Scene (2)

The third direction art may take is the one of the artist-craftsman. Because of the increased importance of self-referential and conceptual art, craftsmanship has lost much of its high value among artists during the second half of the twentieth century. The last few decades however, artists with a keen interest in craftsmanship began to move in front. They began to reinstitute old techniques and developed new, more positive attitudes towards craftsmanship. Artists who actually do their own work with their own hands and who derive their identity and success partly from their craftsmanship are typical of this new or rather reinvented type of artist. It is because of them that paintings, ballets and musical compositions are again allowed to be admired for their technical virtuosity and can be considered 'beautiful' again according to some critics. Examples of this type of artist in the visual arts are Alex Katz and Dutch painters like Constant, Van Koningsbrugge, and Hans van Hoek. (This type of artist can also be found in the performing arts, but to be honest, their sort of craftsmanship has hardly ever really fallen into total disfavor. Nevertheless, movements like punk music were a temporary deviation from craftsmanship as was most of 'educational theatre'.)

The renewed passion for craftsmanship could have a sobering influence on the arts and it could eventually make the economy of the arts less exceptional. Even though craftsmen need some modest kind of magic to showoff their tricks, their primary ambition is to be good at what they do. In general, they have no real desire to be stars. They know the value of their time and materials and so they ask fair prices for their work. They have no great need to put art on a pedestal, make it over into something sacred, or deny the economy.

But the real craftsman is a character from a past when art and artists as we now know them, did not really exist. Art has changed so much since then and there is no turning back. Perhaps craftsmanship is more significant again, but it is unlikely that the artist-craftsman will be representative for the future artist.

The artist-entertainer is our fourth type of artist. Creative artists, who set out to entertain the public, are universal and timeless, as the likes of Shakespeare, Mozart, and Dickens clearly demonstrate. In the course of the twentieth century, however, entertainers gradually began to be taken less and less seriously and often found themselves outside the realm of (high) art. The notion that artists shouldn't deliberately set out to please audiences is something that the artist-researcher adheres to.[8] Nevertheless, over three decades already in part of contemporary art, be it music, theatre, dance, literature, or visual art, (high) artists can be found who

are not afraid of entertaining people. The Italians Clemente and Chia are examples of this trend in the visual arts. Another example is how contemporary classical music, after the hegemony of serial music, saw the return of the triad with composers like Philip Glass and more recently, a renewed interest in melody.

The growing (financial) importance of the mass media-oriented arts has contributed to this development toward more openly entertaining formats. In this respect, it's interesting that the disdain for entertainment has never been very strong in the world of literature, which is dependent on technical reproduction and large readerships. It is also revealing that classical musicians and dancers currently can often be seen performing on television in various concourses that are above all entertaining. Most conductors of major symphony orchestras can serve examples of the artist-entertainer. (The Dutchman, André Rieu, is probably the foremost example.)

Artist-entertainers seem to undermine the exceptional nature of the economy of the arts because they consciously set out to please their audiences. They orient themselves toward their audiences and thus, towards the market. This applies as much to the circus clown performing for a small audience as to the pop musician, whose hit record can be heard on radio and television almost any time of the day.

Nevertheless, these artists do not really challenge the exceptional economy of the arts. Even though they are oriented toward consumers, at the same time they tend to deny the economy. They resist the secularization of art because they evidently profit from the notion of art being sacred. At the same time, they probably stand a better chance of being the model for the artist of the future than the other three types.

If this analysis is roughly correct the future artist will probably be some kind of artist-entertainer. These artists will probably not be out there promoting change because, in the end, they have an interest in maintaining the notion of sacred art. And so it won't be the artist-entertainer who will help dismantle the exceptional economy of the arts. But perhaps I've discarded the other three too readily or maybe I've overlooked other important developments in the artistic attitudes. I therefore invite readers to revise these sections, based on their own experiences, knowledge, and evaluations.

4 'Art Becomes Demystified as Society Becomes More Rational'

Changes in artists' attitudes may or may not influence the course of the economy of the arts. But societal developments affecting the sacredness

of art are bound to affect the economy. This is based on the book's fundamental thesis that the exceptional nature of the economy of the arts depends on the high status of the arts. In this context, I see three interrelated developments that may contribute to a demystification of the arts and therefore to a less exceptional economy. (Readers are invited to contribute other developments.)

a Rationalization: As society becomes more and more rational, the arts will gradually go through a process of demystification.

b Fading borders: Because the high status of art depends on borders and because borders in our postmodern society have lost much of their significance, the status of art is bound to experience some shrinkage.

c Technical developments: The growing importance of technically reproduced artwork, of mass-produced artwork, and of media culture will further contribute to the demystification of art.

Rationalization, fading borders, and technological developments are not autonomous influences that can be examined divorced from their context. The three are interdependent. Moreover, demystification through rationalization does not have to be a contradiction of chapter 12's notion that art is a counterforce to an overly rational society. After quite some delay and from quite a distance back, art could follow the general trend towards rationalization and still end up representing a counterforce.

In this context, Norbert Elias's description of the civilizing process applies here.[9] According to Elias, people become more 'controlled' in the course of a long term civilizing process. Their behavior becomes less and less colored by impulses and affective fantasies.[10] This process is ongoing because art is part of society, and thus cannot divorce itself from this development.[11] And so in the long run art will probably also become more regulated and rational. The artist-researcher fits well into such a development.

Both art and science have a cognitive and an emotional dimension.[12] The same applies to the civilizing process.[13] Emotions remain important in a regulated and sublimated way. Art contributes to sublimation and thus to rationalization as well. Art, regulated and secularized, plays a vital role in the civilizing process.

But how restrained can art get? On the one hand, it's difficult to imagine art serving sublimation without maintaining some seductive charm or magic spell. Magic, on the on the other hand, does not necessarily have to involve mystification and consecration. In the long run, given the civilizing process, there might very well be a place for a magical art form that is not sacred.

In order to clarify the relation between the magical, the sacred, and the

rational, I would like to add a few, rather speculative remarks about the magical aspect of art. (They are based on the analysis found in Section 1.7.) Magic in art is not really magic but a kind of pseudo-magic. Artists as pseudo-magicians pretend they can perform magic and appear to be using supernatural powers, but they aren't. They merely use their imaginations to create illusions.

Artists use illusions to uncover truths about themselves and the world around them. Through illusions, art exposes reality and discovers 'truth'. This is the kind of cognition Nelson Goodman talks about. Both art and science contribute to cognition; they, in fact, compliment one another. Science also employs illusions – a graph is not what it represents but it uses illusions in a formal and hardly a 'magical' way.[14] The symbolic systems that science utilizes tend to be discrete rather than dense, while with art it's the other way around. Because art tends to use dense symbol systems, its interpretations are richer and more undetermined. As a result, art is more likely to be experienced as magical than science.

This does not mean that all art looks magical. There are huge variations depending on the art form. Some modern sculptures have totem-like qualities, while in others any such reference seems to be banned. Some modern music and poetry can actually resemble magical prayers in their use of repetition and rhythm, while others totally lack this kind of 'charm'. Nevertheless, in the end artists inevitably disturb and charm their audiences. (According to Deirdre McCloskey, scientists also charm their audiences.[15] Given their largely discrete analyses, however, their offerings are seldom as magical.)

The pseudo-magic that characterizes art exists regardless of whether art is considered sacred or not. An art form that has become fully secularized can still be magical. But at this time, art's magic still contributes to it being perceived as sacred.

The pseudo-magic and density of artistic expressions are not irrational. Therefore, any ongoing process of rationalization does not necessarily mean that art will lose its 'charm'. In an increasingly rational society, there is plenty of room for charming artist-entertainers. They are, however, likely to keep the arts at least somewhat sacred and hence maintain some of the exceptionality of the economy of the arts.

5 'Borders in and Around the Arts Disappear'

If there were no such thing as high and low in the arts, art would certainly lose its sacredness and, as a consequence, its economy would become less exceptional. Ever since the emergence of the avant-garde, borders in and

around the arts have been challenged. At this time, many borders seem to be vanishing.[16] For instance, many people are of the opinion that there are no recognizable styles in contemporary visual art anymore: anything is permitted and everything can be done. The cosmopolitan omnivorous nature of many modern art consumers, who consume both high and low art, suggests that borders have lost much of their significance.[17]

Without borders, anything can be art and anybody can be an artist. If there are no more borders that surround art and make art distinguishable, art as we know it will stop to exist. – It could be the much-predicted 'end of art'. – If not, art will certainly lose much of its aura. Therefore, the postmodern development represents a force that, in the long run, clearly ends up demystifying art.[18] After reaching the right momentum, this development is bound to end up changing the economy of the arts dramatically. If, in daily practice, artworks and loaves of bread come to be perceived as equal, the economy of the arts will certainly cease to be exceptional.

These conclusions would apply if people were to eventually lose interest in creative and authentic works of art. But as we have noted earlier, this is not the case. And as long as people appreciate creativity and originality in art, borders will remain.[19] The appreciation of creativity necessarily rests on comparisons, differences, and consequently on borders. Without borders, one would no longer be able to distinguish between artworks or discuss issues of their qualities (or aesthetic values) with friends or experts.

Moreover, in Goodman's approach to art discussed in Section 1.6, artists need borders as well. Borders give artists the framework to transgress and trespass and ultimately change the rules. To be original, the existing borders must be breached, and others must be able to notice it. Because people expect art to be creative and original, and because artists want their products to noticed between other poducts, borders are bound to remain important in the arts. (This is why it's difficult to imagine that the postmodern artist can truly represent the artist of the future.)

Because people always assume that their own times are dramatically different from earlier times, they believe that rules and borders have vanished from the arts. In my own life as a visual artist however, I am aware of numerous rules all around me. It's true that certain rules have become more elusive and complex; one needs to be pretty much an insider to understand them. Other rules have shifted to another level and have become a kind of set of meta-rules. Sometimes these rules apply more to artists' attitudes than to actual artworks.[20] Other rules describe which rule violations are acceptable and which are not. (For example, at this point in time, certain violations can be allowed, but only if they are no

heartfelt cries but deliberately planned trespasses. – Serrano for instance carefully designs the extreme sexual content in his art works. –) Rules remain important, in any case.

The belief that there are no rules in one's own time might be a universal truism. For instance, I'm convinced that twenty-five years from now, the art rules and borders of the 1990s will be obvious to almost everybody. (It's only now that we can actually distinguish 1970s visual art because it's only now that we have learned to discern the rules and borders those artists respected or played with.)

It's true that better-educated consumers nowadays are more diversified and omnivorous in their consumption behavior. One day they might go to the opera while the next they might applaud a local star singing his or her schmaltzy pop songs. This behavior does not, however, contradict the existence of borders because this scenario is basically asymmetrical because it applies more to elite art consumers than to the average consumer of low art. Moreover, as was noted earlier, even when the same products are being consumed, the ways in which they are consumed and the symbolic values they represent, continue to vary. Omnivorous consumption patterns often tend toward camp, which involves an ambiguous standard, whereby elite consumers simultaneously enjoy and mock the lower class' culture.

If borders eventually fail to actually wither, their appreciation may nevertheless change. More importantly however, the character of how we appreciate high and low art could change. Sign 11 in Table 5 pointed out the phenomenon that high and low in the arts increasingly refer to different domains in the arts rather than to an artwork's superiority or inferiority. And without some form of superiority, social groups would no longer have a reason to look up to the high and sacred art of other groups, whereas the elite would no longer have a reason to look down on the low art of the lower classes. The fine arts would no longer be distinctive. Because we have observed that cultural inferiority and asymmetric valuations are the cornerstones of the exceptional economy of the arts, this economy would be a lot less exceptional, if the importance of a symbolic high and low in the arts were gradually to diminish.

Terms like 'high' and 'low' would still be employed but without their former symbolic connotations. They would simply indicate areas or genres. With respect to distinction, symbolic practices or ways of consuming art would emerge as being more important than specific artworks.[21] These kinds of practices can still be considered superior or inferior, however, even if they are now called something else. But one would need to be an insider to be able to properly classify these practices. Superior art and art practices have become extremely flexible categories; their

sphere of reference is constantly mutating. This process was described in Chapter 11. Insiders continuously redefine the aesthetic borders of high and low, good and bad, modern and obsolete. Outsiders can only assume some kind of approximate shifting average.

So far, there is no reason to think that people climbing the social ladder in the future will suddenly stop signifying their status with art. As was noted in Section 1.2 this means that valuations will remain basically asymmetrical. As long as there is social stratification and as long as art serves to symbolize people's positions in social space, art will maintain its special status and its economy will remain exceptional.

I think art borders basically don't fade; some may vanish, but others will replace them. Moreover, borders will continue to serve distinction.[22] Therefore, it is unlikely that the postmodern project will make the economy of the arts less exceptional.

6 'New Techniques, Mass Consumption and Mass Media Help Demystify the Arts'

Firstly, new techniques, especially those produced by the digital revolution, could very well portend a process of demystification in the arts.[23] Many exciting new art products come into being. Moreover, digitally produced and digitally distributed music, images and moving images will be cheaper to produce and to distribute than their predecessors were. At this time, some of this phenomenon's products are de facto free, but that situation may not last much longer. On the one hand mass-produced new products are reaching larger audiences all over the world. On the other hand the smallest scale at which products can be profitably produced is becoming ever smaller. This means that there is more room for larger varieties of specialized products. Moreover, fragments of older artworks, be it legally or illegally, are increasingly being incorporated in newer works, thus rendering authenticity an ever more relative concept.

The same problem we saw with the withering of borders comes up when we consider technological change since it's difficult to get a perspective on one's own generation. Is the impact of technological change more profound today than it was in earlier times, for instance, during the introduction of the printing press or the introduction of electricity?[24]

Because new techniques are usually first applied in art forms with relatively little status, it seems that new techniques could very well undermine the mystique of the arts. But after a while the status of these art forms often rises or the more established art forms learn to adopt the new techniques.

It is true that some current new techniques in new media might lead to unknown interdisciplinary approaches that undermine existing borders. Modern, sometimes anonymous, artists sometimes create hybrid artworks that may temporarily fall outside the experts' realm of awareness. But these attempts to circumvent the cult of personality are not the first. And it usually doesn't take very long before the new artistic endeavors get absorbed by the established art forms and become visible. Artists emerge and some become heroes. This has happened before and is currently happening with DJs and VJs. It appears that the digital revolution has manufactured its own new heroes and thus its demystifying capacities are temporary.

Secondly, the current technological evolution continues to aggrandize the growing body of mass-produced artwork. Apart from the phenomenon of printing, the large-scale reproduction of high quality art works only began to take off in the twentieth century. Although the two are related, the mass production of art is probably more likely to herald a less exceptional economy of the arts than the digital revolution. As early as 1935, Walter Benjamin predicted that the technical reproduction of art would lead to a breaking of art's spell ('Entzauberung').[25] Art became less obscure, more accessible and thus less magical because of technical reproduction. Moreover, as was already evident in filmmaking, art could stand to lose its autonomy, which might ultimately contribute to the demystification of art.[26]

Benjamin's prediction is not difficult to grasp. Technical (re)production enables a massive production of artworks at low prices. It would be very strange indeed if this didn't reduce the exclusive and glamorous allure of art products. People in the Netherlands today can buy a 10-CD set of Bach recordings performed by one of the world's top orchestras in a chain drugstore for little more than the cost of a bottle of massage oil – little more than a Euro per CD.) And so one would predict that Bach's music would become totally ordinary, vulgar even. But thus far, this hasn't happened; Bach and his oeuvre maintain their aura. In general, when one observes the high, if not augmented status and worship of art since Benjamin's essay first appeared, his prediction was either wrong or it is going to take longer before his predictions are borne out.

In this context, a common misunderstanding tends to lead to faulty expectations. Many people still think that originality, uniqueness, and authenticity means a single unique artwork made by an artist's own hands, be it a manuscript, score, or art object. They forget that in the allographic arts – arts based on a notational system, like writing and most theatre, music, and even dance – there is seldom one original art work.[27] A hand-written manuscript, score, or choreography is just a col-

lection of directions based on a symbol system. The relevant details do not change, just because they are printed or performed. Therefore, the work of art resides in all written or printed specimens of a manuscript or score and in all performances of them irrespective of their total number. Each book and each performance is an instance of the particular artwork. The millionth live performance of the Saint Matthew's Passion by Bach or the millionth copy of James Joyce's Ulysses is as much an authentic and original work of art as the first. (First editions and original manuscripts are sometimes valuable, but primarily as collectors items and not as works of art.) The same applies to the numerous technical reproductions of the Saint Matthew's Passion on CD. As long as the notes have been played correctly, all of them can be considered authentic originals.[28]

To reiterate, most technical (re)productions are instances of an artwork and are therefore originals. People continue to experience them as animated and authentic, not unlike a painting. At home, listening to Verdi or Rod Stewart, listeners can be transported by the 'genius' of the composer or performer regardless of the number of copies in circulation. Thus far, these reproductions actually seem to enhance rather than diminish the high status of art.

For centuries, original works of art have been copied. It's only the astronomical numbers of reproductions and the speed at which they can be reproduced that has changed. In a literal sense, many artworks have become 'common'. Unprecedented numbers of people reading books, listening to CDs, watching television and surfing the Internet end up sharing original artworks. One could argue that when the numbers become this large, it becomes more and more difficult to associate the consumption of art with exclusivity. Therefore, it just seems to lose its former status.

It is true that some of the modern mass-produced artworks are no longer obscure and mysterious. They are consumed as part of a daily routine, not unlike food or transportation. Many artworks probably live shorter lives than they did in the past; they are trendy and ultimately disposable. Thus to some degree, mass production and consumption can actually exacerbate the secularization of the arts and hasten in a less exceptional economy.

It is not true however, that the general public and the experts treat all mass-produced art in the same manner. Some works are selected and placed on a pedestal while others are not, irrespective of their total numbers. Some have longer, sometimes much longer lives. They too are subject to trends, but these are recurrent trends. Whether today's distinguished artworks will survive as long as the works of, say, Bach, is impossible to predict, but modern artworks and artists – from Prince to

Spielberg – are just as subject to selection, canonization, consecration, and mystification as earlier artworks and artists were.[29]

Third, the modern media augment the mass consumption of artworks, as is the case with films broadcast on television. Modern media also add their own dimension. The increased media attention accorded art and artists may at first sight seem to contribute to the consecration of art and artists, but in fact it makes success more ordinary and thus demystifies art. The media can be said to have a leveling effect. Modern newspapers and television broadcasting are considered transparent media.[30] They give most topics equal significance. For instance, most daily newspapers have, for a considerable time now, been publishing their articles on high and low art on the same page. Meanwhile, modern television tends to treat sports heroes, high and low artists, and entertainment stars with equality. (They often even appear on the same talk shows.)

The media have this leveling effect more than earlier forms of technical reproduction because they actually show the heroes and so make them more human. In the long run, this leveling effect could contribute to the eventual elimination of the distinct status of the arts. Why should artists be more sacred than sports stars or television's talking heads, for instance? In the end, all these 'entertainers' can be designated as heroes, they can have plenty of status and money, but they are not necessarily sacred. As in the case of mass-produced art products, certain careers in the modern visual arts and pop music scenes, for instance, can be very short-lived and temporary. The spectrum of these careers and the way they develop begins to resemble those of sports or entertainment stars. And the media contribute to this egalitarian treatment.

Nevertheless, not all artists are public figures and even when they are, important differences remain between artists and other celebrities. Artworks generally maintain an existence independent of television appearances and other public performances. In consuming artworks at home, in a concert hall or a cinema, people construct their own artists. This way they maintain an intimate and mysterious contact with authentic but relatively obscure artists. Therefore, I believe the aura and special status of art and artists will continue to exist for a long time to come.

The findings in this epilogue are highly inconclusive. Although there are signs that there is a change in the air, actual change seems to be circumscribed. This can be expected as long as social stratification remains a reality and art continues to serve as a symbol of an individual's or a social group's position in social space. Thus, I believe that this book's analysis of the economy of the arts is not outdated. Nevertheless, it's possible that other signifiers may replace art as a marker of social status in the future.

If that becomes the case, the forces that demystify the arts may become stronger than the forces that keep art sacred. As a result, the economy of the arts would become less exceptional. Personally however, I would not be amazed if the exceptional economy of the arts will continue to color the arts for a long time to come.

Discussion

1 Table 5 lists some signs that might indicate a less exceptional economy of the arts. Are there signs among them you would have treated differently? Are there other signs that were ignored that you would add?
2 Do you think attitudes in the arts are becoming more commercial?
3 Do you agree with the notion that art and science supplement each other in their contribution to cognition?
4 Do you agree with the four directions in which artists' attitudes move, or do you see others?
5 Are the three causes that would make the economy of the arts less exceptional, relevant? Should other or additional causes have been discussed?
6 Do you expect the economy of the arts to become less exceptional in the decades to come? And how do you view this development?
7 Can you imagine that the merciless economy of the arts may come to an end in the near future because most artists will be classified as amateurs with well-paid jobs outside the arts?

Notes

Preface

1 'Two Cultures and the Scientific Revolution' (1950) in C.P. Snow, *Public Affairs* (1971).
2 Cf. Lavoye (1990).

1 Sacred Art

1 The term 'outsider art' is used for the work of artists who make art without properly applying important contemporary (grammatical) rules. They may be self-taught or received their schooling at an older age or in an unusual educational situation such as a mental institution, for instance.
2 Throsby (1994) 2.
3 The philosopher Laermans (1992) 64 reproaches the economist Grauwe (1990) for making mistakes by not making his notion of art explicit.
4 Cf. Danto (1964), Dickie (1971), Becker (1982) 34, 148-149 and 153-164 and Bevers (1993) 16-20.
5 Bourdieu (1979), DiMaggio (1987), Calcar (1984) andLamont and Fournier (1992). More references and details about differences in findings in Peterson (1997) 87.
6 By using the term 'asymmetry' I want to stress the asymmetry in the appreciation of each other's culture. In another respect however, behavior is symmetric: groups are the same in the sense that they orient themselves toward the art of groups above them on the social ladder.
7 See note 5.
8 Of these five assumptions the assumption regarding social coherence is the most questionable. Rapid changes in society can cause a reduction in the coherence of social values. Given all the rapid and radical changes in the media, this could be the contemporary scenario. In that case this thesis would not be valid, because coherence today is insufficient to maintain shared notions of high and low in the arts. If this is the case, the book's analysis loses its significance. However, although I cannot prove my case, I shall try to make it plausible in the course of this book that there is sufficient social coherence to support thesis of asymmetric judgment based on cultural inferiority and superiority.
9 Cf. Peterson and Kern (1996) and Peterson (1997) and the references they present.
10 Peterson (1997) 88.
11 Peterson and Kern (1996) 904 also found from their empirical data that "high-

brows are more omnivorous than non-highbrows".

12 Bourdieu (1979) also cited by Peterson and Kern (1996) 904.

13 Peterson and Kern (1996) 904 state: "...omnivorousness does not imply an indifference to distinctions".

14 I return to the controversy in the Epilogue. A related argument is brought forward by Eijck (1999). He shows that people moving up the social ladder often do not adapt the art of people above them on the social ladder. Instead they take their own art along with them. And so their art rises in status. Nevertheless, status differences remain important.

15 Levine (1988) has described the historic process of 'sacralization'.

16 Hide (1979) defends this view. He quotes many well-known artists.

17 Cf. Uitert (1986).

18 Cf. Smithuijsen (1997).

19 Braembussche (1994) 238, Benjamin (1974). Instead of the term 'sacred' I could have used the term 'aura', which Benjamin used in connection with art. It has less of a religious connotation. However, most of the time I shall use the terms 'sacred' and 'sacredness', because the religious connotation of the term 'sacred' is 'telling' about art. Moreover, the term 'aura' has no adjective to replace 'sacred'.

20 The English moralist and aesthetician Arnold (1875) (as Peterson (1997) 81 notes) already successfully propagated the view that the fine arts embody the highest values of civilization.

21 Bloom (1987) 185, 188, 322 (also cited by Peterson (1997) 82-86). Writing about the distinction between high and low, Peterson gives other references as well.

22 Authenticity is a container word. Different uses contribute to an overall meaning. In this book the notion of personal uniqueness expressed in works of art is emphasized. Linko (1998) uses the term 'authenticity' also in the sense of personal uniqueness. This is one of several uses of the term 'authenticity' as analyzed by Peterson (1997) 205-209.

23 'Creativity' and 'originality', terms which are often used in relation to art, imply authenticity, but a work can be authentic without being original or creative. Amateur 'art', children's 'art' and 'art' made by deranged people are authentic, but not always creative or original.

24 In this particular case there were also bits of tape on the canvas, because the painting was unfinished and Mondrian was still experimenting.

25 Janssen (2001) 326.

26 On the one hand by strongly identifying with the artist the art consumer apparently becomes less of an authentic individual. On the other hand, however, temporal identification and even symbiosis can contribute to the formation of personal identities.

27 In 1988, Hans-Onno van den Berg suggested the use of this term to me.

28 Bourdieu (1979) 53-56; Laermans (1993) 88.

29 Laermans (1993) 88.

30 Cf. Laermans (1993).

31 Bourdieu has investigated the notion of distinction with respect to the arts. He also emphasizes that art is remote from everyday worries. He relates this to a remote aesthetic in modern art and with a corresponding aesthetic disposition, in which an emphasis on form has replaced expressive and descriptive qualities and capacities. Bourdieu (1979) 28-32. Cf. Swaan (1986). As far as this special aesthetic is concerned, I do not agree. I think that in the long run expressive and

descriptive qualities will remain just as important as formal qualities. Abbing (1989) 54-59.
32 Cf. Braembussche (1994) 181-290, Hegel (1986, 1832-1845), Adorno (1970-1986), Goodman (1954), Barthes (1988), Lyotard (1997, ed princ 1984).
33 Heusden (1996).
34 Unlike Lyotard, recent postmodern philosophers of art like Derrida, Baudrillard, and Jameson no longer treat innovation as typical of art. Cf. Braembussche (1994) 292-314.
35 Cf. Doorman (1994) 211-213.
36 Goodman (1954). In the context of this book Goodman's approach is of special interest, but the outcomes would not be very different if I had instead elaborated on any of the other aforementioned philosophers of art.
37 Goodman (1954) does not treat such broad changes. I therefore 'extrapolate' his approach.
38 Kellendonck (1977).
39 When this painting was exhibited in the Sensation Show at the Royal Academy in London in 1997, it caused a scandal. In 1999, the Brooklyn Museum of Modern Art exhibited almost the same Sensation Show. This time Chris Ofili's 'The Holy Virgin Mary' was the cause of a scandal, which forced New York's Mayor Giuliani to eliminate the funding of the museum.
40 Goodman (1954) 248. This contribution to cognition does not imply that art is formal or intellectual. Goodman ibid. 259 writes: "This subsumption of aesthetic under cognitive excellence calls for one more reminder that the cognitive ... does not exclude the sensory or the emotive, that what we know through art is felt in our bones and nerves and muscles as well as grasped by our minds, that all the sensitivity and responsiveness of the organism participates in the invention and interpretation of symbols."
41 Goodman (1954) 258.
42 Modern audiences, well educated in the languages of the arts, show little amazement, as if they have already been exposed to these new metaphors. Generally speaking, the expressions of aesthetic experience have become more controlled and subdued in the high arts. Nevertheless, when art is really new, feelings of wonder can be suppressed but not eliminated.
43 Goodman (1954) discusses the terms 'dense' and 'discrete' in relation to art and science.

2 The Denial of the Economy

1 According to Peterson (1997) 84 this elite view of popular culture has been persistent throughout the twentieth century. Peterson offers many references.
2 In chapter 10, the unusual choice to divide government activity across all three areas will be clarified in some detail. The choice implies that the area of forced transfers differs from the area of redistribution as noted in Polanyi (1992, 1957) and the government sphere as noted in Klamer and Zuidhof (1999).
3 O'Hagan (1998) 133-39 and 157.
4 O'Hagan (1998) 133-39 and 157.
5 Meulenbeek, Brouwer et al. (2000) 41.
6 One would expect that the broader the interpretation of art, the more important the market becomes. This is, however, not necessarily true. In artistic areas that receive few donations or subsidies, artists often donate their time by working

for low incomes or free. But, because there are no reliable figures on the amount of gifts that come from the partners and friends of artists and the amount of self-subsidizing including artists using money earned from second jobs for their art, I have ignored this type of gift. Moreover, as will be discussed in chapter 6, it is not immediately clear how much of these subsidies are gifts. Nevertheless subsidizing by oneself, family, and friends is particularly strong in areas where artists are primarily self-employed, such as pop music, literature, and the visual arts. If these subsidies were (in part) included in the overall gift, the percentage of gifts would not necessarily become smaller when literature and pop music are included.

7 Lottery revenues are certainly not a gift to the arts from those playing. Government regulations impose taxes paid by the lottery players and this money is passed on to the arts as a gift from the government, even though government has delegated the distribution of the money to semi-independent institutions. See also O'Hagan (1998) 152-3.

8 The comparison also applies to teachers, doctors, and scientists. I interpret the intervention of governmental bodies with the activities of these professionals as the purchase of services from these groups by the government, which are transferred to benefactors, or as mediation in the sale of their services to others and not as gifts. It can be argued that subsidies for education and health care belong to the gift sphere. In that case, the gift sphere in the arts remains larger than that of other sectors with the exception of health care and education. Even when we consider health care and education, the presence of a large gift sphere in the arts remains exceptional because in the health care and education sectors the gift follows from a social obligation (cf. Swaan (1988)), while no social obligation ever developed with respect to art.

9 People or institutions receive gifts. The arts cannot receive gifts. Nevertheless, it is common practice to speak of gifts to the arts (and subsidies for the arts) and I shall do the same. In a metaphorical sense these are 'gifts to the arts'.

10 Often people use the terms 'Patron' and 'Maecenas' without distinction, or with meanings that differ from mine. Cf. Kempers (1998).

11 Cf. Bevers (1993) 9-57, Hitters (1996) 71-105 and Pots (2000) 85-248.

12 The term 'value' is used in many different ways. Here it suffices to say that in this chapter I am primarily interested in higher order values. As will be explained in section 3.3. higher order values relate to general virtues and vices of different states of the world.

13 Klamer and Zuidhof (1999) and Staveren (1999) discuss certain virtues of the gift sphere in more detail. McCloskey (1996) treats bourgeois and market virtues at length.

14 Cf. Hide (1979).

15 At first sight, sharing implies what the economist calls non-rivalry, which is an oft-mentioned attribute of a collective good as opposed to a private good. Culture appears to be a collective good. Not sharing culture and similar collective goods, which could be shared without extra costs, is usually deemed as unfair. But upon closer observation, however, we notice that non-rivalry hardly ever exists. Most culture exists because there are others who do not have this type of culture. If it is shared with those outside the own group, it loses value. The consumption by others goes at the cost of the in-group's consumption. Thus, we observe that rivalry is very present in most (sub)cultures.

16 With respect to the diffusion of art Swaan (1986) 35-8 has argued that the emphasis on superficial forms of diffusion of art and the necessary failure of actual

diffusion increase the income of the group of art lovers by demonstrating the other groups unfitness for art.

17 Swaan (1986).

18 Williamson (1986) has drawn attention to large-scale idiosyncrasy within the market sphere.

19 Simmel (1978 princ. ed. in German 1907). Simmel calls it the reversal of means and purpose.

20 Klamer (1996) 22-24.

21 In this respect, there is a difference with religious services, where consumers 'pay' with voluntary gifts. The same applies to street artists who receive gifts.

22 In discussions, Klamer explains his earlier statement (Klamer (1996) 22-24) that 'the arts are beyond measurement' in that the exact valuation in monetary terms devalues (or increases) *certain* values of art. Braembussche (1996) presents varying points of view in philosophy on this subject. For instance, in social science Smith (1988) takes the opposite position of Klamer.

23 Bourdieu (1990) 98-134 and Bourdieu (1997, 1996).

24 The latter is my translation of the German title of the play: *Bring mir den Kopf von Adolf Hitler.* Another less funny, but better-known example would be the Jew in Fassbinder's: *Der Müll, die Stadt und der Tod* (The Dirt, the Town and the Death).

25 The high status of the artist does not depend on the artist being a member of a successful professional. As will be explained in chapter 11 the artistic profession has little status compared to other professions. In this sense the status of artists is ambiguous. Anheier and Gerhards (1991) remark that a status indeterminacy exists in the arts.

26 Cf. Abbing (1989) 135.

27 The term 'economy' is used in a wider sense than the term 'economic' is used in, for instance economic sphere, value, capital and power. Economic in these combinations is used in the sense of monetary. For instance, in the economic sphere assets and transactions can be measured in terms of money. An economy however, refers to the way people choose and organize means in order to reach certain ends. Cf. Becker (1976) 3-14. Therefore, not all economies need money.

28 The medical profession is an example. Here the borderline between the two spheres is permanently in flux as professionals ask which medical services can and cannot be traded. Different standards apply in both spheres, but the plural value system is hardly asymmetrical.

29 The denial of the economy refers, above all, to the economy in the market sphere, but it can also apply to the economy in the gift sphere. For instance, artists, art companies and donors pretend to be selfless, but de facto many donors seek publicity and artists and art companies do everything possible to increase their chances in the donations and subsidies system.

30 On the basis of the characteristics that differentiate gift from trade, the majority of present-day sponsorship activities are closer to market exchange. A quid pro quo has arisen and exchange rates have also emerged. Firms pay cultural institutions for the right to advertise their brand name in association with the particular cultural institution. Some cultural institutions actually publicize the 'prices' they charge for different levels of sponsorship, which correspond with different levels of logo- and name recognition in posters, catalogues, etc. Nevertheless, parties publicly continue to play the game of giving. In this respect sponsorship has a special attraction that pure advertising does not have. It enables the sponsor to associate with the gift sphere. And because the association with

the gift sphere impresses the customers of the sponsoring company, this becomes attractive in a commercial sense as well.

31 The artist's character is related to the 'habitus', which will be discussed at some length in chapter 4.

32 Bourdieu (1992) 121-128 uses the expression 'sense of the game' (*'sens de jeux'*). From a different point of view, Hütter (1996) also applies the notion of play to economics.

33 Bourdieu (1977) demonstrates and explains this double standard in more detail.

34 Cf. Kattenburg (1996). Notwithstanding the business instinct of Warhol, Kattenburg draws attention to the religious aspect in Warhol's work with its emphasis on transformation.

35 Velthuis interviewed gallery owners for other purposes; see Velthuis (2002).

36 Bourdieu gives many descriptions of the stiffness of newcomers opposed to the ease of 'born nobility'. Cf. Bourdieu (1979).

37 Cf. Laermans (1993).

3 Economic Value Versus Aesthetic Value

1 This is the opinion of Woude (1987) 309. This is not an undisputed opinion. Nevertheless, even if the real number is much higher – for instance, five times as high or 5% – the percentage of surviving paintings is still amazingly low.

2 Cf. Velthuis (2002a).

3 Throsby (2000) 45-50. In his admirable attempt to widen the horizon of economics, Throsby lets cultural value complement economic value. However, I think that by introducing a second major concept into economics is too high a price to pay for a relatively small increase in explanatory capacity. I find it more useful to let the term 'economic' stand for an approach rather than a scope. In this respect, I agree with Becker (1976) 3-14. In this chapter however, I shall also use the term 'economic' in the limited sense of monetary or financial.

4 Cf. Velthuis (2002).

5 Price is not always an adequate indicator even when it comes to paintings. In particular, it's inadequate when market value refers to the value of an oeuvre and is compared with the aesthetic value or reputation of the oeuvre. For instance, the average price of a painting by a highly regarded painter, deceased or living, who produced (produces) many paintings annually, can well be lower than those of a less-renowned painter who painted very few paintings; nevertheless the sales of the most renowned painter can still be higher. Moreover, it appears that in a local market like the Dutch visual art market, an average artist's success is more likely to be revealed by the large number of works sold and not in higher prices. This is confirmed by the data that Rengers and Velthuis (2002) gathered for their article.

6 In writing this paragraph, I am indebted to Velthuis (2002), who speaks of two models of price and value: an independent spheres model and a hostile spheres model. He mentions Bell, Steiner, Fry, and Fried in association with the first, and Kopytoff, Burn, Hughes, and Klamer in relation with the second.

7 This applies to subsidization in general. It does not apply to all forms of subsidization. For instance, subsidy schemes in which subsidies are linked with performance in the market evidently do not assume a negative relation.

8 Grampp (1989) 37.

9 A much weaker proposition, which underlies thesis of correspondence between aesthetic and market value, is that price signals quality. Price is one of many signals consumers perceive. A higher price is generally a signal of higher quality. This line of thinking comes from Veblen (1934) and Leibenstein (1950). Velthuis (2002) applies it to the visual arts.

10 Grampp (1989) 35.

11 It should be noted that if this chapter were to prove that aesthetic and market value do not have to correspond, this does not necessarily refute the thesis the way Grampp (1989) uses it. First, Grampp applied the thesis only to the visual art market, whereas I shall also try it out on mass markets as the market of literature. Second and more fundamental, for Grampp, divergence in aesthetic and market value seems to be impossible almost by definition. Reading Grampp's text carefully, it turns out that the way he implicitly defines aesthetic value, anything that enters the price also enters aesthetic value. In his definition of aesthetic value, there doesn't appear to be a place for selection by experts. However, Grampp is not consistent, because he still finds it necessary to confirm his theory by showing that the judgments of experts broadly correspond with the prices of art.

12 Cowen (1998). Frank and Cook (1995) 189–211 on the other hand emphasize circumstances that make it likely that free markets in media and culture harm quality.

13 This is also the opinion of Frey and Pommerehne (1989) 93. Like Grampp (1989) and Cowen (1998) they compared auction prices and reputations and came to the conclusion that price and aesthetic value basically correspond. According to them, taking into account different styles adds to the explanation of discrepancies.

14 Utility functions are interdependent. (Some economists, like Becker (1996) 7-18, try to stick to the traditional approach by compromising; they assume that basic preferences are given, while many day-to-day preferences depend on social factors.)

15 Cf. Blaug (1980) 49.

16 Bourdieu (1992), Elias (1981, ed princ 1970), Goudsblom (1977), Janssen (2001) 348 and Luhmann (1995 ed. princip. 1984 in German).

17 In the analysis of government behavior in Chapter 10 I shall, however, depart from methodological individualism.

18 Extensive literature exists on value concepts. Cf. Smith (1988), Anderson (1993), Klamer (1996) and Throsby (2000).

19 The economist Sen (1982) in his well-known chapter on Rational Fools used the related notion of meta-ranking. The notion of values of different orders is used, among others, by the literary theorist Smith (1988).

20 This example I borrow from Plattner (1996) 18.

21 Experts may argue that the Rembrandt example is of a different order, because the new techniques only bring forward what was already there. This argument, however, applies as much to the Monroe portraits, the provenance or corporate purchases. All of these are social events that make viewers look anew, see things they hadn't seen before and thus have a new aesthetic experience.

22 Smith (1988) 32. Speaking about the role of interpretation, the philosopher Danto (1986) 26-43 comes to a similar conclusion.

23 I find this an acceptable approximation. In spite of the uniqueness of art products and in spite of the strong effects of fame, art markets are relatively competitive from top to bottom. However, unlike in neo-classical economics, I do not

assume that consumer preferences are independent.

24 Frank and Cook (1995) 26.

25 In a commercial gallery, consumers do not influence the price in the short run, because prices are given. The first willing to pay the price gets the painting. However, when many consumers are interested, prices increase over the long run. On the other hand, when consumers are basically uninterested, prices seldom go down. Cf. Velthuis (2002). Nevertheless, in the latter case, artists sell fewer paintings and the market value of their oeuvre rather than of single works of art goes down. It is a matter of quantity not price. (Although Rengers and Velthuis (2002) use their data for other purposes, as noted before, their data confirm this finding.)

26 Frank and Cook (1995) 26.

27 Bourdieu (1977).

28 The work of Bourdieu, for instance Bourdieu (1986) 241-258, contributed to the narrow use of the term 'economic' as in 'economic capital'.

29 So far, not one definition exists of cultural and social capital. In economics, there is a tendency to start all over again and to ignore definitions developed earlier in sociology. Cf. Becker (1996) 7-18, Throsby (1999) and Throsby (2000) 45-50. Whereas Throsby uses the term 'cultural capital', Becker uses the term 'personal capital' instead. Both use the term 'social capital'. Both have evidently been influenced by Bourdieu who was the first to present a differential capital theory; among others in Bourdieu (1986) 241-258. His theory directly and indirectly had an enormous impact in sociology as well as economics. For the purpose of this book, a precise definition of the various forms of capital is not necessary. However, in order to prevent too many parallel approaches, I prefer to stay close to the way Bourdieu handles the capital categories. His approach is subtle and versatile. A large variety of problems can be handled by it.

30 According to Bourdieu (1986) 241-258 cultural capital can also take institutionalized forms like a diploma, or objectified forms like books and paintings.

31 If social and cultural capital was easy to transfer into monetary capital and vice versa, there would be no need to distinguish them. It is only because of the conversion problem that a differential capital theory is necessary. It should be noted that economic, cultural and social capital add to symbolic capital. Bourdieu (1986) 241-258. Not to complicate matters, I do not treat symbolic capital.

32 For instance Crane (1976), Janssen (1998), Nooy (1993), Peterson (1994), White and White (1995) and sections in Albrecht, Barnett et al. (1970) and Foster and Blau (1989).

33 See note 11.

34 Heinich (1998).

35 Some people in the 'established' avant-garde or contemporary circle do not use the term 'avant-garde' any more. ('The avant-garde is dead', or 'everything is avant-garde.')

36 This estimate and the earlier statement about the lower prices in the top of the avant-garde is based on interviews with dealers, employees of auction-houses in Britain and the Netherlands and on my own observations at art fairs in the Netherlands, Germany and Belgium.

37 The term 'cultural elite' stems from Bourdieu (1979). Swaan (1986) introduced the term in the Netherlands. As in the case of economic capital, the term 'economic' in combination with elite is used in the limited sense of 'financial'. The term 'cultural elite' stems from introduced the term in the Netherlands. As in the case of 'economic capital', the term 'economic' in combination with elite is

used in the limited sense of 'financial'.

38 The differences between the two groups in personnel and taste is demonstrated at length in Bourdieu (1979) 260-317.

39 Bourdieu (1979) 11-63 attaches specific characteristics of art – not only visual art – to the different preferences of these elite's. He states that the members of the new elite prefer art in which the emphasis is on formal qualities, while the older elite prefers works of art, which are more descriptive and expressive. This latter preference can also be found among common people. In a broad sense, the distinction probably holds some truth. Traditional modern art is often expressive and otherwise its realism is of a story-telling nature, while avant-garde art is more self-referential. And in its formality, avant-garde art invites to the kind of intellectual activity that the cultural elite particularly enjoys. Nevertheless, in my view these preferences are not fixed. It is hard to predict how they will develop. Bourdieu (1979) and Swaan (1986) 30-32 tend to interpret the preference of the new cultural elite for formality at the cost of description and emotion as a logical step in a civilizing process. However, it could well be that they misinterpret the role of the arts in the civilizing process. In my view, it is not impossible that, for instance, in the future description and expression will become more important in elite art, while the 'common man' will prefer abstraction. (For instance, popular strips and animation series' on television are already very abstract.

40 According to Meulenbeek, Brouwer et al. (2000) 41 this percentage is 25%. Meulenbeek et al. underestimate this percentage, because they attribute the money that foundations ('stichtingen' and 'instellingen') spend in the art market to the private sector (p.10-2), while part of it is public money. Because it is impossible to determine how much money comes indirectly from the government through these institutions, it is safe to say that the government share in the visual art market lies somewhere between a quarter and a third. (However, the present growth of the visual art market in the Netherlands comes exclusive on account of private buyers. Therefore, the large government share is becoming a little smaller.)

41 Although government spending on visual art per capita is high in the Netherlands, it is not much higher than in most other mainland Western European countries. Cf. Ernst (1999).

42 An investigation, commissioned by the French Foreign Ministry and reported on by Charles Bremner in the internet edition of *The Times* of June 13 2001, emphasizes the negative effects of state patronage on contemporary French visual art. 'French contemporary artists are being pushed out of the world market because of stifling state patronage...', '...neglecting the visual for the sake of philosophical texts'.

43 Colleagues and experts I know, who are familiar with the present situation of the visual arts in both countries, basically agree. Nevertheless this view can be disputed, and the differences between the countries can also be explained in other ways.

44 The merit good argument and rent seeking are treated more extensively in Chapter 9.

45 Among others, this type of rating can be found in the German magazine *Capital*.

46 Bourdieu (1977).

47 Symbolic gains can be made by gradually converting the form of capital that is redundant into forms of capital, which are relatively failing. For instance in

families, which have been successful in industry and commerce, their children's cultural education is likely to be emphasized. On the other hand, members of the cultural elite manage, often with the assistance of the government, to find increasingly well-paid jobs for themselves and their offspring and so their monetary capital increases.

4 The Selflessly Devoted Artist

1 People by definition maximize utility under constraints.

2 Private satisfaction is not the same as utility; it is an internal reward that offers utility.

3 Frey (1997) is not specific about the line between intrinsic and extrinsic motivation, but he tends to limit extrinsic motivation primarily to being motivated by money. Therefore in his view somebody who is motivated by recognition is intrinsically motivated. Towse (2001) follows Frey and only refers to extrinsic motivation in the case of an orientation towards monetary rewards. I think their distinction is confusing. Almost anybody would say that, for instance, an actor who tries to please the audience is extrinsically motivated. Therefore to denote the distinction Frey examines it would have been preferable to use terms like 'monetary' versus 'non-monetary motivation' in stead of 'extrinsic' versus 'intrinsic motivation'. The precise distinction, however, is not that important for Frey (p.14), as he primarily investigates the implications of non-monetary motivation in the economy generally. The notion of non-monetary motivation is important for the evaluation of the reward-systems that exist in firms or that follow from government subsidy-schemes. Frey (1999) applies his theory to government involvement in the arts. He demonstrates that monetary motivation can easily run against non-monetary motivation.

4 Frey (1997) not only speaks of intrinsic motivation but also uses the term 'intrinsic rewards'. I prefer to speak of 'internal rewards'. As in the case of intrinsic value treated in the previous chapter rewards can never be altogether intrinsic because they have a social origin. Moreover the term 'intrinsic reward' would unjustly distract attention away from the actor and point to a rewarding object or activity. (I see no problem in using the term 'intrinsic (or extrinsic) motivation', because 'motivation' clearly points to both an actor and an activity.)

5 In the welfare function of artists, internal rewards have a relatively high elasticity, while external rewards have a relatively low elasticity.

6 The expression 'serving art' (or serving money and recognition) is used in a metaphorical sense here and elsewhere. (Ultimately 'art' is not an entity that artists can serve.)

7 It does not matter whether artists are deliberately 'selfless' or deliberately try to better themselves. All that matters is whether it can be observed that artists are indeed 'selfless' or that artists are only trying to improve their position. Most economists assume that people unconsciously pursue rewards in order to become better off. In this approach, asking artists about their intentions serves no purpose. And when artists are asked about their intentions, the outcomes are likely to be biased. Because artists deny the importance of the economy, artists will almost certainly stress their devotion and deny that they are in it for personal gain.

8 In the case of average artists, income enters in the welfare function and also as input in the production function.

9 Throsby (1994a).

10 Towse (2001) 485, Rengers and Madden (2000) 347, Throsby (1996) 233 and Throsby (1996a).

11 If artists have an inheritance, this money can be spent on making art without reducing the time available for making art. Therefore, rich artists, whether they are talented or not, can be seen buying the most expensive paint, the best musical instruments, etc., things that more talented artists might be jealous of.

12 Throsby (1994a) 74.

13 On average, artists who earn more than the minimum income constraint are *mainly* interested in non-monetary rewards, but are not totally immune to extra financial income. Therefore, it should be stressed that the conclusion *broadly* applies to *large groups* of artists and not necessarily to specific groups. In discussing the response to money Rengers and Madden (2000) 339 distinguish various groups of artists. They argue that a group of 'regular' artists exists that is just as responsive to money as other professionals are. These are primarily applied artists, who therefore fall outside the scope of this book.
Generally the marginal returns of more money is said to diminish quickly. In a graphic representation, the curve representing the returns corresponding with increasing income will, at the survival level for artists, show a sudden change in direction. In cases of other types of rewards such as private satisfaction or recognition, marginal returns are likely to diminish as well but less abruptly. See the figures mentioned in the notes 44 and 48 of Chapter 5.

14 For a general philosophical approach to 'autonomy' see for instance Blokland (1997 ed. princ. in Dutch 1991).

15 A binary ordering replaces a continuous ordering.

16 Cf. Berg (1994). Bevers (1992) 77 emphasizes that autonomy does not exclude the possibility of a convergence of the cultural, political, and business spheres in technical and instrumental aspects.

17 Cowen and Grier (1996) 5.

18 These phrases stem from Freidson (1990) and Jeffri and Throsby (1994) respectively. Both are cited by Menger (1999) 554. In analyzing incentives and rewards Towse (2001) 477 states that artists are motivated by an intrinsic inner drive, and that therefore, in her view, incentive and reward diverge. Because in my approach artists can reward themselves, I do not stress the divergence.

19 Cf. Gogh (1980).

20 Although Frey (1997) 14 uses another distinction between internal and external rewards and motivation (see note 3), he also acknowledges interdependence.

21 Cf. Finney (1995).

22 Cf. Janssen (2001) 342.

23 This approach to learning rests on the primacy of rewards: within a stimulus-response approach past rewards (and punishments) govern future behavior. Present day learning theories are not that simple. Other learning principals like imitation supplement the older approach based on stimulus-response. Cf. Kohlberg (1984).

24 Cf. Abbing (1996).

25 Klamer, Mignosa et al. (2000)

26 Jenkins (1992) and Jong (1997) present useful introductory texts on the habitus-field theory of Bourdieu.

27 Bourdieu uses lengthy descriptions to give meaning to the concept of the habitus. He refuses to develop immanent 'definitions' of the habitus and related concepts. Cf.Bourdieu (1990) 66-69 and Bourdieu (1992).

28 Cf. Jong (1997).

29 In my view, the habitus-field theory can be of special interest for economists. I give four examples: (1) this theory reminds the economist that there is more under the sun than just preferences, rewards, and calculation. Human beings are neither puppets, which can be moved at will by pulling a string or offering them a reward, nor are they fully independent, rational, and calculating individuals. In their habitus they are linked to their social surroundings in ways, which go beyond a simple motivation by rewards. (2) Economics has problems in explaining behavior that apparently goes against its own interests. For instance, a doctor leaves his house in the middle of the night to voluntarily help a patient without anybody noticing. Given the habitus, this is the 'natural' way to behave. (3) Because of the free rider problem, economists expect voluntary groups pursuing a common cause to be unstable, because it is advantageous to leave the group. Given the habitus and its dispositions, short-term advantages of leaving are not even perceived. The 'culture' is such, that leaving simply does not come to most people's minds. (4) The notion of the habitus contributes to a better understanding of informal monopolization – Chapter 11.

30 Bourdieu (1992) 121-128 uses the expression 'sense of the game' ('*sens de jeux*').

31 A sense of the game does not imply that accidents do not occur and that chance is unimportant. Moreover, some initial choices can predetermine future actions such as the case of so-called path dependence. See also note 33.

32 I doubt the usefulness of a fully interdisciplinary approach compared to a multidisciplinary approach. I think that the latter should precede the former and that it may not always be wise to aim for interdisciplinarity.

33 Laermans (1996) criticizes Bourdieu's habitus-field theory because it puts too much emphasis on the assumed strategic behavior of people in the art world. It follows that this criticism *a fortiori* applies to the approach of this book. Laermans tries to offer an alternative based on the system-theoretical constructivism of Luhmann (1995 ed. princip. 1984 in German). According to Laermans, choices in the arts are not that strategic. Initially there is often plenty of choice and in that situation, chance is sometimes more important than strategy. Moreover, once the initial choice is made, there is often little left to choose. Because of what economists call path dependency, future choices are broadly predetermined and can therefore no longer be strategic. Laermans seems to present this theory or approach both as a substitute for Bourdieu's habitus-field theory and as a supplement. It certainly is a useful addition, but in my view, especially when more than just individual artistic decisions are studied, it cannot replace the habitus-field theory. In this context, it should be noted that most theories do not try to explain individual decisions in detail. They try to explain the average behavior of small or large groups, and such behavior can very often best be explained by assuming strategic behavior.

34 Cf. Finney (1995).

35 Cf. Janssen (2001) 342.

36 Bourdieu (1983) 349.

37 Rengers and Plug (2001) 11 discovered that a relatively large proportion of self-taught fine artists receive no money from the government, and depend solely on market income, which implies that art colleges form part of the 'official', government-oriented art world.

38 Products can be practices. According to Finney (1995) 27 artists are naturally attracted to that particular style or game judged most likely to lead to success.

39 Artists themselves can also be a source of reward, because of internal subsidization and because they 'offer' personal satisfaction to themselves.

40 Cf. Rengers and Plug (2001) 4. They write "An artist, who is working on a government assignment, cannot produce for the market. Artists now compete for subsidies, and the requirements for receiving these may very well be different from the criteria for receiving market recognition."

41 Bourdieu (1992) rejects any association between his approach and Neoclassical Economics or the Rational Action Theory.

42 Only a small portion of these paintings is made in factory-like conditions.

43 Rengers and Plug (2001) 13-5 also found path dependency in the careers of Dutch visual artists.

44 Rengers and Plug (2001) 14, who examined data on Dutch visual artists, confirm this finding. On pages 8 and 9 they ask whether it is a specialized market, a winner-take-all market or an independent market that is typical for the structure of the visual arts market in the Netherlands. In my view, these are not mutually exclusive structures. Specialization for younger artists can evolve into a winner-take-all situation for some older artists.

45 Bourdieu (1977) uses this example.

46 As noted in the previous chapter, if there was an exchange rate and capital could be exchanged easily, it would not have been necessary to distinguish different kinds of reward and capital. A conversion problem exists: it is hard to transform monetary capital into cultural capital or social capital and vice versa. This phenomenon is central in the work of Bourdieu (1992).

47 Presently in some areas in the performing arts, the government tries to stimulate the underdeveloped orientation towards the market by matching its funding to market performance. Such schemes are confusing for companies, because in the short-term, more orientation towards the market can lead to more income from the government, but this is bound to cause a reduction of income from the government in the long-term.

48 Meulenbeek, Brouwer et al. (2000) 15 and 41. Adding social security benefits it is 55%. Because it was especially true in those days that social security benefits served as an indirect form of subsidization, the latter percentage is not irrelevant.

49 For instance, during this period at the Amsterdam Rietveld Academy, a painter like Herman Gordijn and many of his less well-known colleagues were in fact forced to leave.

50 This particular subsidy scheme will be discussed in more detail in section 6.5.

51 Not all of the duped artists left the field. Unsurprisingly, some of them found their way to the new but reduced levels of subsidies. Only a small number of artists managed to adopt new attitudes and turned successfully to the private market for their incomes. Dun, Muskens et al. (1997)

5 Money for the Artist

1 In 1999, Lannoye (2000) interviewed mostly fine arts students at a Dutch art school. Among them first-born male students were under-represented. (The fact that according to Getzels and Czikszentmihalyi (1976) famous artists are often eldest sons does not necessarily contradict Lannoye's finding.)

2 This analysis of the family and of the position of the artist is similar to Bourdieu's analyses of class in relation to the position of the artist. Bourdieu (1979).

3 See also note 3 of Chapter 4.

4 Forbes (1998-1999) These and the following data stem from the lists 'Forbes Celebrity Hundred', 'Forbes Top 40 athletes', 'Forbes Top 40 Entertainers', 'Corporate America's Most Powerful People' and 'Top Executive Incomes Outside the US' published in issues between September 1998 and September 1999. Updated versions of these lists can be found at: http://www.forbes.com. Owners and entrepreneurs, who sometimes earn more than top artists and athletes, are not really professionals. It is debatable whether politicians and administrators are really professionals. Nevertheless, if managers are considered professionals, the average income among the Top 40 managers in the US is less than the average income of the Top 40 entertainers including the aforementioned artists. Forbes excludes politicians in office from its annual study, but the ex-politician, George Bush Sr., appears at the bottom of the Celebrity 100 list, as does Colin Powell. At that time, both were active on the lecture circuit.

5 Most professionals with extremely high incomes are really also entrepreneurs. The income earned from their companies' activities exceeds their income earned from their professional functions; moreover, they often earn money trading stocks. This certainly applies to many successful artists like Michael Jackson, John Irving, and Steven Spielberg. In theory, their income from general entrepreneurial activities should be subtracted when discussing professional incomes, but in practice this is impossible. Because almost every professional with a high income develops this kind of activities, the effects broadly offset one another and rough comparisons can still be made.

6 Wassall and Alper (1992) show that the incomes of fine artists are more unequally distributed than usual.

7 Frank and Cook (1995).

8 Frank and Cook (1995) 24. Not to confuse readers I shall use the phrase winner-takes-all and not winner-take-all as Frank and Cook do.

9 Frank and Cook (1995) 24; Rosen (1981).

10 Rosen (1981). Depending on one' notion of talent, major income differences can also arise when there is no difference in talent. This is the thesis of Adler (1985). MacDonald (1988) again offers a slightly different explanation of the skewed income distribution in the arts. Towse (1992) 209-217 assesses and complements the models of Rosen (1981), Adler and MacDonald. Moreover, Towse (1992) 211 shows that difference in talent matters and is often larger than the other authors tend to think. Hamlen (1991) also concludes that the large income differences of pop singers correspond with substantial differences in voice quality.

11 Relative differences can vary over time. In the case of paintings made by Vermeer and 'Vermeer paintings' made by Van Meegeren experts have had problems in the past telling the difference, while nowadays almost anybody can tell the difference.

12 Frank and Cook (1995) 32.

13 Frank and Cook (1995) 38-39. They mention a total of nine sources for the emergence of winner-takes-all markets.

14 Abbing (1989) 126.

15 Cf. Towse (1993).

16 Frank and Cook (1995) 200-9.

17 Cowen (1998) 131 challenges Frank and Cook's thesis of cultural impoverishment. He defends the position that cultural diversity increases.

18 The fact that essential qualities cannot be measured does not exclude that cer-

tain qualities, which matter to the consumer, can be measured, like singing, for instance. Cf. Hamlen (1991) and Towse (1993).

19 In this context Rosen (1981) 846 uses the word 'charisma', which has a slightly different meaning.

20 Authenticity in the arts was treated in chapter 1 in relation to the assumed sacredness of art.

21 Everybody is necessarily creative and authentic at times – for instance, in finding solutions in a problematic relationship or in solving problems at work.

22 I do not want to suggest that people have no urge to conform. It could well be argued that both the urge to conform and the need for distinction, i.e., the wish to be 'somebody who differs from everybody else' are powerful impulses in many people's lives. In our culture, however, the latter has probably gained more momentum, and the artist serves as its model. Although it is true that by strongly identifying with artists or stars people apparently become less of an authentic individual themselves, this kind of identification and degree of symbiosis are usually temporal. In the long run they help in the formation of identities. These identities naturally exist in relation to the 'identities' of the social groups or subcultures somebody takes part in. After all, distinction can only exist in a social environment.

23 Frank and Cook (1995) 29, emphasize that, although entities other than persons may compete in winner-takes-all markets, identifiable individuals are almost always involved, when the stakes are high.

24 Abbing (1989) 124-135, Frey and Pommerehne (1989) 137-164, Jeffri (1989), Towse (1993), Elstad (1997) and Rengers and Madden (2000). Many other studies, which confirm low incomes and a skewed distribution of incomes, were reviewed by Throsby (1994), O'Brien (1997) and Wassall and Alper (1992). A different opinion comes from Filer (1986), who states that artists earn only a little less (not more than 10% less) than comparable professionals, but his use of census data has been criticized, for instance by Menger (1999) 553. See also note 213.

25 Baumol and Bowen (1966) 103.

26 Frey and Pommerehne (1989) 152-55.

27 "Surveys (and official statistics) on artists show they are younger, better qualified in the sense of having higher levels of educational achievement, earn less and work longer hours than other professionals." Towse (2001) 485.

28 Menger (1999) 545.

29 Throsby (1994) 18.

30 Alper, Wassal et al. (1996).

31 Throsby (1996).

32 Menger (1999) 545. Earlier Peacock, Shoesmith et al. (1982) 39 noted that between 1970 and 1980 in Britain the real value of performers' incomes working in established companies decreased.

33 On the basis of census data, Cowen and Grier (1996) 14-20 discovered that incomes and the numbers of artists in the US rose slightly between 1970 and 1990. However, in the census data, people are categorized by their primary source of income. Many artists earn most of their incomes outside the arts. Measuring the income of a group already selected on a financial criterion can lead to incorrect or irrelevant results.

34 Throsby (1996) 228.

35 Meulenbeek, Brouwer et al. (2000) 36. Fifty percent earned less than 100 Euros a month. And more than 75% could not make a living, in the sense that they

earned less than the equivalent of social security benefits in the Netherlands. Unlike in some other surveys, the respondents had no incentive to hide their illegal earnings.

36 Rengers and Madden (2000) 339 discovered that in Australia artists with low art incomes and artists with high art incomes work long weeks, while artists with intermediate incomes tend to work shorter weeks in the arts. The latter group probably consists of predominantly non-fine arts artists.

37 Meulenbeek, Brouwer et al. (2000) 24.

38 Struyk and Rengers (2000) 24.

39 Median income implies that 50% of a group earns less and 50% more than this figure. Because income distribution is always skewed, the median income is less than the average income. The top of the median income is not influenced by coincidentally high incomes. Therefore, it is generally more informative than average income. Nevertheless, average income is often used, because median income figures are not always available.

40 Heilbrun and Gray (2001, ed princ 1993) 15, Menger (1999) 542. See also section 7.7.

41 Cf. Menger (1999) 607-8.

42 Frank and Cook are not primarily interested in the height of low incomes in winner-takes-all markets. They are interested in social efficiency. They demonstrate that from a social point of view, there tends to be too many participants in these markets. Their analysis implies that even when the other causes of low incomes in the table do not apply, there would still be a surplus of participants and therefore, social waste. Frank and Cook (1995) 107-110. Frank and Cook (1995) 102-103 do not agree with the popular notion that society needs a very big pond in order to catch a few very talented artists. They evidently disagree with Adler (1985) who has tried to offer a scientific basis for the notion of the big point. In Chapter 9, I will return to this point.

43 Menger (1999) 554 presents related explanations.

44 A figure can be drawn (figure 1 presented at: <www.hansabbing.nl>) in which the y-axis stands for monetary income and the x-axis for non-monetary income. Ua,b, etc. are the indifference curves of an average artist with respect to both forms of income and Up,q, etc. are similar indifference curves of a non-arts professional. Where the indifference curves of the artist cross the curves of the other professional, the slope of the first is greater.

45 Frey (1997) and Towse (2001) assume that artists who seek status are intrinsically instead of extrinsically motivated. See note 3 of chapter 4. In my opinion, the way they distinguish intrinsic and extrinsic motivation is confusing. Therefore, I use non-monetary versus monetary rewards and motivation.

46 Economists have been reluctant to use the concept of psychic income because they think it has too often served as an easy way out for the explanation of phenomena, which are otherwise difficult to explain. Cf. Towse (1996b) 310.

47 This shows in the changing slope of the indifference curve in figure 1 mentioned in note 44.

48 In a figure (figure 2, presented at: <www.hansabbing.nl>) which is a more detailed version of figure 1 mentioned in note 44, the kink in the indifference curves of artists, where the survival constraint for artists is approached, expresses this phenomenon.

49 Not to complicate matters, in this chapter, the term 'risk' also covers the notion of uncertainty.

50 Cf. Singer (1981b), Frey and Pommerehne (1989) 157 and Frank and Cook

(1995) 116-118. Singer was probably the first to acknowledge the importance of risk taking in explaining artist behavior. He applied the Friedman-Savage gambling model to the visual arts.

51 Throsby (1994) 19.

52 Cf. Frank and Cook (1995) 103-105.

53 Frank and Cook (1995) 104.

54 Menger (1999) 553-4. See also note 63 of Chapter 6.

55 Menger (1999) 601.

56 Another outcome can be a so-called pig cycle, which exists in a mild form in most professions: periods of too much entrance alternate with periods with too little.

57 In the Netherlands, for instance, the percentage of self-taught artists with no official art education is approximately 12%. This percentage for visual artists was found by Meulenbeek, Brouwer et al. (2000) 21 and the same percentage was found by Struyk and Rengers (2000) 22 for performing artists. There are indications that among younger artists this percentage is even lower.

58 The percentage of students at Dutch art schools with more highly educated parents, according to Allen and Ramaekers (1999) 18, is 40% higher than in other higher education institutions. If figures were available for the fine arts departments at arts colleges this figure could be even higher.

6 Structural Poverty

1 Cf. Frey and Pommerehne (1989).

2 Cf. Montias (1987).

3 Cf. Hoogenboom (1993) and Stolwijk (1998).

4 Different types of bohemian artists can be distinguished – cf. Kreuzer (1971). The social backgrounds of various bohemian artists varies considerably. Nevertheless, a majority of bohemian artists probably come from families with above-average incomes.

5 The effect of more stringent restrictions of numbers can be shown in a figure (figure 3 presented on <www.hansabbing.nl>). With average hourly income on the y-axis and the total number of hours that all artists spend making art on the x-axis, the relevant part of the supply curve of artistic hours S moves to S', which appears above and to the left of S. S' is also steeper than S. With more control applied, the intersection with the demand curve also moves up and income rises as well. Cf. Frey and Pommerehne (1989) 160.

6 In the US there was support for artists in the 1930s through the Work's Progress Association, which was part of Roosevelt's New Deal.

7 Chapter 9 discusses other arguments for subsidization.

8 For increased spending, see note 28 of Chapter 7 and for low incomes note 24 of Chapter 5.

9 Presently I prefer to ignore the sixth explanation, the winner-takes-all explanation, because artists are not exceptional in that respect.

10 In figure 3 described in note 5 (and presented on: <www.hansabbing.nl>) the relevant part of the curve that represents total number of hours worked in the arts at different income levels runs almost horizontal. The three inclinations in combination with the survival constraint for artists cause a high income-elasticity in the relevant part of the curve. According to Towse (2001) 485 this is confirmed by empirical evidence. The effect of misinformation, on the other hand,

is that a persistent overestimation of expected returns shifts the 'supply' curve to the right and thus increases the total number of hours worked in the arts and therefore, also the number of artists.

11 See also note 13 of Chapter 4.

12 The notion of an oversupply of artists can be found, among others, in Menger (1999) and Towse (2001). The use of terms like 'oversupply' and 'overproduction' is not unproblematic. I return to the subject in sections 9.6 and 9.8.

13 Even when artists on average do not become poorer, poverty can be said to 'increase' because extra available money leads to more poor artists per hundred thousand inhabitants.

14 The model I present in this section leads to largely the same result as Throsby (1994a), 'A work-preference model of artist behavior'. In Throsby's model, artists tend to forsake consumer goods in order to make art. Passionate artists want to maximize their time doing art at the expense of monetary gain and the leisure time that comes with working less. My approach is more general and more in line with neo-classical thinking in the sense that artwork is not a goal in itself but a means for gaining non-monetary income like private satisfaction and recognition. Therefore, artists are inclined to forsake earned income for non-monetary income. In both approaches there is a survival constraint for artists. Although the approaches differ, the results can be the same. Moreover, it should be noted that my model refers to fine artists and not necessarily to all artists, i.e., including applied artists. For other comments on Throsby's model see Rengers and Madden (2000).

15 In theory it's possible that more subsidization does not by itself lead to more artists, but that, instead, more artists and more subsidies have a common cause. For instance, the Netherlands is a relatively prosperous country. On the one hand, because the Dutch are prosperous and have enough money to do something about the economic plight of artists, they are perhaps more likely to be concerned about the low incomes in the arts and may decide to increase subsidies for artists. On the other hand, because of the prosperity in the Netherlands, people may be more tempted to seek out a romantic alternative in the arts. Therefore, it is possible that higher subsidies do not necessarily create more artists, but that both have a common cause. Although it is not impossible that there are also general causes that contribute to both subsidization and high numbers, I nevertheless argue that subsidization primarily causes the large numbers of artists and overcrowding.

16 Throsby (1994a) in his work preference model for artists, presents indirect evidence for this thesis. Cf. Towse (2001) 485.

17 An international comparison of income figures is tricky, as will be pointed out below. Nevertheless, in most areas, evidence more likely points in the direction of lower than higher incomes. (As noted before, visual artists in the Netherlands earn close to zero.)

18 Higher subsidies in mainland Western Europe are only partly offset by lower donation and spending levels. Therefore, I claim that subsidies result in a net-increase in numbers.

19 Cf. Ernst (1999). Measuring methods are almost always indirect; they often depend on a form of registration that only exists in a specific country, like registrations based on unique tax measure, for instance. The relativity of measures is also evident because of the fact that in one country there can be two ways of counting artists whose outcomes deviate by more than 100%. And, even though the registration of subsidies appears to be less complicated, the way in which

subsidy levels are measured in different countries, especially subsidies by local governments, also differs too much to enable a comparison that makes sense. Cf. ibid. Ernst.

20 Even then, some reservation in the interpretation of results would be required because of the necessary limitation inherent in the definition of who is counted as an artist and who is not.

21 Dun, Muskens et al. (1997) 9.

22 Dun, Muskens et al. (1997).

23 Haanstra (1987) 22-5.

24 Dun, Muskens et al. (1997) 51 also point to the increase in the number of students but I see this as an independent variable that contributed to the attraction of the program instead of the other way around.

25 Although 40% of the money spent on the program continued to pour into the visual arts through other subsidies, overall spending by the ministries of social welfare and culture on visual art went down by more than 40%. Because spending on the visual arts by local governments remained largely the same, the total reduction was approximately 20%.

26 Dun, Muskens et al. (1997).

27 Dun, Muskens et al. (1997) 46-8.

28 IJdens and Vet (2001) 31.

29 Cf. section 5.7.

30 In their direct effects, increased spending, donations, and subsidies tend to increase the number of artists, and they sometimes influence the income distribution and average income figures as well, while the willingness to work for a low income and therefore the inclination to become an artist remains the same. In the case of signals that are interpreted positively by artists, numbers increase and average income can decrease because artists become more willing to work for low incomes. The inclination of people to become artists increases. (The supply curve shifts to the right and starts to run more horizontally.)

31 This is also the opinion of Grampp (1989a) 114.

32 When it's mainly highly successful artists who are profiting, average incomes are likely to show a slight increase.

33 See also O'Hagan (1998) 148-151.

34 Through the 'Intermittent de Spectacle', income is transferred from the average employee to the average performing artist. Because officially there is no government involvement, it is seen as more of a collective donation than a subsidy. The effect is the same, however.

35 Although the amount of money the NEA gives in the form of grants is relatively small, the grants are well-known and fine arts graduates usually first turn to the NEA.

36 Because they are scattered, the signaling effect of the Regional Boards is weaker. The same does not apply to the Arts Council, but at the moment it does not give grants to artists. This situation is likely to change in the near future.

37 IJdens (1999) gives other examples. Nooy (1996) also points to the unintended effects of subsidization. He argues that unwanted effects can be reduced by a periodic change in the system of subsidization. Another interesting example is presented by Benhamou (2000) who discusses the effects of different public policies on the temporary and self-employment situations among performing artists in France and England.

38 It is only recently (in 2000) that the Dutch government changed its policy. Using financial means, it installed an indirect *numerus clausus* by discouraging

schools from accepting too many students. In France, England, and Germany meanwhile, the population of fine arts students continues to grow unabated.

39 It seems possible that the pressure of the art lobby encourages colleges to increase their numbers even more in order to offer teaching jobs to the growing number of artists who cannot find proper employment elsewhere. In this respect, Menger (1999) 607 suggests that the training method both adapts and contributes to the 'oversupply' of artists. Towse (1996b) 318-19 mentions the existence of a 'training lobby' in the UK, which is engaged in 'rent seeking', the seeking of profits for the own group. It has a financial incentive to supply more training positions to students.

40 Among others, Towse (2001) and Linden and Rengers (1999) point to the fact that the parents of art students are better educated than those of other students in higher education. In the Netherlands, there are at least 40% more students at arts colleges with higher educated parents than in other schools for higher education. See Allen and Ramaekers (1999) 18. These figure apply to all departments in art colleges, including the relatively large applied apartments. If figures were known for the students in only the fine arts departments in comparison to other students the difference is likely to be even larger. This is confirmed by research done by Lannoye. She questioned a group of art students, a majority of whom were fine arts students. According to her data, almost 70% more art students than other students had parents with a higher than average education. Lannoye (2000) 37.

41 Authorities are often aware of the fact that professional artists use allowances to continue working but administrators often turn a blind eye to it. In the Netherlands, this became quite clear when it took several years to agree on the WIK-program, a new subsidy program whose aim was to stop artists from depending on social benefits. In that period of time authorities were instructed to postpone a strict application of the official rules for social benefits in the case of artists who made illegal use of social benefits. When illegal was no longer 'illegal', it revealed just how widespread the illegal but tolerated utilization of benefits had always been.

42 Benhamou (2000).

43 Presently in the Netherlands the so-called Melkert-baan plan is a good example.

44 Meulenbeek, Brouwer et al. (2000) 34. (The median yearly income in 1998 was 1200 Euro as one of the authors of the report, Natasha Brouwer informed me.)

45 Meulenbeek, Brouwer et al. (2000) 34. These artists earn less than the level of social security benefits in the Netherlands.

46 According to Janssen (2001) 342, who presents other references, in the nineteenth century, most artists came from the middle class (in most cases from a professional family) and most had also gone to public school or a university. Therefore, family financial assistance was possible and likely, but as far as I know, no empirical findings exist regarding the extent of family patronage. The same applies to the present family patronage. See also note 40.

47 See note 40.

48 Another explanation for the different social background of art students is that these students have more cultural capital and therefore more chances to succeed in the arts.

49 Throsby (1996) 232-4, Menger (1999) 602.

50 Wassall and Alper (1992).

51 Throsby (1996) 235.

52 These figures are derived from Meulenbeek, Brouwer et al. (2000) 25-6.

53 Linden and Rengers (1999).
54 Wassall and Alper (1992) 191.
55 This is a trend not only in Britain as Benhamou (2000) demonstrates, but in several European countries. In France, however, due to the incentives of a specific system of social benefits, the trend has been most strongly towards shorter contracts rather than to situations of self-employment. See Benhamou (2000). In countries like the Netherlands and Germany, both developments occurred.
56 Throsby (1996) 232-4 presents evidence of better payment.
57 According to Throsby (1996) 233 and Throsby (1996a) the relationship between arts training and income from art is weak, while the relationship between training and income from arts-related activities as teaching is relatively strong.
58 Menger (1999) 602-606.
59 Menger (1999) 604.
60 The professional bureaucracy in the arts is discussed in chapter 10.
61 Menger (1999) 607.
62 This implies that the survival constraint for artists loses significance.
63 According to O'Brien and Feist (1997) only half of those with cultural occupations in Britain in 1981 were still employed in these occupations ten years later. According to Menger (1999) 553-554 however, fewer artists withdraw from artistic careers than one might expect. The Dutch figures in Linden and Rengers (1999) show that comparatively speaking, more artists leave the profession within the first year and a half after graduation, but after that they tend to stay for a comparatively long period. (Those who leave almost immediately after college could be people for whom education is basically a form of consumption rather than a preparation for professional activities.)
64 The criterion is spending as opposed to earning. Therefore satisfaction is not relevant. A producer who enjoys a lot of satisfaction while at work, as many artists probably do, can still be a producer.
65 Towse (1996b) 316-320 and Menger (1999) 606-609 speak of oversupply. Blaug (2001) uses the more cautious term 'excess supply'. The terms 'oversupply' and 'overproduction' can also be used in a welfare economic sense. See section 9.8.
66 See also O'Hagan (1998) 148-151.

7 The Cost Disease

1 Baumol and Bowen (1965) and Baumol and Bowen (1966) 161-176. More recent writings on the subject by Baumol and colleagues can be found in Towse (1997). A small collection of sometimes-critical writings by other authors was published in a special issue of the *Journal of Cultural Economics* 20, 3 (1996).
2 Baumol (1996) and Towse (1997) 438-522.
3 Towse (1997) 103-244 and Throsby (1996). Peacock, Shoesmith et al. (1982) 39 demonstrate that there would have been a cost disease in the performing arts in Britain if they had not lowered wages in the performing arts. The existence of a cost disease is disputed by Cowen and Grier (1996). However, as Towse (1996a) 245 notes, their results are dubious because they used census data for artists' figures and incomes. Many artists are not included in this data.
4 Because quality is never constant, Blaug (1996) argues that the notion of the cost disease has little relevance. Nevertheless, I believe that the notion of the cost disease is useful. As a theoretical concept it can influence one's perspective. More-

over, if the assumptions are not interpreted in an all-or-nothing sense, the cost disease can be applied to the real world to varying degrees.

5 Baumol and Bowen (1965) and Baumol and Bowen (1966).

6 Using the terminology of Goodman (1954) 113-123 by using notational systems, allographic art replaced autographic art. I discussed the implications this has for productivity in Abbing (1989) 89-91.

7 Cowen (1998) 136-137.

8 In 1985 in the Netherlands attending an average (subsidized!) live concert cost some 50 times more than enjoying a concert at home on television. Abbing (1989) 119. For a concert by a well-known ensemble the difference would be much larger.

9 Cowen and Grier (1996) 10-12.

10 Cowen (1996).

11 If the soloist earns more than other members of an orchestra, the difference is still large but not as large.

12 The costs per 'unit of consumption' – like attendance, or hours of consumption, or purchases – matter when it comes to the severity of the cost disease and not the costs per production or performance. Two performances can have the same production costs, but if one production is performed only twice and the other two hundred times the ticket prices of the latter can be much lower. This allows the latter to compete more effectively with alternatives such as cinemas. Costs of production can only be used when the attendance of a production remains constant. This is what Baumol assumes. However, other than in classical music and the theatre, attendance is seldom constant. Baumol and Baumol (1984), in discussing technical reproduction, sometimes also, but not consistently, used costs per unit of consumption. Nevertheless, it is understandable, that costs per production are sometimes used because costs per unit of consumption can be difficult to measure. It is often the case that there isn't even a unit of consumption to measure. For instance, for a live performance that is rebroadcast on television a different unit of consumption is needed to count home viewers. The question is how to divide total costs.

13 Baumol (1997).

14 Baumol (1997).

15 Cf. Goodman (1954).

16 Most conductors do not follow Stravinsky's directions of a very strict tempo be kept with a metronome. This is often simply too difficult for the performers; moreover a less strict tempo is thought to sound better. Stravinsky himself didn't even stick to his own prescription. Nevertheless, these performances are, in a formal sense adaptations.

17 Stage sets for *Macbeth* exist that can be considered authentic copies because all of the directions have been followed, and still be so different that the author might as well have been someone completely different. Or people who see the film version of *Romeo and Juliet* with Leonardo DiCaprio are watching a true copy, even though it takes a while before viewers realize that the text is the original Shakespearean text. Despite the totally modern setting and characters, no lines or directions have been altered.

18 In the Anton Philips Hall in Eindhoven, the Netherlands, experiments with electronic amplification were stopped, because the audience resisted amplified performances. However, nowadays, the Muziek Theater audiences in Amsterdam seem to appreciate similar experiments, because they improve the hall's terrible acoustics.

19 Cf. Smithuijsen (2001).

20 Sometimes the opposite occurred. This was the case when musicians began returning to older and quieter instruments. It may not be mere coincidence that this movement has been particularly strong in Austria, Switzerland, and the Netherlands. In these countries the classical music subsidies have been relatively generous, enabling orchestras to ignore the effects of the cost disease.

21 Because of the pressure of a host of under-employed performers, one would expect the average income of performers in established companies to be not much higher than of performers generally. However, due to barriers, considerable income differences can exist.

22 Frank and Cook (1995) 61-84.

23 Cf. Langenberg (1999).

24 Evidence was previously presented in 5.4.

25 It can be argued that the cost disease must be added to the explanations of low income presented in chapter 5. That would be incorrect. The cost disease does not explain poverty; it only exacerbates poverty. Cowen and Grier (1996) 8 tell a similar story, but their criteria differ: because of general prosperity and because of the joy of creating art, artists are prepared to work for low incomes and thus the cost disease is contained.

26 Baumol and Baumol (1984), Baumol, Blackman et al. (1985) and Baumol, Blackman et al. (1989) 131-5 have argued that the cost disease also applies to most of the technically reproduced art products such as literature, films, and CDs. Even a large increase in productivity related to technical production will sooner or later be offset by the rising cost of the indispensable, often real time, personal service that is essential to the production of art products. For instance, there is an audience size limit in the case of films, even when the limit might be the population of the entire planet. Baumol et al. however overlook the possibility that new cost-saving techniques will be developed in future reproduction and diffusion techniques. Moreover, Cowen and Grier (1996) 209 present a more fundamental criticism. They have pointed out that any production process involves an irreducible amount of labor. In the agricultural sector, for instance, the share of total costs of an irreducible amount of labor will also increase in the long run, if no new savings occur elsewhere in the production process.

27 In their original discussion of the cost disease Baumol and Bowen (1965) and Baumol and Bowen (1966) neglected the effects of rising income among the population as an antidote to the effects of the cost disease. This has been noted, among others, by Heilbrun and Gray (2001, ed princ 1993) 146-47.

28 Menger (1999) 542 and Benhamou (2000) 303. For the performing arts, see for the US Heilbrun and Gray (2001, ed princ 1993) 15, see for Britain Feist and Hutchison (1990) 2, and for the Netherlands Statistiek (2000) 11, as well as earlier editions of Statistiek (1996).

29 Linder (1970).

30 Cf. Baumol (1973).

31 As noted, this is the opinion of Woude (1987) 309. This opinion does not go undisputed. Nevertheless, even if the real number is much higher, for instance five times higher – i.e., 5% – the percentage of surviving paintings is still amazingly low.

32 Cowen (1996) 145.

33 Cowen (1996) 176 predicts that with more and more music created in the studio – dance and techno – music will become more composition-based again. He could be right in the long run, but the emergence of the popular DJ as an authen-

tic and charismatic artist demonstrates that the need for performer-based authenticity is still strong.

34 Because the visual aspect in traditional theatre, opera, and dance is stronger, these art forms do not compete with CDs, but with video, film, and above all television. Although both live performances and technical (re)productions have important qualities of their own, the latter have gained an ever-increasing share of the market. Therefore it would not amaze me, if in these areas as well in new forms of live performances we will see the emergence of new techniques and offer new formats and products comparable to successful live pop music performances.

35 Cowen (1996) analyzes cultural pessimism.

36 Cf. Doorman (1994).

37 Cowen (1996) 182 notes that Indian classical music is more complex than Western classical music. He also states that there is considerable complexity in some of our new musical genres.

38 Ploeg (1998) 412 stresses the choice the government necessarily makes when it assists one victim of the disease and not another.

39 Because donations and subsidies are additional sources of income, they necessarily relieve the cost disease, i.e., in a literal sense. When the directors of art companies succeed in attracting more donations and subsidies, their organizations become 'healthier', at least in the short run and from their own point of view. From the point of view of governments they probably seem less healthy, however, because governments generally see their assistance as temporary – the aim of assistance is to make art companies less dependent on assistance over time.

40 In the case where a government is consistently subsidizing the deficits of particular companies, they will actually be punished for introducing successful innovations. Cf. Pommerehne and Frey (1990), Frey (1999).

41 See section 6.6.

42 Schuster (1985), O'Hagan (1998) 135-138. In the present context, the higher tax deduction in the US can be ignored.

43 Throsby (1994) 7-9 presents a number of references. For the Netherlands, see Goudriaan (1990).

44 As noted, higher indirect subsidization through tax deductions in the US reduces the difference to almost zero, but in the present context this is irrelevant.

45 O'Hagan (1998) 135-9.

46 For instance, in the case of theatre, the average audience size for performances by regular theatre companies was in 1992 in the US 50% higher than in the Netherlands; see Hoogerwerf (1993) 100 and 109. When the same performance is repeated for years the performers are often replaced.

47 Even though the share of donations in the US is no larger than the share of market-generated income, the influence of donors is relatively large in the US. This is not so amazing because in practice many personal ties exist between paid employees at art companies and private donors and their representatives in donor organizations. The latter often hold key positions on the boards of directors of the various art companies. The influence of donors is often (but not always) conservative. The reasoning that applies to governments largely applies to donors as well. On the other hand, European governments, with their connections to the new cultural elite, sometimes have a more progressive 'taste'. This is most evident in the visual arts.

8 The Power and the Duty to Give

1 O'Hagan (1998) 157.

2 Cf. Komter (1996).

3 Sometimes regulations just exacerbate the situation. For instance in the Nether-lands, structurally subsidized performing arts companies receive approximately 85% of their income in the form of subsidies on the condition that they pay reasonable wages.

4 In the short term, government subsidies beholden to national laws are forced transfers. If the government refuses to 'give' to the applicants, applicants can appeal in court. Nevertheless, most arts subsidies must be seen as gifts, because in the long run government can simply change the laws.

5 Schwartz (1967) emphasizes the importance of 'identity' for both giver and recipient.

6 On the basis of the characteristics of the gift, not only private individuals but also corporations, large foundations, and government agencies give to the arts. If however, 'symmetrical groupings' became a requirement for gift-giving, as in the approach of Polanyi (1992, 1957) 35, most donations from corporations, foundations, and government agencies could no longer be considered gifts.

7 Cf. Mauss (1990 ed.princ. in French: 1923), Malinofsky (1970 ed.princ. 1922) 39-45, Levi-Strauss (1957 ed. princ. in French 1949) 84-94, Sahlins (1978) 185-205 and Gouldner (1960). According to Oliner and Oliner (1988), however, reciprocity can be absent under extreme circumstances. (With the exception of Mauss, these texts are reprinted in Komter (1996)).

8 This struggle was discussed in 3.8.

9 Epstein (1967) and Lash (1968) 63-113. More references in: Guilbaut (1983) 237-8.

10 Klamer, Mignosa et al. (2000).

11 Cf. Abbing (1992).

12 This also applies to the Dutch foundations, the 'Nationaal Instituut' and the 'Prins Bernhard Fonds', which were originally primarily privately funded. Cf. Pots (2000) 274-5.

13 Cf. Veblen (1934).

14 Meulenbeek, Brouwer et al. (2000).

15 As mentioned earlier, the English moralist and aesthetician Arnold (1875) has already successfully promoted the view that the fine arts embody the highest values of civilization.

16 In this respect, the Dutch royal family paled by comparison with other royal families in Europe. It did not have a strong court tradition to rely on. The present monarch, however, Queen Beatrix, has assumed the more traditional role. She is a fervent collector of visual art.

17 See the first illustration of Chapter 10.

18 The nouveau riche, like pop stars, athletes and IT experts, usually prefer to give to charities rather than to art. Pop stars veil their commercial background by giving, but they have no real need to legitimize their wealth.

19 Cf. Komter (1996) 118.

20 Drees Jr. founded a new social democratic party in the Netherlands called DS70. His father, Drees sr., is better known. After the Second World War he presided over a number of cabinets.

21 Meulenbeek, Brouwer et al. (2000) 41.

22 For the incomes of visual artists in the Netherlands see Meulenbeek, Brouwer et al. (2000) 34. (The amount of 1200 Euro is a specification that was presented to

me by one of the authors of the report, Natasha Brouwer.) In 1998, in the Netherlands the annual net income, i.e., after taxes, of the average forty-year-old employee with a higher education was 25,000 Euros.

23 An obligation to give plays an important role in almost every profession, not just in the arts. What appears to be exceptional is that in the arts this kind of obligation is vested in a loosely organized art world.

24 If partners, family and friends would form a so-called economic household with the artist, their support of the artist would also be a form of internal subsidization. However, presently relatives are most of the time financially independent and therefore the term 'donation' is more fitting.

25 Cf. Allen and Ramaekers (1999) 18.

26 The power to help a partner, son or daughter or close friend also brings at least some rewards in highlighting the power difference between donor and artist. Nevertheless, in modern families the difference in power must be veiled and overtly 'helping the artist' can be problematic. It can lead to all sorts of hilarious misunderstandings as in the last illustration.

27 Volunteer-labor from private donors is likely to be substantial. Klamer and Zuidhof (1999) 52 found that museums in the Netherlands save 27% on their labor costs by the use of volunteer labor. In the case of other art-organizations no estimates exist, but this type of donation is bound to contribute substantially to the large gift-sphere in the arts.

28 For the history of private giving in relation to government giving in the Netherlands, see Bevers (1993) 38-109 and Pots (2000).

29 In this context it is worth noting that Kushner and Brooks (2000) 65-77 argue that street performances have certain efficiency advantages in comparison with indoor performances with tickets-sale.

30 Donors may however be aware of the costs and benefits of giving. For instance, donors realize that although in the short run it is possible to consume street art without giving, street artists only return when they earn enough money. Nevertheless, conventions are likely to over-shadow calculation. Therefore, for many donors free riding, enjoying the performance without paying, stops being an alternative.

31 Ostrower (1995) 132.

32 Ostrower (1995) 133.

33 In some circles veiling the gift is regarded chic. However, to earn the reputation of 'somebody who inconspicuously gives' gifts must be noticed by at least a few people, who then spread the news.

34 Because donors can sometimes ask for their money back, when they don't receive the agreed upon exclusive perks, these transactions can also be considered as commerce with prices that are artificially high, i.e., prices that don't conform to the market. The surcharge then represents the net gift.

35 See note 30.

36 Cf. Boogaarts and Hitters (1993) 165-6, Council (2000) and Feist and Hutchison (1990) 24. For theatre in the US, see Janowitz (1993) 7. According to Wijngaarden (1995) 43 the total sum of corporate sponsorship in the Netherlands amounts to less than 5% of the ministry of culture's budget. See also Bevers (1993) 64-8. Moreover as noted, sponsoring cannot be considered giving. Therefore, according to O'Hagan and Harvey (2000) corporate philanthropy is almost absent in Europe.

37 Wijngaarden (1995) 43 states that the requirements art-sponsoring must meet are increasingly the same as other forms of communication must meet.

38 In this respect, it is noteworthy that a particularly sincere Dutch intermediary, who brings firms and art institutions together, only uses the term 'patronage' – or 'partnership' as they call it – if the value of contracted returns does not exceed 30% of the total donation.

39 O'Hagan and Harvey (2000). In the Netherlands as well, philanthropy is unimportant but not altogether absent as Wijngaarden (1995) shows.

40 Cf. O'Hagan and Harvey (2000).

41 O'Hagan and Harvey (2000) 222. According to O'Hagan and Harvey, cohesion in the supply chain is another important return. As a form of goodwill it can be attributed to the imago of the firm.

9 The Government Serves Art

1 See section 9.11.

2 Artists' gifts and those received from artists' families are not included. In mainland Western Europe about twice as much money as in the US flows from government agencies to the arts, while Britain appears somewhere in between these two extremes. O'Hagan (1998) 139. The large 'subsidies' in the form of tax deductions in the US has been taken into account. The considerable indirect subsidization of the arts by American private and state universities is not included however. If these figures were to become available and were added to public expenditures the difference between the US and mainland Western Europe would probably be much smaller.

3 On lottery money as a form of subsidy, see note 7 of Chapter 2. Not all government conduct with consequences for the arts is included, however. This applies for instance to legislation that guarantees artistic freedom or enforces copyright laws. Although countries vary, the general aims of the legislation are based on notions of justice. Therefore, such legislation is usually not an instrument of art policy. The same applies to numerous general tax measures, which have an impact on the arts. Only when such measures apply specifically to the arts and are an exception to existing regulation, like a special tax deduction or a lowered VAT tariff, does this need any explanation in the context of this chapter. Because the VAT measures cost public money, they will be treated as subsidies to the arts. O'Hagan (1998) 73-129 addresses all these subjects; he presents a general treatise on the impact of all sorts of regulations and taxes on the arts.

4 Abbing (1978), Abbing (1980), Austen-Smith (1980), Cwi (1980), Fullerton (1991), Peacock (1969), Robbins (1963), Scitovsky (1983). O'Hagan (1998) 21-47 presents a useful survey including recent references. Other Dutch references can be found in Puffelen (2000) 14-36.

5 The relative success of welfare economics can in part be explained by the fact that its notions are close to common wisdom. Welfare economics describes a hypothetical situation of a free market economy where there is 'maximum welfare'. In the real world, activities that survive in the market also appear to serve the general interest. In other words, 'free markets serve the general interest'. This is most notably evident in the fact that obsolete businesses tend to go out of business while other necessary businesses emerge to take their place. 'Only those activities, which can sustain themselves, because people are prepared to pay for them, have a right to exist.' This is the 'logic' of the market that everybody understands. Welfare economics departs from this logic.

6 Social philosophers, like Blokland (1992) and Laermans (1992) reject the wel-

fare economic interpretation of the general interest. Rushton (1999) rejects the outcomes of welfare economics because it is based on methodological individualism.

7 Although all three arguments can be seen as referring to forms of market failure, the term 'market failure' is sometimes reserved for the third argument because the inability to sell certain goods appears to be the most direct failure of markets.

8 I ignore the difficulties welfare economics has in the case of meddling preferences. Cf. Sen (1970).

9 Pots (2000) 272-78.

10 There are economists who argue against the merit argument. Because of their preoccupation with free markets and consumer sovereignty these economists prefer to see as little interference with the consumer preferences as possible and therefore they warn against the development of merit goods. Nevertheless, it is a matter of political choice, whether general interest is served best by safeguarding consumer sovereignty or by allowing interference on the basis of responsibility. Economics has little to say about that. Personally, I would find it strange if people with better educations and more money didn't 'care' or feel responsible for others. Individuals express their sense of responsibility with all kinds of actions, including gifts, and collectively they employ the government to further these ends. Responsibility does not stop with the family nor does education stop at the age of eighteen. Therefore, merit policies exist in every responsible society. What concerns me in this chapter, however, is this question of whether subsidies are effective and whether selfish motives are hiding behind the merit argument.

11 Cf. Pots (2000).

12 For the Netherlands see Pots (2000) 177-82.

13 For the Netherlands see Pots (2000) 295-326.

14 Swaan (1988).

15 Abbing (1992) treats the comparison between art and the other sectors more extensively.

16 Levine (1988) and Peterson (1997). Pots (2000) describes the importance of the phenomenon in the Netherlands.

17 See note 43 of Chapter 7.

18 Cf. Swaan (1986).

19 Different forms of direct and indirect assistance in various countries are described in O'Hagan (1998). IJdens (1999) presents examples from the Netherlands.

20 The Dutch government, which has been particularly generous to poor artists, nevertheless has always tried to keep social subsidies for artists separate from art subsidies. Pots (2000) 262 and 319.

21 People who do not pay cannot be excluded from these goods and effects. This approach is based on the so-called non-excludability criterion for collective goods and external effects as formulated by, among others, Musgrave (1959). Samuelson (1954) (who speaks of public goods rather than collective goods) developed another well-known criterion for collective goods and external effects based on non-rivalry: one person's consumption does not necessarily diminish the amount of a collective good or external effect left for another. Theoretically, the latter definition is the only relevant definition within the welfare economic approach. For the explanation of public expenditure, however, the use of the excludability definition is the only relevant definition. (Combining the two serves

no purpose.)

22 Because this book treats the explanation of art subsidies rather than their legit-imization, I only touch upon the subject of collective goods and external effects in the arts. Readers interested in the effects of economic legitimization of subsidies for the arts on welfare arguments can consult many articles and books that treat collective goods and external effects in the arts. Abbing (1978), Abbing (1980), Abbing (1989), Austen-Smith (1980), Cwi (1980), Fullerton (1991), Grampp (1989), Peacock (1969), Robbins (1963), Scitovsky (1983) and Throsby (2000). A useful survey including recent references is presented by O'Hagan (1998) 21-47.

23 See references in note 4.

24 Cf. Throsby (2000).

25 Attempts have been made to measure the willingness to pay for intangible collective goods in the arts by, among others, Throsby and Withers (1986). The outcomes of such analyses should be treated with care. Because valuations are not part of a continuing valuation process, they can be shots in the dark. Abbing (1989) 21-22. Therefore, the 'measurement' of the preferences for collective goods and external effects is a matter of political debate.

26 Cf. Throsby (2000). In his chapter on artistic innovation, Throsby speaks of quasi-public goods.

27 In the latter case copyright applies.

28 This subject is treated more extensively in the sections 9.9 and 11.7.

29 The situations with and without intervention are not completely the same, because subsidization changes collective goods and effects, but this does not imply that by taking into account the cost of the intervention the situation with intervention is necessarily superior to the situation without intervention or vice versa.

30 As indicated in the previous chapter, the free-rider problem is a less important obstacle for collective actions than economists used to think.

31 In a welfare economic sense there is a waste of human resources. Cf. Frank and Cook (1995) 102-3 and 107-10.

32 Cf. Klamer and Zuidhof (1999).

33 I do not agree with Hütter (1997) 171 who states that in the classical cultural heritage 'we find the typical conditions of underinvestment'.

34 I refer to the common impact study that is based on consumer spending. Cf. Seaman (1987) and Abbing (1989) 218. Puffelen (1992) and Puffelen (2000) 64-71 present a more extensive discussion of impact studies.

35 If the price of petrol goes down, more cars are sold. Similarly, if hotel accommodations become cheaper or more attractive, more people will go to the Rijks Museum. On the other hand, if the Rijks Museum lowers its prices or becomes otherwise more attractive, more people will stay in the aforementioned hotels. Therefore, these are price effects instead of external effects. (Abbing (1989) 218 presents a few exceptions.)

36 Although the term 'collective good' is sometimes reserved for consumer products, in this case I prefer collective good rather than externalities or a 'common good' so as not to complicate matters. The term 'collective good' can be used because excludability is limited in the sphere of production.

37 Frank and Cook (1995) 102-3 and 107-10 demonstrate that from a social point of view there tend to be too many participants in these markets. They evidently disagree with Adler (1985) who has tried to provide a scientific basis for the necessity of the big pond in the arts. Towse (2001) 484 speaks of an expensive effi-

ciency benefit. (The normative conclusions of Frank and Cook rest on so-called Pareto-optimality.)

38 Average tastes have changed. This does not mean that the taste of individuals has necessarily changed as well. Cf. section 7.8.

39 This information was supplied by Bas de Koning at the Dutch NVPI.

40 The Dutch musical award, 'the Edison', was an early entry among awards, but it never became really prestigious.

41 As noted before, an investigation, commissioned by the French Foreign Ministry and reported on by Charles Bremner in the internet edition of *The Times* of June 13 2001, emphasizes the negative effects of state patronage on contemporary French visual art. 'French contemporary artists are being pushed out of the world market because of stifling state patronage.'

42 In this respect it is not amazing that a social right to art never developed as noted in section 9.4. A right to art just can't be compared with the aforementioned basic social rights to education and health care as analyzed by Swaan (1988).

43 Goudriaan (1990).

44 See section 9.11.

45 Frey and Pommerehne (1989) 184-5 and Goudriaan (1990). Experiments with vouchers are rare. Price discrimination is not unusual. For instance, students or young people often pay lower prices. But they also pay lower admission prices at unsubsidized art institutions. Moreover, the quality offered is often lower. (For instance, the reduction may only apply in last minute purchases of tickets.) Therefore, existing price discrimination is largely a commercial instrument. The only plan that might serve merit policies is much stronger price discrimination or vouchers.

46 Grampp (1989), Grampp (1989a), Frey and Pommerehne (1989), Abbing (1992) and Cordes and Goldfarb (1996). Rent seeking is emphasized in the public choice approach in economics.

47 Among others Lindblom (1959) toyed with the idea that the influence of the various groups is largely offset by one another. Therefore, the actions of these groups primarily informed governments and so could potentially improve a democracy. Later Lindblom and others revised their opinion. The notion however, that pressure groups also inform the government is still essential to public choice theory.

48 Cf. Buchanan (1962).

49 Grampp (1989a) presents a thorough discussion of the rent seeking theory as applied to the arts. Grampp adds two conditions I do not mention, because they are too technical in the context of this chapter. In Grampp (1989) 205-31 a less technical treatment of rent seeking in the arts is given.

50 The average price of theatre with subsidization mentioned in the text is probably lower than one may have expected. The large number of free tickets is the cause of this.

51 Visitors not only receive subsidies because art companies are subsidized, but also because accommodations are subsidized. Therefore, in calculating these price increases, I assume that it's not just art companies but also accommodations that lose their subsidies. The price rise irrespective of accommodations is derived from OCW (1999) Appendix 2, table B. I increased the subsidies per visitor by 60% to cover the subsidy per visitor that comes in via accommodations. I derived this percentage from the table in section 3 of Schouwburg- en Concertgebouw Directies (2001).

52 Given subsidization performing arts patrons enjoy an income advantage that

they receive from the average taxpayer. In the Netherlands, the upper-income half of the population receives 73% of the performing arts subsidies. The upper 10% income bracket receives 29%. Pommer and Ruitenberg (1994) 167. These figures in theory show that it pays for current consumers of the subsidized performing arts to put pressure on the government to support subsidies for the performing arts. They are candidates for rent seeking. (Incomes are secondary incomes. These are 1991 figures. More recent figures are unavailable. Compared with earlier figures, the advantage upper-income brackets gain from performing art subsidies increases over time. Also, when the differences in tax rates are taken into account, the advantage of the richest 10% is considerable and it is much larger than in the case of other forms of subsidization.)

53 Grampp (1989a).
54 Art lobbies in one form or another probably exist in most countries with considerable levels of arts subsidization. With respect to arts training Towse (1996b) 319 points to rent seeking by the 'training lobby'.
55 The Dutch minister Hedy D'Ancona and to a lesser extent, Aad Nuis were reproached for their connections with and indebtedness to the art world.
56 A saying by the Dutch poet and visual artist, Lucebert. ('*Alles van waarde is weerloos*'.)

10 Art Serves the Government

1 The next step could be linking this chapter's approach to a political theory. Cf. Lindblom (1990), Dahl (1956), Dahl (1985).
2 Thorbecke gave cause to these different interpretations, which at times confused the political debate in the Netherlands. Cf. Pots (2000).
3 The approach of a neutral government is present in many textbooks on public finance, for instance Musgrave (1959). In modern textbooks, like Wolfson (1988) 308-13, some attention is paid to the possibility of a non-neutral government, but it is not emphasized.
4 Mueller (1997), Koopmans, Wellink et al. (1999) 49-58.
5 The concept of the State having an independent existence is eschewed by libertarian individualism, which is central to modern economics, as Throsby (2000) 2 remarks.
6 Since the acknowledgement of satisfying behavior (Simon (1982)) the notion of discretionary space makes sense. With respect to the arts, *The Financial Times* (special survey, February 2000) Business and the Arts (www.ft.com, downloaded July 7, 2000) reports many cases of business involvement in the arts that seem to rest on the use of discretionary space.
7 See note 16 of chapter 3.
8 Among many others Buchanan (1962) and Wilson (1989) have emphasized rent seeking by magistrates.
9 Cf. Kempers (1994 ed.princ. in Dutch: 1987) and Pots (2000).
10 The term 'conspicuous consumption' was introduced by Veblen (1934).
11 Abbing (1992).
12 See note 10 of chapter 2.
13 Abbing (1989) 221-7.
14 Epstein (1967) and Lash (1968) 63-113. More references in: Guilbaut (1983) 237-8.
15 O'Hagan (1998) 8-11. The assistance offered artists in the thirties through the

Work's Progress Association, part of Roosevelt's New Deal is interesting.

16 For the Netherlands, see Pots (2000). He presents few figures, but the tenure of his analysis confirms the low level of support.

17 Although in the Netherlands, the initiative to support music and museums usually came from private people, the government usually joined forces at an early stage and soon began paying the larger share of the assistance. (Theatre was an exception.) Cf. Bevers (1993) 40-5. Nevertheless, until 1945 spending per capita was small compared with for instance France at that time as well as with the Netherlands fifty years later.

18 A different but related opinion is presented by Bevers (1992). Bevers emphasizes internal forces that promoted a degree of integration of the cultural, business, and political spheres.

19 The existence of national debts diminishes collective wealth, but because of the monopolies of the state, its power is still extraordinary.

20 Although it must be said that in general government display in the US, as in ostentatious ceremonies, an election or an inauguration, pomp and circumstance are very present.

21 The origin of present cultural policies and the organization of government power can be traced back to developments that took place many centuries ago, as Staay (1999) shows with respect to the Netherlands.

22 According to Pots (2000), who analyzed the history of government involvement in the arts in the Netherlands, Dutch art policy can be explained by noting two objectives: the wish to promote social coherence and the wish to educate or civilize people.

23 Some public broadcasting organizations like the BBC still receive considerable amounts, but less than they did in the past.

24 Bevers (1995) 422 also distinguishes cultural as an interest in and of itself or culture serving foreign policy.

25 Weil (1991) writes: "Not only do (the arts) provide a kind of social 'glue', but they also furnish a means by which society can identify and distinguish itself from others." In Weil's view however the second function becomes less important. (Also cited by O'Hagan (1998)).

26 Inez Boogaarts in (the Dutch paper) de Volkskrant 14-2-01.

27 Cf. Bevers (1995) 424.

28 Boogaarts (1999) discusses the actual ins and outs of Dutch cultural policy abroad since World War II. See also Bevers (1995).

29 Cf. Boogaarts (1991).

30 Janssen (2001) writes: "...it is clear that funding bodies are no more neutral than any social organization, and that the success of some artists in gaining sponsorship and the failure of others is likely to be related to the type of work they do." See also Pearson (1980).

31 At present, Dutch government officials are more aware of the limitations of government choice. They admit that the government cannot be neutral, as well as that the government does not necessarily make better choices. At a conference at the Erasmus University in December 1999, the highest civil servant in charge of Dutch art-policy cited Commandeur (1999) who presented three lists of names of visual artists: one of artists favored by the government, another of artists favored by the market, and a third of artists favored by both. His position was amazingly modest. He emphasized that by having a taste of its own, the government could complement the market.

32 Quality judgments within an art form are sometimes changeable. For instance

in the first illustration to Chapter 11 shows that in the eighties Dutch government bodies rather abruptly started to subsidize artists, who made figurative work, and who could not get subsidies a few years earlier. Only the notion that a government has a taste and is not neutral can explain these phenomena.

33 Various histories contribute to differences in status. By generalizing greatly, the following can be noted. On the one hand, jazz and pop music developed outside the music establishment and so could not easily usurp the high status owned by classical music. The chances of contemporary musicians were better, but they basically stayed submissive with respect to their predecessors. On the other hand, avant-garde visual artists developed their art from within the establishment and at the same time challenged their predecessors and so managed to take over their high status relatively easily.

34 Council (2000).

35 Swaan (1988) 230.

36 The arts experts regime covers approximately the same area as what Bevers (1993) 191 calls 'the specialists of organized culture'.

37 The latter regimes ensure the fulfillment of established social rights to health care, social security, and education. After centuries of collective actions, these regimes represent the most recent stage in the development of these social rights. Cf. Swaan (1988). According to Abbing (1992) the arts have no history of substantial collective action and therefore no social right to art ever became established.

38 In this sense, governments joined the larger group of mediators who Bourdieu (1977) had already called 'co-producers' of the work of art.

39 Cf. O'Hagan (1998) 3-13 who presents a short historic account of the evolution of state involvement in Western Europe and the US.

40 Mulcahy (2000) 173.

41 Benedict (1991) 54.

42 Mulcahy (2000) 171.

43 Montias (1983). (Also cited by O'Hagan (1998)).

44 These companies also sponsor music, but this is less exceptional as they almost exclusively sponsor risk-free old music.

45 O'Hagan (1998) 139 and 156. O'Hagan, 104-30, presents an illuminating survey of the many forms of tax concessions.

46 Mulcahy (2000) 178. In other words, the government indirectly increases the power of money and the power to define art – Chapter 3 – of mainly the wealthy and the corporations. The US government sides with the power of money, while European governments sides with the 'power of the words' of experts.

11 Informal Barriers Structure the Arts

1 In the Netherlands, the most prestigious grants are the '*werkbeurs*' and the '*start-stipendium*'. The first is for artists with a body of outstanding and innovative work, who have been working professionally for more then two years. The latter is for beginning artists who are particularly promising. The third, the '*basis-stipendium*', is somewhat less prestigious and a bit easier to get, as its aim is not only to promote quality, but also to improve the economic situation of artists.

2 Without the sign, both consumers and the higher quality producers would be worse off. Akerlof (1970) analyzed asymmetric information. Spence (1974) introduced a model of signaling. Explanations of either phenomenon can be found

in any recent textbook on microeconomics, for instance Varian (1999) 641-53.

3 Cf. Janssen (2001) 333-5. Janssen presents a number of references.

4 I shall show that insider-discourses exist in the arts as well, which sometimes effectively exclude intruders. Nevertheless, the implicit barriers are not dependent on an official authority, and therefore they are informal rather than formal barriers.

5 Moreover, the push for unemployed self-taught artists receiving social benefits to find non-arts employment is no greater than it is on trained artists in the Netherlands.

6 Cf. Towse (1996b) 317 and 322. For artists seeking an attractive second job in art teaching these degrees are not irrelevant because unlike in the arts, degrees matter in the teaching profession.

7 Filer (1986), Towse (1992), Throsby (1992) and Throsby (1996a). Throsby however, also concluded that the trained artist is better of in arts-related jobs, like teaching. Diplomas are required for a number of teaching jobs, but in the Netherlands these are not diplomas issued by art schools but by schools that teach people to become art teachers. The only situation that contradicts the notion of the absence of formal control in the arts is the one of artists connected to American universities, who work as artists-in-residence or who have a small teaching assignment in exchange for a good salary and the use of working facilities. These artists usually need diplomas, but not always.

In this context it is worth mentioning that Filer (1987) argues that arts education is a form of general education, and that those who leave the arts find relatively well-paid jobs outside the arts.

Towse (1996b) (and Towse (2001) 483-4) argues that because self-taught artists do as well as trained artists, the choice to go to art school cannot be explained by the educational benefits, as one might expect from the human capital approach or from a winner-take-all perspective. Instead, it can be explained in the process of signaling, screening, and learning about one's own abilities. Students have more chance of being selected by the various arts intermediaries. In my view however, increased capabilities also matter. Towse remarks that self-taught artists are as successful as trained artists, but it should be noted that it's mostly successful self-taught artists who get noticed. Therefore, for every successful self-taught artist there may well be an army of failed self-taught artists much larger than the numbers of failed trained artists that disappear behind each successful trained artist. See also Rengers and Plug (2001) note 9.

8 At the university level however, a numerus clausus generally only existed when professions were unusually powerful, as in the medical fields in Europe.

9 On the contrary, as already noted in 6.5, it is likely that the pressures applied by the art lobbies helped increased enrollments even more in order to offer teaching jobs to the growing number of artists with not enough work as artists. In this respect, Menger (1999) 607 suggests that the training system both adapts and contributes to the 'oversupply' of artists. Towse (1996b) 318-19 mentions the existence of a 'training lobby' in the UK, which is engaged in rent seeking. It has a financial incentive to supply more training positions to students.

10 Cf. Janssen (2001) 335.

11 Cf. Frey and Pommerehne (1989), Moulin (1987, ed princ in French 1967) and White and White (1995).

12 Even by increasing its membership and by organizing a 'Salon des Refugés' the French Academy could not control the large number of newcomers. The Impressionists, for instance, became generally known and successfully sold paintings

that did not conform to the style of the Academy. Unlike before, newcomers could now become successful without being accepted by the Academy. Cf. Jensen (1994) and White and White (1995).

13 Unlike other European countries, the Netherlands has never had strong formal control in the visual arts. In the seventeenth century, the market for visual art was larger and guilds were less active and restrictive than in other countries. Since then and up until the second half of the nineteenth century the art market was relatively weak in the Netherlands due to the economic stagnation. In the second half of the nineteenth century, the economic situation in the Netherlands began to improve and gradually the income and status of artists began to rise. Cf. Stolwijk (1998). At this time associations of artists with limited memberships indirectly helped to keep the total numbers of artists down. Large numbers began to emerge in the twentieth century and they put an end to the little control there had been.

14 Anheier and Gerhards (1991) remark that a status indeterminacy exists in the arts.

15 IJdens (1999) 221-231 remarks that the arts as a profession is self-made and not institutionalized. Kempers (1987) examined the ups and downs in the process of professionalization in the arts. He speaks of de- and reprofessionalization.

16 In the case of the fair, the barrier was more than just a price barrier. Even considering the high entrance fees, many more galleries applied to be in the fair than were admitted.

17 Gubbels (1995) 152-66.

18 The new regime involved in the fair and the subsidy plan did not last long. For a number of reasons, both the plan and the fair became more accessible again a few years later. Gubbels (1995) 152-66.

19 For instance on gatekeepers, see the section on Patrons, Gatekeepers and Critics in Albrecht, Barnett et al. (1970) and in Foster and Blau (1989) and White and White (1995). On classifications and reputations, see Janssen (1998) and Nooy (1993), on networks Crane (1976), Nooy (1993) and Peterson (1994) and on the mentor protege relationship Bourdieu (1979).

20 Instead of discourse, I could have used the term 'rhetoric'. Due to the work of McCloskey (1986) and Klamer and McCloskey (1988) the term 'rhetoric' sounds more familiar to economists than the term 'discourse'. In the present context the term 'discourse' is better, as 'rhetoric' is outward oriented – it wants to convince – while discourse is primarily a group affair.

21 Peterson and White (1989) gives an example of trumpet players. It reveals how important 'correct' attitudes can be for joining a group of studio musicians.

22 Cf. Rosengren (1985).

23 Zolberg (1990) uses the term 'support structure' instead of 'reward system'.

24 The expression 'uncertainty of taste' stems from Oosterbaan Martinius (1990).

25 In the arts, price as well can signal quality. For many consumers high and very high prices signal that a painting must be good. Cf. Velthuis (2002). However, this does not mean that any young painter can earn a lot of money simply by demanding high prices. Price only signals quality when combined with other signals.

26 The term 'appropriability' is used by Weinberg and Gemser (2000).

27 Abbing (1980).

28 Goodman's approach to art, presented in Chapter one, also emphasizes renewal, the renewal of symbol systems. Cf. Goodman (1954).

29 Singer (1981a).

30 This phenomenon is part of the production of belief in the arts as described by Bourdieu (1977).

31 Using variety and continuity as criteria Crane (1976) has evaluated the reward systems in art, science, and religion. Zolberg (1990) also treats this subject. As noted, she uses the term 'support structure' instead of 'reward system'.

32 If committee members are ignorant of the discourse, they will keep this hidden. In this case, one or two committee members can end up decisively influencing decisions. Cf. Hekkert and Wieringen (1993). This is one way that newcomers learn the discourse.

33 In his approach to art Goodman (1954) emphasizes that, although new art violates rules, it leaves the grammatical system largely intact. In this respect it is illustrative that 'revolutionaries' often stress that their approach is more true to the core, to the achievements of the great predecessors, than the present approach is, which they are challenging. Cf. Bourdieu (1977).

34 Parallels exist with the way paradigms change in science, as discussed by Kuhn (1962), and with respect to the way science is also thought to develop around more or less fixed cores, as suggested by Lakatos and Alan (1978).

35 Cf. Bourdieu (1977). Heilbron (1993), Strauss (1970) and Tas (1990) treat the mentor-protege relationship. Peterson and White (1989) used the terms 'rookies' and 'rebels' in their analysis of the market for the services of trumpet players.

36 As before the term 'risk' also covers uncertainty.

12 Conclusion: a Cruel Economy

1 Chapter 9 argues that the same applies to merit and market-failure arguments.

2 Menger (1999). To be precise, according to Linden and Rengers (1999) more artists leave the arts within a year and a half after graduating from college than other professionals do, but after the first two years they tend to remain longer, even if they continue to earn low incomes. When they leave at a later point in their careers, they are particularly prone to income penalties; financially they are worse off than if they had not become artists. (Those students who leave almost immediately after college could be among those for whom education is a form of consumption rather than a preparation for professional activities.) According to Filer (1987) however, the penalty is not that large.

3 As noted in Section 6.10, in that case a larger part of artistic activity would be transformed into leisure activities. Serious amateurs would become the main producers of art. They would have satisfying non-artistic jobs commensurate to their education levels. There would still be a few full time professional artists. The latter would have little extra status or maybe even less status than the amateurs. Art would turn into a truly privileged occupation again.

Irrespective of whether this kind of scenario is attractive or not, a number of reasons make it unlikely that this situation will occur any time soon. One reason is that most art forms currently demand considerable amounts of training. Therefore, potential artists need all their time for artistic training and thus have no time left over to be trained for attractive second jobs. Therefore, with the exception of teaching art, second jobs will remain largely unskilled labor. They continue to represent a necessary evil. Nevertheless, letting one's fantasies run wild, there could be a day in late-capitalism when Marx's ideal becomes true; people are free to go fishing or hunting, or, in the present context, to make music, poems, plays, and paintings. The economy of the arts would no longer be

merciless.
4 Gouldner (1960).
5 See Chapters 8, 9 and 10.
6 See Chapters 8 and 10.
7 See Section 9.8.
8 Goodman (1954) 225-65.
9 Durkheim (1964, ed princ 1914) 325-340 and Giddens (1978) 80-100.
10 See note 20 of chapter 1.
11 More will be said about the magic in art and science in the epilogue.
12 This point was discussed in Section 9.9.

Epilogue: the Future Economy of the Arts

1 Laermans (1996) would probably argue that not only my view of the economy of
 the arts is outdated, but also my analysis, which relies heavily on the habitus-
 field theory of Bourdieu. I address this notion in note 33 of Chapter 4.
2 This applies to *overall* donations and subsidies. In the US however, private indi-
 viduals have been decreasing the amounts they donate to the arts over the past
 few decades. Humanities (1997) 19.
3 This is not true in most European countries. In the Netherlands however, where a
 new and more restrictive government finance system for art schools was imple-
 mented in 2000, according to information from the ministry of OCW, the first
 signs indicate that at present fewer students are being admitted to the fine arts
 departments of Dutch art schools.
4 Laermans (1993).
5 This was reflected in an increase in literature on theatre management in Ger-
 many. Noordman (1989) 180.
6 These four types simultaneously differ from and are related to the integrated pro-
 fessionals of Becker (1982) Chapter 8.
7 For lack of a better alternative, I use 'postmodern artist' as a provisional expres-
 sion. Given the everyday connotation of 'postmodern' this adjective is the best I
 could come up with. However, these postmodern artists do not need to be con-
 nected with the postmodernist movement. Other adjectives like hybrid, bound-
 less, limitless, pluralist or unruly would be too specific in their connotations.
8 Personally, I think that this kind of ban is contrary to the very nature of art. I
 strongly believe that all great art both shocks *and* pleases.
9 Elias (1994, ed.princ. in German 1939).
10 Elias (1994, ed.princ. in German 1939) 488.
11 After the Second World War, a decline in control or a process of informalization
 may have set in, however. Whether this (1) applies to a sub-sector, (2) is tempo-
 rary, (3) plays a (sublimating) role within the overall process or (4) contradicts
 the civilizing process, is difficult to surmise. Cf. Wouters (1977). Art itself can
 be said to have become more informal. This is particularly evident in music with
 its shift from composition-based music to performer-based music – cf. Cowen
 (1998).
12 Goodman (1954) 225-65.
13 Elias (1994, ed.princ. in German 1939) 475-492.
14 Goodman (1954).
15 Deirdre McCloskey suggested the use of the term 'charm' to me. It fits well into
 her and Klamer's approach to the rhetoric of economics. Cf. Klamer and Mc-

Closkey (1988).

16 Doorman analyzes seven types of borders, which are affected by erosion. Doorman (1997) 8-18. See also Braembussche (1994) 278-308 and Jameson (1991).

17 Cf. Peterson and Kern (1996) and Peterson (1997). They present more references.

18 Cf. Braembussche (1994) and Jameson (1991).

19 Doorman (1997) 28.

20 Cf. Heilbron (1993).

21 Bourdieu (1979).

22 Peterson and Kern (1996) also state that 'omnivorousness does not imply an indifference to distinctions'.

23 Given my limited intentions in this chapter, I treat technological change as a given. Technological 'progress' is, however, not a force of nature, but a cultural product. Cf. Schwarz (1999).

24 Cf. Standage (1999).

25 Benjamin (1974).

26 Cf. Braembussche (1994) 239-240. Whereas Benjamin applauded these developments, Adorno (Adorno and Bernstein (1991, 1949-1968)) feared above all the consequential loss of autonomy.

27 Goodman (1954) 113-123.

28 Painting as an autographic art form is a different matter. In the case of painting, in general there is only one original; reproductions are not originals but copies. Cf. Goodman (1954) 113-123. Copies often do not have certain aspects that the originals have, which may be essential to the work of art – in this they are of a different order than copies of a book or a CD. Nevertheless, given the high quality of modern reproduction techniques, this fundamental difference has become a difference of degree. High quality reproductions of photographs, for instance, are not originals, but it can be argued that as copies they are almost perfect and that therefore the creativity and authenticity of the original is still largely present in these copies. Moreover, in the autographic arts there has been a tremendous increase in artists making multiples or editions. All of these works of art are considered originals. In graphics and photography, the numbers of editions remain relatively small. In film and video, they can be quite large. And with digitally created sounds and images, editions can be almost limitless; often their number is beyond the control of the artists and their publishers.

29 Adorno, contrary to Benjamin, emphasizes that reproduced works of art can become mystified as well; they are 'more' than the things themselves. Adorno (1970) 73 cited by Braembussche (1994) 244.

30 Cf. Hilhorst (1999).

Literature

Abbing, H. (1978). *Economie En Cultuur*. 's-Gravenhage: Staatsuitgeverij

Abbing, H. (1980). On the Rationale of Public Support to the Arts: Externalities in the Arts Revisited. *Economic Policy for the Arts*. W.S. Hendon. Cambridge (Mass.)

Abbing, H. (1989). *Een Economie Van De Kunsten*. Groningen: Historische Uitgeverij Groningen

Abbing, H. (1992). Externe Effecten Van Kunst. Verklaring En Legitimering Van De Overheidsbemoeienis Met Kunst Op Lange Termijn. *Schoonheid, Smaak En Welbehagen. Over Kunst En Culturele Politiek*. D. Diels. Antwerpen: Dedalus: 171-212

Abbing, H. (1996). The Economics of the Artistic Conscience. A Veiled Economy. *The Value of Culture*. A. Klamer. Amsterdam: Amsterdam University Press

Adler, M. (1985). 'Stardom and Talent.' *American Economic Review* 75 (I): 208-12

Adorno, T. W. (1970). *Uber Walter Benjamin*. Frankfurt am Main, Tiedemann

Adorno, T. W. (1970-1986). *Gesammelte Werke*. Frankfurt am Main, Tiedemann

Adorno, T. W. and J. M. Bernstein (1991, 1949-1968). *The Culture Industry. Selected Essays on Mass Culture*. London, Routledge

Akerlof, G. (1970). 'The Market for Lemons: Quality Uncertainty and the Market Mechanism.' *The Quarterly Journal of Economics* 84: 488-500

Albrecht, M. C., J. H. Barnett, et al., Eds. (1970). *The Sociology of Art and Literature. A Reader*. London, Duckworth

Allen, J. P. and G. W. M. Ramaekers (1999). Hbo-Monitor 1998, De Arbeidsmarkt Van Afgestudeerden Van Het Hogerberoepsonderwijs. Den Haag, HBO-raad

Alper, N., G. Wassal, et al., Eds. (1996). *Artists in the Work Force: Employment and Earnings 1970-1990*. Santa Anna, National Endowment for the Arts; Seven Locks Press

Anderson, E. (1993). *Value in Ethics and Economics*. Cambridge, MA, Harvard University Press

Anheier, H. K. and J. Gerhards (1991). 'Literary Myths and Social Structure.' *Social Forces* 69: 811-30

Arnold, M. (1875). *Culture and Anarchy*. New York, Smith, Elder

Austen-Smith, D. (1980). On Justifying Subsidies to the Performing Arts. *Economic Policy for the Arts*. W.S. Hendon. Cambridge (Mass.)

Barthes, R. (1988). *The Semiotic Challenge*. New York, Hill and Wang

Baumol, H. and W. D. Baumol (1984). The Mass Media and the Cost Disease. *The Economics of Cultural Industries*. W.S. Hendon. Akron, The association for

cultural economics

Baumol, W. J. (1973). 'Income and Substitution Effects in the Lindner Theorem.' *Quarterly Journal of Economics* 87 (4): 629-33

Baumol, W. J. (1996). 'Children of Performing Arts, the Economic Dilemma: The Climbing Costs of Health Care and Education.' *Journal of Cultural Economics* 20 (3): 183-206

Baumol, W. J. (1997). Public Support for the Arts: Why and Wherefore. Washington, President's Committeee on the Arts and the Humanities

Baumol, W. J., S. A. W. Blackman, et al. (1985). 'Unbalanced Growth Revisited: Asymptotic Stagnancy and New Evidence.' *American Economic Review* 75: 806-17

Baumol, W. J., S. A. W. Blackman, et al. (1989). *Productivity and American Leadership: The Long View.* Cambridge, MA, MIT Press

Baumol, W. J. and W. G. Bowen (1965). 'On the Performing Arts: The Anatomy of Their Economic Problems.' *American Economic Review,* 57 (3): 495-502

Baumol, W. J. and W. G. Bowen (1966). *Performing Arts. The Economic Dilemma.* New York: The Twentieth Century Fund

Becker, G. S. (1976). *The Economic Approach to Human Behavior.* Chicago: The University of Chicago Press

Becker, G. S. (1996). *Accounting for Tastes.* Cambridge, Massachusetts etc., Harvard University Press

Becker, H. S. (1982). *Art Worlds.* Berkeley, University of California Press

Benedict, S. (1991). *Public Money and the Muse.* New York, Norton

Benhamou, F. (2000). 'The Opposition between Two Models of Labour Market Adjustment: The Case of Audiovisual and Performing Arts Activities in France and Great Britain over a Ten Year Period.' *Journal of Cultural Economics* 24: 301-19

Benjamin, W. (1974). Das Kunstwerk Im Zeitalter Seiner Technischen Reproduzierbarkeit (1935). *Gesammelte Schriften.* W. Benjamin. R. Tiedeman & H. Schweppenhuser, ed. 6 dln. I Frankfurt

Berg, H. O. v. d. (1994). 'Autonomie in De Kunsten: Een Hardnekkige Illusie.' *Boekmancahier* 6 (19): 50-3

Bevers, T. (1992). *De Georganiseerde Cultuur: De Rol Van Overheid En Markt in De Kunstwereld.* Antwerpen, Dedalus

Bevers, T. (1993). *Georganiseerde Cultuur. De Rol Van Overheid En Markt in De Kunstwereld.* Bussum, Coutinho

Bevers, T. (1995). 'Het Nederlands Internationaal Cultuurbeleid.' *Boekmancahier* 7 (26): 422-7

Blaug, M. (1980). *The Methodology of Economics.* Cambridge, Cambridge University Press

Blaug, M. (1996). 'Final Comments on the Plenary Session on Baumol and Bowen.' *Journal of Culural Economics* 20 (3): 249-50

Blaug, M. (2001). 'Where Are We Now in Cultural Economics.' *Journal of Economic Surveys* 15: 123-43

Blokland, H. (1992). Een Politieke Theorie over Kunst En Economie. *Schoonheid, Smaak En Welbehagen.* D. Diels. Antwerpen, Dedalus: 13-54

Blokland, H. (1997 ed. princ. in Dutch 1991). *Freedom and Culture in Western Society.* London, Routledge

Bloom, A. (1987). *The Closing of the American Mind.* New York, Simon and Schuster

Boogaarts, I. (1991). 'Stad, Kunst En Cultuur: De Nieuwe Rol Van De Kunst in De

Stad.' *Boekmancahier* 3 (7): 26-36

Boogaarts, I. (1999). 'From Holland Promotion to International Cultural Policy.' *Boekmancahier* 11 (42): 368-79

Boogaarts, I. and K. Hitters (1993). 'Financiering Van De Kunst in De Vs.' *Boekmancahier* 5 (16): 162-77

Bourdieu, P. (1977). The Production of Belief: Contribution to an Economy of Symbolic Goods. *The Field of Cultural Production. Essays on Art and Literature. Edited by Randall Johnson.* Oxford: Polity Press, 1992

Bourdieu, P. (1979). *Distinction. A Social Critique of the Judgement of Taste.* London, Routledge and Kegan Paul, 1986

Bourdieu, P. (1983). 'The Field of Cultural Production, Or : The Economic World Reversed.' *Poetics* (12): 311-56

Bourdieu, P. (1986). The Forms of Capital. *Handbook of Theory and Research for the Sociology of Education.* J. G. Richardson. New York, Greenwood Press

Bourdieu, P. (1990). *The Logic of Practice.* Cambridge: Polity Press

Bourdieu, P. (1992). *An Invitation to Reflexive Sociology.* Cambridge: Polity press

Bourdieu, P. (1997, 1996). Marginalia - Some Additional Notes on the Gift. *The Logic of the Gift, toward an Ethic of Generosity.* A. D. Schrift. New York, Routledge

Braembussche, A. A. v. d. (1994). *Denken over Kunst. Een Kennismaking Met De Kunstfilosofie.* Bussum, Coutinho

Braembussche, A. v. d. (1996). The Value of Art. A Philosophical Perspective. *The Value of Culture. On the Relationship between Economics and Art.* A. Klamer. Amsterdam, Amsterdam University Press: 31-43

Buchanan, J. M. G. T. (1962). *The Calculus of Consent. Logical Foundations of Constitutional Democracy.* Michigan: The University of Michigan Press

Calcar, C. v. and J.K. Koppen (1984). *Cultureel Kapitaal: Op Weg Naar Een Instrument.* Amsterdam: Stichting Kohnstam Fonds

Commandeur, I. (1999). 'Het Gelijk En Ongelijk Van Riki Simons.' *Boekmancahier* 11 (Juni 1999): 117-30

Cordes, J. J. and R. S. Goldfarb (1996). The Value of Public Art as Public Culture. *The Value of Culture.* A. Klamer. Amsterdam, Amsterdam University Press: 77-95

Council, T. A. (2000). A Comparative Study of Levels of Arts Expenditure in Selected Countries and Regions. Dublin, The Arts Council

Cowen, T. (1996). 'Why I Do Not Believe in the Cost-Disease. Comment on Baumol.' *Journal of Culural Economics* 20: 207-14

Cowen, T. (1998). *In Praise of Commercial Culture.* Cambridge, Mass., Harvard University Press

Cowen, T. and R. Grier (1996). 'Do Artists Suffer from a Cost-Disease.' *Rationality and Society* 8 (1): 5-24

Crane, D. (1976). 'Reward Systems in Art, Science, and Religion.' *American Behavioral Scientist* 19: 719-34

Cwi, D. (1980). 'Public Support of the Arts: Three Arguments Examined.' *Journal of Cultural Economics,*: 455 p.

Dahl, R. A. (1956). *A Preface to Democratic Theory.* Chicago, University of Chicago Press

Dahl, R. A. (1985). *A Preface to Economic Democracy.* Berkeley: University of California Press

Danto, A.C. (1964). 'The Artworld.' *The Journal of Philosophy* 61

Danto, A.C. (1986). *The Philosophical Disenfranchisement of Works of Art*. New York, Colombia University Press

Dickie, G. (1971). *Aesthetics: An Introduction*. Indianapolis, Pegasus

DiMaggio, P. J. (1987). 'Classification in Art.' *American Sociological Review* 52: 440-55

Doorman, M. (1994). *Steeds Mooier. Over Vooruitgang in De Kunst*. Amsterdam, Bert Bakker

Doorman, M. (1997). *Grensvervaging in De Kunst*. Amsterdam, Stichting Fonds voor Beeldende Kunsten, Vormgeving en Bouwkunst

Dun, L. v., G. Muskens, et al. (1997). *Ex-Bkr-Kunstenaars in Het Rijkscircuit. Een Vergelijkend Onderzoek Naar Erkenning En Inkomstenvorming*. Zoetermeer, Ministerie van OCenW

Durkheim, E. (1964, ed princ 1914). The Dualism of Human Nature and Its Social Conditions. *Emile Durkheim [Et All] Essays on Sociology and Philosophy*. K. H. Wolff. New York, The Academy Library: 325-40

Eijck, K. v. (1999). 'Socialization, Education and Lyfestyle: How Social Mobility Increases the Cultural Heterogeneity of Status Groups.' *Poetics* 26: 309-28

Elias, N. (1981, ed princ 1970). *Was Ist Soziologie*. München, Juventa

Elias, N. (1994, ed.princ. in German 1939). *The Civilizing Process*. Oxford, Blackwell, 1993

Elstad, J. I. (1997). 'Collective Reproduction through Individual Efforts: The Location of Norwegian Artists in the Income Herarchy.' *European Journal of Culturral Policy* (June 1997)

Epstein, J. (1967). 'The C.I.A. And the Intellectuals.' *New York Review of Books* (April 20): 16-21

Ernst, K. (1999). *Variations on a Theme. From Cultural Policy to Subsidies for Visual Artists*. Rotterdam, The Erasmus Center for Art and Culture

Feist, A. and R. Hutchison (1990). Cultural Trends 1990. London, Policy Studies Institute

Filer, R.K. (1986). 'The "Starving Artist" - Myth or Reality? Earnings of Artists in the United States.' *Journal of Political Economy* 94 (1 (feb)): 56-75

Filer, R. K. (1987). *The Price of Failure: Earnings of Former Artists*. Artists and Cultural Consumers, Akron, Association for Cultural Economics

Finney, H. C. (1995). 'The Stilistic Games That Visual Artists Play.' *Boekmancahier* 7 (23): 23-34

Forbes (1998-1999). *Forbes Global Business and Finance*

Foster, A. W. and J. R. Blau, Eds. (1989). *Art and Society. Readings in the Sociology of the Arts*. Albany NY, State University of New York Press

Frank, R. H. and P. J. Cook (1995). *The Winner-Take-All Society*. New York etc., The Free Press

Freidson, E. (1990). Labor of Love: A Prospectus. *The Nature of Work: Sociological Perspectives*. K. Erikson and S. P. Vallas. New Haven, Yale University Press: 149-61

Frey, B. S. (1997). *Not Just for the Money. An Economic Theory of Human Behaviour*. Cheltenham, U.K. and Brookfield, U.S.A., Edward Elgar

Frey, B. S. (1999). 'State Support and Creativity in the Arts: Some New Considerations.' *Journal of Cultural Econonmics* 23: 71-85

Frey, B. S. and W. Pommerehne (1989). *Muses and Markets. Explorations in the*

Economics of the Arts. Oxford, Basil Blackwell

Fullerton, D. (1991). 'On Public Justification for Public Support of the Arts.' *Journal of Cultural Economics*: 67-82

Getzels, J. W. and M. Czikszentmihalyi (1976). *The Creative Vision. A Longitudinal Study of Problem Finding in Art*. New York, Wiley

Giddens, A. (1978). *Durkheim*. Hassocks, Sussex, The Harvestor Press

Gogh, V. v. (1980). *Een Leven in Brieven*. Amsterdam: Meulenhoff

Goodman, N. (1954). *Languages of Art, an Approach to a Theory of Symbols*. Londen: Oxford University Press, 1968

Goudriaan, R. (1990). 'Kunst En Consumentengunst. Een Economische Benadering.' *Boekmancahier* 2: 245-62

Goudsblom, J. (1977). *Sociology in the Balance: A Critical Essay*. Oxford, Blackwell

Gouldner, A. (1960). 'The Norm of Reciprocity: A Preliminary Statement.' *American Sociological Review* 25 (2): 161-78 (Also in: Komter, 1996)

Grampp, W. D. (1989). *Pricing the Priceless. Art, Artists and Economics*. New York, Basic Books

Grampp, W. D. (1989a). 'Rentseeking in Arts Policy.' *Public Choice* (60): 113-21

Grauwe, P. d. (1990). *De Nachtwacht in Het Donker*. Tielt: Lanno

Gubbels, T. (1995). 'Korting En Krediet Voor Beeldende Kunst. De Rente Subsidieregeling.' *Boekmancahier* 7 (24): 193-204

Guilbaut, S. (1983). *How New York Stole the Idea of Modern Art*. Chicago, The University of Chicago Press

Haanstra, F., Koppen, J.K. & Oostwoud Wijdenes, J. (1987). Samenhang Onderwijs Beroepspraktijk in De Sector Van De Beeldende Kunsten. Zoetermeer/'s-Gravenhage: Distributiecentrum Overheidspublicaties

Hamlen, W. A. (1991). 'Superstardom in Popular Music: Empirical Evidence.' *Review of Economics and Statistics* (4): 729-33

Hegel, G. W. F. (1986, 1832-1845). *Vorlesungen Ueber Die Aesthetik*. Frankfurt am Main, Suhrkamp

Heilbron, J. (1993). Leerprocessen in De Beeldende Kunst. *Produktie, Distributie En Receptie in De Wereld Van Kunst En Cultuur*. T. Bevers. Hilversum, Verloren: 102-18

Heilbrun, J. and C. M. Gray (2001, ed princ 1993). *The Economics of Art and Culture. An American Perspective*. Cambridge USA, Cambridge University Press

Heinich, N. (1998). *Le Triple Jeu D'art Contemporain Sociologie Des Art Plastiques*. Paris, Edition de Minuit, Collection Paradoxe

Hekkert, P. and P. v. Wieringen (1993). Oordeel over Kunst. Kwaliteitsbeoordelingen in De Beeldende Kunst. Rijswijk, Ministerie van Welzijn, Volksgezondheid en Cultuur

Heusden, B. v. (1996). The Value of Culture: A Dialogue. *The Value of Culture*. A. Klamer. Amsterdam, Amsterdam University Press: 31-43

Hide, L. (1979). *The Gift. Imagination and the Erotic Life of Property*. New York, Vintage Books

Hilhorst, P. (1999). 'Het Onzichtbare Venster.' *De Groene Amsterdammer* 1999 (36)

Hitters, E. (1996). *Patronen Van Patronage. Mecenaat, Protectoraat En Markt in De Kunstwereld*. Utrecht, Uitgeverij Jan van Arkel

Hoogenboom, A. (1993). *De Stand Des Kunstenaars. De Positie Van Kunst-schilders in Nederland in De Eerste Helft Van De Negentiende Eeuw.* Leiden, Primavera Pers

Hoogerwerf, P. F. (1993). Spelen Met Geld. *Vakgroep Theaterwetenschap.* Utrecht, Universiteit Utrecht

Humanities (1997). *President's Committee on the Arts and the Humanities: Creative America. A Report to the President.* Washington, D.C.

Hütter, M. (1996). The Value of Play. *The Value of Culture.* A. Klamer. Amsterdam, Amsterdam University Press: 122-37

Hütter, M. (1997). 'From Public to Private Rights in the Arts Sector.' *Boekman-cahier* 9: 170-83

IJdens, T. (1999). *Schots En Scheef. Artistiek Werk Tussen Markt En Organisatie.* Rotterdam, Proefschrift Erasmus Universiteit Rotterdam

IJdens, T. and O. v. d. Vet (2001). *Het Flankerend Beleid Bij De Wik. Monitor 1999-2000.* Rotterdam, Erasmus Centrum voor Kunst- en Cultuurwetenschappen

Jameson, F. (1991). *Postmodernism, or, the Cultural Logic of Late Capitalism.* Durham, Duke University Press

Janowitz, B. B. (1993). 'Theatre Facts 92. Annual Survey of the Finances and Productivity of the American Nonproft Theatre.' *Theatre Facts* (April 1993): 2-15

Janssen, S. (1998). 'Art Journalism and Cultural Change: The Coverage of the Arts in Dutch Newspapers 1965-1990.' *Poetics* 25: 265-80

Janssen, S. (2001). The Empirical Study of Careers in Literature and the Arts. *The Psychology and Sociology of Literature.* D. Schram and G. Steen. Philadelphia, John Benjamins: 323-57

Jeffri, J. (1989). Information on Artists. New York, Colombia University, Research Center for Art and Culture

Jeffri, J. and D. Throsby (1994). 'Professionalim and the Visual Artist.' *European Journal of Cultural Policy* I: 99-108

Jenkins, R. (1992). *Pierre Bourdieu: Key Sociologists.* London, Routledge

Jensen, R. (1994). *Marketing Modernism in Fin-De-Siecle Europe.* Princeton, Princeton University Press

Jong, M.-J. d. (1997). *Grootmeesters Van De Sociologie.* Amsterdam Meppel, Boom

Kattenburg, P. (1996). The Value of Warhol. *The Value of Culture.* A. Klamer. Amsterdam, Amsterdam University Press: 205-13

Kellendonck, F. (1977). *Bouwval.* Amsterdam

Kempers, B. (1987). 'Symboliek, Monumentaliteit En Abstractie.' *Sociologisch Tijdschrift,*: 3-61

Kempers, B. (1994 ed.princ. in Dutch: 1987). *Painting, Power and Patronage.* London, Pinguin Books

Kempers, B. (1998). 'Van Maecenas Naar Modern Mecenaat: Twee Millenia Inhoud En Illusie.' *Tijdschrift voor Literatuurwetenschappen* 4: 258-72

Klamer, A. (1996). The Value of Culture. *The Value of Culture.* A. Klamer. Amsterdam: Amsterdam University Press

Klamer, A. and D. N. McCloskey (1988). *The Consequences of Economic Rhetoric.* Cambridge, Cambridge University Press

Klamer, A., A. Mignosa, et al. (2000). 'The Economics of Attention.' *Cultural*

Economics (Japan Association for Cultural Economics) 2 (March)

Klamer, A. and P. W. Zuidhof (1999). *The Values of Cultural Heritage Conservation: A Discussion.* Economics and Heritage Conservation, Los Angeles, The Getti Conservation Institute

Kohlberg, L. (1984). *The Psychology of Moral Development.* San Francisco, Harper and Row

Komter, A. E. (1996). *The Gift. An Interdisciplinary Perspective.* Amsterdam: Amsterdam University Press

Koopmans, L., A. H. E. M. Wellink, et al. (1999). *Overheidsfinanciën.* Houten, EPN

Kreuzer, H. (1971). *Die Boheme. Analyse Und Dokumentation Der Intellektuellen Subkultur Vom 19 Jahrhundert Bis Zur Gegenwart.* Stuttgart, J.B.Metzlersche Verlagbuchhandlung

Kuhn, T. S. (1962). *The Structure of Scientific Revolutions.* Chicago, 1972

Kushner, R. J. and A. C. Brooks (2000). 'The One-Man Band by the Quick Lunch Stand.' *Journal of Culural Economics* 24 (1): 65-77

Laermans, R. (1992). De Vergeten Openbaarheid Van Cultuur. *Schoonheid, Smaak En Welbehagen.* D. Diels. Brussel, Dedalus

Laermans, R. (1993). Splitting the Difference: Over Kunst, Massacultuur en Cultuurbeleid. *Sociaal-Democratie, Kunst, Politiek.* H. van Dulken and P. Kalma. Amsterdam, Boekmanstichting

Laermans, R. (1996). 'Complexiteit Als Opgave: Bourdieus Veldanalyse in Systeemtheoretisch Perspectief.' *Boekmancahier* 8 (30): 435-47

Lakatos, I. and M. Alan (1978). *Criticism and the Growth of Knowledge.* London, Cambridge University Press

Lamont, M. and M. Fournier, Eds. (1992). *Cultivating Differencies.* Chicago, The University of Chicago Press

Langenberg, B. J. (1999). *Collectief Arbeidsvoorwaardenoverleg in De Culturele Sector. Het Ontstaan Van Een Institutie.* Amsterdam, Boekmanstichting

Lannoye, M. C. (2000). Attitude. *Faculty of Culture and the Arts.* Rotterdam, Erasmus University

Lash, C. (1968). *The Agony of the American Left.* New York, Random House

Lavoye, D. (1990). *Economics and Hermeneutics.* London, Routledge

Leibenstein, H. (1950). 'Bandwagon, Snob and Veblen Effects in the Theory of Consumers' Demand.' *Quarterly Journal of Economics*: 200-20

Levine, L. W. (1988). *Highbrow/Lowbrow: The Emergence of Cultural Hierarchy in America.* Cambridge , M.A., Harvard University Press

Levi-Strauss, C. (1957 ed. princ. in French 1949). *Sociological Reason: A Book of Readings.* New York, Macmillan (The chapter 'The Principle of Reciprocity' has been reprinted in Komter 1996)

Lindblom, C. E. (1959). The 'Science of "Muddling through". *Public Administration Review.* XIX

Lindblom, C. E. (1990). *Inquiry and Change. The Troubled Event to Understand and Shape Society.* New Haven, Yale University Press

Linden, A. S. R. v. d. and M. Rengers (1999). Kunstenmonitor. De Arbeidsmarktpositie Van Afgestudeerden Van Het Kunstonderwijs 1997. Maastricht, Researchcentrum voor Onderwijs en Arbeidsmarkt

Linder, S. B. (1970). *The Harried Leisure Class.* New York, Colombia University Press

Linko, M. (1998). *Aitojen Elamysten Kaipuu [the Longing for Authentic Experi-*

ences]. Jyvaskyla, Finland, Research Unit for Contemporary Culture, publication no. 57. (Summary in English.)

Luhmann, N. (1995 ed. princip. 1984 in German). *Social Systems*. Stanford, Stanford University Press

Lyotard, J.-F. (1997, ed princ 1984). *The Postmodern Condition: A Report on Knowledge*. Manchester, Manchester University Press

MacDonald, G. W. (1988). 'The Economics of Rising Stars.' *American Economic Review* 78 (I): 155-66

Malinofsky, B. (1970 ed.princ. 1922). *Crime and Custom in Savage Society*. London, Routledge and Kegan Paul (The chapter: The Principle of Give and Take, is reprinted in: Komter 1996)

Mauss, M. (1990 ed.princ. in French: 1923). *The Gift. The Form and Reason for Exchange in Archaic Societies*. London, Routledge

McCloskey, D. N. (1986). *The Rhetoric of Economics*. Brighton, Wheatsheaf Books

McCloskey, D. N. (1996). *The Vices of Economics. The Virtues of the Bourgeoisie*. Amsterdam, Amsterdam University Press

Menger, P.-M. (1999). 'Artists Labor Markets and Careers.' *Annual Reviews* 25: 541-74

Meulenbeek, H., N. Brouwer, et al. (2000). De Markt Voor Beeldende Kunst. De Markt En De Financiele Positie Van Beeldend Kunstenaars 1998. Zoetermeer, Instituut voor Economisch Onderzoek der Universiteit van Amsterdam in opdracht van het Ministerie van Onderwijs, Cultuur en Wetenschappen

Montias, J. (1983). Public Support for the Performing Arts in Europe and the United States. *Comparative Development Perspectives*. G. Ranis and R. West. Boulder Colorado, Westview Press

Montias, J. M. (1987). 'Cost and Value in Seventeenth-Century Dutch Art.' *Art History* 10 (4 (December)): 455-66

Moulin, R. (1987, ed princ in French 1967). *The French Art Market: A Sociological View*. New Brunswick, Rutger University Press

Mueller, D. C. (1997). *Perspectives on Public Choice: A Handbook*. Cambridge, Cambridge University Press

Mulcahy, K. V. (2000). 'The Abused Patron of Culture. Public Culture and Cultural Patronage in the United States.' *Boekmancahier* 12 (44): 169-81

Musgrave, R. A. (1959). *The Theory of Public Finance*. New York

Noordman, D. (1989). Kunstmanagement, Hoe Bestaat Het!? Amsterdam: Bioton, 183 p.

Nooy, W. d. (1993). *Richtingen En Lichtingen. Literaire Classificaties, Netwerken, Instituties*, Proefschrift Katholieke Universiteit Brabant

Nooy, W. d. (1996). 'De Kracht Van Verandering: Onvoorziene Effecten Van Het Nieuwe Beeldende-Kunstbeleid.' *Boekmancahier* 8 (29): 321-8

O'Brien, J. (1997). Professional Status as a Means of Improving Visual Artists' Income. London, Arts Council of England

O'Brien, J. and A. Feist (1997). Employment in the Arts and Cultural Industries: An Analysis of the 1991 Census. London, The Arts Council of England

OCW, Ministerie van (1999). Cultuur Als Confrontatie. Uitgangspunten Voor Het Cultuurbeleid 2001-2004. Zoetermeer, Ministerie van OCW

O'Hagan, J. (1998). *The State and the Arts. An Analysis of Key Economic Policy*

Issues in Europe and the United States. Cheltenham, Edward Elgar

O'Hagan, J. and D. Harvey (2000). 'Why Do Companies Sponsor Art Events? Some Evidence and a Proposed Classification.' *Journal of Culural Economics* 24: 205-24

Oliner, S. P. and P. M. Oliner (1988). *The Altruistic Personality: Rescuers of Jews in Nazi Europe.* New York, The Free Press, 1-13 and 249-216 (Reprinted in Komter, 1996)

Oosterbaan Martinius, W. (1990). Schoonheid, Welzijn, Kwaliteit. Kunstbeleid En Verantwoording Na 1945. Den Haag: Gary Schwartz SDU

Ostrower, F. (1995). *Why the Wealthy Give. The Culture of Elite Philanthropy.* Princeton, Princeton University Press

Peacock, A., E. Shoesmith, et al. (1982). *Inflation and the Performed Arts.* London, Arts Council of Great Britain

Peacock, A. T. (1969). Welfare Economics and Public Subsidies to the Arts. *The Economics of the Arts.* M. Blaug. Londen, 1976: 18: 151-61, 1994.)

Pearson, N. M. (1980). *The State and the Visual Arts: State Intervention in the Visual Arts since 1760.* London, Macmillan

Peterson, R. A. (1994). Cultural Studies through the Production Perspective. Progress and Prospects. *The Sociology of Culture: Emerging Theoretical Perspectives.* D. Crane. Cambridge, MA, Basil Blackwell

Peterson, R. A. (1997). *Creating Country Music. Fabricating Authenticity.* Chicago etc., The University of Chigago Press

Peterson, R. A. (1997). 'The Rise and Fall of Highbrow Snobbery as a Status Marker.' *Poetics* 25: 75-92

Peterson, R. A. and R. M. Kern (1996). 'Changing Highbrow Taste: From Snob to Omnivore.' *American Sociological Rewview* 61: 900-7

Peterson, R. A. and H. G. White (1989). The Simplex Located in Art Worlds. *Art and Society. Readings in the Sociology of the Arts.* A. W. Foster and J. R. Blau. Albany, N.Y., State University of New York Press: 243-59

Plattner, S. (1996). *High Art Down Home, an Economic Ethnogrphy of a Local Art Market.* Chicago & London, The University of Chicago Press

Ploeg, R. v. d. (1998). 'Is De Kostenziekte Te Genezen?' *Boekmancahier* 10 (38): 410-2

Polanyi, K. (1992, 1957). The Economy as Instituted Process. *The Sociology of Economic Life.* M. Grannovetter and R. Swedberg. Boulder etc., Westview Press

Pommer, E. and L. Ruitenberg (1994). *Profijt Van De Overheid III. De Verdeling Van Gebonden Inkomensoverdrachten.* Den Haag, Sociaal en Cultureel Planbureau

Pommerehne, W. W. and B. S. Frey (1990). 'Public Promotion of the Arts: A Survey of Means.' *Journal of Cultural Economics* 14: 73-92

Pots, R. (2000). *Cultuur, Koningen En Democraten. Overheid En Cultuur in Nederland.* Nijmegen, Sun

Puffelen, F. v. (1992). De Betekenis Van Impactstudies. *Boekmancahier.* 12: 181-91

Puffelen, F. v. (2000). *Culturele Economie in De Lage Landen. De Bijdrage Van Nederlandse Economen Aan Kunstbeleid En Kunstmanagement. Literatuurstudie.* Amsterdam, Boekmanstudies

Rengers, M. and C. Madden (2000). 'Living Art: Artists between Making Art and

Making a Living.' *Australian Bulletin of Labour* 26: 325-54

Rengers, M. and E. Plug (2001). 'Private or Public? How Dutch Visual Artists Choose between Working for the Market and the Government.' *Journal of Cultural Economics* 25: 1-20

Rengers, M. and O. Velthuis (2002). 'Seizing Price or Pricing Size.' *Journal of Cultural Economics* 26

Robbins, L. (1963). Art and the State. *Politics and Economics*. L.Robbins. Londen, MacMillan

Rosen, S. (1981). 'The Economics of Superstars.' *American Economic Review* 71: 845-58

Rosengren, K. E. (1985). 'Time and Literary Fame.' *Poetics* 14: 157-72

Rushton, M. (1999). 'Methodological Individualism and Cultural Economics.' *Journal of Cultural Economics* 23: 137-47

Sahlins, M. D. (1978). *Stone Age Economics*. London, Routledge (An abridged version of the chapter 'On the Sociology of Primitive Exchange' has been reprinted in Komker 1996)

Samuelson, P. A. (1954). The Pure Theory of Public Expenditure. *Review of Economics and Statistics*. XXXVI: 221 p.

Schouwburg- en Concertgebouw Directies, v. v. (2001). Theaters 1996 -1999. Totaalcijfers En Kengetallen Op Basis Van Het Theater Analyse Systeem. Amsterdam, Vereniging van Schouwburg- en Concertgebouw Directies

Schuster, M. D. (1985). *Supporting the Arts: An International Comparative Study*. Washington D.C., National Endownment for the Arts

Schwartz, B. (1967). 'The Social Psychology of the Gift.' *American Journal of Psychology* 73 (1): 1-11 (Also in Komter, 1996)

Schwarz, M. (1999). *Digitale Media in De Technologische Cultuur*. Zoetermeer, Ministerie van OCW

Scitovsky, T. (1983). Subsidies for the Arts: The Economic Argument. *Economic Support for the Arts*. J.L. Shanahan et al. Akron (Ohio): 69

Seaman, B. A. (1987). Arts Impact Studies: A Fashionable Excess. *Economic Impact of the Arts: A Source Book*. A. J. Radich and S. Schwach. Denver (Colo.), National Conference of State Legislatures

Sen, A. K. (1970). *Collective Choice and Social Welfare*. San Francisco, Holden-Day

Sen, A. K. (1982). *Choice, Welfare and Measurement*. Oxford, Basil Blackwell

Simmel, G. (1978 princ. ed. in German 1907). *The Philosophy of Money*. London, Routledge and Kegan Paul

Simon, H. (1982). *Models of Bounded Rationality*. Cambridge MA, MIT Press

Singer, L. P. (1981a). 'Rivalry and Externalities in Secondary Art Markets.' *Journal of Cultural Economics*, 5 (2): 39-57

Singer, L. P. (1981b). 'Supply Decisions of Professional Artists.' *American Economic Review* 71: 341-6

Smith, B. H. (1988). *Contingencies of Value. Alternative Perspectives for Critical Theory*. Cambridge, M.A.

Smithuijsen, C. (1997). 'Puriteins Kunstbeleid. Het Nederland Cultuurbestel Na De Religieuze Omslag.' *Boekmancahier* 9: 8-17

Smithuijsen, C. (2001). *Een Verbazende Stilte. Klassieke Muziek Gedragsregels En Sociale Controle in De Concertzaal*. Amsterdam, Boekmanstudies

Spence, M. (1974). *Market Signaling*. Cambridge, Mass, Harvard University Press

Staay, A. v. d. (1999). 'De Voorgeschiedenis Van De Nederlandse Cultuurpolitiek.' *Boekmancahier* 11 (42): 383-94

Standage, T. (1999). *The Victorian Internet*. London, Weidenfeld & Nicolson

Statistiek, C. B. v. d. (1996). Jaarboek Cultuur 1996. Voorburg Heerlen, Centraal Bureau voor de Statistiek

Statistiek, C. B. v. d. (2000). Budgetonderzoek 1998. Voorburg/Heerlen, Centraal Bureau voor de statistiek

Staveren, I. v. (1999). *Caring for Economics. An Aristotelian Perspective*. Delft, Oberon

Stolwijk, C. (1998). *Uit De Schilderswereld. Nederlandse Kunstschilders in De Tweede Helft Van De Negentiede Eeuw*. Leiden, Primavera Pers

Strauss, A. (1970). The Artschool and its Students: A Study and an Interpretation. *The Sociology of Art and Literature. A Reader*. M.C. Albrecht et al. London, Duckworth

Struyk, I. and M. Rengers (2000). Rollen En Rolpatronen. Loopbanen Van Mannen En Vrouwen in De Podiumkunsten. Amsterdam, Theater Instituut Nederland

Swaan, A. d. (1986). *Kwaliteit Is Klasse. De Sociale Wording En Werking Van Het Cultureel Smaakverschil*. Amsterdam, Bert Bakker

Swaan, A. d. (1988). *In Care of the State: Health Care, Education and Welfare in Europe and the Usa in the Modern Era*. Cambridge, Polity Press

Tas, J. v. d. (1990). *Kunst als Beroep en Roeping*. Zeist, Kerckebosch

Throsby, D. (1992). Artists as Workers. *Cultural Economics*. R. Towse and A. Khakee. Berlin, Springer Verlag: 201-8

Throsby, D. (1994). 'The Production and Consumption of the Arts: A View of Cultural Economics.' *Journal of Economic Literature* 32 (March 1994): 1-29

Throsby, D. (1994a). A Work-Preference Model of Artist Behaviour. *Cultural Economics and Cultural Policies*. A. Peacock and I. Rizzo. Dordrecht etc., Kluwer Academic Publishers

Throsby, D. (1996). 'Economic Circumstances of the Performing Artist: Baumol and Bowen Thirty Years On.' *Journal of Culural Economics* 20 (3): 225-40

Throsby, D. (1996a). Disaggregated Earnings Functions for Artists. *Economics of the Arts – Selected Essays*. V. A. Ginsburgh and P. M. Menger. Amsterdam, Elsevier

Throsby, D. (1999). 'Cultural Capital.' *Journal of Cultural Economics* 23: 3-12

Throsby, D. (2000). *Economics and Culture*. Cambridge, Cambridge University Press

Throsby, D. and G. Withers (1986). 'Strategic Bias and Demand for Public Goods: Theory and an Application to the Arts.' *Journal of Public Economics* 31

Towse, R. (1992). The Earnings of Singers: An Economic Analysis. *Cultural Economics*. R. Towse and A. Khakee. Heidelberg, Springer-Verlag: 209-17

Towse, R. (1992). *The Economic and Social Characteristics of Artists in Wales*. Cardiff, Welsh Arts Council

Towse, R. (1993). *Singers in the Marketplace. The Economics of the Singing Profession*. Oxford, UK, Clarendon Press

Towse, R. (1996a). 'Comment's on David Throsby's Paper.' *Journal of Cultural Economics* 20: 245-7

Towse, R. (1996b). Economics of Training Artists. *Economics of the Arts*. V. A. Ginsburgh and P.-M. Menger. Amsterdam etc., Elsevier Science B.V.: 303-30

Towse, R., Ed. (1997). *Baumol's Cost Disease. The Arts and Other Victims*. Cheltenham, etc., Edward Elgar

Towse, R. (2001). 'Partly for the Money: Rewards and Incentives to Artists.' *Kyk-*

los 54: 473-90

Uitert, E. v. (1986). *Het Geloof in De Moderne Kunst*. Amsterdam, Meulenhof/Landshoff

Varian, H.R. (1999). *Intermediate Microeconomics*. New York, Norton

Veblen, T. (1934). The Theory of the Leisure Class. New York: Modern Library

Velthuis, O. (2002). 'Cultural Meanings of Prices. Constructing the Value of Contemporary Art in Amsterdam and New York Galleries.' *Theory & Society* 31 (forthcoming)

Velthuis, O. (2002a). *Talking Prices. Contemporary Art on the Market in Amsterdam and New York*. Unpublished Dissertation, Erasmus University Rotterdam

Wassall, G. H. and N. O. Alper (1992). Towards a Unified Theory of the Determinants of the Earnings of Artists. *Cultural Economics*. R. Towse and A. Khakee. Heidelberg, Springer-Verlag

Weil, S. (1991). Tax Policy and Private Giving. *Public Money and the Muse: Essays on Government Money for the Arts*. S. Benedict. New York, Norton

Weinberg, N. and G. Gemser (2000). 'Adding Value to Innovation: Impressionism and the Transformation of the Selection System in the Visual Arts.' *Organisation Science* 11: 323-9

White, H. C. and C. A. White (1995). *Canvases and Careers*. New York, Wiley

Wijngaarden, G. J. v. (1995). 'Het Succes van Kunstsponsoring in Nederland.' *Boekmancahier* 7: 35-47

Williamson, O. E. (1986). *Economic Organisation: Firms, Markets and Policy Control*. New York, New York University Press

Wilson, J. Q. (1989). *Bureaucracy*. New York, Basic Books

Wolfson (1988). *Publieke Sector En Economische Orde*. Groningen, Wolters-Noordhoff

Woude, v. d. (1987). The Volume and Value of Painting in Holland at the Time of the Dutch Republic. *Art in History, History in Art*. D. Freedberg and J. d. Vries. Chicago, The Getty Center for the History of Art and the Humanities

Wouters, C. (1977). Informalisation and the Civilising Process. *Human Figurations. Essays for Norbert Elias*. P. R. Gleichmann, J. Goudsblom and H. d. Korte. Amsterdam: 557 p.

Zolberg, V. L. (1990). *Constructing a Sociology of the Arts*. Cambridge, Cambridge University Press

Index of names

Index of subjects